LAURENT AMIOT

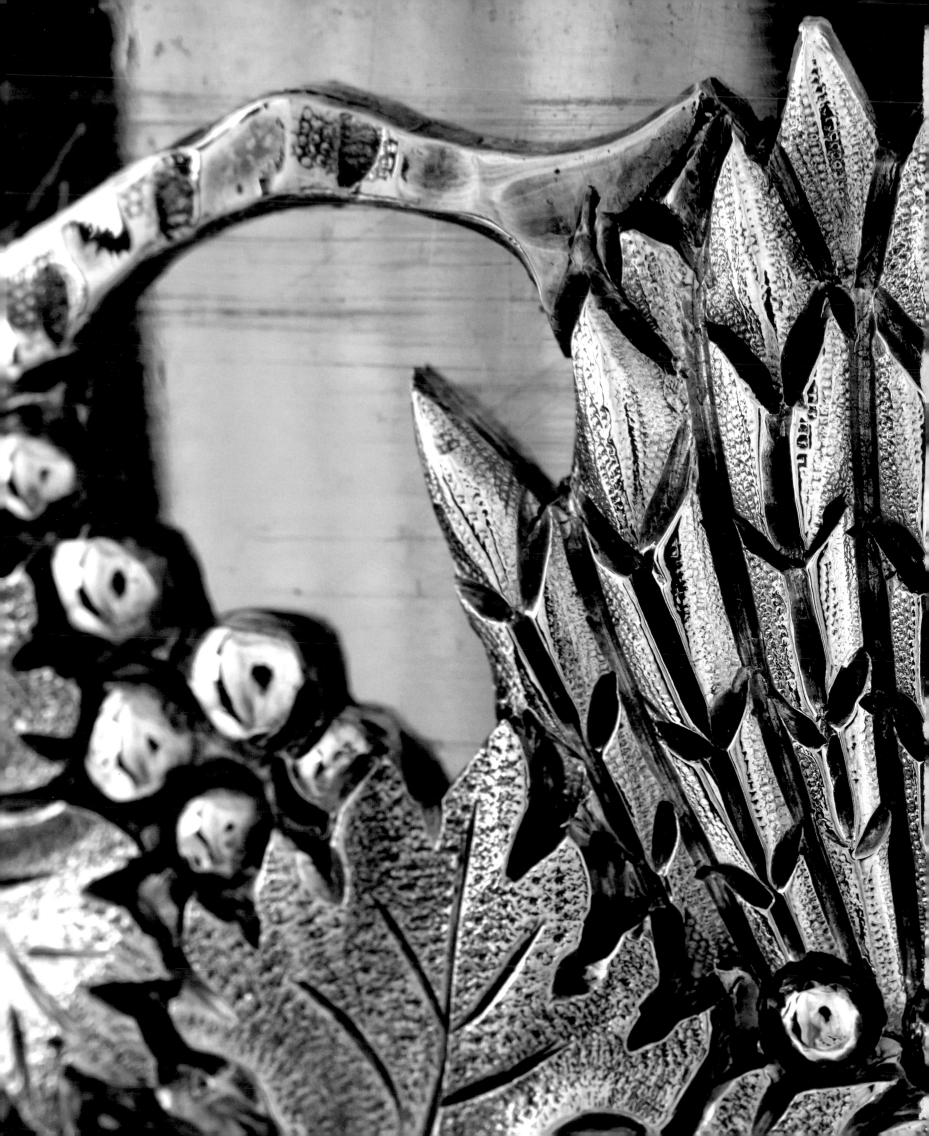

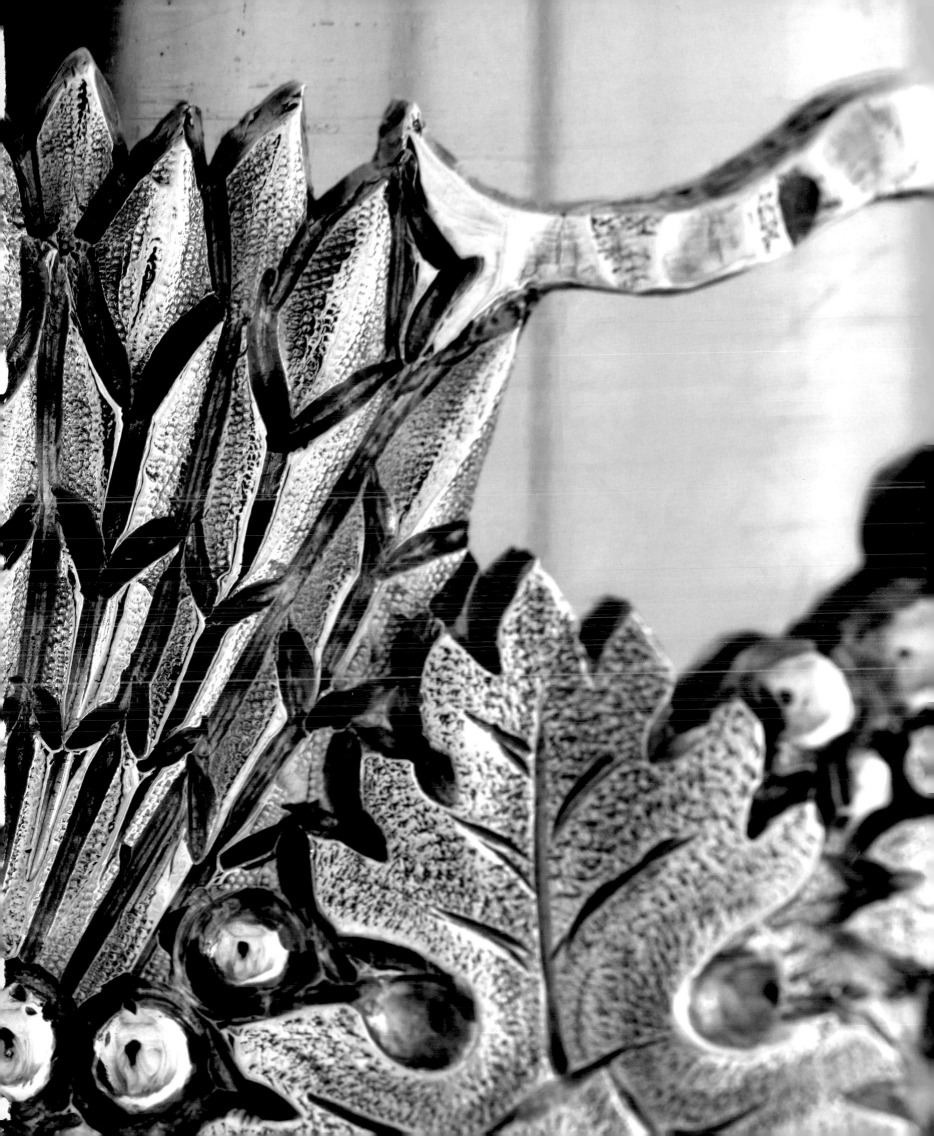

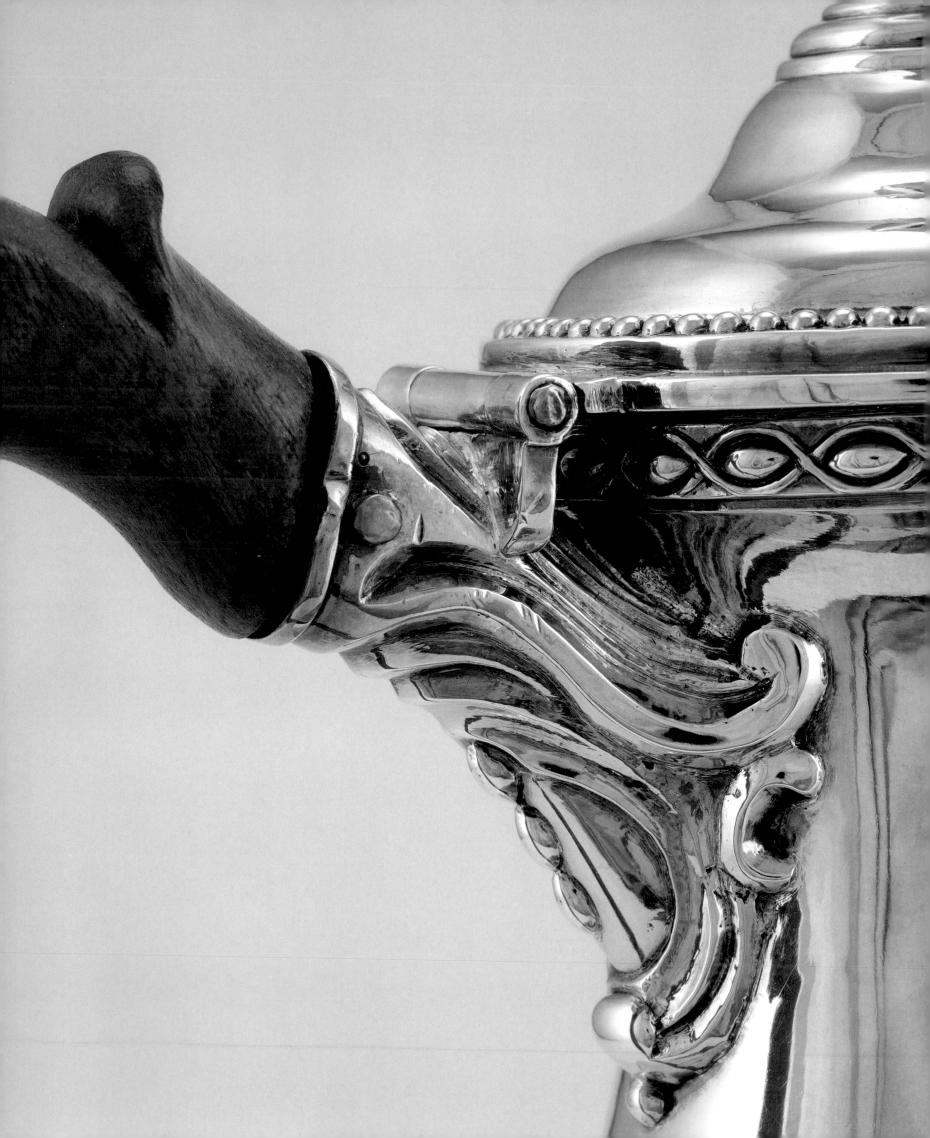

RENÉ VILLENEUVE

LAURENT AMIOT

CANADIAN MASTER SILVERSMITH

National Gallery of Canada, Ottawa
Figure 1 Publishing, Vancouver
2018

Published in conjunction with the exhibition
Laurent Amiot: Canadian Master Silversmith, organized by
the National Gallery of Canada and presented in Ottawa
from 11 May to 23 September 2018.

National Gallery of Canada
Chief, Publications and Copyright: Ivan Parisien
Editor: Caroline Wetherilt
Picture Editor: Andrea Fajrajsl
Production Manager: Anne Tessier

Translator: Judith Terry
Designed and typeset in Caecilia by Réjean Myette
Printed in Italy on GardaMatt by Conti Tipocolor

Front cover: *Reliquary-Monstrance of Saint Charles Borromeo* (detail), c. 1823 (cat. 52)
Back cover: *Censer of Saint-Joachim* (detail of the maker's mark), 1788 (cat. 1)
pp. 2–3: *Chalice of Saint-Ambroise-de-la-Jeune-Lorette* (detail), 1811 (cat. 29)
p. 4: *Coffee Pot of the Le Moine Family* (detail), c. 1796 (cat. 15)
p. 8: *Bowl of the Hanging Sanctuary Lamp of Repentigny* (detail), 1788 (cat. 3)

Cataloguing data available from Library and Archives Canada.

ISBN 978-1-77327-041-8

Co-published and distributed by
Figure 1 Publishing Inc.
Vancouver, BC, Canada
www.figure1publishing.com

Photo credits

Images were provided by the owners or custodians of the works
reproduced, except where noted below:

Photo NGC: cats. 1–17, 19, 20, 22, 24, 25, 27–39, 41, 51–58, 60–62,
64–66, 69, 71–75, 81, 83, 84, 86, 91; figs. 1.7, 2.1–2.5, 2.11, 3.2–3.6,
3.8–3.10, 3.12, 3.14

With permission of the Royal Ontario Museum © ROM:
figs. 3.11, 3.15

Image © The Metropolitan Museum of Art / Image source:
Art Resource, NY: cat. 18

With permission of the Royal Ontario Museum © ROM.
Photo Brian Boyle: cats. 21, 26, 42, 44–50, 63, 89

Photo MMFA/MBAM, Denis Farley: cat. 23; maker's mark
photographed by Christine Guest

Photo MNBAQ, Idra Labrie: cats. 40, 67, 68

Musée de la civilisation, collection du Séminaire de Québec,
photographe: Jessy Bernier – Perspective Photo, 1992.325: cat. 70

Courtesy the Winterthur Library, Printed Book and Periodical
Collection: cat. 76

© Victoria and Albert Museum, London: cats. 77, 79, 80

© McCord Museum: cat. 82

Photo MNBAQ, Patrick Altman: cat. 85

Musée de la civilisation, collection de l'Archevêché de Québec,
1993.53859: cat. 90

Canada

CONTENTS

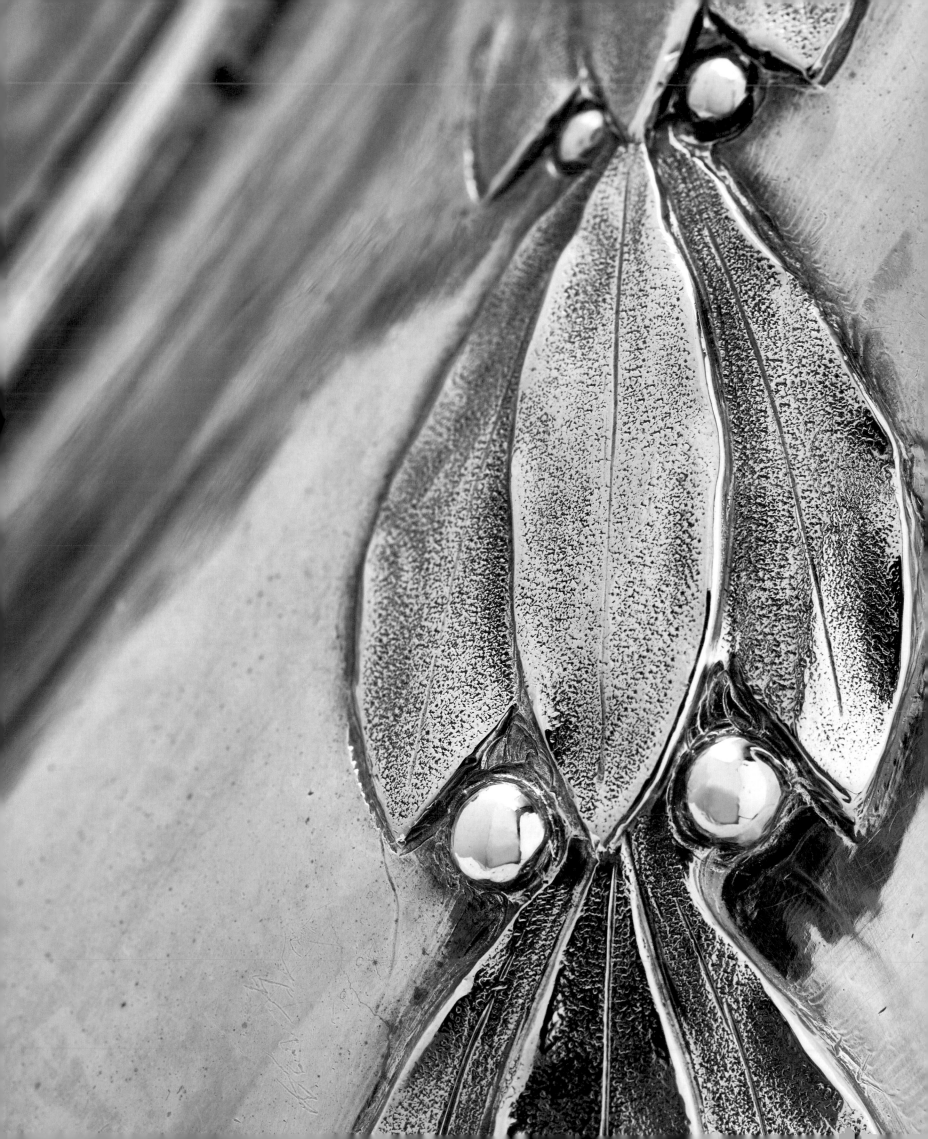

Foreword

Contemporary art practices inspire us to cast a fresh eye over those of the past and to consider previous modes through the lens of our own era and preoccupations. During the twentieth century, the boundaries between the various forms of artistic expression began to disappear; today, the academically imposed hierarchies of artistic genres no longer have the same authority. It is the Gallery's mission to embrace all the periods and types of art in Canada. This includes taking a new look at art forms classified until recently as decorative, with the aim of assigning them the status they merit.

During the eighteenth and nineteenth centuries, the making of silver objects was a major creative practice. Among the silversmiths working during the period Laurent Amiot is notable for his reputation in the field and the scale of his production. His career lasted for over five decades, and forty years after his death he was still considered one of the greatest practitioners of the genre. His creations travelled beyond Quebec City, where he lived and worked, for he had clients in the Montreal region and even – a less well-known fact – in New Brunswick and Nova Scotia. With Amiot, a fundamental change took place: working with silver was no longer considered a craft but an art, and the silversmith, once an artisan, became an artist.

The richness of the Gallery's collection and an expertise developed over many years were at the root of our decision to mount this retrospective of Amiot's work, the first exhibition devoted to Canadian silver since the start of the twenty-first century. We are grateful to René Villeneuve, Curator of Early Canadian Art at the Gallery, for having conducted this brilliant reassessment of a vital facet of our artistic heritage, which we hope will serve as a stimulus for other similar initiatives.

Marc Mayer
Director and Chief Executive Officer
National Gallery of Canada

Preface

My interest in the career and work of Laurent Amiot has been like a long thread running through my professional life. The first encounter – over forty years ago, in a darkly panelled sacristy – was electrifying, and also, in many ways, decisive. Some time later, in 1986, I was invited by the dynamic team at the *Dictionary of Canadian Biography* to write the first biography of the artist. By the time it was published, I was working at the National Gallery of Canada as the curator responsible for the collection of early Canadian art. Although the master silversmith's work was already remarkably well represented in the collection – owing to the donation in 1979 of the Henry Birks Collection of Canadian Silver – I have persevered, succeeding over the past three decades in adding eleven more pieces to the corpus, including several masterpieces. The research undertaken with each acquisition has confirmed that every one of the works possesses some unique feature that offers rich scholarly potential. The oeuvre of Amiot, who was active in Quebec City between 1787 and 1839, is now an object of study.

Two factors have driven this ambitious project. First, I was conscious that despite the abundance of high-quality works there is a dearth of studies on Canadian silver. Although now outdated, inventories of the marks used by silversmiths to identify their creations have appeared, and a few biographies have been written. But without underestimating the utility and interest of these contributions, it cannot be denied that there has been little published about the artists' preoccupations and motivations, or about the context within which their works were executed and the way they have been received. The time had come, so it seemed to me, to explore new territory. Second, I felt that the richness of the National Gallery of Canada's collection, combined with the responsibility to study and promote it, fully justified the publication of a monograph devoted to Amiot. Surely it is in formulating our intuitions and asking fresh questions that we can achieve a fuller understanding and a clearer view?

Rather than simply presenting new facts, the goal of this study has been to collate what is already known and to try and approach the subject from angles

other than those generally adopted by Canadian art history. My aim has been to focus attention on the outstanding contribution made by the silversmith to the development of his art in this country. What was Amiot's social background; what kind of training did he have; how did he organize his practice; how did he establish a client base; what aesthetic choices did he make? These are the questions that have shaped the venture. The wide dispersal of the institutional and private collections in which the works are held and the difficulty of tracking down the relevant archival sources in both this country and abroad have brought their own risks. Nevertheless, as interpretations accumulated, as important works and key moments in our artistic heritage came to light, as a mass of new information emerged, the project seemed more pertinent than ever. Despite much effort some works have not been found, and certain others, I was distressed to discover, have been vandalized. But these lacunae, though regrettable, have not prevented the composition of a new and honest account of Amiot and his work – an account that I hope will better enable readers to amplify, enrich and perhaps challenge the information it contains.

The generosity of owners and individuals responsible for collections has been a crucial factor in the success of this project. The exhibition depended, of course, on the accessibility of the works – but also on their state of conservation and the possibility of treating them. The National Gallery of Canada's Restoration and Conservation Laboratory has been able to provide treatment for a number of exceptional pieces from which they might otherwise not have benefited, and this is a matter for some pride.

Although this is the first monographic exhibition dedicated to exploring the work of Amiot and his contribution to the development of art in this country, it was clear to me from the outset that it is very much part of a continuum. His name appears regularly in the literature, and his works have featured prominently in numerous exhibitions over the past century. As I explain in the opening chapter, the first institutions to acquire his works were foreign. The second chapter, rather than focusing on the introduction of new data, offers a review of the artist's biography that is aimed at exploring his background, looking in detail at the training he received and the approach he developed, and clarifying his role within a complex network of professional relationships. This leads to the final chapter, which is devoted to an assessment of the work itself. The pieces I have selected to illustrate my topic come from every period of the artist's career and reflect the various genres he practised: religious vessels and accessories, domestic silverware and

commemorative pieces. Discussion of the works has allowed me to characterize the master silversmith's clientele, to examine the workings of the patronage system, and to describe the aesthetic approaches he favoured. It is my hope that this study will stimulate appreciation of the quality and importance of Amiot's oeuvre while providing a fresh perspective on the history of the society he helped shape and define.

Inevitably full of obstacles, the mounting of such a project, comprising an exhibition and a catalogue, has enabled me – as curator turned exhibition organizer – to fully grasp the extent and generosity of the professional family to which I belong. The research fundamental to such an endeavour has involved many individuals and a multitude of institutions, at home and abroad, and I offer them my admiration and deepest gratitude. My thanks go first to the owners of the works and to those responsible for them, who have allowed me unrestricted access to the works themselves and to the archives associated with them. A number of particular contributions warrant special mention.

In Quebec, I have had the pleasure of benefiting from the expertise of Pierre Lafontaine, archivist for the Archidiocèse de Québec; Jean Thivierge at the Holy Trinity Cathedral; Peter Gagné, Juliette Delrieu and Marie-Paule Robitaille of the Musée de la civilisation; Nicolas Tremblay of the Archives of the Ville de Québec; Jean-Pierre Labiau, Nicole Gastonguay and Nathalie Thibault of the Musée national des beaux-arts du Québec; Christine Cheyroux of the Musée des Ursulines de Québec; Reynald Lessard and the most accommodating reference staff at Bibliothèque et Archives nationales du Québec in Quebec City; Annie Bélanger at the library of the Assemblée nationale; Olivier Bolduc of the Service des archives privées de la Ville de Lévis; François Taillon and Pierrette Maurais of the Archives of the Côte-du-Sud; Pierre Wilson and Isolda Gavidia of the Musée des maîtres et artisans du Québec; Cynthia Cooper and Anne McKay of the McCord Museum; Gilles Lafontaine of Archives Montréal; Philippe Legault of Bibliothèque et Archives nationales du Québec in Montreal; and Benoît Thériault of the Canadian Museum of History.

In Ontario, I received invaluable support from Peter Kaellgren and Carol Baum of the Royal Ontario Museum; Elizabeth Semmelhack of the Bata Shoe Museum; Shane McCord at Library and Archives Canada; and Claire Boudreau, Chief Herald of Canada. In the United States, I was graciously assisted by Beth Carver Wees and Elizabeth Zanis of the Metropolitan Museum of Art; Patricia Kane and John Stuart

Gordon of the Yale University Art Gallery; David Thompson and Kraig Binkowski of the Yale Center for British Art; and Emily Guthrie of the Winterthur Museum.

In London, I was able to count on the kind collaboration of Eric Turner and Louise Cooling of the Victoria and Albert Museum; David Beasley of the Goldsmiths' Company; and the efficient team at the National Archives (UK). In Paris, I received the generous assistance of Anne Dion of the Musée du Louvre; Brigitte Appavou of the Missions Étrangères de Paris; and the dedicated team at the Archives nationales (France). Monsignor Denis Bélanger, C.S.S., rector and curé of the cathedral of Notre-Dame de Québec, has been an enthusiastic and generous supporter of the project. Monsignor Armand Gagné, C.S.S., archivist emeritus of the Archidiocèse de Québec has been liberal in sharing his vast knowledge and unique expertise.

A number of individuals – independent scholars, collectors, art dealers and conservators – have received me warmly and offered their help in countless ways, and I thank them all: Claude Thibault, Wynyard Wilkinson, Ross Morrow, Chris Toogood, Victor Isganaitis, Warren Baker, Gilbert L. Gignac and Paul Racine, along with others who prefer to remain anonymous. I am particularly grateful to Abbé Garrick Huang, F.S.S.P.

Finally, I would like to express my gratitude to the entire team at the National Gallery of Canada for its professionalism. Clive Cretney, photographer emeritus, took the majority of the photographs, and Christopher Davidson assisted me at the research stage with remarkable generosity and efficiency. Particular thanks are also due to Doris Couture-Rigert, Sheilah Mackinnon, Janie Kennedy, Susan Walker and Ainsley Walton in the Conservation Laboratory, and to Ivan Parisien and his team in Publications and Copyright.

René Villeneuve
Curator, Early Canadian Art
National Gallery of Canada

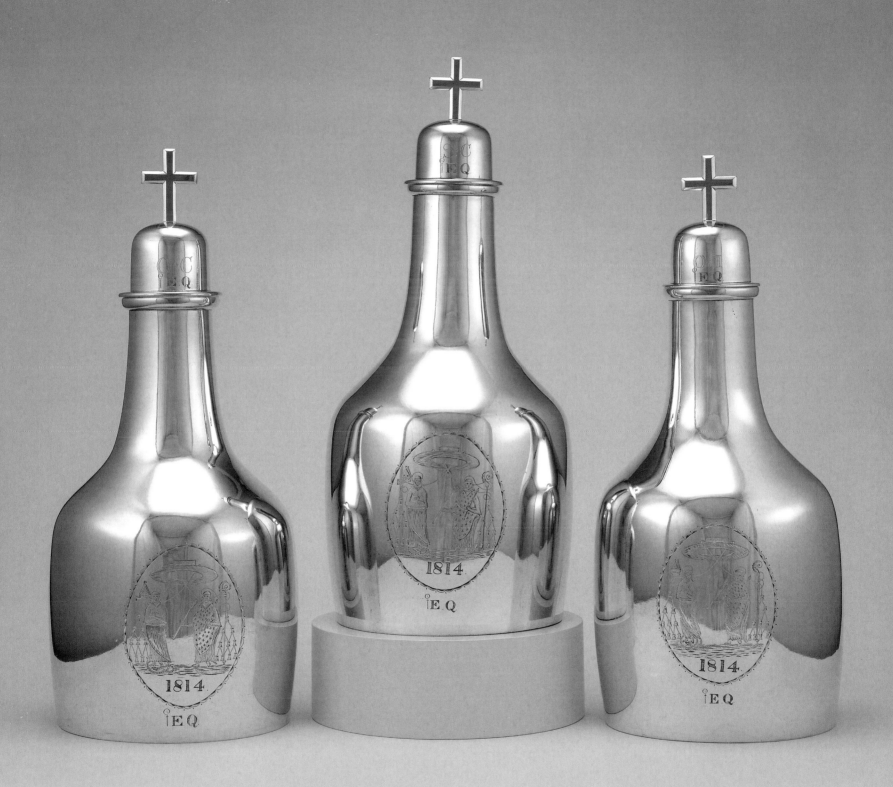

THE RECOGNITION OF A MASTER

Memories of Laurent Amiot may have dimmed after his death, but his art has never been forgotten. Until quite recently, traditional historiography saw this popularity as originating with E. Alfred Jones' visit to Canada at the beginning of the twentieth century. But this rather simplistic view underestimated the part played by the many other researchers, collectors and art lovers who have appreciated, studied and promoted the master's work. To fully understand Amiot's place in art history, it is important to re-examine and assess the contributions of all those who have helped preserve his memory.

Lionel Saint-George Lindsay

A precursor to E. Alfred Jones was Abbé Lionel Saint-George Lindsay (see fig. 1.1), whose interest in silver developed very early. Even as a small child in Jeune-Lorette, he was dazzled by the splendour of the treasures belonging to the parish church and, particularly, those in the chapel of Notre-Dame de Lorette, whose elderly sexton taught him how to distinguish between the solid silver wine and water cruets.[1] Lindsay was ordained as a priest in the archdiocese of Quebec City in 1875, and it was in the exercise of his ministry that he first encountered Amiot's work. After beginning his career as a teacher, he founded the journal *Nouvelle-France,* published from 1902 to 1918, and served between 1905 and 1907 as secretary of the archbishopric. In 1907 he was appointed secretary-archivist, and he remained in this position until his death in 1921.[2] His circumstances helped to cultivate a taste for history and ecclesiastical silver, and he was able to study Amiot's creations first-hand. It was no doubt shortly after his appointment as secretary-archivist that he came upon the catalogue *Objets dignes de remarque dans le palais épiscopal* (Notable Objects at the Bishop's Palace), compiled by his predecessor at the archdiocese, Monsignor Charles-Octave Gagnon,[3] which includes a description of three large holy oil flasks (cat. 32) by Amiot. This was the first publication to clearly identify the master's mark and link it to particular works.

Fig. 1.1
Jules-Ernest Livernois (1851–1933)
Abbé Lionel Saint-George Lindsay c. 1879

Holy Oil Flasks with the Coat of Arms of the Diocese of Quebec c. 1814
Cat. 32

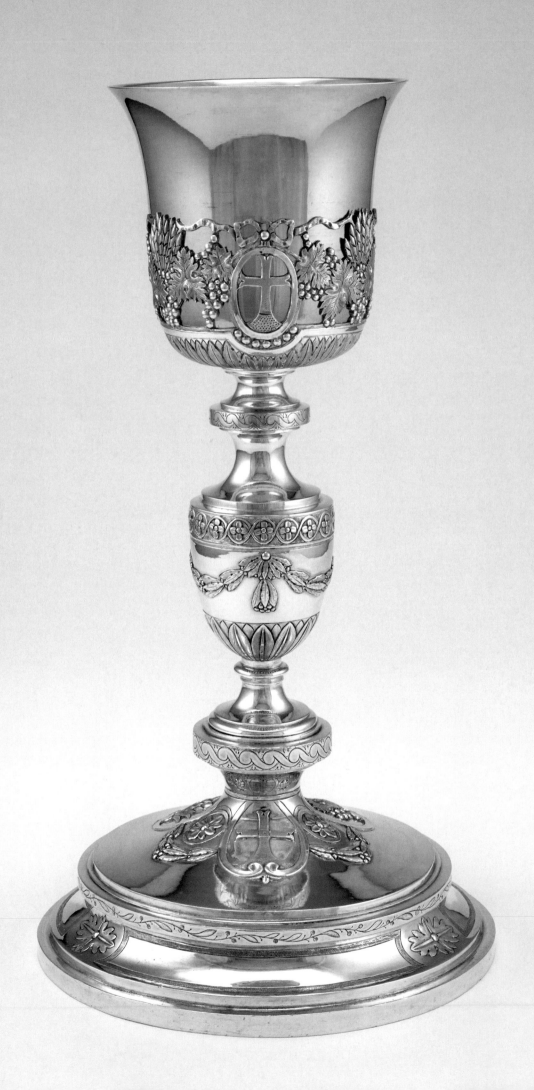

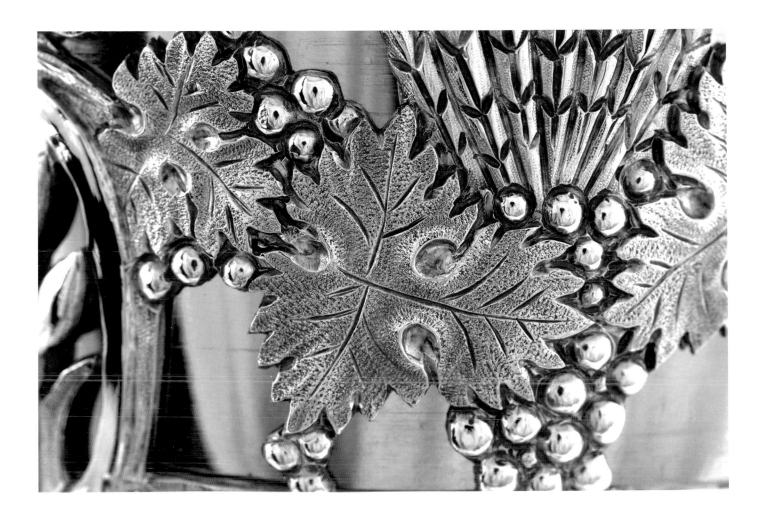

Chalice of Saint-Ambroise-de-la-Jeune-Lorette (detail) 1811

In his monograph on Notre-Dame de la Jeune-Lorette, published in 1900, Lindsay identified another of the master's works – the sumptuous chalice belonging to the parish of Saint-Ambroise-de-la-Jeune Lorette (cat. 29).[4] The churchman's enthusiasm and appreciation for silver is confirmed by correspondence he conducted in 1902 and 1903, while serving as chaplain for Quebec City's Ursuline monastery, with the Lyon firm of *Armand-Calliat et Fils* concerning the fabrication of a silver lamp to be donated by Marie Madeleine Anthon.[5] This lamp still hangs in the monastery's chapel, in front of the altar dedicated to Our Lady of Great Power. Participation in the mounting of exhibitions gave Lindsay the opportunity to refine his knowledge and become part of a network of collectors. His name appears on the list of lenders to an exhibition presented during the 15th International Congress of Americanists, held in Quebec City in September 1906. Also listed is the notary Cyrille Tessier,[6] one of the first collectors of Amiot's work.[7] His family had known Amiot since at least 1839, when the silversmith loaned a sum of money to Michel Tessier, Cyrille's father.[8]

Chalice of Saint-Ambroise-de-la-Jeune-Lorette 1811
Cat. 29

Later, in 1917, when an inventory was made of the treasures belonging to the cathedral of Notre-Dame de Québec, Lindsay was asked by the curé to appraise the ensemble, and he identified the marks on the sanctuary lamp and the votive lamp in the chapel of Sainte-Anne as Amiot's.[9]

This brief preamble serves to demonstrate that Lindsay had a particular interest in the work of Amiot. It also reveals that the first body to contribute concretely to the silversmith's enduring reputation was the archbishopric of Quebec, seat of the Catholic church in the region, which was located quite close to his workshop. It will become clear that this institution played a decisive role in Amiot's success. But to better understand the fundamental impact that Lindsay had on Amiot's rise to fame, we must examine a couple encounters that occurred during the 1910s and 1920s, when other scholars appealed to the master's expertise.

E. Alfred Jones

The Welsh-born E. Alfred Jones played an important part during the first half of the twentieth century in the development and dissemination of knowledge about English silver.[10] He became interested in silver imported to or produced in Canada while working on a project that took him to New England, which resulted in the publication in 1913 of a lavish book.[11] While in America he travelled north, spending time in Nova Scotia, New Brunswick and finally, in 1912, Quebec City – a visit facilitated by a letter of introduction from Lord Strathcona to Archbishop (later Cardinal) Bégin.[12] Jones' meeting with Lindsay added considerably to the value of his sojourn, since through the Abbé he was able to examine the archbishopric's collection and gain access to the city's various monasteries – a privilege, at the time – as well as the church of Notre-Dame de la Jeune-Lorette. As Jones himself wrote about his encounter with Lindsay:

> The most important collection of old silver examined by the writer in Quebec was that of the Archbishop, permission having been graciously granted and every facility accorded for its examination by the help and enthusiasm, combined with historical knowledge of the subject of Father Lionel St. G. Lindsay.[13]

During his various visits, Jones would study the pieces and note his observations. He acknowledged the quality of Amiot's work by making sketches in his notebook of the two jugs he saw at the archbishop's palace (fig. 1.2)[14] and reproducing them on the first page of an article he published in England some years later.[15] Clearly, he was much impressed by the creations of the Quebec silversmith.

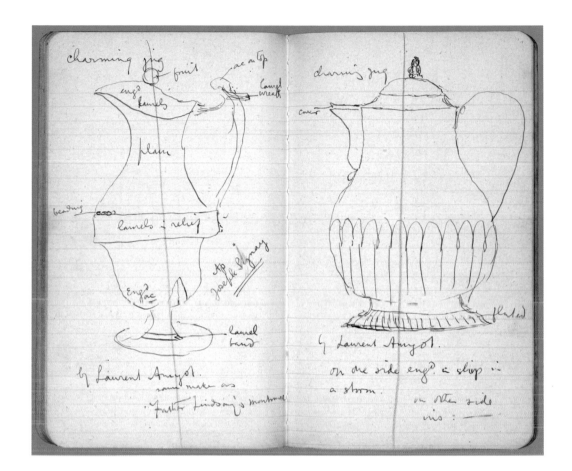

Fig. 1.2
E. Alfred Jones (1873–1943)
*Drawing of Two Jugs by Laurent Amiot Held
at the Archevêché de Québec* c. 1912

He does not seem to have conducted any archival research, but was provided with documentary information by Lindsay.[16] While on this trip to Quebec, Jones acquired several pieces of silver and a group of drawings, which included those by Amiot owned by the widow of Ambroise Lafrance, and he lost no time in trying to promote this exceptional ensemble. In 1914 he approached Arthur Doughty, the Dominion Archivist, with the idea of offering the collection to the Public Archives of Canada,[17] but the offer came to nothing. Then, in 1918, Jones published the first article on Canada's silverware tradition, which prompted an immediate critical response from an interested reader.[18] On 23 December 1919, a year after the end of the First World War, Jones presented the Victoria and Albert Museum with one of the pieces he had acquired on his trip to Quebec City – a ladle by Amiot, which he donated "In memory of Canadian Soldiers killed in the Great War." This museum thus became the first in the world to possess an example of the master's work.[19] Jones kept the other items until, in November 1929, Francis Patrick Garvan – one

of the leading collectors of American silver of the period – acquired his collection of "Catholic Silver from Canada"[20] and deposited it at the Yale University Art Gallery, which was already home to the Mabel Brady Garvan Collection.[21] In 1947, when the Garvan estate was being settled, Henry G. Birks purchased the collection, including the drawings. He placed it on deposit at the Royal Ontario Museum, and on 16 January 1948 the sanctuary lamp by Amiot and the drawings were duly sent from New Haven to Toronto.[22] Following Jones' death, his library and archives were broken up: the books were disposed of at auction,[23] and the executors sold the archives to a reputed London dealer, Commander G.E.P. How. The latter sub-

Beaker (detail) c. 1800

sequently gave the documents related to North American silver to John Marshall Phillips, then director of the Yale University Art Gallery,[24] who in turn passed all the material concerning Quebec on to John E. Langdon. The last time Jones wrote on the subject of Canadian silver, he devoted considerable space to Amiot.[25] Evidently, it was Jones' sojourn in Quebec and his tours of the city's most valuable collections under the guidance of Abbé Lindsay that enabled him to gather first-hand the material to publish a groundbreaking study. The items of silver he examined, collected and wrote about were, together with the drawings, among the first works by Amiot to attract the attention of scholars and thereby lay the foundations of his fame.

When Jones made his trip to North America, there were already several keen collectors of silver in the United States busy accumulating masterpieces. Just as active as Garvan was the New York judge Alphonso T. Clearwater.[26] Sometime prior to 1920, the latter had acquired a small beaker (cat. 18) that he believed had been made in the United States around 1800 and that he saw as an example of the "classic revival" style. He was unable to identify the maker, however, since no index of marks had as yet been compiled.[27] This piece has been at the Metropolitan Museum of Art since 1933, but it was not until July 1944 that the Montreal collector Louis Carrier examined it and correctly identified its marks as those of Amiot.[28]

Beaker c. 1800
Cat. 18

Marius Barbeau

The anthropologist Marius Barbeau (see fig. 1.3) also visited Abbé Lindsay in Quebec City – in August 1919[29] – and the encounter seems to have sparked in him a new interest in silver. There exists no documentary account of the meeting other than Barbeau's descriptions of the items in the collection at the archbishop's palace.[30] An essay published by the anthropologist twenty years later, in 1939, contains reflections and comments on Amiot that echo those made by Jones and that were undoubtedly inspired by Lindsay.[31] Barbeau's main contribution to the development of Amiot's reputation was his inclusion of the master's works in various exhibitions. In Toronto, for example, in 1935, six major pieces, all presented here, were put on public display for the first time.[32] In 1937 Barbeau became the first Canadian researcher to show an interest in the rare set of drawings by Amiot mentioned earlier. The anthropologist learned about this treasure from John Marshall Phillips, director of the Yale University Art Gallery, where it was then held. In an exchange of letters that took place between 17 April and 5 June 1939, Barbeau stressed the need to keep the portfolio of twenty-three drawings together and emphasized their importance to the study of Canadian silver.[33] Convinced of their great value, he apparently travelled to Yale (on the 9 or 13 June), determined to persuade Phillips to allow a selection of thirteen of the drawings to be sent to Ottawa in order to have full-scale reproductions made of them by the photostat process. The gallery director quickly agreed: the drawings made the trip and were returned on 6 July to Phillips, who acknowledged their receipt four days later.[34] In January 1940 Barbeau lent the thirteen photostats to an exhibition organized by the Canadian Handicrafts Guild,[35] where they were joined by two other magnificent works by Amiot never shown publicly before (cat. 7 and fig. 1.4).[36] Later, in 1955, four original drawings were exhibited for the first time at the Art Association of Montreal.[37] When, in the fall of 1945, E.P. Richardson was planning a huge exhibition of early Quebec art, he enlisted Barbeau's help.[38] The anthropologist became one of the principal collaborators on the project, drawing upon his thirty-five years of research to establish the list of works. So it was he who selected six outstanding pieces by Amiot to be part of *The Arts of French Canada, 1613–1870*, presented in 1946. Hailed at the time as one of the most important historical surveys of Canadian art ever mounted, the exhibition was accompanied by a catalogue that illustrated the silversmith's works.[39] After opening in Detroit, it travelled to Cleveland, Albany, Montreal, Ottawa and Quebec City. Interestingly, not a single Canadian art museum owned examples of Amiot's work at the time,

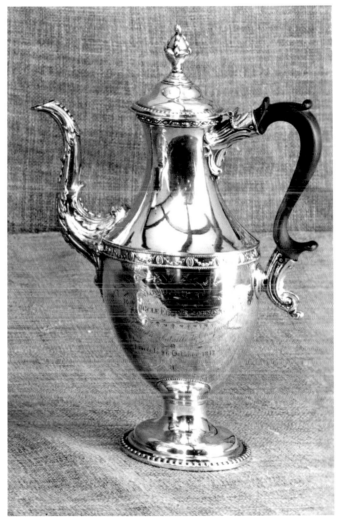

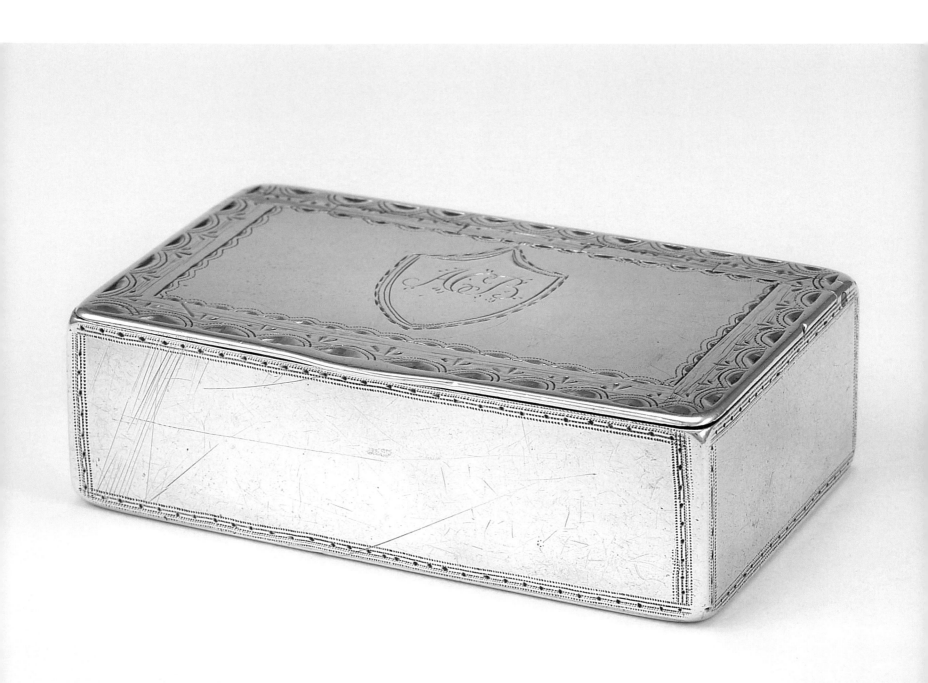

so all the loans came from ecclesiastical or private collections. One such collection was that of Henry G. Birks of Montreal, who had a great interest in the field. He had begun collecting Quebec silver in 1936 and acquired his first piece by Amiot in February 1938 (cat. 35). If we include the numerous utensils, Birks owned 185 items of silver by Amiot by the time he ceased collecting in 1979.

In retrospect, it is clear that Barbeau played a part in the development of Amiot's reputation. The information he gathered in the field enables us today to better understand the context in which the silversmith worked and to learn more about him as an artist. For example, it was during an interview Barbeau conducted with the Quebec City jeweller Alfred Charles Routhier in his establishment at 50, côte de la Montagne that he learned the whereabouts of Amiot's workshop – located in a particularly strategic spot. When questioned in detail, Routhier related: "My father Charles, a clock and watch maker, said that Amiot lived on the other side of the street, opposite the staircase. It was there that he began working. People always said that Amiot's place was there."[40] This detail, recorded first by Barbeau, is historically highly significant, for during this period all of Quebec City's inhabitants were obliged to use this thoroughfare to make their way from the upper to the lower town. The fact that by the time the interview took place all the buildings on the side opposite Routhier's premises, including Amiot's workshop, had been demolished, made the information all the more valuable.

It is hard to say if Barbeau's interest in Amiot's work was the result of intellectual curiosity or of his encounter with Lindsay. Whatever the case, by promoting the exhibition of the silversmith's creations and by instinctively recognizing the exceptional value of his drawings he helped bring them to a wide public. And, as Lindsay had for him and for Jones, Barbeau would share the fruit of his research with the Scottish-born Ramsay H. Traquair.

Snuffbox with the Monogram ACB c. 1815
Cat. 35

Fig. 1.5
Gordon Antoine Neilson (1901–1942)
*Ramsay H. Traquair in the Refectory of
the Hôpital-Général de Québec* c. 1928

Ramsay H. Traquair

Ramsay H. Traquair (see fig. 1.5) arrived in Canada in 1913 – the year after Jones' visit – to take up a position at McGill University, where the following year he succeeded Percy Nobbs as MacDonald Professor of Architecture. As well as teaching, he became an expert on early Quebec architecture, visiting many churches and making visual records of their interior decor. This was how he first encountered items of silver by Amiot. As a result of their common interests, an informal collaboration was forged between him and Marius Barbeau, who shared generously the data accumulated during his research. Traquair took many photographs of silver objects,[41] showing a penchant for the work of silversmiths active during the French regime and those who continued to pursue their ideals. In the summer of 1935 he visited Quebec City with Gordon A. Neilson. Following in Jones' footsteps, he examined and photographed numerous works kept at the seminary, the cathedral and the archbishop's palace. Later that year, in December, he presented Monsignor Pelletier and Monsignor Roy, respectively superior of the seminary and rector of the university, with annotated sets of pictures of works photographed during his sojourn.[42]

Traquair's most important contribution to the field was his publication of the first book devoted to Quebec silver, produced under the auspices of the Art Association of Montreal.[43] Lauded by international critics – including Jones – when it appeared in 1940,[44] this study helped consolidate Amiot's reputation by confirming his talent and inventiveness as a silversmith and paying tribute to the refinement of his work, two superlative examples of which it illustrated. An entire generation of collectors with links to the Art Association of Montreal were influenced by Traquair's book. He himself acquired several Quebec pieces, moreover, including a teapot (cat. 23) by Amiot – for fifty years the only known one – which he bequeathed to the Art Association in 1952, along with the rest of his collection.

The Art Association also benefited from the generous and unprecedented loan by David Y. Hodgson of a large Amiot tureen (fig. 3.11, p. 169), which was exhibited alongside the institution's own collection from February 1949 to December 1959.[45] This outstanding piece ultimately entered the Royal Ontario Museum in 1992.[46]

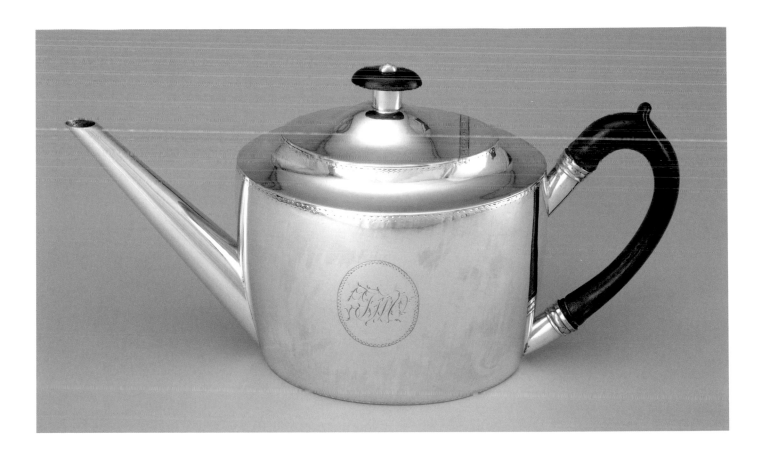

Teapot c. 1805
Cat. 23

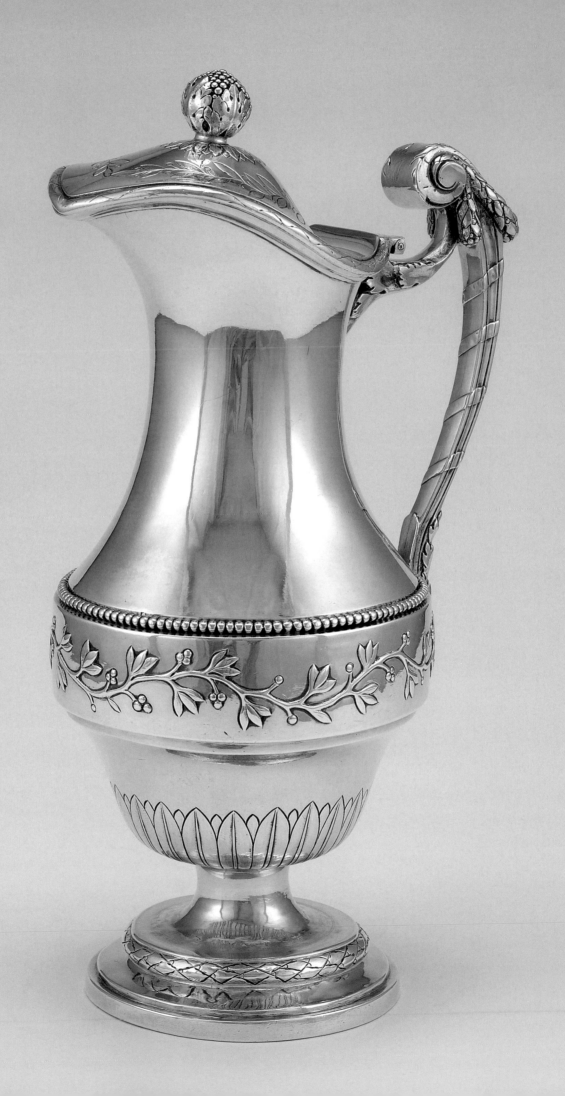

Gérard Morisset

Barbeau and Traquair had already been active for a while when Gérard Morisset (see fig. 1.6) appeared on the scene. The latter's academic training differed significantly from that of the others, and his arrival marked a shift in perspective and the development of a new approach to Amiot's work. Morisset had left Quebec in 1929 to study in France, returning in 1934 with a doctorate in art history. After being appointed director of drawing instruction for Quebec, he was charged in 1937 with establishing an inventory of the province's artworks.[47] Through his field and archival studies he quickly built up a rich reservoir of information that surpassed that of any of his contemporaries and afforded him considerable independence as a researcher. As an art historian, Morisset was interested in painting, sculpture and architecture, as well as silver, and was much preoccupied with form and decorative style. This set him apart from numerous other researchers, who tended to classify all early works as craft or folk productions whose main value was to legitimize the nation's past and act as a foil for contemporary creations. Morisset began studying Amiot's works in 1941, set on revealing the unique character of his art and identifying its essence.[48] And this continued to be his approach each time he discussed Amiot's creations – when, for example, he presented a church and its treasure to a broad public.[49] In 1942 Morisset included six pieces by Amiot in the *Exposition de photographies d'argenterie québécoise*, an exhibition devoted principally to the work of François Ranvoyzé.[50] Then, in March of the same year, as part of Radio-Canada's *Radio-Collège* series, he gave a talk on Amiot that would be followed in April by another on the artists who came after him.[51] The content of both revealed their author's keen interest in the silversmith and comprehensive knowledge of both him and his successors.[52] Given Morisset's particular interest in Amiot, it may seem surprising that he never made him the subject of a monograph or an in-depth article. In fact, he kept Amiot very much in his sights, but the plan was that his collaborator and friend Jules Bazin would author the study, likely at Morisset's instigation.[53] A number of letters from the latter to Bazin refer to this project, some mentioning specific works, others informing his friend about progress in his research.[54] A reference to the monograph and its anticipated publication in 1944 even appears on a printed order form,[55] but the project did not get beyond the planning stage and the book was never published. Morisset was a meticulous and motivated researcher.

Fig. 1.6
Jules Bazin (1905–1995)
Gérard Morisset in His Office August 1941

Jug with Lid c. 1790
Cat. 4

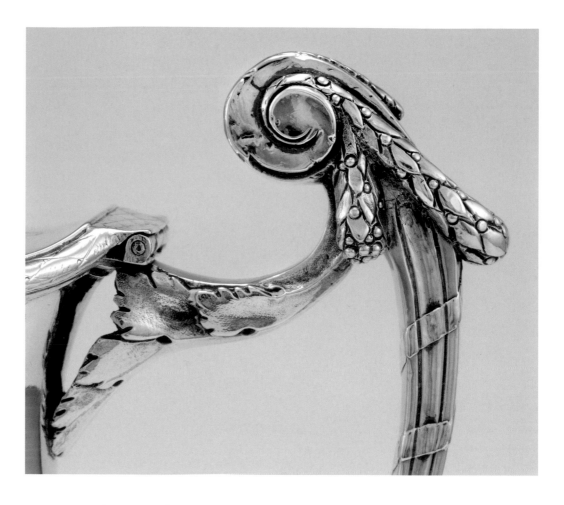

Jug with Lid (detail) c. 1790

In a November 1944 letter to John E. Langdon he described the scope of his discoveries:

> You would be astonished by the sheer number of certificates of apprentice-ship, inventories and all sorts of contracts that we have found in the court records of Quebec and Montreal. I dare say that the entire history of silverware has changed, and that Monsieur Traquair's book has lost all value.[56]

For the huge *Exposition rétrospective de l'art au Canada français* held in Quebec City in 1952 and organized as part of the centenary celebrations of Université Laval, Morisset selected twelve works by Amiot, including the large *Jug with Lid* (cat. 4) once owned by Cyrille Tessier and then in the collection of Louis Carrier.[57] The jug had already been exhibited in Toronto in 1935[58] and in Detroit in 1951.[59] The outstanding quality of this piece was extolled in 1953, when it was shown in Windsor, Ontario,[60] and although it was absent from various exhibitions held over the following decade it reappeared in 1965 on the cover of the catalogue accompanying the sale of the collection of Joseph H. Bauer.[61] Acquired at that time by Henry G. Birks, it became one of the emblematic images of his collection.[62] A half-century passed before another work by Amiot was featured on the cover of a sales catalogue.[63] At the time, Amiot was the only Canadian silversmith to enjoy such standing in the art market – further proof of the enthusiasm his work inspired among collectors.

The major part played by Morisset in the growing recognition of Amiot's production went beyond the new artistic viewpoint he brought to bear upon it, however: he enhanced the artist's reputation by exhibiting a wider range of his works and by focusing on key pieces. Several, including one of the large jugs from the archbishop's palace in Quebec City – already considered iconic – were included in *Visages du Canada – Vallée du Saint-Laurent* (better known as the *Exposition de la Province de Québec*), which was presented in Paris at the Grands Magasins du Louvre in the winter of 1958.[64] No fewer than fourteen works by Amiot (the largest number to date for a single exhibition) were chosen for *The Arts in French Canada*, held in Vancouver in 1959.[65] And although Quebec silver was assigned a comparatively modest place in *L'art au Canada*, shown in Bordeaux in 1962, it nonetheless included two pieces by Amiot.[66]

Morisset promoted the work of Amiot over a period of two decades. Aside from examining it from an art historical viewpoint in scholarly texts, he introduced many of the silversmith's creations to a broad public by including them in major historical exhibitions presented outside Quebec and Canada.

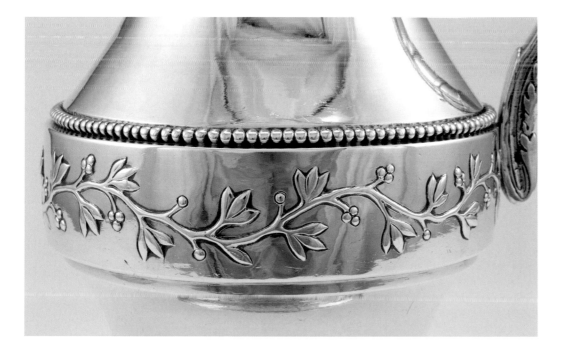

Jug with Lid (detail) c. 1790

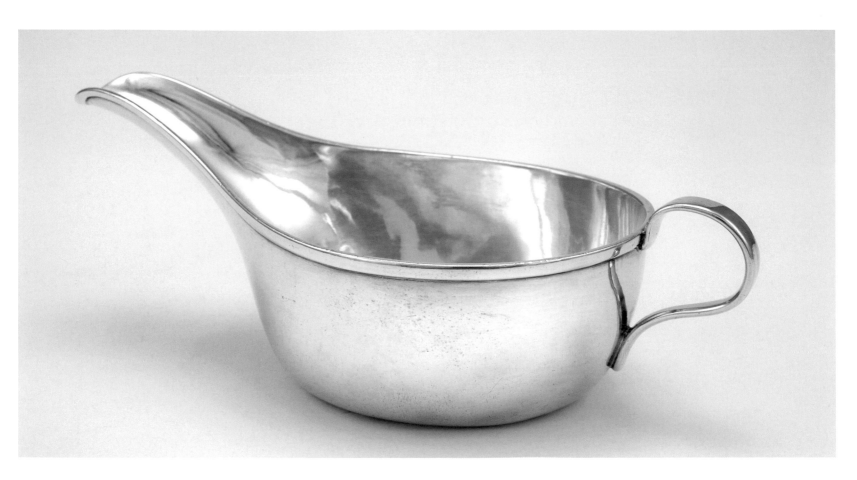

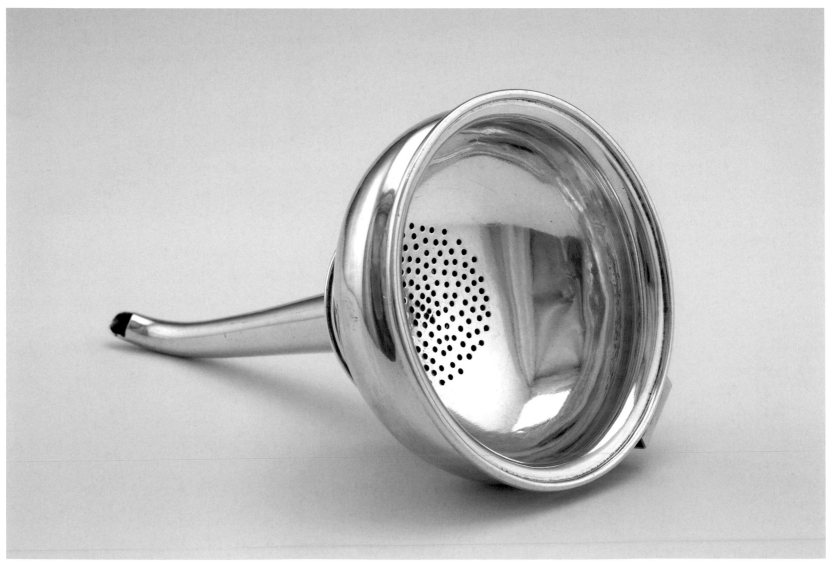

More Recent Bearers of Memory

Amiot's works continued to be exhibited, analyzed and reproduced in various academic and museum contexts during the 1960s and 1970s, but these interventions were essentially supplementary to what had gone before, without decisive impact. The most significant advances in the state of Amiot research during this period – and later – arose principally from the discovery of hitherto unknown pieces and the consequent expansion of the catalogue of the oeuvre. For example, at the Bauer sale of 1965, along with the *Jug with Lid* (cat. 4) mentioned earlier, Henry G. Birks also acquired a unique pap boat (cat. 20), an ecuelle with lid, a pair of altar cruets and a wine funnel (fig. 1.7)[67] – a considerable coup for this collector, who was so generous in loaning and exhibiting his collection.[68] In 1971, as enthusiastic as ever, Birks purchased a covered sugar bowl (cat. 60) from Cyrille Tessier's granddaughter.

Pap Boat c. 1800–35
Cat. 20

In 1966 John E. Langdon published his index of Canadian silversmiths and their marks. Unfortunately, the entry on Amiot is full of errors, the most obvious being an incorrect death date, and it must be said that much of the information the book contains was already out of date when it was published. Nevertheless, it devotes six full pages to reproductions of works by Amiot (more than any other silversmith), reaffirms the importance of a number of pivotal works and introduces new ones.[69] When the collector Austin S. Thomson published a report, he chose a work by Laurent Amiot to illustrate it.[70] That same year Clare Le Corbeiller, a curator at the Metropolitan Museum of Art, mentioned Amiot and illustrated one of his works in her monograph on snuff boxes,[71] which has become a classic of the literature on *objets d'art*.

Fig. 1.7
Wine Funnel c. 1800–35

Three Hundred Years of Canadian Art – a huge retrospective exhibition held in 1967 in celebration of the centenary of Confederation and composed principally of paintings – included more works by Amiot than any other silversmith.[72] In 1976 a group of drawings originating with one of his successors (and including a few sheets by Amiot), preserved by the collector Bernard Altman but previously unknown to specialists, was acquired from the bookseller William Wolfe by the Musée d'art de Saint-Laurent (since renamed the Musée des maîtres et artisans du Québec). When the Detroit Institute of Arts published a catalogue of its Quebec silver in 1978, it marked a turning point in the study of the subject. The catalogue's author, Ross Fox, a specialist of Canadian decorative arts, included a first biography of the master. Based on Gérard Morisset's research, it added nothing new, but the thirteen works by Amiot catalogued are described in minute detail: each work's dimensions and weight are given, along with descriptions and photographs

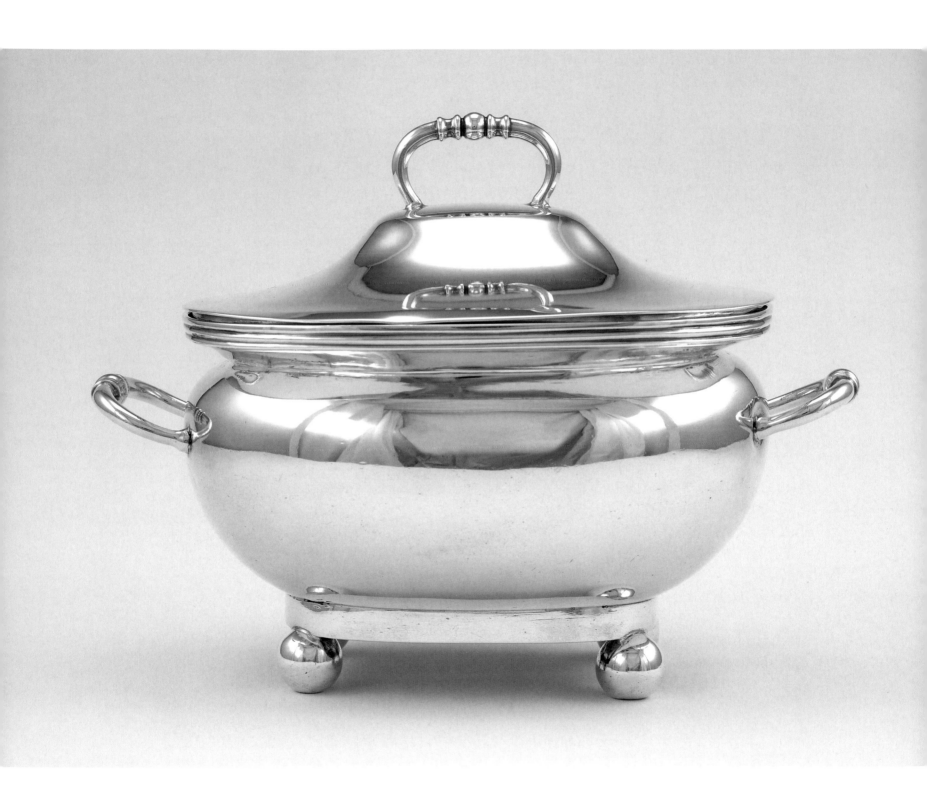

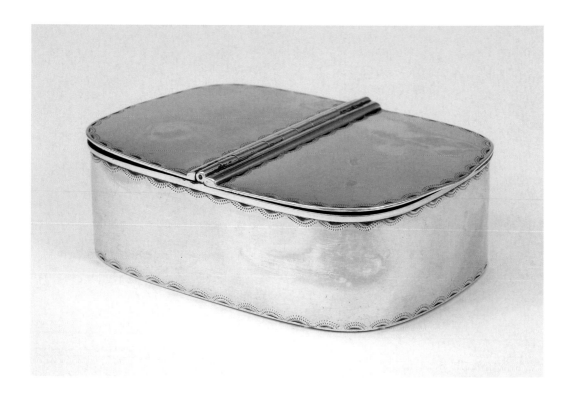

Double Snuffbox c. 1795
Cat. 11

of the marks, any inscriptions, the provenance of the piece, a bibliography and exhibition details, the whole accompanied by a lengthy entry outlining the techniques employed in its fabrication. There is even an appendix giving detailed analyses of the metal composition of each piece.[73] This technical research, innovative at the time, offered insight into a new aspect of Amiot's contribution to Canadian silver. It is worth noting that the same year the Quebec government classed the *Hanging Sanctuary Lamp of Repentigny* (cat. 3) as "cultural property," a status analogous to a historical monument.[74] In the spring of 1979 Birks further enhanced his huge collection by purchasing one of the jewels of the Charles De Volpi Collection of Canadian Silver, a double snuffbox (cat. 11) that is unique in the field of Canadian art.[75] This work, along with the rest of the Henry Birks Collection of Canadian Silver, would enter the National Gallery of Canada the following December. Thus, shortly before celebrating its centenary, the Gallery became home to the largest public collection of works by Amiot, a corpus as extensive as it is diverse. A final interesting footnote on Amiot's fame: he is mentioned in terms of high praise in a historical novel by Émile Castonguay – whose action takes place in Quebec City in 1825–26.[76]

Sugar Bowl and Cover c. 1825
Cat. 60

◊ ◊ ◊

Coffee Pot of the Le Moine Family c. 1796
Cat. 15

I had already been fascinated by the career and work of Amiot for some years when I was asked in 1988 to write about the silversmith for the *Dictionary of Canadian Biography*.[77] Close to a century after his name had begun attracting serious historical attention, I published an essay combining the first general survey of his career with an assessment of his work. My appointment in 1987 as curator for the National Gallery of Canada's collection of early Canadian art put me in an ideal position to pursue my research and help advance Amiot studies. For example, when the Gallery's present building was inaugurated, a popular magazine invited those in charge of the institution's various collections to mark the event by publishing a selection of works. I chose to focus on Amiot's large *Jug with Lid* (cat. 4).[78] In accordance with the institution's acquisitions policy, which requires that artists who have contributed significantly to the development of Canadian art be comprehensively represented in the national collection, sustained effort has led to the acquisition of eleven more works by Amiot (all except one previously unexhibited and unpublished), either as the result of generous donations or judicious purchases that have been unanimously endorsed by successive directors over the past three decades. In 1998, with the support of my colleagues, I chose the *Coffee Pot of the Le Moine Family* (cat. 15) to adorn the cover of my catalogue *Quebec Silver from the Collection of the National Gallery of Canada*, thereby focusing attention on this recent discovery. The location and repatriation of the *Cup Presented to George Taylor* (cat. 64), the most important piece of presentation silverware made in this country during the first third of the nineteenth century, were the impetus behind the exhibition on Lord Dalhousie presented in 2008.[79] At the time, the Royal Ontario Museum published a short article acknowledging Amiot's eminence.[80] Then, in 2013, I undertook an initial exploration of the group of drawings by Amiot that, over a century earlier, had been noticed and purchased by E. Alfred Jones during his visit to Quebec City, extending my study to include the sheets belonging to the Musée des maîtres et artisans du Québec.[81]

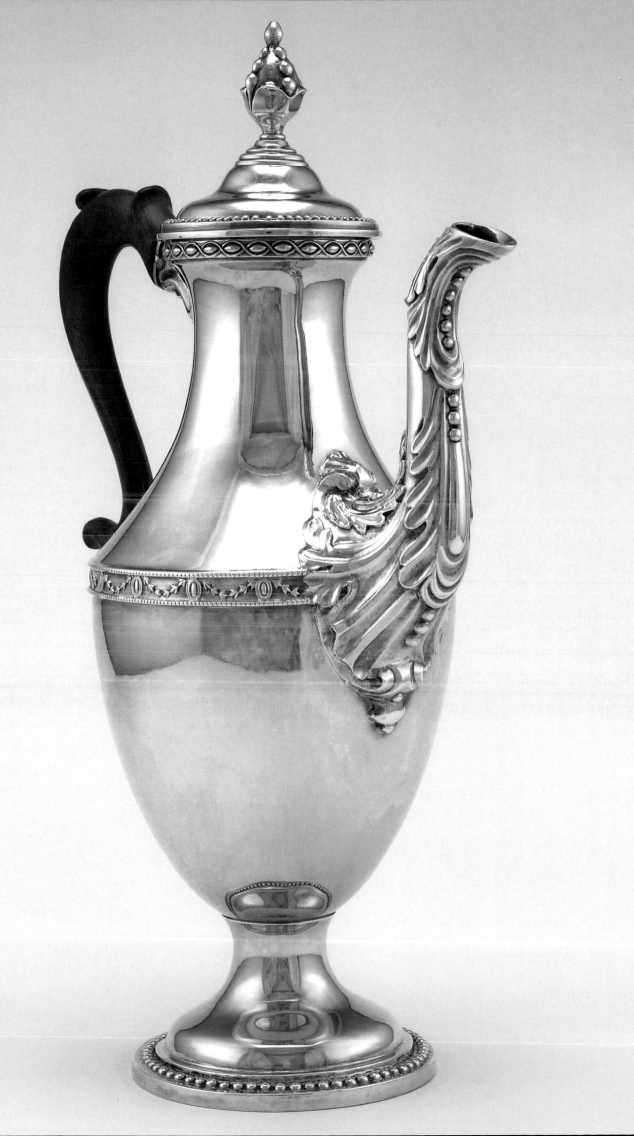

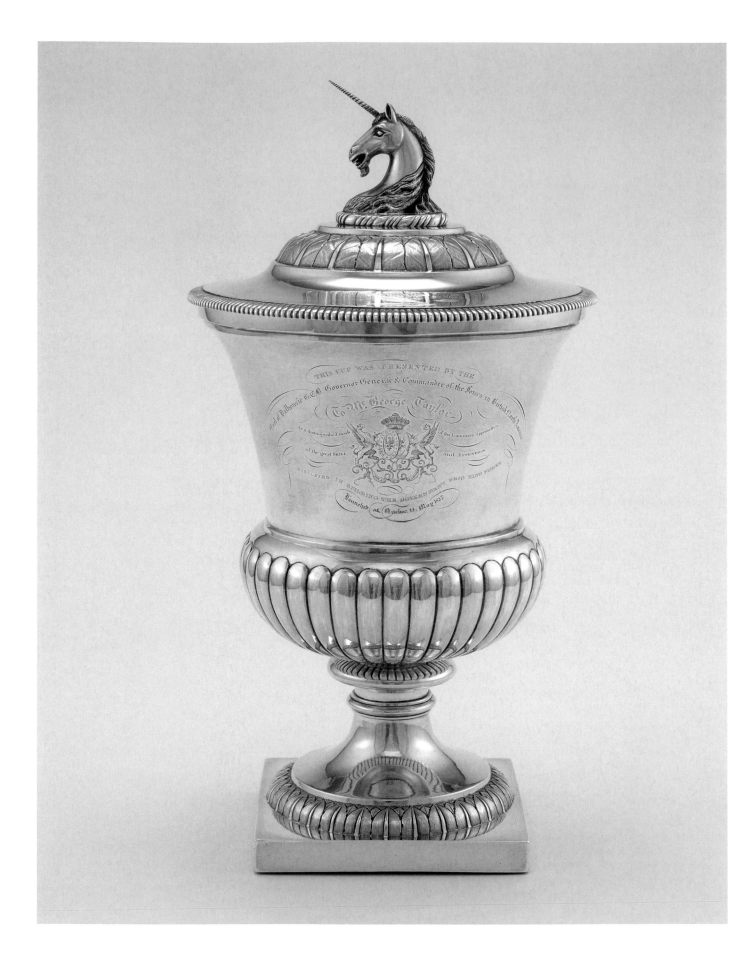

Cup Presented to George Taylor 1827
Cat. 64

Over the past twenty-five years, individuals from different realms have recognized and paid tribute in a variety of ways to Amiot's remarkable talent and his impact on the development of Canadian art. They must be credited with having preserved his memory by regularly presenting his work in numerous exhibitions, at home and abroad, and by promoting his art through their writings. The time has come to explain what lies behind their admiration for Amiot, what makes his oeuvre unique in the eyes of collectors, scholars, art lovers and museum curators. To this end, I intend to retrace the path taken by the artist's career to look in detail at his milieu, his training, his practice and his workshop – and ultimately to reveal how Amiot became a master.

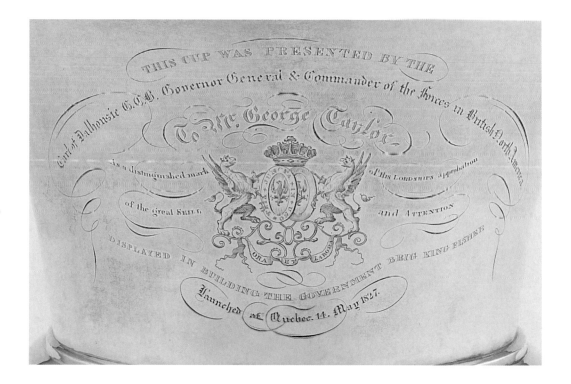

Cup Presented to George Taylor (detail) 1827

NOTES

1 Lionel Saint-George Lindsay, *Notre-Dame-de-la-Jeune-Lorette en la Nouvelle-France: étude historique* (Montreal: C^ie de Publication de la Revue Canadienne, 1900), p. 14. The cruets by Paul Lambert are still kept in the chapel.

2 Élias Roy, *Le collège de Lévis. Biographie. Mgr Lionel St-Georges Lindsay* (Lévis: La compagnie de publication de Lévis, 1921).

3 Charles-Octave Gagnon, "Objets dignes de remarque dans le palais épiscopal," in Henri Têtu, *Histoire du palais épiscopal de Québec* (Quebec City: Pruneau & Kirouac, 1896), pp. 290–299.

4 Lindsay, *Notre-Dame-de-la-Jeune-Lorette,* p. 316.

5 Letter dated 6 November 1902 and invoice dated 19 March 1903, Lionel Saint-George Lindsay fonds, Archives privées de la ville de Lévis, Bibliothèque Saint-David, Lévis. The American-born Marie Madeleine Anthon was a distant cousin of Marie Madeleine de Repentigny. Extremely wealthy, she played a major role in the reconstruction of the monastery's chapel. See Musée du Québec, Claude Thibault, *Trésors des communautés religieuses de la ville de Québec* (Quebec City: Éditeur officiel du Québec, 1973), p. 109.

6 *Catalogue des manuscrits et des imprimés en langues sauvages ainsi que des reliques indiennes, exposés à Québec à l'occasion du XV^e Congrès international des américanistes,* exhib. cat. (Quebec City: Dussault & Proulx, 1906), p. 41.

7 René Villeneuve, *Quebec Silver from the Collection of the National Gallery of Canada,* exhib. cat. (Ottawa: National Gallery of Canada, 1998), pp. 19–22. Joseph Signaÿ, the second archbishop of Quebec, was another of the country's first collectors and patrons of silver. He is discussed further in Chapter 3.

8 Bond from Michel Tessier to Laurent Amiot, 28 May 1839, minute book of the notary Antoine-Archange Parent (minute no. 8463), Bibliothèque et Archives nationales du Québec, Quebec City.

9 Inventory of the basilica of Notre-Dame de Québec and church of the Lower Town, 1917, vol. 2 (CM2/C2.11), Fabrique Notre-Dame de Québec fonds, Archives de l'Archidiocèse de Québec, Quebec City.

10 W. Telfer, "Obituary: Edward Alfred Jones," *The Cambridge Review* (13 November 1943), p. 74.

11 E. Alfred Jones, *The Old Silver of American Churches* (Letchworth, UK: Arden Press for the National Society of Colonial Dames of America, 1913).

12 Letter from E. Alfred Jones to an unidentified recipient, 20 November 1926 (90CM, Angleterre, 5: 170), Archives de l'Archidiocèse de Québec, Quebec City.

13 E. Alfred Jones, "Old Church Silver in Canada," *Royal Society of Canada: Proceedings and Transactions,* third series, section 2, vol. 12 (1918), p. 143.

14 Notebook of E. Alfred Jones, 1912, John E. Langdon fonds (box 15, file 13), Thomas Fisher Rare Book Library, University of Toronto.

15 E. Alfred Jones, "Silver in the Archbishop's Palace at Quebec," *International Studio* 97, no. 400 (September 1930), pp. 25–27 and 80.

16 Handwritten transcription of the certificate of apprenticeship of Jean Nicolas Amiot with Joseph Schindler, in the hand of Abbé Lindsay on the letterhead of the archbishopric of Quebec, John E. Langdon fonds (box 15, file 13), Thomas Fisher Rare Book Library, University of Toronto. On 20 November 1926, Jones wrote to the archbishopric again to request a series of photographs of various works he had examined in 1912. Letter from E. Alfred Jones to an unidentified recipient, 20 November 1926 (90CM, Angleterre, 5: 170), Archives de l'archevêché de Québec, Quebec City.

17 Letter from E. Alfred Jones to Arthur Doughty, Arthur Doughty papers, 6 October 1914 (RG37), Library and Archives Canada, Ottawa. My thanks to Gilbert Gignac for supplying this information.

18 Fred C. Wurtele, "Silver Communion Plate at Quebec,"
 The Gazette (Montreal) 147, no. 305 (21 December 1918), p. 14.

19 Acquisitions register, M568-1916 to M21-1920, p. 508, Silver
 Department, Victoria and Albert Museum, London. The ladle
 is numbered M161-1919.

20 Letter from E. Alfred Jones to Francis Patrick Garvan,
 1 November 1929, Francis Patrick Garvan fonds, Archives of
 American Art, Washington Center, Washington, D.C. Transport
 was undertaken by the firm of J. Chenue, whose shipping order
 is dated 12 November 1929.

21 Gerald W.R. Ward, Patricia E. Kane and Helen A. Cooper, *Francis
 P. Garvan, Collector* (New Haven: Yale University Art Gallery, 1980).

22 Customs declaration, 29 January 1948, Francis Patrick Garvan
 fonds, Archives of American Art, Washington Center,
 Washington, D.C. For more on Henry Birks' acquisition of the
 collection, see Villeneuve, *Quebec Silver*, pp. 41–43.

23 Christie, Manson & Woods Ltd., Derby House, Oxford Street,
 London, Tuesday 25 July 1944.

24 Letter from John Marshall Phillips to George R. Hughes, 25 July
 1944, Edward Alfred Jones folder (Livery Men Deceased),
 Archives of the Goldsmiths' Company, London. There may have
 been other documents related to this transfer; How's archives
 were destroyed some decades ago, when the roof of the building
 where they were stored collapsed.

25 E. Alfred Jones, "Canadian Art: Old Quebec Silver," *The Times*
 (London), no. 48137 (Friday 28 October 1938), p. 10.

26 Beth Carver Wees and Medill Higgins Harvey, *Early American
 Silver in the Metropolitan Museum of Art*, exhib. cat. (New York:
 The Metropolitan Museum of Art, 2013), pp. 11–16.

27 C. Louise Avery, *American Silver of the XVII & XVIII Centuries:
 A Study Based on the Clearwater Collection* (New York:
 The Metropolitan Museum of Art, 1920), p. 119.

28 Letter from Louis Carrier to C. Louise Avery, 5 July 1944, Laurent
 Amiot beaker (33.120.102) conservation file, American Wing,
 The Metropolitan Museum of Art, New York.

29 Marius Barbeau, field notes, Lorette, August 1919, Marius
 Barbeau fonds (B332 F4), Archives of the Canadian Museum of
 History, Gatineau.

30 Marius Barbeau, catalogue raisonné of Quebec silver, n.d. (p. 44),
 Marius Barbeau fonds (B120 F4), Archives of the Canadian
 Museum of History, Gatineau.

31 Marius Barbeau, "Deux cents ans d'orfèvrerie chez nous," *Royal
 Society of Canada: Proceedings and Transactions*, third series, section
 1, vol. 33 (1939), pp. 183–191.

32 See *Catalogue of the Fifth Biennial Exhibition of Architecture and Allied
 Arts: Toronto Chapter, Ontario Association of Architects* (Toronto:
 The Art Gallery of Toronto, 1935), cats. 512, 513, 549, 624, 625 and
 630. Barbeau's annotated copy of this catalogue is kept in the
 Archives of the Canadian Museum of History, Gatineau
 (Exhibition of Architecture and Allied Arts 1935 file [Art Gallery
 Toronto], Marius Barbeau fonds [B349 F1]).

33 Argenterie – Silversmiths file, Marius Barbeau fonds (B120 F2),
 Archives of the Canadian Museum of History, Gatineau.

34 John Marshall Phillips correspondence (1936–40) (B229 F31);
 Photostats (B278 F6), Marius Barbeau fonds, Archives of the
 Canadian Museum of History, Gatineau.

35 Letter from Marius Barbeau to Helen I. Drummond, 16 January
 1940, Archives of the Canadian Guild of Crafts (formerly the
 Canadian Handicrafts Guild), Montreal.

36 Exhibition by the Canadian Handicrafts Guild, 1940. See
 Canadian silverware file, Marius Barbeau fonds (B276 F11),
 Archives of the Canadian Museum of History, Gatineau.
 See also, *Canadian Handicrafts Guild Annual Report for the Year 1940*
 (Montreal: s.n., 1941).

37 *French Canadian Arts Exhibition*, Art Association of Montreal,
 25 June – 28 August 1955, no. 64. The exhibition list is kept in the
 library of the Montreal Museum of Fine Arts.

38 Letters from E.P. Richardson to Marius Barbeau, 26 October and
 1 November 1945, E.P. Richardson correspondence, Marius
 Barbeau fonds (B233 F1), Archives of the Canadian Museum of
 History, Gatineau.

39 *The Arts of French Canada, 1613–1870*, exhib. cat. (Detroit: City of
 Detroit Printing Division, 1946), cats. 161–166. The catalogue
 includes a preface by E.P. Richardson and essays by Marius
 Barbeau (sculpture and furniture), Louis Carrier (silver) and
 R.H. Hubbard (painting).

40 Laurent Amiot and his works file, Marius Barbeau fonds (B277
 F19), Archives of the Canadian Museum of History, Gatineau.

41 Robert Derome, "Ramsay Traquair: The History of Silver in
 Quebec and the McGill University Archives," in *Ramsay Traquair
 and His Successors: A Guide to the Archive*, vol. 1 (Montreal: McGill
 University, Blackader-Lauterman Library of Architecture and
 Art, Canadian Architecture Collection, 1987), pp. 78–105.

42 Old Silver in the Seminary at Quebec (NK 7126 Q3 T774, 1935)
 and Old Silver in the Archevêché, the Seminary and the Basilica
 at Quebec (NK 7126 Q3 T774 1935), Bibliothèque des sciences
 humaines et sociales, thèses et livres rares, Université Laval.

43 Ramsay Traquair, *The Old Silver of Quebec* (Toronto: Macmillan,
 1940).

44 See Harold E. Gillingham, "The Old Silver of Quebec,"
 The Magazine Antiques (March 1941), p. 114; *Journal – Royal
 Architectural Institute of Canada* 18, no. 3 (March 1941), p. 46;
 The Connoisseur 109, no. 484 (June 1942), pp. 171–172; E. Alfred
 Jones, "The Old Silver of Quebec," *The Burlington Magazine for
 Connoisseurs* 30, no. 466 (January–December 1942), p. 155.

45 David Y. Hodgson, loan file, 1959 (A1549), Archives of the
 Montreal Museum of Fine Arts.

46 Donald Blake Webster, "Growing Collection: Silver Tureen
 Acquired by Canadiana Department," *Rotunda* (ROM magazine)
 26, no. 2 (fall 1993), pp. 5–6.

47 Michel Cauchon, "L'Inventaire des Œuvres d'Art," in *À la décou-
 verte du patrimoine avec Gérard Morisset*, exhib. cat. (Quebec City:
 Ministère des affaires culturelles, 1981), pp. 35–44, and Claude
 Thibault, "Gérard Morisset, conservateur du Musée de la
 Province de Québec (1953–1965)," ibid., pp. 46–56.

48 Gérard Morisset, *Coup d'œil sur les arts en Nouvelle-France*
 (Quebec City: Charrier et Dugal, 1941), pp. 99–100.

49 Gérard Morisset, *Le Cap-Santé, ses églises et son trésor* (Quebec City:
 Médium, 1944), pp. 55–59.

50 Gérard Morisset, *Exposition de photographies d'argenterie québécoise:
 François Ranvoyzé (Québec 1739 – Québec 1819)*, exhib. cat.
 (Quebec City: Secrétariat de la Province, 1942). This exhibition
 was shown successively in 1942 at the École des beaux-arts de
 Québec, in Montreal (venue unknown) and at the Institut
 français in New York.

51 *Radio-Collège* 1941–42 schedule, Société Radio-Canada. The talks
 were broadcast on 25 March and 8 April 1942.

52 The texts of these talks are kept in a private collection.

53 It was Jules Bazin who informed Morisset of the existence of the
 Tureen of the Hertel de Rouville Family (cat. 7), providing him with
 its dimensions and even a photograph. He added an amusing
 comment: "The piece bears the crest shown below, which could
 have served as a slogan for Curé Labelle and his intrepid settlers
 of the North (Harrow Harrow)." The photo of the work would be
 included with the *Radio-Collège* schedule for 1941–42. Letter
 from Jules Bazin to Gérard Morisset, 27 July 1941, Jules Bazin
 correspondence, 1935–59, Fonds Ministère de la Culture et
 des Communications. Les grands inventaires nationaux,
 Bibliothèque et Archives nationales du Québec, Quebec City.

54 Letters dated 10, 23, 24 and 26 February, 30 March, 15 and
 21 October, 7, 16 and 24 December 1943, 5 and 14 January,
 14 February 1944, correspondence with Gérard Morisset
 (1935–65), Jules Bazin fonds (P013), Archives of the Musée
 national des beaux-arts du Québec, Quebec City.

55 Order form, Laurent Amiot beaker (33.120.102) conservation file,
 American Wing, The Metropolitan Museum of Art, New York.
 The form reads: "Coming out in 1944: Jules Bazin, a graduate of
 the Institut d'art et d'archéologie de Paris, librarian and profes-
 sor at the École des Beaux-arts de Montréal, will be publishing a
 fully documented biography on Laurent Amyot [sic] and his style."

56 Letter from Gérard Morriset to John E. Langdon, 6 November
 1944, box 12, file 6, John E. Langdon fonds, Thomas Fisher Rare
 Book Library, University of Toronto.

57 *The Arts in French Canada*, exhib. cat. (Quebec City: Musée de la
 province de Québec, 1952), pp. 60–61.

58 *Catalogue of the Fifth Biennial Exhibition of Architecture and Allied Arts*,
 exhib. cat. (Toronto: The Art Gallery of Toronto, 1935), no. 624.

59 *The French in America, 1520–1880*, exhib. cat. (Detroit: The Detroit
 Institute of Arts, 1951), no. 121. The photograph reproduced in
 the catalogue is actually that of another piece.

60 *A Selection from the Louis Carrier Collection of Canadian Silver*, exhib.
 cat. (Windsor: Windsor Art Gallery, 1953), no. 11. For more on
 Louis Carrier, see Gilles Corbeil, "Collectionneurs et collections
 canadiens: Louis Carrier," *Arts et pensées*, no. 16 (April 1954),
 pp. 115–118.

61 *Collections of the Late Joseph H. Bauer, Esquire*, catalogue of the sale
 held 15–17 June 1965, Gardner Auctions Limited, Toronto,
 no. 100.

62 Villeneuve, *Quebec Silver*, pp. 43–44.

63 *The Tureen of the Hertel de Rouville Family* would be given this
 honour in 2015. See *Decorative Arts and International Art Auction*,
 catalogue of the sale held 7 December 2015, Waddington,
 Toronto, no. 248.

64 Exhibition list, *Exposition de la Province de Québec (Visages du
 Canada – Vallée du Saint-Laurent)*, 17 January – 28 February 1958,
 Grands Magasins du Louvre, Paris, curatorial archives of the
 Musée national des beaux-arts de Québec, Quebec City. It is not
 known which of the two large jugs was shown.

65 *The Arts in French Canada*, exhib. cat. (Vancouver: Vancouver Art
 Gallery, 1959), pp. 65–66.

66 *L'art au Canada*, exhib. cat. (Bordeaux: Musée de Bordeaux, 1962),
 pp. 55–56.

67 *Collections of the Late Joseph H. Bauer*, nos. 229, 102, 215 and 29.

68 Villeneuve, *Quebec Silver*, pp. 44–49.

69 John E. Langdon, *Canadian Silversmiths, 1700–1900* (Toronto:
 Stinehour Press, 1966).

70 A.S. Thomson, "Canadian Silversmiths," *Canadian Collector*
 (February 1967), p. 12.

71 Clare Le Corbeiller, *European and American Snuff Boxes, 1730–1830* (New York: Viking Press, 1966), p. 52 and ill. 409.

72 R.H. Hubbard and Jean-René Ostiguy, *Three Hundred Years of Canadian Art*, exhib. cat. (Ottawa: National Gallery of Canada, 1967), nos. 72–79.

73 Ross Allan C. Fox, *Quebec and Related Silver at the Detroit Institute of Arts* (Detroit: Wayne State University Press, 1978).

74 René Villeneuve, "Orfèvrerie de l'église de la Purification-de-la-Bienheureuse-Vierge-Marie," in *Les chemins de la mémoire*, vol. 3, *Biens mobiliers du Québec* (Quebec City: Les publications du Québec, 1999), p. 238.

75 *The Charles De Volpi Collection of Canadian Silver*, catalogue of the sale held 18 May 1979, Phillips Ward-Price Limited, Toronto, no. 180, p. 39. This work was once part of the Joseph H. Bauer collection. See *Collections of the Late Joseph H. Bauer*, no. 299.

76 Émile Castonguay, *Le journal d'un bourgeois de Québec* (Quebec City: s.n., 1960), pp. 259, 264 and 271.

77 René Villeneuve, "Amiot, Laurent," in *Dictionary of Canadian Biography*, vol. 7 (Quebec City: Université Laval / Toronto: University of Toronto, 1988), pp. 16–18.

78 René Villeneuve, "A Ewer by Laurent Amiot," *City and Country Home 7*, no. 4 (May 1988), p. 48.

79 René Villeneuve, *Lord Dalhousie: Patron and Collector*, exhib. cat. (Ottawa: National Gallery of Canada, 2008).

80 Ross Fox, "Silver Standard," *Rotunda* (ROM magazine) 37, no. 3 (spring 2005), pp. 32–39.

81 René Villeneuve, "Drawings by Silversmiths: Reflections on Some Key Works from Nineteenth-Century Quebec," *National Gallery of Canada Review* 4 (2013), pp. 149–158.

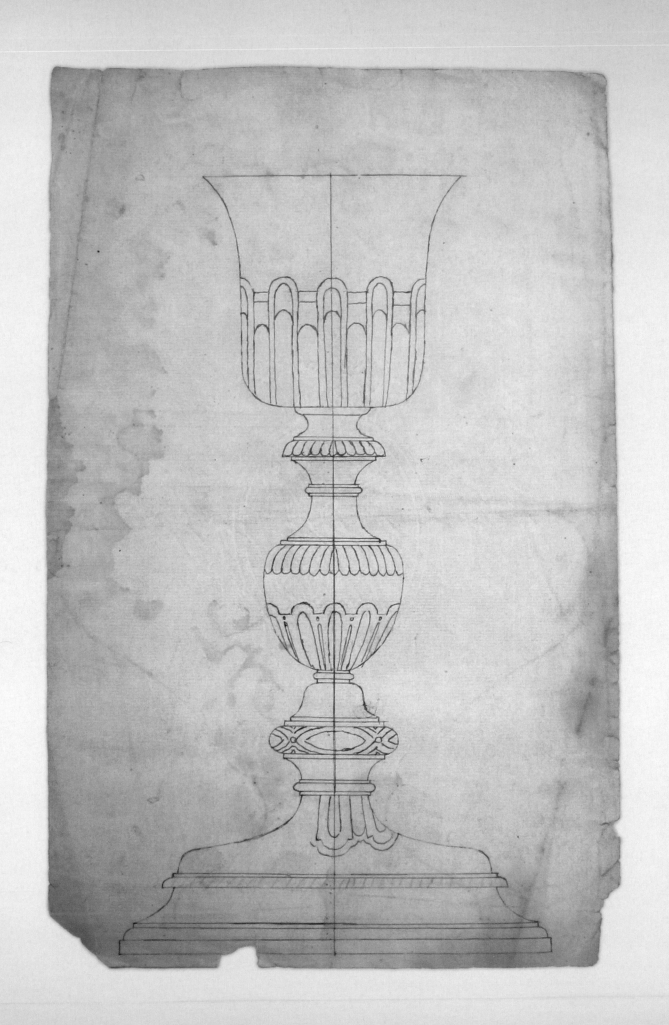

THE PROFESSIONAL LIFE OF A CANADIAN MASTER SILVERSMITH

The Amiot Family

On 11 August 1764 the bells of Notre-Dame Cathedral rang out over Quebec City, announcing to its citizens that Curé Jean-Félix Récher had just baptized the baby Laurent, born the previous day to Jean Amiot and Marie-Louise Chrestien.[1] Laurent Amiot was the ninth of the couple's ten children and the youngest boy to survive to adulthood (six of his siblings would die young). His father Jean was the son of François Amiot and Marie Bobière, of the parish of Saint-Pierre in the diocese of Luçon, in France, and according to Pierre-Georges Roy he had arrived in New France sometime between 1740 and 1748.[2] Jean's marriage to Marie-Louise, which had taken place on 9 September 1749 – in the same cathedral and by the same Curé Récher – had clearly been something of an event, for it had been attended by François-Pierre de Rigaud de Vaudreuil, governor of Trois-Rivières, and Charles Claude de Beauharnois, commander of the artillery in Canada.[3]

Jean Amiot was a caterer and innkeeper.[4] He owned a "silver cup from Paris," inherited from his family, that he bequeathed in his first will to his eldest child, Jean Nicolas.[5] On three occasions between 1779 and 1781 he was called upon to supply the cathedral with substantial quantities of communion wine.[6] Another regular client was the architect, sculptor and painter François Baillairgé, whom Jean provided with red and white wine, French brandy, liqueurs, beer, olive oil and vinegar.[7]

Jean Nicolas himself became a silversmith when he was older. He followed a short apprenticeship in Quebec City under Joseph Schindler,[8] who would admit some years later that he had never received formal training in the trade.[9] Jean Nicolas married Geneviève Robitaille, sister of Louis Robitaille, a trader and importer of silverware, and their daughter, also named Geneviève, married a silversmith called François-Xavier Delagrave.[10] The second child in the Amiot family, Louis, became a fur trader based in Quebec City. Several of his children with his wife Madeleine Corbin would practise as notaries or marry into the profession, including their son Joseph, who became the husband of Marguerite Fraser, daughter of the seigneur of Rivière-du-Loup. Marie-Louise, the youngest female child of the Jean Amiot family, married Antoine Parant, a Quebec City merchant who was appointed sergeant-at-arms of the National Assembly in August 1789.[11]

Design for a Chalice c. 1822
Cat. 43

Youth and Training

Little is known about Laurent Amiot's early years, or indeed about those of many children born during this period into a similar social milieu. Nevertheless, there is every reason to believe that he would have been raised in an atmosphere of affection and encouragement. The young Laurent likely received his education in one or other of the city's smaller schools.[12] Although the student list of the Séminaire de Québec – compiled long after the fact – indicates that he was a boarder there in 1778 and 1779, enrolled in the eighth grade,[13] further research has not uncovered other documents confirming this information.[14]

According to the writings of E. Alfred Jones, which date from the early twentieth century, Amiot began his career in the workshop of François Ranvoyzé. The latter, perceiving the youth to be a potential rival, apparently fired him, which might explain the decision by Amiot's father to send his son to Paris.[15] Although repeated many times, this colourful story is probably apocryphal. It is, rather, my belief that around 1778 – the year Amiot turned fourteen, the age at which a silversmith apprenticeship generally started – he began attending the workshop of his older brother, Jean Nicolas. Laurent showed a keen interest in the trade, and his remarkable skill and aptitude for working precious metals resulted in him spending five years completing his training in Paris – something no silversmith born in Canada during the eighteenth century had done before. Certain factors made the trip possible: for instance, increased political stability in the wake of the Conquest and the Church's desire to encourage the emergence of a French-Canadian intellectual elite. The Paris sojourn of Quebec artist François Baillairgé also no doubt helped pave the way. While Baillairgé was in the French capital, between 1778 and 1781, he attended the Académie royale de peinture et de sculpture and worked in the studio of the sculptor Jean-Baptiste Stouf. On his return to Canada he pursued a highly successful career that would have a decisive impact on sculpture and architecture in the country, establishing new foundations for the disciplines and resulting in a number of masterpieces.[16] He also had a significant influence on portraiture.

Amiot's trip to Europe was organized shortly after Baillairgé's return. The question as to why and by whom he was chosen to go abroad remains open, since no documentary evidence has so far been found. But his exceptional skills and an environment receptive to the development of his talent certainly played a part.

In 1782 Amiot was eighteen years old – an ideal age at which to travel abroad to continue his professional training as a silversmith. He had evidently displayed

sufficient stability, independence and judgement to leave his family and live for an extended period on another continent. Like his predecessor Baillairgé, he was the son of a French immigrant, and it is possible he still had relatives in France. His father, gratified that his son was being offered this opportunity to visit the land of his forefathers, no doubt encouraged the venture.

As they had in Baillairgé's case, the staff of the Séminaire de Québec played an important role in the organization and supervision of his journey. The apprentice silversmith left his family and embarked on the voyage in 1782, possibly accompanied by Abbé Arnaud Germain Dudevant, a priest from the Séminaire des Missions Étrangères de Paris who was returning to the city. There is evidence that Dudevant shared Amiot's interest in the arts, for in July 1779 he paid for the purchase of a violin for the seminary.[17]

Prompted by a desire to practise as a silversmith that had yet to fully crystallize, Amiot began laying the foundations of his remarkable career, gradually assuming the features of the creative and original genius he would eventually become. On his arrival in Paris, he was doubtless taken aback by the clothes and accents of its citizens. During the entire stay he remained under the supervision of Abbé François Sorbier de Villars, who supported and encouraged him, and on three occasions over the years reported on his progress in missives to his colleagues in Quebec City – as he had for Baillairgé.[18] Villars was not assigned this task by chance: procurator at the Séminaire des Missions Étrangères de Paris, he knew Canada well, having lived in Quebec City from 1744 to 1756. He had been appointed director of the Séminaire de Québec in the spring of 1746, and had served as its superior from 1750 to 1756. Before leaving the city, his colleagues had entrusted him with a procuration to administer the seminary's possessions and interests in France, a charge he undertook until his death in 1788.[19] This was the man – someone who had lived twelve years in Quebec City and possibly knew Amiot's parents – who kept an eye on the young Laurent while he was in Paris.

Silversmithing in Paris

From the Middle Ages until the end of the Ancien Régime, the silversmiths of Paris were distinguished by their skill, their degree of specialization and the aura bestowed by the noble material they employed. They formed a distinct guild that was strictly organized and controlled. It would not be until the eighteenth century, however, which saw a growing appreciation for the decorative arts, that French silver would reach unprecedented heights, in both design and execution.

During the years Amiot spent in the French capital, the Séminaire des Missions Étrangères de Paris had dealings with three silversmiths: Hostier,[20] Porcher[21] and Sévérin Parisy.[22] All we know of Hostier is that his widow was listed in 1782 as living on Rue Saint-Martin in Paris.[23] The Porchers were a family of silversmiths, but it is not clear which individual was being referred to in the Missions Étrangères records. In light of the dates and specialities of the family's various members it may have been Louis-Claude, son of Alexis Porcher, who ran a store called *Au vase d'or*, located successively on the Pont Notre-Dame, the Pont au Change and Rue de la Sonnerie.[24] But it could also have been the widow of Charles, who continued to operate her husband's workshop – also situated near the Pont Notre-Dame – after his death in 1776.[25] Sévérin Parisy, who lived on Rue de Gesvres, in the parish of Saint-Jacques-de-la-Boucherie, registered his mark on 23 January 1771.[26]

Although no documents in the archives of the Séminaire des Missions Étrangères de Paris give details concerning these three silversmiths, they clearly had links to the institution. Based on what we know of Baillairgé's Paris training, such a connection likely existed with the master under whom Amiot studied, but he has not been identified. Information regarding the conditions governing the training of silversmiths can be gleaned from several apprenticeship contracts drawn up in Paris toward the end of the Ancien Régime. These precious documents establish obligations and set out guidelines for both master and apprentice. We know, for example, that when Jean Simon Pontanneau joined the workshop of Pierre Germain, on 6 February 1761, he was fifteen years old. His apprenticeship was to last eight years, which was standard for the time, and his master undertook to provide him with instruction in his art and all aspects of the trade, concealing nothing. The apprentice was to be housed (in lodgings provided with heating and light) and fed, and his clothes and laundry taken care of. In return, he promised to learn to the best of his ability everything he was shown and taught, to do everything asked of him that was legal and honest, to generate profits, to avoid losses and to inform his master of any that came to his attention.[27] The remarkably detailed terms of this type of contract reflect a clear desire to prevent exploitation or any form of slavery. Basically, the master was required to train the apprentice, withholding nothing, and the apprentice was expected to be diligent and loyal.

Amiot was older than most when he began his apprenticeship, and his training period – possibly tailored especially – would be shorter. The goal was to develop the talents and abilities that would enable him to run his own workshop on his return to the New World.

Drawing

Amiot likely assimilated the fundamentals of his art in his native city. Over the course of his five-year stay in Paris he learned how to plan his creations on paper, in accordance with centuries-old tradition. The acquisition of this skill was essential, for drawing was integral to several aspects of the silversmith's task: it enabled the practitioner to understand and transpose a design from an existing source, to develop a form, to study proportion and to invent a decorative motif or determine how one should be integrated. Equally vital was the ability to execute a simple full-scale drawing, including a plan and an elevation, using a drawing board, a T-square and a pencil. The curves that were segments of circles were executed with a compass, the others freehand. The details represented on elevation drawings could be useful, particularly for indicating joints, and another of their functions was to enable the silversmith to evaluate the precise amount of metal required to make the piece and its cost. Amiot, for example, occasionally wrote a price on the sheet that may have been the sum he was intending to ask (see cats. 42, 47). Drawing was also a way of developing and disseminating new ideas.

Design for a Holy Water Stoup c. 1822
Cat. 42

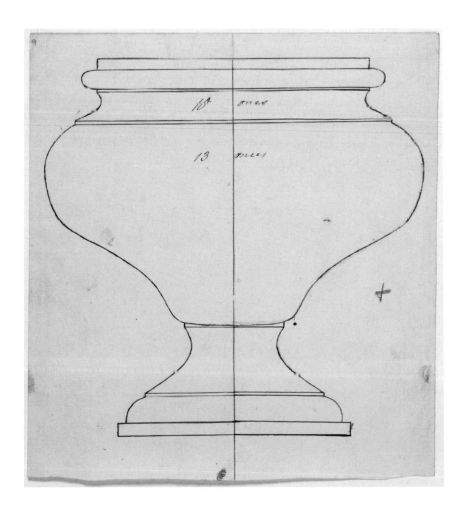

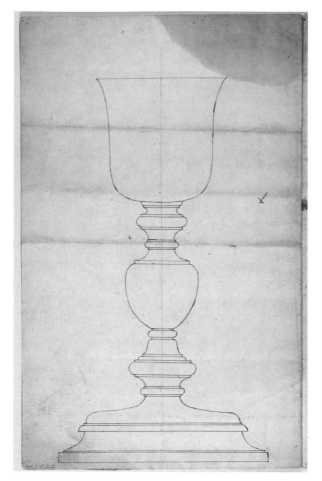

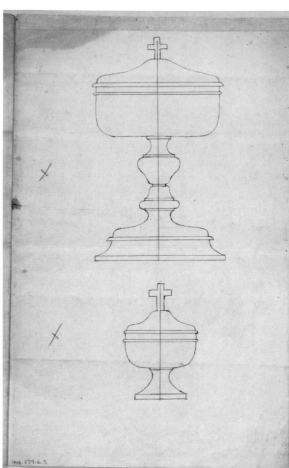

**Designs for a Chalice,
Ciborium and
Viaticum Pyx** c. 1822
Cat. 46

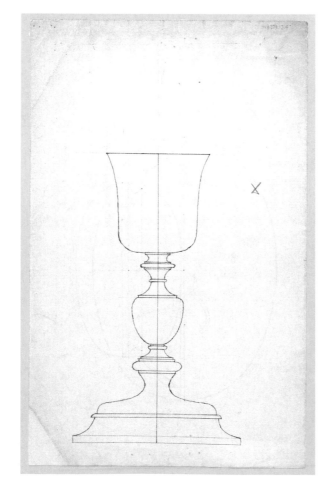

**Designs for a Chalice
and the Socket of
a Processional Cross** c. 1822
Cat. 47

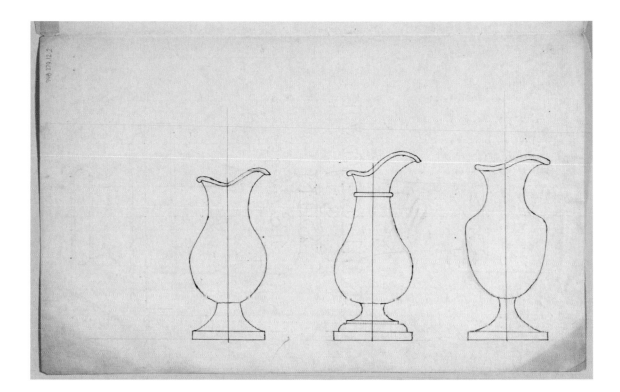

Three Designs for Cruets and Design for a Cruet Basin c. 1822
Cat. 50

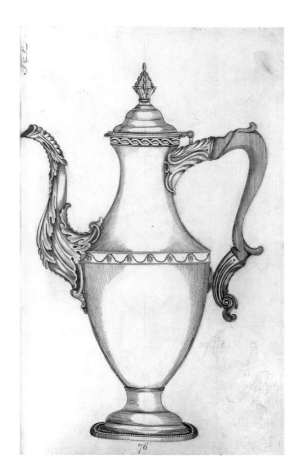

Tudor & Leader
Coffee Pot c. 1765–70
Cat. 76

Unidentified engraver
Candlestick c. 1785
Cat. 77

Unidentified engraver
Cup with Two Handles, Beaker and Wine Funnel c. 1800
Cat. 79

During his French sojourn, Amiot almost certainly acquired drawings by other silversmiths – friends and fellow students – along with engravings illustrating different models that would enable him to expand his formal and ornamental repertoire (see cats. 76, 77, 79, 80).[28]

Learning the Craft

In Paris, Amiot was introduced to the formal and decorative vocabulary – entirely new to him – that would give birth some years later to neoclassicism. Like the baroque and the rococo that preceded it and the romanticism that would come after, neoclassicism is hard to define. It was more than simply a revival of antiquity in the art of the early modern period. Reflecting a fundamental shift in thinking that occurred in the years prior to the French Revolution, it based its language on a new understanding of the ancient world. Stylistically, neoclassicism was

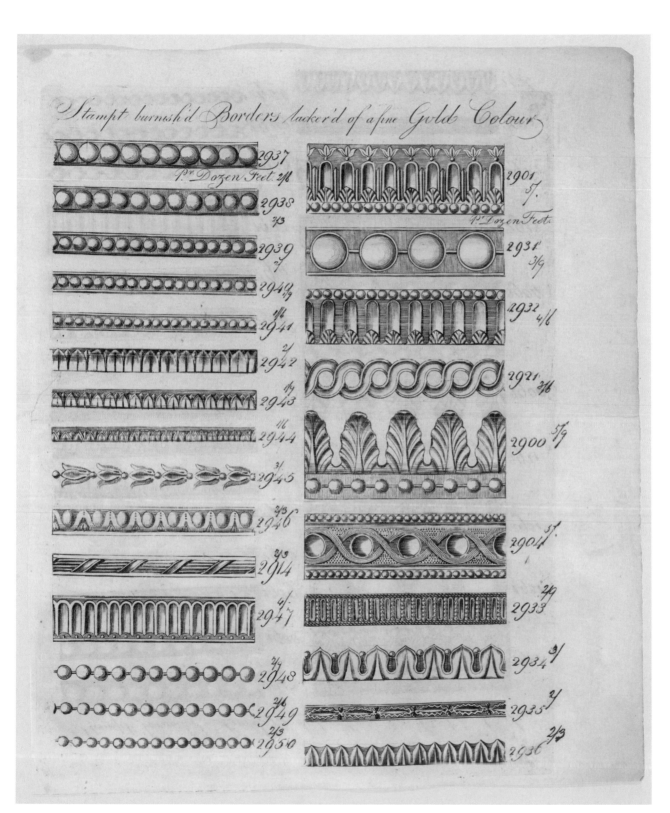

Unidentified engraver
Types of Borders, c. 1800
Cat. 80

characterized by austerity of line, colour, form and even subject. It expressed the cult of sensibility in a glorification of the classical virtues, seen as essential to attainment of nature's simplicity.

During his stay in Paris, Amiot also perfected his mastery of the techniques of construction, decoration, colouring, assembling and finishing peculiar to the silversmith's art, as well as the essential preliminaries of metal refinement and the preparation of sheet silver by hammering.[29] As with all the applied arts, execution was all-important, but basic technique and the development of skills were not the only goals of the training period: the cultivation of intuition, an element our own highly technical society tends to downplay, was also considered vital.

The principal task of the silversmith is to hammer a sheet of metal into a predesigned shape, thereby producing a three-dimensional object from a material that is virtually two-dimensional (discounting the thickness of the sheet). It demands a sustained intellectual engagement, with eye, brain and hand working together to give concrete form to a concept. The period of apprenticeship is aimed at developing these various faculties. In Amiot's case, the goal was to produce a general silversmith, a practitioner capable of executing a wide range of works rather than a specialist in one particular type of object, like most of those working in London.[30] Such a craftsman had to be able to make objects for domestic and ecclesiastical use, but also flatware and wedding rings. And last, but by no means least, he had to know how to organize and supervise a workshop where journeymen and apprentices worked side by side, and to possess the acumen to successfully run the technical and financial aspects of a business.

For this young man of eighteen, it was an ambitious program. Although there is a lack of documentary detail regarding Amiot's development in the various facets of his craft, we do know from his protector that he worked steadily and with diligence. In May 1783 Villars wrote: "Mr. Amiot continues to work successfully in Paris, and behaves himself well, as far as I can judge. I include his letter with mine."[31] Two years later, the assessment was even more positive: "You may assure Mr. Amiot that his son is working very hard, has made considerable progress and should be ready to return to Canada next year."[32]

Back in Quebec City

Amiot left Paris for good in the spring of 1787 and returned to the bosom of his family and friends – no doubt accompanied by various tools of his trade. He arrived in Quebec City carrying a letter from Villars recommending him to the protection of the superior of the Séminaire de Québec, Abbé Thomas-Laurent Bédard: "The bearer of this letter will be Mr. Laurent Amiot, who has thoroughly learned the art of silversmithing in Paris, who has conducted himself well while there, and whom I entreat you to assist, as far as you are able, in the exercise of his talent."[33] If Amiot had remained in Paris at the end of his training, he could have expected to hold a respectable position in a workshop. Instead, armed with this excellent recommendation and, more importantly, with greater theoretical and technical knowledge than any of the silversmiths working in Quebec City at the time, he chose to settle permanently in his hometown and contribute toward the artistic development of his native land.

The place he discovered on his return was not quite the one he had left, for the political and economic situation had changed. After many difficult years, the city had entered a period of stability and prosperity that would last for half a century[34] and that, as we shall see, would provide a context conducive to the development of Amiot's career. The capital was already home to a large quantity of silverware, owing in no small part to the cathedral of Notre-Dame and the different religious communities established since the seventeenth century, which between them had assembled many seventeenth- and eighteenth-century objects, French and Canadian, designed for use in celebration of the liturgy (fig. 2.1).[35]

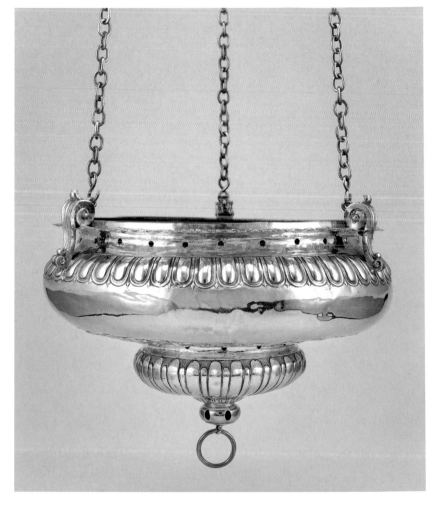

Fig. 2.1
Jean-Baptiste Loir (active in Paris, 1689–1716)
Votive Lamp from the Church of Sainte-Famille
1697–1703

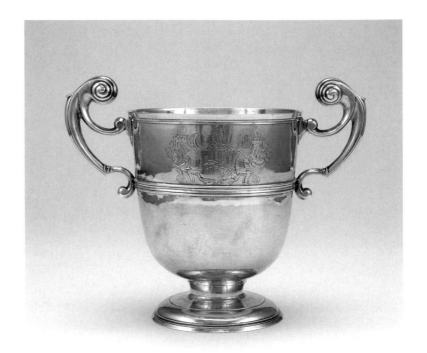

Fig. 2.2
Unidentified artist
Cup of the Woolsey Family 1736–37

Fig. 2.3
John Robins (active in London, 1771–1831)
*Pair of Covered Sauce Tureens and Matching Trays
with Monogram of the Duperron-Bâby Family*
1782–83

The Church was not alone, moreover: the community's old aristocratic
families also possessed treasures. The Chaussegros de Lérys, for example, boasted
a large collection of silverware[36] that subsequent generations would continue to
expand and diversify throughout the nineteenth century (see fig. 3.12, p. 177), and
the Duperron Bâbys, well known fur-traders, also owned a rich selection of silver
tableware (see fig. 2.3).[37] Other more recent settlers, like the Woolseys, had arrived
in Canada accompanied by proudly preserved family heirlooms (see fig. 2.2). The
new passion for collecting silver, which would begin to emerge around this time,
helped ensure the preservation of a number of early works.[38]

The Silversmiths of Quebec City and Montreal

There were a number of silversmiths working in Quebec City during this period. The city's first directory, published in 1790, lists Jean Nicolas Amiot, Laurent Amiot, Michel Forton, James Hanna, Alexandre Picard, François Ranvoyzé and Louis Robitaille.[39] All these men except Robitaille were signatories of a 1795 petition (also signed by James Orkney) aimed at exempting them from a new regulation concerning kilns and forges issued by the Court of Quarter Sessions.[40]

Jean Nicolas Amiot practised the profession for many years, specializing in small objects such as table utensils.[41] Forton was a jeweller and engraver,[42] while Hanna[43] and Orkney[44] were both clockmakers and dealers. They designed small items of silver, but also sold imported works. The French-born Picard made mostly silverware and jewellery for use in the fur trade.[45] Little is known about Robitaille's work, but he apparently produced small objects and sold imported jewellery before leaving Quebec around 1793 to practise in Detroit. He executed his masterpiece – a sugar bowl – after settling in Ste. Geneviève, Missouri.[46] Of the group, Ranvoyzé was definitely predominant: over the course of a practice that began in 1771 he produced a considerable body of work, consisting for the most part of religious vessels (see fig. 2.4) and high-quality domestic pieces.[47]

There were also a number of talented silversmiths working in Montreal. Some took an essentially commercial approach, but there were a few genuine artists, including Michael Arnoldi (see fig. 2.5),[48] who apprenticed under Robert Cruickshank, a London-trained Scot who settled in Montreal in 1773 and successfully ran the city's largest workshop.[49]

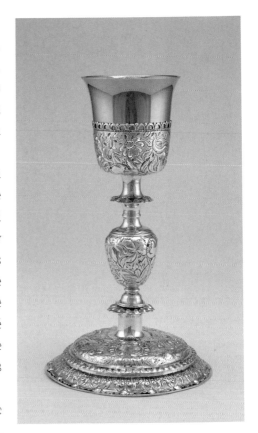

Fig. 2.4
François Ranvoyzé (1739–1819)
Chalice c. 1784

Fig. 2.5
Michael Arnoldi and Société d'Arnoldi &
Oakes (active in Montreal, c. 1792)
Tea Service 1792

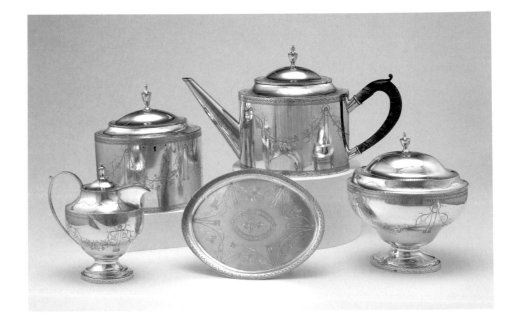

Amiot's Workshop

Amiot started working very shortly after his return to Quebec City in 1787. The recommendation from Villars had an immediate effect, for he soon began receiving commissions for items of ecclesiastical silver. By the end of 1788 the parish of Saint-Joachim had paid him for a censer and incense boat (cat. 1) and the parish of Deschaillons for a pair of altar cruets (cat. 2), while the parish of Repentigny spent a substantial sum that year on a large hanging sanctuary lamp (cat. 3). The dates of these payments suggest that the objects were commissioned in 1787. In 1789 Amiot gilded and polished a chalice and a patent for Notre-Dame-des-Victoires, a succursal of the cathedral.[50] Had he arranged to make use of the workshop of another silversmith, possibly that of his older brother? We cannot be certain, but we do know that by 13 May 1789 François Baillairgé had finished making his store sign[51] and that in 1790 Amiot purchased a property – no doubt selected with considerable care – from the locksmith Jacques Duval. Located, as mentioned previously, on the côte de la Montagne, the lot was fifteen feet wide and forty feet deep. The house that stood on it had been damaged by fire in the winter of 1789 and was in the process of being repaired when Amiot acquired it.[52] He borrowed the money needed to complete the transaction from Alexander Gray.[53]

Censer and Incense Boat of Saint-Joachim 1788
Cat. 1

Bowl of the Hanging Sanctuary Lamp of Repentigny 1788
Cat. 3

Pair of Altar Cruets of Deschaillons 1788
Cat. 2

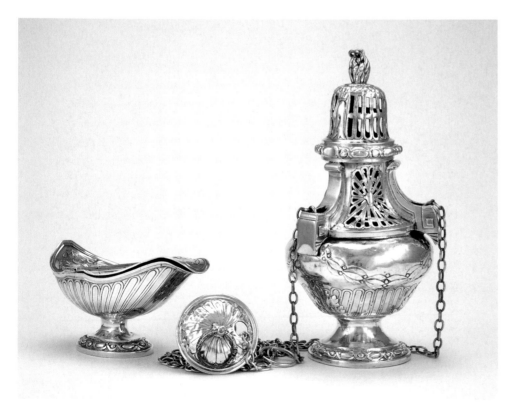

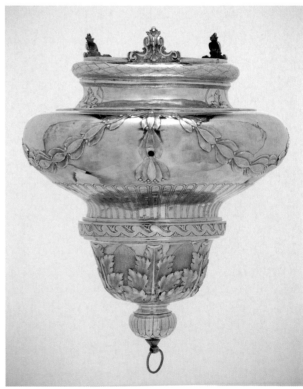

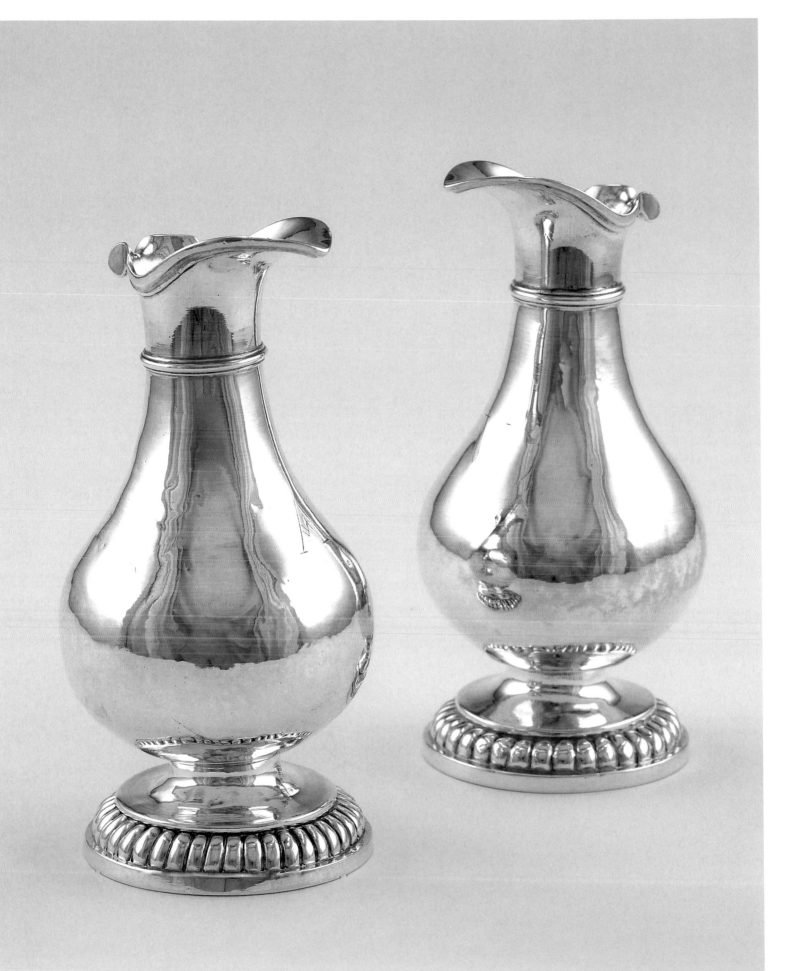

The côte de la Montagne, a street first laid out by the founder of Quebec City, Samuel de Champlain, was at that time the only link between the Lower and Upper towns and as such the main thoroughfare connecting the city's commercial and institutional sectors. Originating near the port, it twists its tortuous way up the cliff to the Prescott Gate (see cats. 87, 89). Michel Forton and James Orkney already occupied premises on the street, and Jean Nicolas Amiot and Louis Robitaille had establishments nearby.[54] According to one contemporary chronicler, "De la Montagne Street meanders between trim and well aligned houses, luxurious and elegant stores."[55] Amiot's property, just opposite the Champlain Staircase (nicknamed the "breakneck" staircase),[56] was therefore situated in a strategic position, a busy spot in the heart of a neighbourhood humming with all sorts of commercial activities (see cat. 88). Just two houses away were the premises of *La Gazette de Québec* (see fig. 2.6), run by the Neilson family, who as well as the newspaper published a large number of religious books.[57] Amiot's immediate neighbour was Jean-Paschal Létourneau, identified variously as a blacksmith or a gunsmith, who was married to Marie-Françoise Antoinette Baillairgé, older sister to François.[58] All in all, it was an ideal location.

Fig. 2.6
Joseph Légaré (1795–1855)
Location of La Gazette de Québec c. 1835

Amiot's profession imposed particular requirements, and his workshop had to be located in a building suited to a working silversmith. There exists a watercolour showing the one he chose (cat. 84). The stone structure was composed of a ground floor, two upper storeys and a gabled roof. The workshop was likely at street level, and Amiot and his family would have made their home on the two upper floors. The attic would have been used to accommodate extra beds and for storage. The presence of precious metals meant someone needed to be on hand around the clock, and it was common at the time for an apprentice to sleep in the workshop to act as night watchman.

The building was situated on the north side of the street opposite a gap in the urban fabric – the Champlain Staircase – and its main façade faced south, exposing it to maximum sunlight, which would have been useful in the workshop and pleasant in the apartment above. Since the house had previously been owned by a locksmith (another trade requiring the use of fire), the workshop would have been equipped with a furnace, probably on the west side, where a tall chimney can be seen rising above the roof. In silversmithing at the time, all the operations

James Pattison Cockburn (1779–1847)
***Looking up the Steps of Champlain Street,
Quebec City*** 1830
Cat. 88

requiring fire took place in proximity to a furnace equipped with a bellows. This part of the workshop was kept rather dark, so the craftsman could see the subtle shades of colour in the red-hot metal on which he based his decisions. This was where he heated the sheet silver to make it malleable, made small casts and practised the technique of fire gilding. Tools commonly found in this area were the anvil, the dapping die and the creasing stake. The workbench had to be situated near a window and placed on a raised wooden riddle in order to collect any bits of precious metal that fell. Most of the assembling, decorating and finishing, which required as much light as possible, would take place at this spot. Lamps equipped with a device to increase the intensity of the flame were sometimes used for precision work, particularly in wintertime, when daylight hours were shorter. The shape of the workbench, which featured a large cut-out section in front, was designed to enable the silversmith to get very close to his work while providing support to his arms and elbows, thereby ensuring his hands remained steady. Traditionally, a kind of leather apron would be suspended beneath the cut-out section of the bench in order to catch any scraps of precious metal that might fall, which would be recycled and were of greater value if already polished. Among the wide range of tools hanging on the wall or laid out nearby were pliers, many different shaped hammers, files, gravers and chasing tools. Wood, wax or plaster models made to execute a particular piece would be kept in the workshop and sometimes used in creating new works. Drawings and engravings were stored in a drawer or pinned up on the wall. This small, hot space – where efficiency depended on strict order – resonated daily with the sound of tools, blending with the noises wafting in from the busy street.

Unidentified artist
De la Montagne Street at the Top of the Champlain Staircase c. 1818
Cat. 84

A Place in Society

Amiot quickly established his position in Quebec City society. On 31 October 1790, along with François Baillairgé, Jean Baillairgé and James Hanna, he signed a petition addressed to the governor advocating the founding of a university in the city. Among the reasons put forward to justify the idea were the high cost of completing a student's training in Europe and the risk that young people sent to study in the United States would lose their connection to the province.[59]

The following winter Amiot served as an expert on a government commission of inquiry. After the wreck of the *Atlas* on the shores of Isle-aux-Grues the previous fall, the authorities wished to establish the value of the goods the ship had been carrying. The cargo had included a large quantity of medals destined for trade

with Aboriginal people, shipped by the London firm of Masterman & Springhall. James Hanna, James Orkney and Laurent Amiot were all asked to assess the value of the medals and their cost of fabrication. Amiot pointed out that the cost of such medals would be lower in Europe than in Canada, since they could be struck there but no Canadian engraver was capable of making the dies. In presenting his assessment, he submitted a detailed document indicating the quantity of silver used and the way the medals were fabricated. When asked if he would agree to lower his fee if he were paid for his services immediately (a common practice at the time), he refused.[60] It is interesting to note that Amiot was already considered an established professional and that his expertise was sought in a delicate case such as this. His reluctance to work at a reduced rate suggests that he aimed to run a serious business and hesitated to do anything that ran counter to this goal. That same year Amiot once again distinguished himself by renting a pew in the cathedral, as was customary among parishioners at the time; his pew was in the front row of the nave on the north side of the altar, next to the governor's – the most prominent position in the church.[61] What is remarkable here is that the young bachelor, freshly arrived from Paris, was not yet thirty years old. He would keep this pew for the rest of his life, the parish retaking possession of it upon his death.[62]

On 7 April 1793 there was rejoicing in Quebec City: following announcement of the banns by Curé Joseph Octave Plessis on Low Sunday (the first Sunday after Easter),[63] Amiot and Marguerite Levasseur dit Borgia were married in the cathedral[64] in a ceremony performed by Abbé Antoine-Bernardin Robert de la Pommeraye, director of the seminary. In his diary, Baillairgé noted his attendance at both the ceremony and the wedding feast.[65] The young couple's first son, Noël-Laurent Amiot, who would grow up to become a priest,[66] was born in December 1793.

A model citizen, Laurent Amiot became increasingly involved in society and community life. He was the author of a number of addresses marking the arrival or departure of important personages, such as Lord Dorchester,[67] Prince Edward[68] and Governor Prescott.[69] He also took part in fundraising to assist the victims of a fire[70] and (as a daily user of a furnace) became a member of the Quebec Fire Society.[71] He only held one public office; he was appointed churchwarden at the cathedral in 1811 and chief churchwarden in 1815.[72]

James Pattison Cockburn (1779–1847)
The Prescott Gate c. 1829
Cat. 87

James Pattison Cockburn (1779–1847)
Looking up Mountain Street Toward the Prescott Gate 1830
Cat. 89

Apprentices and Collaborators

Although the Church was Amiot's first client, there were soon others. It is not known who commissioned the two large lidded jugs he made shortly after his return from Europe (cats. 4, 5), but their stylistic originality in the Canadian context and the refinement of their execution undoubtedly contributed toward his renown and helped establish his career. A tea urn he made around the same time (not included in this catalogue, since its current whereabouts are unknown) would likely have had the same effect,[73] and Amiot's execution in 1793–94[74] of a large tureen (cat. 7) for the seigneur Jean-Baptiste Melchior Hertel de Rouville confirms the respect his artistry commanded among the aristocracy.

Owing to the nature of the work, a silversmith often required assistance during the execution of a piece – an exceptionally large object like a sanctuary lamp, for example, could not be handled alone. Help was also needed to fulfil

Tureen of the Hertel de Rouville Family 1793–94
Cat. 7

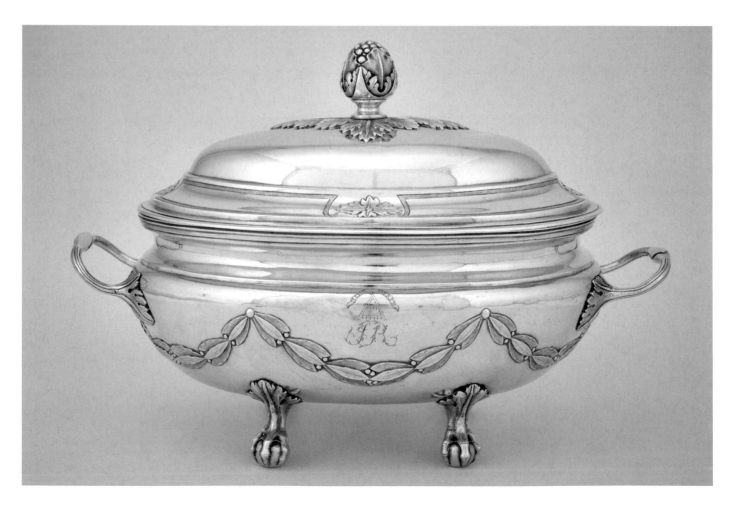

Tureen of the Hertel de Rouville Family (detail) 1793–94

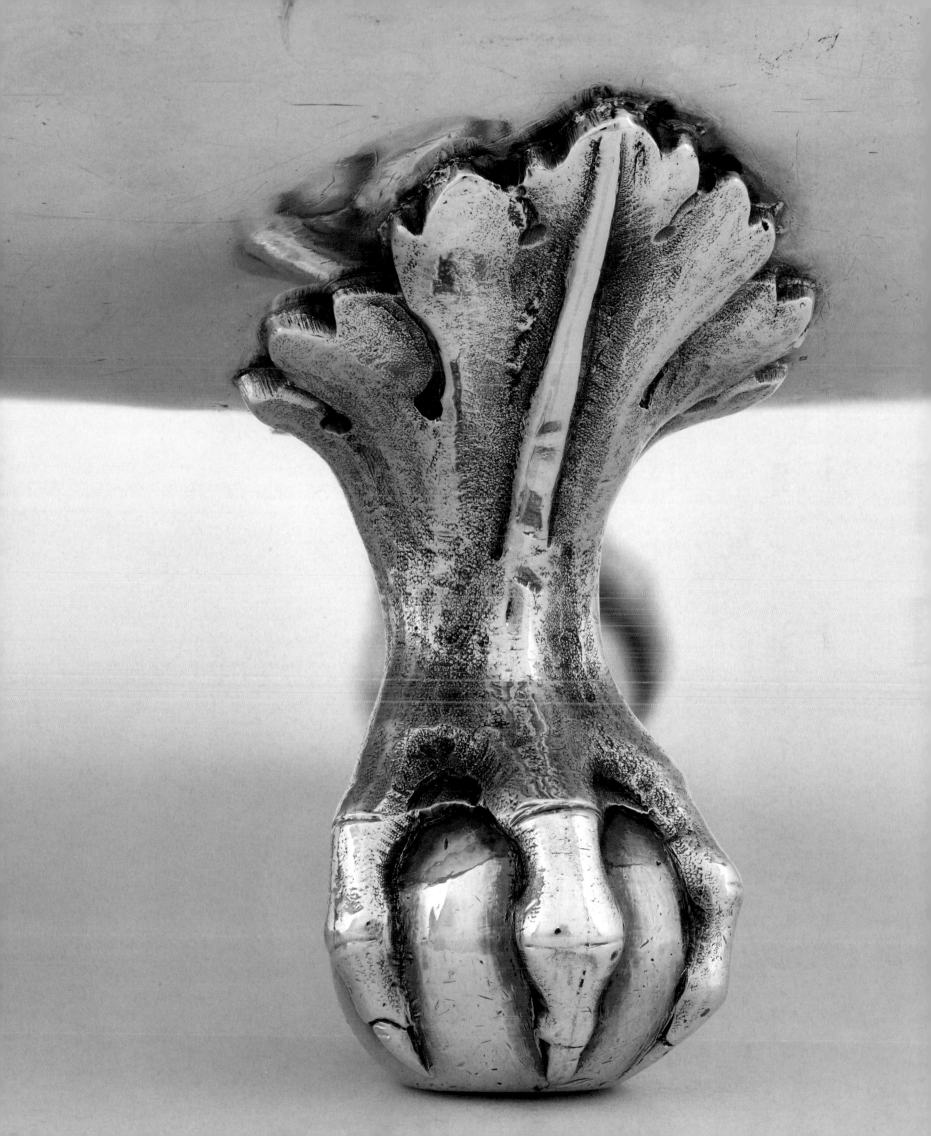

multiple concurrent commissions and in executing specialized tasks. It is no surprise, then, that Amiot took several apprentices into his workshop on côte de la Montagne, resulting in professional relationships that would last until the end of his life. Amiot's first known apprentice was Paul Morin, a young orphan whose certificate of apprenticeship, dated 10 September 1791, indicates that he had joined the workshop two months earlier.[75] Morin had actually entered Louis Robitaille's nearby workshop on 12 May 1790, but their agreement was terminated on 27 June 1791 owing to the latter's plans to leave the city.[76] So Amiot's first apprentice, who would remain with him for five years, had already spent fourteen months working in the studio of a colleague.

On 12 January 1795 Amiot formalized his understanding with a second apprentice, Jacques-Richard Filteau,[77] who had already been working in the studio for ten months and who would remain there for five and a half years. The workshop seems to have been a hive of activity, for in February 1796, when Morin was still a few months away from the end of his contract, Amiot began seeking a third apprentice.[78] The scenario was repeated in the fall of 1815, when an advertisement appeared several times in *La Gazette de Québec*: "Apprentice needed for the profession of silversmith," it read succinctly.[79]

In the same December 1815 issue of the newspaper in which Amiot advertised for an apprentice we learn that James Hanna was seeking two[80] – an indication that the city's silversmiths were doing well. Amiot finally signed a four-year contract on 21 December 1816 with Joseph Babineau, who had been working in the studio since mid-April. It seems likely that, as with Filteau, Amiot had employed the young man initially on a trial basis, in order to assess his talents and be sure of his suitability.

The last apprentice of whom there is documentary evidence is Pierre Lespérance, who joined Amiot in June 1836.[81] He was sixteen – about the same age as his predecessors – and signed on for the standard period of five years. His contract was slightly different, however: when the notary was preparing the certificate, Amiot had him strike out the word "craft" and replace it with "art of silversmithing." He had in fact been referring to himself as a "Maître ès Art Orfèvre" (master of the art of silversmithing) since 1816, and although unusual in Canada this terminology corresponded to that of comparable contracts drawn up in Paris.[82] The change reveals that Amiot was fully conscious of his standing. Thanks to him, working in silver was no longer considered a craft in this country, but an art, and the silversmith was no longer an artisan, but an artist. Another interesting

addition to Lespérance's contract was a clause requiring him to execute all the tasks assigned to him either by Amiot or by any other person in charge of the studio – a clear indication that there were other qualified silversmiths working there. Who were they?

Amiot's first apprentice, Paul Morin, would later open a workshop on the same street as his former master,[83] but none of the others seem to have set up on their own. Given the large number of objects produced, repaired and reconditioned in the Amiot studio, it is possible that they continued their careers working for him, as journeymen or employees. It seems odd that such a busy silversmith apparently hired no new apprentices during a period of two decades, and he may have entered into unnotarized agreements that have yet to be traced. Given that Jean Nicolas Amiot, François Delagrave and Joseph Sasseville, known principally for their flatware and small table pieces, were all working as silversmiths in Quebec City during Amiot's long career, it is highly plausible that they collaborated with him. It is also possible that one or more of them was employed by him on a part-time basis, on the understanding that they would be allowed time to work on their own projects. This was quite a common practice. We know, for example, that François Delagrave made pieces for the retailer James Smillie[84] and that James E. Ellis, despite being himself a qualified silversmith,[85] also employed Delagrave to make utensils for sale under his name.[86]

In a Montreal example, the talented Salomon Marion entered into a well-documented agreement in June 1810 with his former master, Pierre Huguet, *dit Latour*, according to which the former undertook to make twenty-seven large items of ecclesiastical silver in a year. Marion was given permission to work on "lamp and censer chains, and chain-holder," while Huguet agreed to supply the "money, coal and tools." The workers were supervised by Marion, who was required to work "regularly, at least four days per week." An exclusivity clause stipulated that Marion was "not allowed to execute in his workshop or elsewhere any object in silver for the Churches for any other person."[87] It is more than likely that similar agreements were reached between Quebec City silversmiths during the same period.

In order to grasp more fully how the workshops operated and how apprentices were hired, we need to look at another key figure: François Sasseville. According to his biographers, Sasseville leased Amiot's workshop after his death,[88] but it is still not known what led up to this succession. As we have seen, Sasseville's nephew, Pierre Lespérance, signed on as an apprentice with Amiot, not with his

uncle, but he did work for Sasseville after Amiot's death before eventually setting up his own business in 1864. In fact, we know that Sasseville was already working in Amiot's workshop in 1825, for on 20 December of that year he submitted a receipt in the master's name for payment of work done for the church of Notre-Dame-des-Victoires.[89] André Hianveux had undertaken the same task on 5 February 1822.[90] This information encourages us to reassess Sasseville's role and to imagine it somewhat differently. Although nothing is known about his professional training, he is suddenly encountered dealing with the Amiot accounts. It is tempting to believe that when Sasseville first joined this very busy workshop he was responsible for receiving commissions, preparing submissions, looking after the accounts and possibly even organizing and assigning the various jobs. So one facet of Amiot's genius would have been the capacity to make best use of the talents and abilities of those working in his studio at any particular time, thereby ensuring that over the decades his ideas were concretized with consistency – rather as a high-fashion designer produces successive collections with the help of specialized small-time artisans.

Aside from the apprentices and possibly journeymen working in his studio, Amiot relied on a number of occasional collaborators in producing his works. Among them was one of the leading figures of the Quebec art milieu, of whom we have already had a glimpse: François Baillairgé. Although his journal stops in 1800, it reveals that during the first decade of Amiot's career Baillairgé supplied the silversmith with models for the casting of various components. Starting in the spring of 1790, the sculptor provided Amiot with teapot handles and the models for a tap and a Christ figure required to execute particular works.[91] He also supplied him with models for the feet and lid finials of tureens and serving dishes, the spout and socket of coffee pots, a crown and even an eagle's head, all of which could be used more than once.[92] It was not a unique association, for Baillairgé also sculpted a number of models for jewellery for Michel Forton,[93] as well as giving drawing lessons to Forton's apprentice, James Sullivan, during the summer of 1795.[94] But there is evidence that the relationship between Amiot and Baillairgé was not just professional and that they were, in fact, friends. It was Amiot, for example, who accepted delivery of a payment to Baillairgé from a Detroit collector called Bâby,[95] and – in a more domestic context – the sculptor obtained salted butter from the silversmith on at least one occasion.[96] Most conclusive, however, is the fact that Amiot not only attended Baillairgé's funeral, held on 16 September 1830, but also signed the register (as did the painter Joseph Légaré).[97]

A survey of Amiot's production indicates that over his five-decade career he employed the services of a number of engravers, although they are not always easy to identify. These individuals were for the most part specialists who practised their craft on the copper plates used by printers, but also, when required, on silver. They copied their motifs from albums or loose prints illustrating diverse decorative designs, or from objects they had observed. Some would build up their own ornamental repertoire as their career progressed, drawing from a wide variety of sources: a rich bank of ideas and ornamental elements was vital to an engraver's success. Silversmiths often chose to employ an engraver, since theirs was a less expensive technique than embossing and chasing. A crest could be engraved on a teaspoon, for example, at nominal cost. Although it is rare that a particular engraver can be linked to a specific object, there is no doubt that during the period when Amiot was active there were numerous talented engravers in Quebec City capable of undertaking such work for him.

Shortly before Amiot left for Paris, Isaac Clemens (or Clement) was publishing advertisements – sometimes in association with Thomas Rigby – offering his services as an engraver and silversmith (the latter probably as a retailer).[98] Born in Britain, he had worked previously in New York[99] and then in Boston with Paul Revere.[100] Around the same time, Cuming & Douglas, who also offered engraving services, set up shop in the Lower Town,[101] although it is not known how long they remained, and their stay may have been brief.

When he embarked on his career in 1787 Amiot possibly entrusted the engraving work to his brother Jean Nicolas, whose apprenticeship contract stipulated that his master, Joseph Schindler, was to instruct him in the art.[102] He may also have employed the engraver John George Hochsteter, who in March 1793 engraved a portrait of Curé David Augustin Hubert for Amiot's neighbour, the printer John Neilson[103] as well as executing other works in Quebec City that same year.[104] Later, Amiot almost certainly gave contracts to Edward Bennet, who worked in the capital as an engraver from 1821 to 1828, producing among other things visiting cards[105] and a map of the city.[106]

We know that James Smillie – an apprentice who went to Scotland to complete his training after having been rejected by Bennet – also undertook commissions for Amiot.[107] He no doubt used two examples of his work, *A Perpetual Almanack and General Table of New and Full Moons* (figs. 2.7, 2.8), published in 1825 and 1827, to persuade silversmiths of his talent for engraving inscriptions. His younger brother, William Cumming Smillie, who learned the trade under him, also worked

Fig. 2.7
James Smillie (1807–1885)
*A Perpetual Almanack by which may
be found in a few seconds of time the day
of the week, or month, in any year
to come* 1825

Fig. 2.8
James Smillie (1807–1885)
*A General Table of New and Full Moons
Shewing the days of new and
full Moon untill the year 1900 with
the Moons age on every day* 1827

on commission.[108] The chasing of the edge of a medal presented to François Louis Tourhanché in 1834, known to have been cast by Amiot, was the work of Hackett & Oakshott, and the engraving was executed by J. Jones.[109] Jones – who was responsible for the ex libris of the Honourable James Stewart (fig. 2.9) and Samuel Wright (fig. 2.10) – was an excellent engraver, and it seems likely that Amiot availed himself of his talent.

Fig. 2.9
J. Jones (active in Quebec City, c. 1830–1836)
Ex Libris of the Honourable John Stewart, Esq.
c. 1835?

Fig. 2.10
J. Jones (active in Quebec City, c. 1830–1836)
Ex Libris of Samuel Wright c. 1835

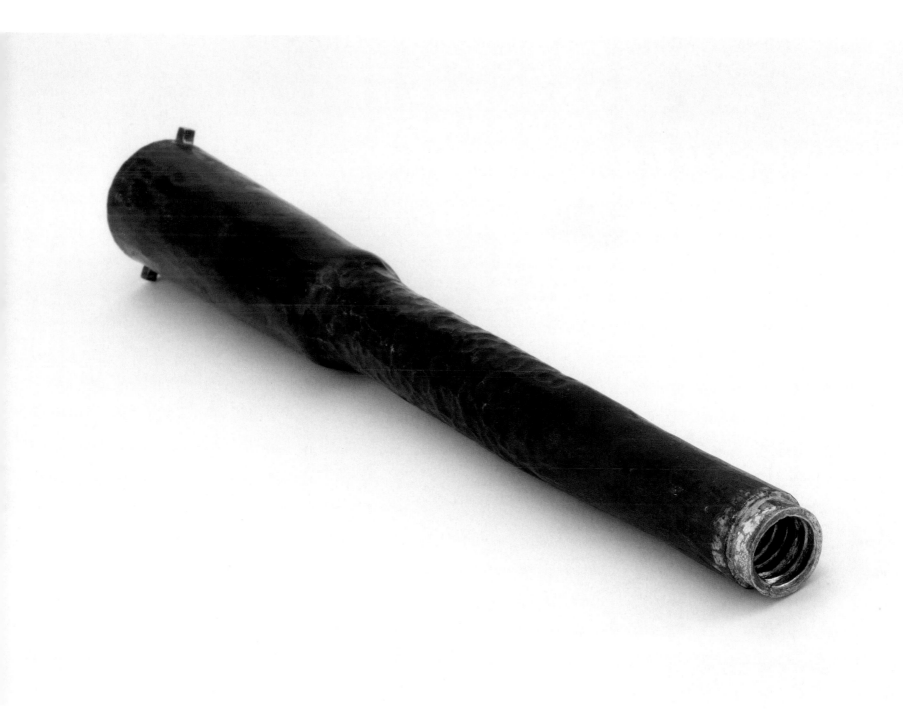

Throughout his career Amiot called upon various other artisans – men and women who remain anonymous – to accomplish certain specialized tasks. Like other silversmiths of the time, he employed an ironsmith to execute the iron inner structure of processional crosses, and perhaps also the copper ferule used to fix the cross to the shaft (although this component could be made in the workshop) (see cat. 34). Some crosses had an inner framework of wood, which made them lighter to carry, and these forms were no doubt executed by a skilled carpenter. For the shafts and handles of utensils Amiot employed a turner, while the piece of varnished mahogany required for a verger's mace would have been made by a cabinetmaker. When working on a mustard pot or a reliquary, the silversmith would have ensured ahead of time that the pot's requisite crystal liner or the glass cylinder used as a window in the reliquary was available from the appropriate supplier. Finally, completed works sometimes required a suitable container before being delivered to their new owner. In such situations, Amiot would have retained the services of a tinsmith to make a case of the necessary size and shape, and of a seamstress to line it with fabric (see cat. 81).

Processional Cross of Sainte-Marie
(copper ferule) c. 1815
Cat. 34

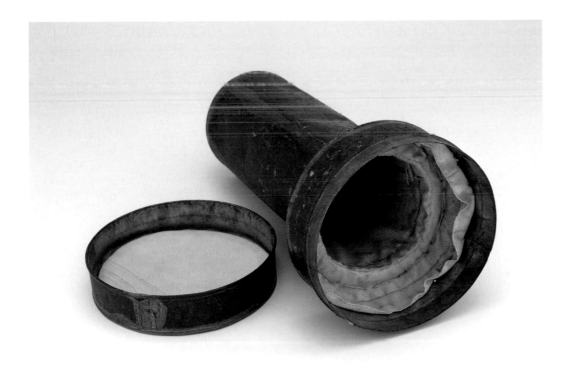

Unidentified artisan
Case for a Chalice c. 1810
Cat. 81

French and English Imports

Between around 1820 and 1835 there was a certain influx into Quebec City of items of ecclesiastical silver made in Paris – something that had not occurred since the French regime. A number came from the workshop of Jean-Charles Cahier, a silversmith who was an early proponent of the Empire style. On a visit to the French capital in 1820, the first archbishop of Quebec, Joseph Octave Plessis, acquired a set of silver-gilt liturgical ornaments and vessels from Cahier, of which the crozier has survived.[110] The following year the same workshop supplied the parish of Saint-Roch des Aulnaies with a censer and matching incense boat, succeeded by a storiated chalice,[111] and it was probably also in 1821 that another chalice by Cahier arrived in Charlesbourg (fig. 2.11).[112] Then, in 1824, the parish of Beaumont bought a censer and incense boat set through the intermediary of Augustin Amiot, a Quebec City merchant.[113] The final item to arrive from this workshop, in 1833, was the large monstrance presented by the religious communities of Montreal to the Sulpicians, who also possessed two paxes by Cahier.[114] The importation of works by Cahier to Quebec City was likely precipitated by the abbés Philippe-Jean-Louis Desjardins and his brother Louis-Joseph, who were both godfathers to the French silversmith's children. They apparently influenced Plessis' initial choice and subsequently suggested other Canadian clients for Cahier's works.[115] Cahier was one of the best-known silversmiths in Paris during the first three decades of the nineteenth century. Engaged frequently by the Church, he was the creator of the extensive group of silver items commissioned for the coronation of Charles X in Reims, in 1825.[116] The appearance of the French silversmith's work in this country undoubtedly had an impact on both Amiot and his clientele, giving them a glimpse of the latest Paris trends. The presence of these pieces likely had a stimulating effect on the silversmith, prompting him to strive even harder to retain the favour of his patrons.

There is evidence that over the five decades of Amiot's career a large number of silver items manufactured in Great Britain were offered for sale in the province by a variety of retailers. Amiot was still a teenager when William Franckling informed the public (first in 1779 and then again in 1781) that he had received from London an assortment of goods that included items of jewellery and objects in silver, both plated and solid.[117] Over the next few years Thomas Powis published similar ads,[118] and both dealers offered engraving services. Although no Canadian studies of the subject have yet been published, we know that objects manufactured in England using the Sheffield plating process were available in this country.[119]

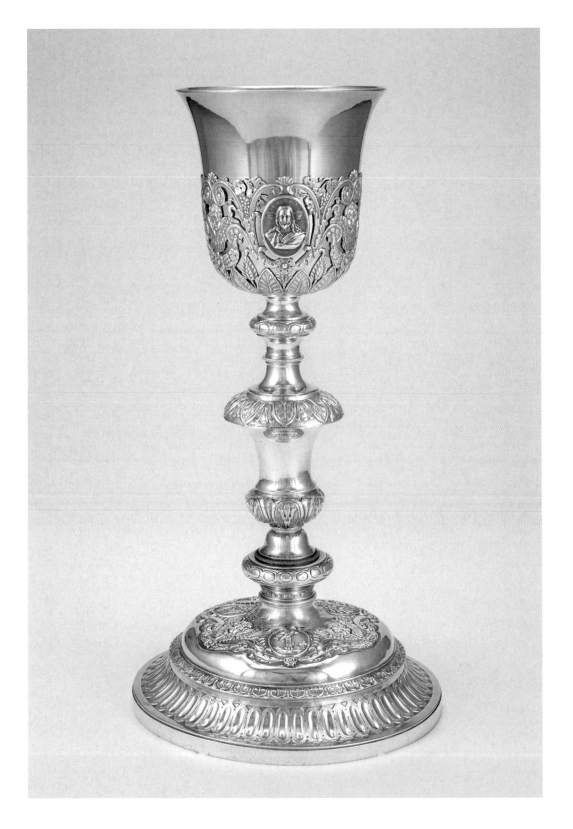

Fig. 2.11
Jean-Charles Cahier (1772–1857)
Chalice of Charlesbourg, c. 1820

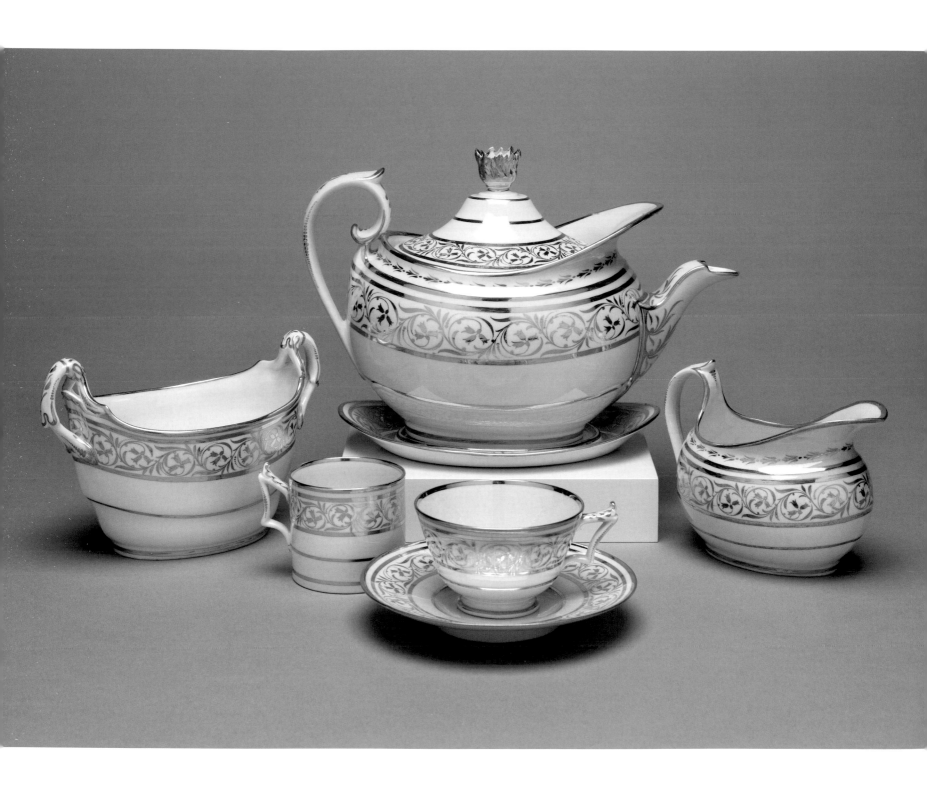

In 1794, for example, Monsignor Charles-François Bailly de Messein bequeathed a pair of silver plate on copper (Sheffield plate) candlesticks to the parish of Neuville, for which the parish authorities commissioned a case.[120] The Breakey family owned salt cellars made using this technique, and some of the items in the enormous set of silverware purchased by James Leslie were Sheffield plate.[121] The seventeen pieces recorded in 1841 as belonging to John Woolsey were probably acquired over an extended period, and some may even have dated from the late eighteenth century.[122]

Around 1825, the display of silverware – some Sheffield plate, some solid silver – in the window of James Smillie's store, located across the street from Amiot's workshop,[123] was calculated to familiarize clients and patrons with the latest styles. There were also items in porcelain imported from England whose aesthetic echoed that of the silverware, such as the tea and coffee service ordered by John Neilson around 1817 (cat. 83). In the summer of 1820, when Amiot was already well established, a certain John Robb, who had a store in the Upper Town on Rue Saint-Stanislas (next to the establishment of the auctioneer Giovanni Domenico Balzaretti), also advertised an assortment of objects in Sheffield plate, along with a variety of utensils.[124] He was just one of the city's many retailers offering similar wares during this period.[125]

It is significant that several of the drawings by Amiot in a valuable portfolio that has come down to us date from 1822, or the years immediately following (see cats. 42–50): apparently the master felt the need to update the basic models of works destined for his religious clientele.[126] He would, in fact, produce a number of vessels based on these drawings. Older parishes were interested in completing their treasures, while new ones needed to acquire the items essential to the liturgy. Several of the drawings bear detailed notes regarding the amount of metal required to execute the object, which meant that the selling price could be calculated before the order was confirmed. And with good reason: when Abbé Jacques Panet commissioned a gold chalice from François Ranvoyzé in 1810, he was not informed of the total cost until the piece was finished – and it both shocked and displeased him.[127] Amiot did everything in his power to increase his business and encourage customer fidelity. A silversmith could not afford to refuse work: the furnace was kept constantly alight, and even repair and refurbishment jobs were a way of keeping the workshop busy and expanding the firm's reputation.

Flight, Barr & Barr (1813–1840)
Selected Elements of John Neilson's Tea Service c. 1817
Cat. 83

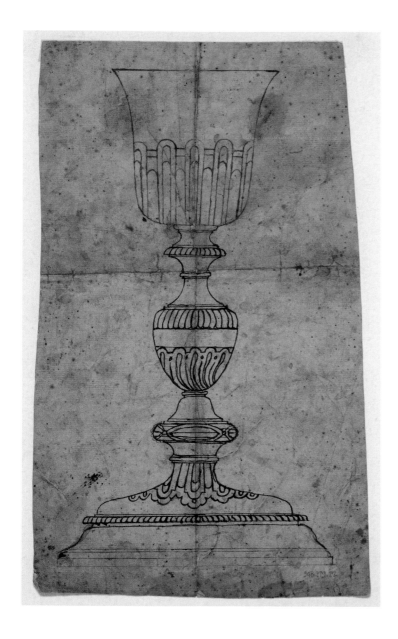

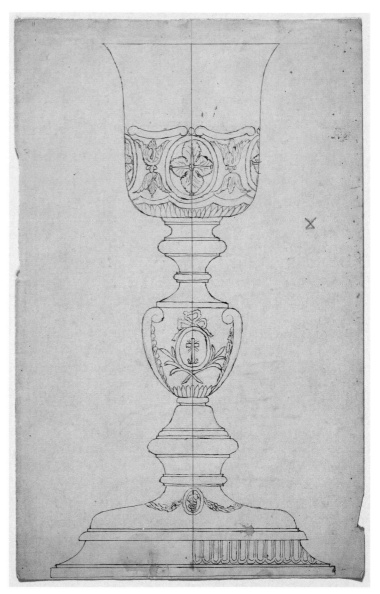

Design for a Chalice c. 1822
Cat. 44

Design for a Chalice c. 1822
Cat. 45

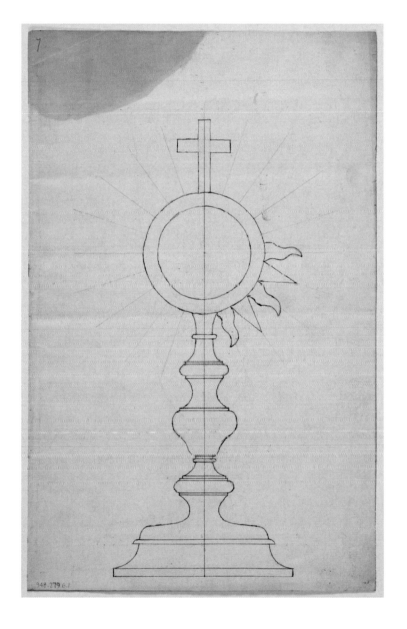

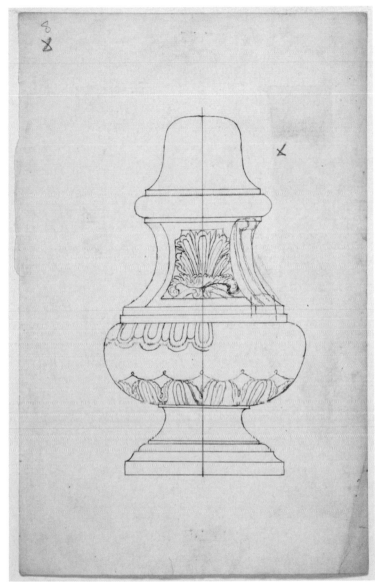

Design for a Monstrance c. 1822
Cat. 49

Design for a Censer c. 1822
Cat. 48

Material and Supplies

Obtaining supplies of precious metals was a constant preoccupation for Amiot, for none were mined locally. A traditional method was to melt down existing objects. The earliest reference to this practice comes from Baillairgé, who on the first day of summer in 1792 sold Amiot his "shoe, garter and stock buckles," along with a cup.[128] This source of supply allowed the silversmith to make pieces that he could offer his clients, rather than waiting for commissions. In 1810, when the church council of Saint-Cuthbert commissioned Amiot to make a processional cross and a monstrance, they gave him their old monstrance in partial payment. The parish of Sainte-Famille de Cap-Santé followed suit in 1822, when under similar circumstances they had their old censer melted down, and the following year the parish of Saint-Michel de Bellechasse gave the silversmith a small holy water bucket to be used in the execution of a larger one.[129] Precious metals were also obtained from melting down collections of coins. When in September 1803 the church councillors of Saint-Cuthbert agreed to take from their coffers a sum of around fifteen hundred *livres* to acquire a sanctuary lamp, a censer with its incense boat, and a holy water bucket, it was apparently the coins themselves that were to constitute the pieces. In Saint-Roch des Aulnaies, in 1809, it was specified in the accounts that the coins supplied would serve "for the material and the execution of the cruets and plate,"[130] a clear distinction being made between the metal and the cost of the work.

In 1826 Amiot gave the churchwarden of the cathedral a receipt for 138 old silver coins for use in works he was to execute, along with fifteen pieces of silver. The origins of the latter were indicated, with a note that the silversmith was aware of their degree of purity. This was repeated the following year, with the parish transferring more coins to Amiot along with a number of pieces of silver from an old lamp and a cross: 200 ounces of precious metal in all.[131] The two sources were combined to fulfil a single commission.

In several cases, detailed notes in church archives reveal that the currency given to Amiot consisted of coins that were no longer legal tender or were too worn to be used. Such was true of the coinage employed for a pax and a baptismal ewer for Saint-Michel de Bellechasse in 1811, a holy water bucket for Neuville in 1812–13, a holy water bucket for Île aux Coudres in 1827, and a pax and a baptismal vessel for Saint-Pierre-de-l'Île-d'Orléans in 1833.[132] The medal that the Séminaire de Québec purchased from Amiot in May 1813, for inclusion in its cabinet of curiosities, may well have been a piece he had acquired to melt down that the seminary

authorities found interesting for aesthetic or historical reasons.[133] Amiot was approached on at least two occasions regarding a mass of silver that had resulted from the melting of religious vessels during a fire. The first time it was following a fire in Saint-Michel de Bellechasse in 1806, when the church council wished to commission new pieces.[134] Seven years later, Abbé Desjardins suggested to Amiot that he purchase a quantity of silver in the possession of the Sulpician Candide-Michel Le Saulnier, curé of Notre-Dame de Montréal, but the parties seem to have been unable to agree on a price.[135]

When called upon to amalgamate precious metal from different sources – and consequently of different grades – Amiot was obliged to first melt it down, refine it and turn it into ingots before it could be used. It was a lengthy and expensive process. Nevertheless, the curé of Saint-François-de-l'Île-d'Orléans seems to have been surprised that the coinage his parish had supplied went down in value as a result.[136] It was a process in which Amiot was evidently proficient, for he successfully refined copper when a deposit was discovered in the province in 1831.[137] Generally speaking, the works he produced early in his career, up until around 1810, were made in silver with a rather white tone, typical of the eighteenth century. From the 1820s on, the metal is greyer. This was undoubtedly a matter of aesthetic choice, and not linked to the relative purity of the metal.[138]

It once again becomes clear that owing to his talent and his sense of organization, Amiot ran a workshop that commanded respect and attracted clients. And it was a workshop on a scale unrivalled in the city. François Ranvoyzé, who was active during the same period but apparently worked alone, quietly pursued his successful career until 1818, when he executed his final piece – a ciborium that he presented as a gift to the new church in the Saint-Roch neighbourhood on 13 September, the day the first bell was blessed.[139] From then on Amiot, who had always maintained a higher profile, seems to have obtained the vast majority of the orders for ecclesiastical silverware given out in the city. The quantity of works the master produced lends credence to this idea, but also his financial success: Amiot was involved in numerous financial transactions. Between 1821 and 1825 he lent money to different individuals on eight occasions, and the period from 1830 to 1839 – the last decade of his life – saw all sorts of transactions, including the issuing of loans, the establishment of life annuities and the purchase of properties.[140] His well-run workshop flourished, and he made a good deal of money. But although he may have been an astute businessman, Amiot's primary concern remained aesthetic.

NOTES

1 Register of births, marriages and deaths, 1759–69, vol. 16 (CM1/A1.1), Fabrique Notre-Dame de Québec fonds, Archives de l'Archidiocèse de Québec, Quebec City.

2 Pierre-Georges Roy, "La Famille de Jean Amyot," *Bulletin des recherches historiques* 25, no. 8 (August 1919), p. 1.

3 Register of births, marriages and deaths, 8 November 1748 – 13 October 1749, 9 September 1749 (pp. 81–82), Fabrique Notre-Dame de Quebec fonds, Archives de l'Archidiocèse de Québec, Quebec City.

4 Will of Jean Amiot, minute book of notary Joseph Bernard Planté, 27 August 1801 (minute no. 2793), Bibliothèque et Archives nationales du Québec, Quebec City.

5 Will of Jean Amiot, minute book of notary Charles Voyer, 16 August 1793, Bibliothèque et Archives nationales du Québec, Quebec City.

6 Account book, 1768–86, vol. 6 (CM2/C1.1, pp. 283, 317 and 330), Fabrique Notre-Dame de Québec fonds, Archives de l'Archidiocèse de Québec, Quebec City.

7 Journal of François Baillairgé, 28 December 1786; 17 February 1787; 19 March 1787; 24 March 1787; 28 June 1787; 30 July 1787; 13 August 1787; 14 July 1787; 1 December 1787; 1 March 1788; 13 March 1788; 17 March 1788; 22 March 1788; 29 March 1788; 31 March 1788; 4 April 1788; 12 April 1788; 17 April 1788; 28 April 1788; (?) May 1788; 17 May 1788; 2 June 1788; 28 June 1788; 3 July 1788; 10 July 1788; 13 September 1788; 7 October 1788; 9 October 1789; 2 October 1790; 19 October 1791; 5 October 1793; 29 June 1795; 24 September 1796 and 6 March 1798, François Baillairgé fonds, Bibliothèque et Archives nationales du Québec, Quebec City.

8 Certificate of apprenticeship of Jean Nicolas Amiot, 9 February 1767, minute book of notary Jean-Claude Louet, Bibliothèque et Archives nationales du Québec, Quebec City.

9 Robert Derome, "Schindler, Joseph (Jonas)," in *Dictionary of Canadian Biography*, vol. 4 (Toronto: University of Toronto / Quebec City: Université Laval, 1979), pp. 702–703.

10 David Karel, *Dictionnaire des artistes de langue française en Amérique du Nord* (Quebec City: Musée du Québec and Université Laval, 1992), pp. 699 and 221.

11 Roy, "La Famille de Jean Amyot," pp. 225–234.

12 The Séminaire de Québec only offered the classical course, designed to prepare students for a career in one of the liberal professions or the Church.

13 "Amiot, Laurent," student list, Archives du Séminaire de Québec, Service des collections, des archives historiques et de la bibliothèque, Musée de la civilisation, Quebec City.

14 My thanks to Peter Gagné, archivist at the Musée de la civilisation, for his valuable assistance in these research efforts.

15 E. Alfred Jones, "Old Church Silver in Canada," *Royal Society of Canada: Proceedings and Transactions*, third series, section 2, vol. 12 (1918), p. 149.

16 René Villeneuve, *Baroque to Neo-Classical: Sculpture in Quebec* (Ottawa: National Gallery of Canada, 1998), pp. 62–75.

17 *Journal de la Dépense du Séminaire des Missions Étrangères établies à Québec*, 1753–80, July 1779, Archives du Séminaire de Québec, Service des collections, des archives historiques et de la bibliothèque, Musée de la civilisation, Quebec City.

18 Journal, 1776–1825, 1779, 1780, 1783, Archives du Séminaire de Québec, Service des collections, des archives historiques et de la bibliothèque, Musée de la civilisation, Quebec City.

19 Honorius Provost, "Sorbier de Villars, François," in *Dictionary of Canadian Biography*, vol. 4, University of Toronto / Université Laval, 2003–, www.biographi.ca/en/bio/sorbier_de_villars_francois_4E.html (accessed 7 March 2013).

20 Expenses, 1776–87, 9 July 1779; 11 February 1782; 27 August 1783 (1519), Archives of the Missions Étrangères de Paris.

21 Expenses, 6 October 1782, ibid.

22 Statements of account (1771–1827 [1791 to 1815 missing]), accounts balanced to 6 March 1788 (1542, p. 102), Archives of the Missions Étrangères de Paris.

23 *Répertoire alphabétique des orfèvres, joailliers, fils d'orfèvres, apprentis, maîtres reçus par arrêt du Conseil, tireurs et batteurs d'or, lapidaires de la ville de Paris 1719–1781. Noms et demeures de Mesdames les Veuves de marchands orfèvres Joailliers et Bijoutiers Tireurs d'or De la Ville de Paris En la présente année 1782* (T1490/27), Archives nationales (France), Paris.

24 Henry Nocq, *Le poinçon de Paris: répertoire des maîtres-orfèvres de la juridiction de Paris depuis le moyen-âge jusqu'à la fin du XVIIIᵉ siècle*, vol. 3 (Paris: H. Floury, 1928), p. 353.

25 *Répertoire alphabétique des orfèvres…*, Archives nationales (France), Paris.

26 Nocq, *Le poinçon de Paris*, p. 301. See also, *Répertoire alphabétique des maîtres et marchands orfèvres, joailliers, fils de maître et apprentis non compris ceux admis par arrêt du Conseil ceux des galeries du Louvre, des Gobelins, de la Trinité 1720–1777. Maîtres et Marchands orfèvres admis au Corps En Vertu d'arrêts du Conseil n'ayant point acquis la qualité d'apprentissage* (T 1490/28), Archives nationales (France), Paris.

27 Certificate of apprenticeship of Jean Simon Pontanneau, 6 February 1761, minute book of notary Jean Simon Vanin, (MC/ET/CXV/739), Archives nationales (France), Paris.

28 No engravings belonging to Amiot have come to light, but it seems likely that he brought back from Paris or subsequently acquired engravings like those published in such collections as Juste-Aurèle Meissonnier, *Œuvre de Juste Aurèle Meissonnier, peintre sculpteur architecte &c: dessinateur de la chambre et cabinet du Roy / Première partie exécutée sous la conduite de l'auteur* (Paris: Chez Charles Huquier, c. 1750) and *A book of eighteen leaves containing divers subjects for the use of goldsmiths, chasers, carvers, etc. / from Messrs. Germain, Messonnier, Sig. Cattarello &c.* (London: To be had of the proprietor Robt. Clee at the Golden Head in Panton Street, St. James's Hay Market, & at the printsellers in London, 1757). These plates and others like them were commonly found in artists' studios. For more on drawings by silversmiths, see Peter Fuhring, "Les dessins d'orfèvrerie," in *Les orfèvres d'Orléans*, exhib. cat. (Paris: Somogy / Orléans: Musée des beaux-arts d'Orléans, 2003), pp. 142–179.

29 For complete information on the techniques of silversmithing, see Erhard Brephol, *The Theory and Practice of Goldsmithing*, trans. Charles Lewton-Brain, ed. Tim McCreight (Portland, Maine: Brynmorgen Press, 2001); Catherine Arminjon, ed., *L'art du métal: vocabulaire technique* (Paris: Caisse nationale des monuments historiques et des sites, 1998).

30 For more on this, see Philippa Glanville, *Silver in England* (New York: Holmes & Meier, 1987), pp. 173–178; Helen Clifford, *Silver in London: The Parker and Wakelin Partnership, 1760–1776* (New Haven: Yale University Press for the Bard Graduate Center for Studies in the Decorative Arts, Design and Culture, 2004), pp. 60–102 and 208–209; Helen Clifford, "The Myth of the Maker: Manufacturing Network in the London Goldsmiths' Trade, 1750–1790," in Kenneth Quickenden and Neal Adrian Quickenden, eds., *Silver and Jewellery: Production and Consumption since 1750* (Birmingham: University of Central England, 1995), pp. 5–12.

31 Letter from François Sorbier de Villars to an unidentified recipient, 22 May 1783 (Letters P, no. 29), Archives du Séminaire de Québec, Service des collections, des archives historiques et de la bibliothèque, Musée de la civilisation, Quebec City.

32 Letter from François Sorbier de Villars to an unidentified recipient, 30 January 1785 (Letters P, no. 35), Archives du Séminaire de Québec, Service des collections, des archives historiques et de la bibliothèque, Musée de la civilisation, Quebec City.

33 Letter from François Sorbier de Villars to Abbé Thomas-Laurent Bédard, 7 February 1787 (Letters P, no. 22), Archives du Séminaire Musée de la civilisation. Service des collections, des archives historiques et de la bibliothèque, Musée de la civilisation, Quebec City.

34 See Jean-Pierre Wallot, *Un Québec qui bougeait: trame socio-politique du Québec au tournant du XIXᵉ siècle* (Montreal: Éditions du Boréal Express, 1973); John Hare, Marc Lafrance and David-Thiery Ruddel, *Histoire de la ville de Québec, 1608–1871* (Montreal: Boréal / Hull: Canadian Museum of Civilization, 1987); David-Thiery Ruddel, *Québec, 1765–1832: l'évolution d'une ville coloniale* (Hull: Canadian Museum of Civilization, 1991).

35 Luc Noppen and René Villeneuve, *Le trésor du Grand Siècle: l'art et l'architecture du XVIIᵉ siècle à Québec*, exhib. cat. (Quebec City: Musée du Québec, 1984), pp. 81–129.

36 Inventory of the estates of the late Monsieur and Madame Joseph Gaspard Chaussegros de Léry, 19 February 1798, minute book of notary Joseph Bernard Planté (minute no. 1665), Bibliothèque et Archives nationales du Québec, Quebec City. Evaluation of the silver was undertaken by François Ranvoyzé. In the Famille Chaussegros de Léry fonds, kept in the same archive, there is a list of silver items giving the prices paid for execution and engraving between 1754 and 1789 (P386, D959).

37 Inventory of the property owned jointly by the late Jacques Duperron Bâby and Suzanne Réaume, his widow, 8 November 1800, minute book of notary Joseph Bernard Planté (minute no. 2508), Bibliothèque et Archives nationales du Québec, Quebec City. Evaluation of the silver was undertaken by François Ranvoyzé.

38 John Neilson owned a pair of emblazoned candlesticks by Jacques Pagé *dit* Quercy, a wine taster by Paul Lambert and a pair of armlets by Joseph Schindler that all still belong to his descendants.

39 Hugh Mackay, *The Directory for the City and Suburbs of Quebec* (Quebec City: William Moore, 1790), pp. 3, 19, 24, 37, 39, 41 and 42.

40 A transcription of this petition is included in the *Inventaire des biens culturels du Québec*, Michel Forton folder, Fonds Ministère de la Culture et des Communications. Les grands inventaires nationaux, Bibliothèque et Archives nationales du Québec, Quebec City.

41 David Karel, *Dictionnaire des artistes de langue française.*

42 Robert Derome, "Forton, Michel," in *Dictionary of Canadian Biography*, vol. 5 (Toronto: University of Toronto / Quebec City: Université Laval, 1983), p. 329.

43 Sylvio Normand, "Hanna, James G.," in ibid., pp. 406–407.

44 René Villeneuve, "Orkney, James," in *Dictionary of Canadian Biography*, vol. 6 (Toronto: University of Toronto / Quebec City: Université Laval, 1987), pp. 556–557.

45 Karel, *Dictionnaire des artistes de langue française*, pp. 637–638.

46 Ibid., p. 699. See also, David L. Barquist, "Refinement in the Illinois Country: Louis Robitaille's Sugar Dish," *Yale University Art Gallery Bulletin* (2004), pp. 58–67; Paul Robitaille, "Louis Robitaille, Orfèvre," *Michigan's Habitant Heritage* 35, nos. 2 and 3 (April and July 2014), n.p.

47 Robert Derome and José Ménard, "Ranvoyzé, François," in *Dictionary of Canadian Biography*, vol. 5, pp. 707–710; *François Ranvoyzé, orfèvre, 1739–1819*, exhib. cat. (Quebec City: Musée du Québec, 1968).

48 René Villeneuve, "A Canadian Masterpiece," *Journal of the Silver Society of Canada* 17 (2014), pp. 16–17.

49 René Villeneuve, "A Scottish-born Silversmith in Montreal: Robert Cruickshank," in Peter E. Rider and Heather McNabb, eds., *A Kingdom of the Mind: How the Scots Helped Make Canada* (Montreal and Kingston: McGill-Queen's University Press, 2006), pp. 137–148; Ross Fox, "Robert Cruickshank (1743–1809), Silversmith of London and Montreal," *Silver Studies: The Journal of the Silver Society* 23 (2008), pp. 83–98.

50 Accounts for the church of the Lower Town, 1789 (p. 89), Account of proceedings of the churchwardens of the parish church of Notre-Dame de Québec, 1786–1804, vol. 7 (CM2/C1.1), Fabrique Notre-Dame de Québec fonds, Archives de l'Archidiocèse de Québec, Quebec City.

51 Journal of François Baillairgé, 13 May 1789 (p. 94), François Baillairgé fonds, Bibliothèque et Archives nationales du Québec, Quebec City. The sign was paid on the following 5 June (see p. 95).

52 Minute from Jacques Duval to Laurent Amiot, 29 April 1790, minute book of notary Charles Voyer (minute no. 397), Bibliothèque et Archives nationales du Québec, Quebec City.

53 Bond from Laurent Amiot to Alexander Gray, 11 May 1790, minute book of notary Jacques Nicolas Pinguet (unnumbered), Bibliothèque et Archives nationales du Québec, Quebec City.

54 Mackay, *The Directory for the City and Suburbs of Quebec*, pp. 3, 19, 37 and 42.

55 Quoted in Antonio Drolet, *La Ville de Québec: histoire municipale*, vol. 3 (Quebec City: La Société historique de Québec, 1967), p. 113. See also, *The Quebec Mercury* 20, no. 81 (16 October 1824), p. 2.

56 Joseph Hamel, *Plan of the Widening of Mountain Hill*, 2 September 1851 (DO1278/DO1279), Archives de la ville de Québec, Quebec City. See also, assessment and tax ledger for 1821 to 1829 (p. 20), Finance, Archives de la ville de Québec, Quebec City. The jeweller Alfred Charles Routhier confirmed the location during an interview with Marius Barbeau. See Laurent Amiot and his works file, Marius Barbeau fonds (B277 F19), Archives of the Canadian Museum of History, Gatineau.

57 *Printing Office Memorandum Commenced 1 oct. 1800*, Neilson fonds (P192/135–141), Bibliothèque et Archives nationales du Québec, Quebec City.

58 Mackay, *The Directory for the City and Suburbs of Quebec*, p. 27; Joseph Signaÿ, *Recensement de la ville de Québec en 1818* (Quebec City: La Société historique de Québec, 1976, Cahiers d'histoire series, no. 29), p. 225; George Frederick Baillairgé, *Notices biographiques, fascicule n°1, Jean Baillairgé, 2ᵐᵉ du nom (souche des Baillairgé du Canada) 1726 à 1805, ses ancêtres et ses descendants (vue d'ensemble) 1645 à 1892* (Joliette: Bureau de l'étudiant, du couvent et de la famille, 1891), pp. 27, 33–36.

59 Petition for a University, 31 October 1790 (CO 42/71), pp. 615–620, Colonial Office, The National Archives (United Kingdom), Richmond.

60 Letter from Lord Dorchester to Lord Grenville, 21 June 1791 (no. 92, CO42/82), pp. 466–523, Colonial Office, The National Archives (United Kingdom), Richmond.

61 Account book, 1786–1802, vol. 7 (CM2/C1.1, p. 119), Fabrique Notre-Dame de Québec fonds, Archives de l'Archidiocèse de Québec, Quebec City.

62 Pew assignment book for the church of Notre-Dame, 28 December 1817 – 26 December 1859, vol. 3, 1839 (CM2/D1.1), Fabrique Notre-Dame de Québec fonds, Archives de l'Archidiocèse de Québec, Quebec City.

63 Book of notices, 3 February 1793 – 27 July 1794, vol. 4, Low Sunday 1793 (CM1/C2.1), Fabrique Notre-Dame de Québec fonds, Archives de l'Archidiocèse de Québec, Quebec City.

64 Register of births, marriages and deaths, 1793–94, vol. 23 (CM1/A1.1), Fabrique Notre-Dame de Québec fonds, Archives de l'Archidiocèse de Québec, Quebec City. See also, marriage certificate between Laurent Amiot and Marguerite Levasseur, dit Borgia, 7 April 1793, minute book of notary Charles Voyer (minute no. 1057, 7 April 1793), Bibliothèque et Archives nationales du Québec, Quebec City.

65 Journal of François Baillairgé, 13 April 1793 (p. 141), François Baillairgé fonds, Bibliothèque et Archives nationales du Québec, Quebec City.

66 Richard Chabot, "Amiot, Noël-Laurent," in *Dictionary of Canadian Biography*, vol. 7, University of Toronto / Université Laval, 2003–, www.biographi.ca/en/bio/amiot_noel_laurent_7E.html (accessed 8 May 2015).

67 *La Gazette de Québec*, no. 1361 (18 August 1791).

68 Ibid., no. 1492 (13 February 1794).

69 Ibid., no. 1799 (18 July 1799).

70 Ibid., no. 1481 (28 November 1793).

71 Ibid., no. 1564 (4 June 1795); no. 1767 (21 March 1799); no. 1824 (10 April 1800); no. 1881 (14 May 1801); no. 2044 (14 June 1804); no. 2098 (27 June 1805); no. 2146 (12 June 1806); no. 2202 (9 July 1807); no. 2253 (30 June 1808); no. 2317 (14 September 1809); no. 3016 (5 June 1820); no. 3319 (21 April 1823).

72 Register of proceedings, 31 August 1777 – 15 December 1825, vol. 3 (CM2/A.1, pp. 361–362 and 343), Fabrique Notre-Dame de Québec fonds, Archives de l'Archidiocèse de Québec, Quebec City.

73 Journal of François Baillairgé, 25 May 1792 (p. 133), François Baillairgé fonds, Bibliothèque et Archives nationales du Québec, Quebec City.

74 Ibid., 14 January 1794 (p. 146).

75 Certificate of apprenticeship of Paul Morin with Laurent Amiot, minute book of notary Charles Voyer (minute no. 720, 10 September 1791), Bibliothèque et Archives nationales du Québec, Quebec City.

76 Cancellation of the agreement (12 May 1790) between Paul Morin and Louis Robitaille, 27 June 1791, minute book of notary Joseph Bernard Planté (minute no. 66), Bibliothèque et Archives nationales du Québec, Quebec City.

77 Agreement between Jacques-Richard Filteau and Laurent Amiot, 12 January 1795, minute book of notary Charles Voyer (minute no. 1427), Bibliothèque et Archives nationales du Québec, Quebec City.

78 *La Gazette de Québec*, no. 1601 (11 February 1796), p. 3; no. 1602 (18 February 1796), p. 4; no. 1603 (25 February 1796), p. 3.

79 Ibid., no. 2650 (16 November 1815), p. 4; no. 2652 (30 November 1815), p. 4; no. 2653 (7 December 1815), p. 8.

80 Ibid., no. 2656 (28 December 1815), p. 4.

81 Agreement between Pierre Rocheleau and Laurent Amiot, 20 June 1836, minute book of notary Antoine-Archange Parent (minute no. 7912), Bibliothèque et Archives nationales du Québec, Quebec City.

82 Certificates of apprenticeship of Michel Bourget (13 June 1761), Jean Joseph André Rouen (20 June 1761), Pierre François Bernard (8 July 1761), Jean-Pierre Faÿs (29 July 1761) and Étienne-Thomas Sentinier (23 September 1761), minute book of Richard Marcel Jarry, Archives nationales (France), Paris.

83 Joseph Octave Plessis, "Dénombrement de la paroisse de Québec en 1805," in *Rapport de l'archiviste de la province de Québec pour 1948–1949* (Quebec City: Redempti Paradis, 1949), p. 177.

84 The National Gallery of Canada owns a mustard pot and spoon, c. 1821–30 (3767/8.1-2) that Delagrave made for James Smillie.

85 Ross Fox, "The Immigrant Element in Quebec City's Precious Metals and Stones Trades during the 1820s," *Silver Society of Canada* 17 (2014), p. 5.

86 *Gravy Strainer*, c. 1820 (27840), Henry Birks Collection of Canadian Silver, National Gallery of Canada, Ottawa.

87 Agreement between Pierre Huguet dit Latour and Salomon Marion, 14 June 1810, minute book of notary Louis Huguet Latour (minute no. 540), Bibliothèque et Archives nationales du Québec, Montreal.

88 Gérard Morisset, "L'orfèvre François Sasseville," *Royal Society of Canada: Proceedings and Transactions*, third series, section 1, vol. 49 (June 1955), pp. 51–54; Jean Trudel, "Sasseville, François," in *Dictionary of Canadian Biography*, vol. 9 (Toronto: University of Toronto / Quebec City: Université Laval, 1976), pp. 701–702.

89 Box 6, nos. 188 a and b, and 189–210, Fabrique Notre-Dame de Québec fonds, Archives de l'Archidiocèse de Québec, Quebec City.

90 Original receipts for payments for silverware (B278 F9), statement dated 1821 and payment dated 5 February 1822, Marius Barbeau fonds, Archives of the Canadian Museum of History, Gatineau.

91 Journal of François Baillairgé, 22 April 1790 (p. 104); 24 October 1791 (p. 125); 25 May 1792 (p. 133); 23 May 1793 (p. 142), François Baillairgé fonds, Bibliothèque et Archives nationales du Québec, Quebec City.

92 Ibid., 22 April 1790 (p. 104); 24 October 1791 (p. 125); 25 May 1792 (p. 133); 23 May 1793 (p. 142); 27 July 1793 (p. 143); 14 January 1794 (p. 146); 24 May 1794 (p. 149); 18 February 1795 (p. 155); 13 October 1795 (p. 160); 16 April 1796 (p. 163); 15 April 1799 (p. 178); 26 January 1800 (p. 182).

93 Ibid., 24 September and 1 October 1796 (p. 165); 10, 16 and 30 November 1797 (p. 171); 4 and 11 November 1797 (p. 172); 26 March 1798 (p. 173); 8 June 1798 (p. 174); 13 October 1798 (p. 176); 5 November, 10 and 16 December 1798 (p. 177); 23–26 July, 18 August and 25 September 1799 (p. 180); 30 November 1799 (p. 181); 27 November 1800 (p. 185).

94 Ibid., 8 June and 11 July 1795 (p. 158); 21 August 1795 (p. 159).

95 Ibid., 19 August 1790 (p. 109).

96 Ibid., 15 September 1796 (p. 165).

97 Register of births, marriages and deaths, 16 September 1830, Fabrique Notre-Dame de Québec fonds, Archives de l'Archidiocèse de Québec, Quebec City.

98 *La Gazette de Québec*, no. 776 (13 July 1780), p. 4; no. 818 (10 May 1781), p. 2; no. 832 (16 August 1781), p. 3.

99 Rita Susswein Gottesman, *The Arts and Crafts in New York, 1726–1776* (New York: The New York Historical Society, 1938), p. 8.

100 Esther Forbes, *Paul Revere and the World He Lived In* (Boston: Houghton Mifflin Company, 1942), pp. 236, 272, 295 and 463. See also, E. Alfred Jones, *The Loyalists of Massachusetts: Their Memorials, Petitions and Claims* (London: The Saint Catherine Press, 1930), pp. XVIII and 93.

101 *La Gazette de Québec*, no. 824 (21 June 1781), n.p.; no. 825 (28 June 1781), p. 2.

102 Certificate of apprenticeship of Jean Nicolas Amiot with S. Schindler, 9 February 1767, minute book of notary Jean-Claude Louet, Bibliothèque et Archives nationales du Québec, Quebec City.

103 The Neilson Paybook, 1793–98, 25 March 1793 (p. 27), 4 April 1793 (p. 30) and 5 June 1795 (p. 84), box 4, item 3 (MS 210), Louis Melzac Collection, Thomas Fisher Rare Book Library, University of Toronto.

104 Mary Allodi, *Printmaking in Canada: The Earliest Views and Portraits / Les débuts de l'estampe imprimée au Canada: vues et portraits*, exhib. cat. (Toronto: Royal Ontario Museum, 1980), pp. 12–23.

105 Mary Macaulay Allodi and Rosemarie L. Tovell, *An Engraver's Pilgrimage: James Smillie in Quebec, 1821–1830*, exhib. cat. (Toronto: Royal Ontario Museum, 1989), pp. 96–98.

106 Thomas Henri Gleason, *The Quebec Directory for 1822 containing an alphabetical list of the merchants, traders and house keepers* (Quebec City: Neilson and Cowan, 1822).

107 René Villeneuve, *Lord Dalhousie: Patron and Collector*, exhib. cat. (Ottawa: National Gallery of Ottawa, 2008), pp. 31–33.

108 Allodi and Tovell, *An Engraver's Pilgrimage*, pp. 4 and 19.

109 *The Gazette* (Montreal) 42, no. 103 (4 September 1834), p. 2. See also, *The Quebec Mercury* 32, no. 2 (5 January 1836), p. 4; Phileas Gagnon, "Graveurs canadiens," *Bulletin des recherches historiques* 2, no. 7 (July 1896), pp. 108–109.

110 In his *Histoire du palais épiscopal de Québec* (Quebec City: Pruneau & Kirouac, 1896) Monsignor Henri Têtu noted a "chalice, ciborium, cruets, censer and incense boat in silver-gilt, from Monsignor Plessis" (p. 291). When E. Alfred Jones visited Quebec City in 1912, he saw the cruets and censer and identified the mark they bore as Cahier's – the same mark that appears on the crozier, the only piece of the set so far discovered.

111 Saint-Roch des Aulnaies church folder, Fonds Ministère de la Culture et des Communications. Les grands inventaires nationaux, Bibliothèque et Archives nationales du Québec, Quebec City.

112 Accounts and proceedings, 1822, vol. 3, Archives of the fabrique Saint-Charles-Borromée de Charlesbourg.

113 Account book, 1824, Archives of the fabrique Saint-Étienne de Beaumont.

114 Dominique Deslandres et al., *Les Sulpiciens de Montréal: une histoire de pouvoir et de discretion, 1657–2007* (Montreal: Fides, 2007), p. 310.

115 Anne Dion-Tenenbaum, "Jean-Charles Cahier et l'orfèvrerie religieuse," in *L'orfèvrerie au XIXe siècle*, proceedings of an international colloquium held at the Galeries nationales du Grand Palais, 12–13 December 1991 (Paris: La documentation française, 1994), p. 36.

116 Anne Dion-Tenenbaum, "Orfèvrerie du sacre de Charles X," in *Un âge d'or des arts décoratifs, 1814–1848*, exhib. cat. (Paris: Galeries nationales du Grand Palais / Réunion des musées nationaux, 1991), pp. 164–166.

117 *La Gazette de Québec*, no. 732 (9 September 1779), p. 3; no. 837 (20 September 1781), p. 3.

118 Ibid., no. 857 (7 February 1782), p. 3; no. 948 (23 October 1783), p. 3; no. 981 (17 June 1784), p. 3.

119 Eric Turner, "Les substituts de l'argent aux XVIIIe et XIXe siècles," in *L'orfèvrerie au XIXe siècle*, pp. 137–143; Henry Newton Veitch, *Sheffield Plate, Its History, Manufacture and Art* (London: George Bell and Sons, 1908); Gordon Crosskey, *Old Sheffield Plate: A History of the 18th Century Plated Trade* (Sheffield: Treffry Publishing, 2011).

120 Neuville church folder, Fonds Ministère de la Culture et des Communications. Les grands inventaires nationaux, Bibliothèque et Archives nationales du Québec, Quebec City. The parish sold the candlesticks in 2010, and they are now part of a private collection.

121 René Villeneuve, *Quebec Silver from the Collection of the National Gallery of Canada*, exhib. cat. (Ottawa: National Gallery of Canada, 1998), p. 66.

122 Inventory of the moveable estate of the *Communauté de Biens* of John W. Wolsey and Julie Lemoine, 4 March 1841, minute book of notary Errol Boyd Lindsay (minute no. 3421), Bibliothèque et Archives nationales du Québec, Quebec City.

123 Although made in Britain, a tea service in the collection of the Royal Ontario Museum (1949.212.4-6) bears James Smillie's mark as retailer.

124 *La Gazette de Québec*, no. 3031 (27 July 1820), supplement, p. 5.

125 Fox, "The Immigrant Element," pp. 4–15.

126 It is interesting to compare these drawings with those produced by an American silversmith of the same period. See Mark B. Letzer, "William Faris's Silver and His Shop Designs," *Antiques* (March 2006), pp. 100–109.

127 Journal of Abbé Jacques Panet, sheet 105, Archives of the fabrique L'Islet-sur-Mer.

128 Journal of François Baillairgé, 21 June 1792 (p. 132), François Baillairgé fonds, Bibliothèque et Archives nationales du Québec, Quebec City.

129 Laurent Amiot folder (pp. 529, 809 and 813), Fonds Ministère de la Culture et des Communications. Les grands inventaires nationaux, Bibliothèque et Archives nationales du Québec, Quebec City.

130 Ibid. (pp. 809 and 998).

131 Receipts dated 14 June 1826 and 23 May 1827, accounts for 1826, box 11, no. 317a, Fabrique Notre-Dame de Québec fonds, Archives de l'Archidiocèse de Québec, Quebec City.

132 Laurent Amiot folder (pp. 943, 675, 593 and 965–966), Fonds Ministère de la Culture et des Communications. Les grands inventaires nationaux, Bibliothèque et Archives nationales du Québec, Quebec City.

133 Journal, 1810–21, May 1813 (p. 73), Archives du Séminaire de Québec, Service des collections, des archives historiques et de la bibliothèque, Musée de la civilisation, Quebec City.

134 Accounts and proceedings, 1806, Archives of the fabrique Saint-Michel de Bellechasse.

135 Laurent Amiot folder (p. 406), Fonds Ministère de la Culture et des Communications. Les grands inventaires nationaux, Bibliothèque et Archives nationales du Québec, Quebec City.

136 Ibid. (pp. 837–839).

137 *La Minerve* 4, no. 73 (24 October 1831), p. 2.

138 The exhibition proposal called for the metal analysis of all the works on display, but it has not been possible to execute this part of the plan.

139 *Bénédiction de la première cloche*, 13 September 1818, B-1, 21st folio (verso), Archives of the fabrique Saint-Roch de Québec. When Gérard Morisset inventoried this ciborium in the church of Saint-Épiphane, in the Témiscouata region, he noted that it bore the following inscription: *Ciboire donné à l'église St Roch de Québec par Mr Fr. Ranvoyzé, orfèvre, 1818* [Ciborium given to the church of St. Roch by Mr. Fr. Ranvoyzé, silversmith, 1818]. The work was apparently destroyed in the fire that ravaged the church in September 1946. See Saint-Épiphane, Témiscouata, folder, Fonds Ministère de la Culture et des Communications. Les grands inventaires nationaux, Bibliothèque et Archives nationales du Québec, Quebec City.

140 See "Bibliography," which offers a non-exhaustive list of transactions recorded in the minute book of notary Antoine-Archange Parent, Bibliothèque et Archives nationales du Québec, Quebec City.

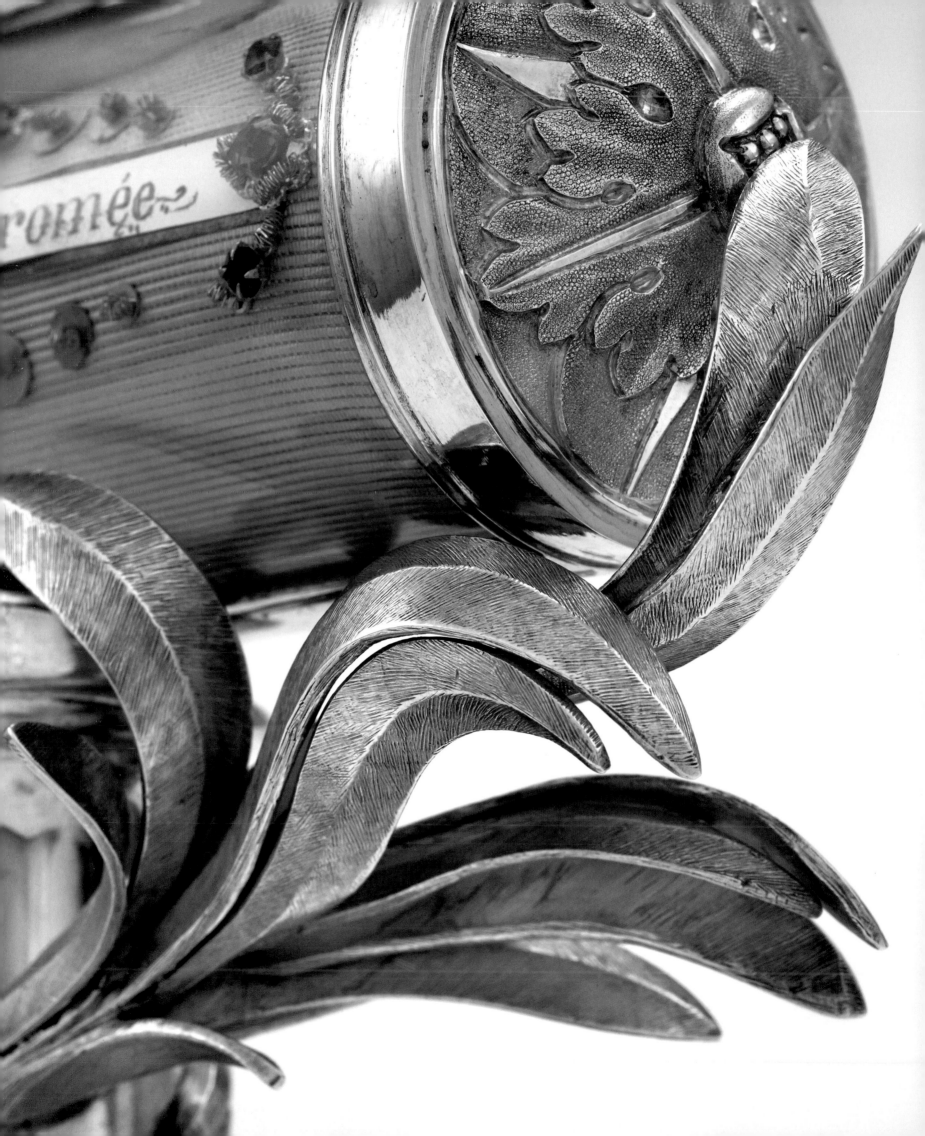

A SILVERSMITH AND HIS WORK

Laurent Amiot made a number of works to stimulate interest among his clientele, but his practice also depended on commissions. The receipt of such orders from individuals, groups or institutions to design and execute particular pieces would have been viewed as an honour by the silversmith. Clients would approach him with a specific request, and he would enlighten them about what they might hope to obtain, guiding their choices and informing their tastes. As noted in the preceding chapter, the requisite supplies of precious metal were an important factor, and it was often the patron's responsibility to provide the artist with this *sine qua non* of his art.

The Roots of Religious Patronage

The significant role played by the Catholic Church in Amiot's career was not restricted to the organization and supervision of his stay in Paris. On the silversmith's return to Canada, religious patronage would prove crucial in the development of his practice. This sustained support from the Church continued an age-old tradition that had its source in Judaism.[1] There are numerous references in the Old Testament to the use of gold and silver in the rituals of worship. The book of Exodus, for example, outlines the requirements for erecting and operating the Temple of Jerusalem, including extremely detailed instructions concerning fabrication of the necessary objects:

> Thou shalt also make a table of shittim wood: two cubits shall be the length thereof, and a cubit the breadth thereof, and a cubit and a half the height thereof. And thou shalt overlay it with pure gold, and make thereto a crown of gold round about … And thou shalt make the dishes thereof, and spoons thereof, and covers thereof, to cover withal: of pure gold shalt thou make them.[2]

The cup, an item integral to Christian worship, is mentioned on several occasions in the scriptures. First, in the book of Genesis, Joseph says: "And put my cup, the silver cup, in the sack's mouth of the youngest, and his corn money."[3] According to the prophet Jeremiah, "Babylon hath been a golden cup in the Lord's

Reliquary-Monstrance of Saint Charles Borromeo (detail) c. 1823

hand, that made all the earth drunken: the nations have drunken of her wine; therefore the nations are mad."[4] Vessels for wine also appear in the book of Numbers, featured on the list of offerings presented by the princes of Israel on the day the Temple altar was anointed, which includes "twelve chargers of silver, twelve silver plates, cups and gobelets of gold."[5] And they are referred to in the New Testament accounts of the marriage at Cana[6] and the Last Supper.[7] In Catholicism, this vessel evolved into the chalice, the sacred goblet that is part of the celebration of Mass and that holds the wine essential to the offertory, the consecration and the priest's communion.

The practice of furnishing churches with objects made of precious materials for use in the liturgy, the veneration of saints and the worship of their relics became widespread in Europe during the reign of Charlemagne. The emperor himself made substantial religious donations to the chapel of his palace, but also to other churches. Such gifts were expressions of the donor's piety and social status. The logic behind the accumulation of ecclesiastical treasures was this: since God created all things, the most valuable objects should be used to honour him and beautify the churches dedicated to his worship. Gold, silver and precious stones were employed to fabricate the liturgical vessels that would enter into contact with the blood and body of Christ, the bindings that served to protect the Holy Scriptures and the reliquaries designed to hold the remains of saints. All these objects were accorded the greatest respect. Abbé Suger, who in the twelfth century was responsible for rebuilding, redecorating and re-equipping the abbey of Saint-Denis, considered such opulence an appropriate way of honouring God and his saints, of rendering spiritual values visible.[8] It was a view supported by the Revelation of St. John, which describes New Jerusalem as a city made of gold and precious gems.[9] The Lateran council of 1215 actually made it compulsory to use a cup of gold or silver for celebrating Mass. Vestments and accessories decorated with gold and encrusted with jewels have always been used to reflect the power of the papacy. Toward the end of the Renaissance, for example, Pope Julius II, a liberal patron of the arts who spent large sums on precious stones, paid 2300 ducats to a Venetian to acquire a ruby for his tiara and 1800 ducats to the Fugger bankers for a diamond to adorn the clasp of his cope.[10]

During the sixteenth century, the Counter-Reformation reiterated and reinforced the parameters that had been established over many years. One of the products of the Council of Trent was the strict and detailed regulation of the Catholic liturgy known as the Tridentine Mass, which, although modified several times, remained in force until the Second Vatican Council. The Counter-Reformation

asserted the central importance of the sacraments, particularly the Eucharist, and clearly aimed to give an impressive, even spectacular dimension to public worship. There are seven sacraments codified by the Roman Catholic Church: three related to initiation into the Church (Baptism, Confirmation and the Eucharist); two associated with healing (Penance and the Anointing of the Sick); and the two sacraments of service (Holy Orders and Matrimony). Celebration of all but one requires the use of special vessels and accessories. Observances known as sacramentals – sacred signs that echo and extend the sacraments, which include blessings, consecrations, expositions and processions – also require specific objects. These, along with the various other accessories (for use on the altar, in the sanctuary or by particular members of the clergy) that form an essential part of Catholic worship, represented multiple opportunities for a master silversmith to practise his art.

The Canadian Context

In Canada, the prerequisites of Catholic worship and their sources were accepted more or less without question. It requires a subtle analysis to fully grasp the richness and complexity of the period, and the dynamics and interests of the powers at play in the issuing of commissions. Purchase and patronage took place within a clearly defined framework.

The religious parish – the Church at the local level – brought together all the faithful who lived within its boundaries. It was seen as a corporate body and the owner of legitimately acquired property. The *fabrique*, or church council – the assembly of churchwardens, former and incumbent, who administered this property along with the parish priest – represented not the individual parishioners, but the parish. The council could not, as a consequence, take any decisions without the approval of the parish or the bishop. An account of the parish's activities would be submitted annually, at the moment the chief churchwarden retired and someone new was appointed. Regulations governing the administration of church councils were established very early in the French regime by Monsignor Saint-Vallier, the second bishop of Quebec, who published a number of statutes during the first diocesan synod. In November 1690 he wrote:

> To maintain the desired union between priests and churchwardens, it has been decreed that priests will inform churchwardens of what they intend to do in their churches, and that churchwardens, for their part, will take care not to make any substantial purchase without having first consulted their priest and asked his opinion.[11]

During the period that concerns us, between 1790 and 1840, instructions for clergymen on how to administer the sacraments and celebrate Mass, as well as the formulas of different prayers and blessings, were provided in the *Rituel du diocèse de Québec*, published by Saint-Vallier in 1703.[12] This work, which held sway for a century and a half, was replaced in 1853, following the first provincial council.[13]

Purchases and commissions came, then, from a dual source, whose parties had to agree and collaborate before approaching the silversmith. Most of the transactions have left little documentary trace, but for a modest commission the agreement was based on mutual trust: generally, a written note was sufficient guarantee of final payment. Owing to their quantity and quality, the archives conserved by the Catholic Church nevertheless provide insight into other aspects of the silversmith's practice. They reveal, for example, that the more elaborate and costly commissions generated more discussion. An examination of three specific cases tells us more about the process. The first dates to February 1804, when, after deliberating on a number of questions, the former and incumbent churchwardens of Saint-Cuthbert adopted a resolution. They concurred "that the arrangement with the silversmith has been accepted, that is to say, 50 Louis for the lamp, 12 L 10 sl for the holy water bucket, & 20 L for the censer, all in silver."[14]

The second case took place in May 1827, when the church council of Notre-Dame de Québec met under the chairmanship of Curé Joseph Signaÿ. It was:

> [r]esolved that Monsieur le curé and Messieurs Brunet and L.A. Lagueux establish a committee to oversee the execution of a lamp for the nave and another for the chapel of Sainte-Anne, both in silver and in the best possible taste.[15]

A final example from the period involves the painter François Baillairgé and the church council of Saint-François de l'Île d'Orléans. Baillairgé wrote:

> On 26 February 1798 Jean-Marie Léné *dit* Laliberté, head churchwarden, and Joseph Hébert, second churchwarden, of the church council of Saint-François on Île d'Orléans; accepted and concluded with me the contract initiated by Mr. Gagnon, their priest; for a painting of St. Francis de Sales, dressed in a purple cassock, a rochet and a cape, and holding a crozier, to be placed on one side of the centre, to avoid the tabernacle; on the other side a monastery and a background of trees and mountains, for the sum of four hundred francs, payable when the work is completed, around Pentecost.[16]

These three extracts reveal that commissions were the object of deliberation: the parish administrators would meet to discuss the matter, and the artist might even be asked to submit a proposal. The records indicate that in the case of silverware, commissioners were preoccupied with both size and decorative style. The setting up of a committee specifically to oversee a major commission reflects the care with which clients would approach such an order. Other examples shed further light on the circumstances surrounding the execution of a work and its significance – sometimes paramount – to those commissioning it.

Amiot's First Works

Abbé Jean-Baptiste Corbin was curé of the parish of Saint-Joachim, on the Côte-de-Beaupré, for over four decades, and it was during his incumbency that the present church was built. In 1811 he bequeathed a sum to the church council that enabled it to undertake the sanctuary's interior decoration. In 1816 François and Thomas Baillairgé began work on the project, creating (in collaboration with Jérôme Demers) an extremely important neoclassical ensemble that marked the advent of a new decorative style in Canada.[17] The seeds of this innovation dated back to 1787–88, when Amiot executed a censer and an incense boat (cat. 1) for the parish that were among the first works made following his return from Paris. Abbé Corbin, who had a penchant for silverware[18] and a particular liking for Amiot's work, paid the cost of the pieces out of his own pocket.[19]

The physical condition of these objects, which are still in use today, should not be allowed to detract from the significance of the revival they embodied. The pot-bellied incense burner, supported on a low base, is surmounted by a two-tiered chimney attached to four chains that are linked together at the top by a chain-holder with two rings. True to the neoclassical spirit, the pedestal is ornamented with a guilloche moulding. The decoration of the paunch is divided into two registers: the upper part is adorned with a festooned frieze of laurel leaves – in using this motif Amiot was introducing it to local silversmiths – while the lower section features fluted forms of two different heights arranged alternately, with three huge acanthus leaves embossed into the body just below the points where the chains are anchored. The chimney accounts for half the object's height. The part surmounting the paunch is divided into three sections by three large buttresses separated by openwork aureoles. Moulding echoes that of the foot and marks off the upper section, adding weight to the piece. In this upper part, openwork fluting is topped by a finial with a flame design, to which the running chain

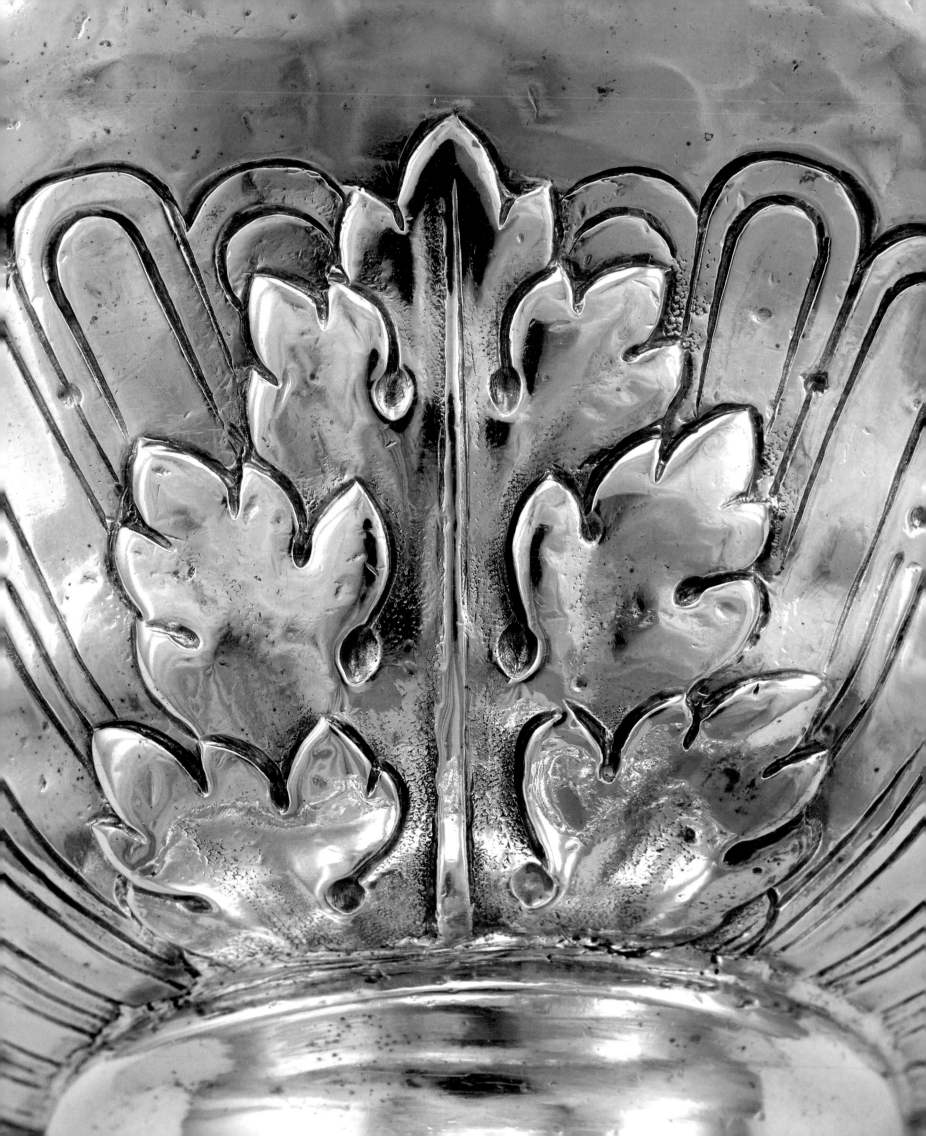

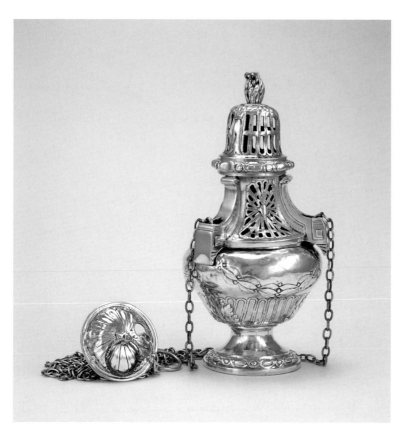

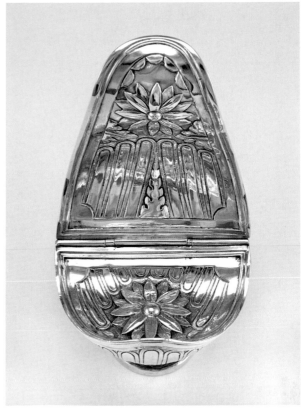

**Censer and Incense Boat of
Saint-Joachim** 1788
Cat. 1

is attached. In both form and ornamentation the censer is highly original, unlike anything made previously in Quebec. The perfect proportion between paunch and chimney means that when the latter is raised the aromatic resin placed on the glowing charcoal is immediately ignited and clouds of perfumed smoke begin billowing out.[20] Even the sound made by the chains when the object is swung is subtle and pleasing to the ear. The matching incense boat, which features the same decorative motifs, is equally innovative: the gondola shape is designed to fit comfortably into the thurifer's hand, and the large hinged lid flaps right back, making it easy to fill. A first manifestation of the neoclassical style in the realm of silver, the ensemble was a remarkable and immediate success. Shortly afterward, the children of sieur Jean-Baptiste Boucher presented a similar set to the church of L'Islet-sur-Mer.[21] It was worlds away, though, from the censers produced by François Ranvoyzé during the same period, whose design harked back to the early eighteenth century. The openwork in the chimney of Ranvoyzé's *Censer for Neuville* forms the letters L and T – a decorative conceit evoking the *Laus Tuum* that would have had no place in the art of Amiot. The Saint-Joachim ensemble would in fact set the standard for the fabrication of such objects in Canada over the next half century.

Censer of Saint-Joachim (detail) 1788

*Bowl of the Hanging Sanctuary Lamp
of Repentigny* (detail) 1788

**Bowl of the Hanging Sanctuary Lamp
of Repentigny** 1788
Cat. 3

A Montreal Work: The Sanctuary Lamp of Repentigny

Contemporaneously with the censer and boat, Amiot created the large sanctuary lamp belonging to the church of Repentigny.[22] It was his first work for a parish in the region of Montreal, which at that time came under the diocese of Quebec City. Such lamps are an essential part of worship, for the Church stipulates that in front of the tabernacle, before the Blessed Sacrament, there be a light kept continuously burning, suspended so it can be seen by the faithful as soon as they enter the sanctuary. It must be fuelled by one or other of two materials of great significance: beeswax, emblematic of the Saviour's virgin birth, or olive oil, whose clarifying, nourishing and fortifying properties echo Christ's capacity to illuminate minds, sustain souls and heal hearts. Less is known about the circumstances surrounding this commission, and unfortunately only the bowl (cat. 3) has survived, the chains and chain-holder having been replaced at some unknown date. But once again this opulent object, whose pure lines have been fashioned from thick sheets of solid silver, contrasts sharply with its more archaic predecessors. Earlier examples were squatter, so the elongated shape was quite new. The decoration draws upon the ornamental repertoire Amiot studied in Paris and continued to employ throughout his career. The belly of the lamp is adorned with a garland of large, powerfully chased laurel leaves, whose marked relief is heightened by their engraved and textured surfaces. The lower part of the lamp is encircled by a dynamic frieze of acanthus leaves, and the contrasts of texture between the embossed and chased elements and the ground create a remarkable sense of vitality. A scrolled moulding separates the two main sections, and the lower part of the paunch is decorated with fluting. All these ornamental elements have been carefully orchestrated so as to complement the forms and increase the overall harmony, just as the treatment of the various surfaces has been calculated to accentuate the three-dimensional impact of this magnificent object.

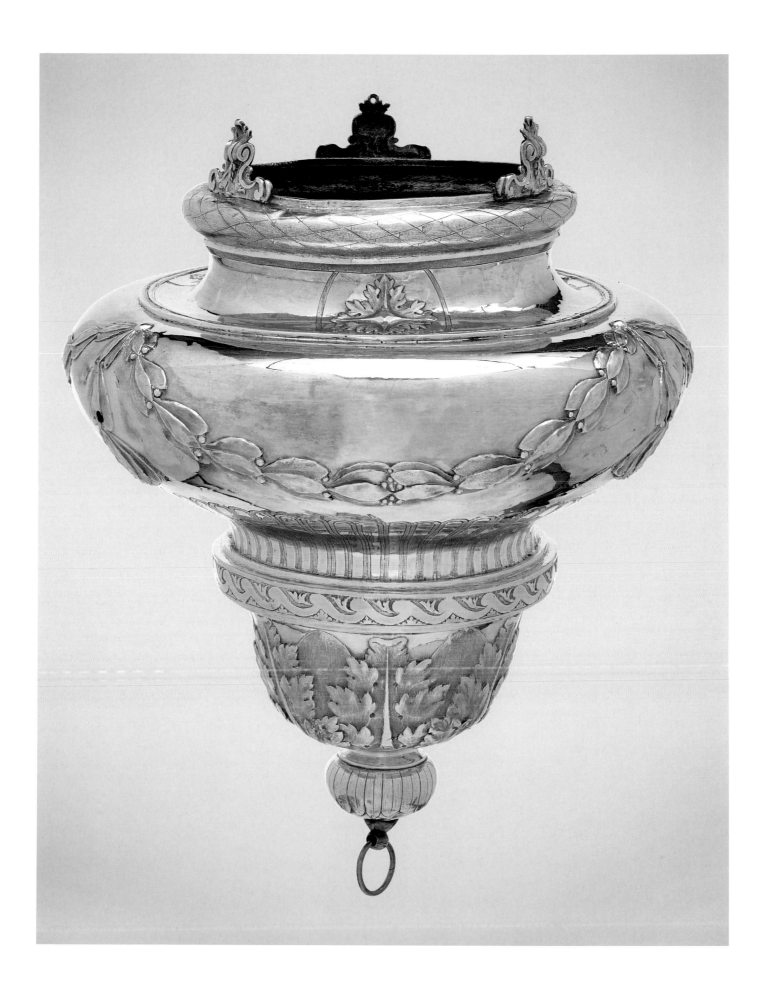

A New Style

During this same period Amiot executed a pair of altar cruets (cat. 2) for the parish of Deschaillons. These small vessels are used to hold the wine and water that are part of the celebration of Mass.[23] Although it was a more modest commission, the objects it produced are in entirely the same spirit as the works just discussed. Each of the small pitchers is supported on a round foot highlighted by a gadroon frieze, and both display the same bulbous paunch that makes them easy to handle. A narrow moulding encircles the neck, and the opening takes the form of a broad spout. Both bear a letter engraved on the spout that identifies the contents: A for *aqua* and V for *vino* – water and wine. In Paris, these miniature pitchers would no doubt have been seen as "classical," but in Quebec they breathed fresh life into the realm of silversmithing and established a new benchmark.[24] Taken together, these three early commissions, stamped with Amiot's first mark, were a revelation: they ushered in a new era, and nothing would ever be the same.

Pair of Altar Cruets of Deschaillons 1788
Cat. 2

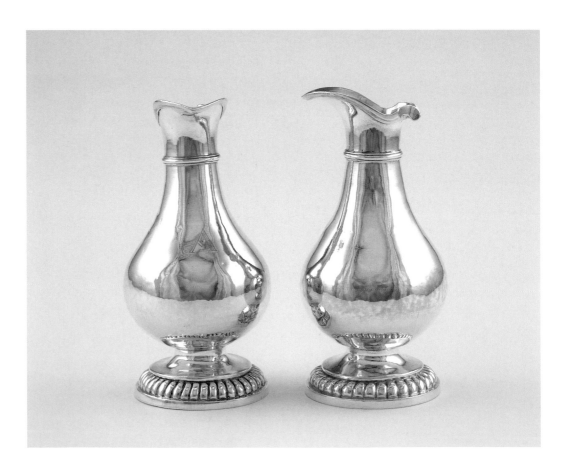

As the list of commissions lengthened, the new approach developed and crystallized. The parish of Baie-du-Febvre, under the pastorate of Abbé Pierre-Victor Archambault (a cousin of Joseph Octave Plessis, future archbishop of Quebec), purchased a chalice (fig. 3.1) from Amiot that was paid for in 1791.[25] This, his first documented chalice, is immediately striking for its size – around thirty centimetres in height. It also illustrates the artist's talent for design, for each of its components – foot, stem and cup – harmonizes perfectly with the others. The matching forms are ornamented with judiciously chosen motifs, and the top of the broad base is embossed with clusters of grapes and vine leaves evoking the sacrament. The body of the knop, which is in the shape of an urn, is enhanced with festooned laurel leaves, while the lower section is decorated with spear-shaped leaves and the top edged with beading that echoes the moulding encircling the foot. The two collar-knops are highlighted with friezes of concentric circles. The sumptuousness and grandeur of the vessel owes much to the openwork calyx, which features four oval medallions that alternate with wheatsheaf and grape motifs – another reference to the Eucharist. The piercing used to execute the calyx sheath is a laborious and difficult technique, undertaken once the object has been raised. It would normally have been entrusted to a specialist, less likely to compromise the already considerable effort invested in shaping the piece. Around the middle of the eighteenth century piercing techniques had changed: like embossing, the traditional method involved a chisel and hammer, but a saw was used in the new approach. The calyx of this chalice seems to have been executed exclusively according to the traditional method. No specialist of the piercing technique operating an independent workshop in Quebec City during this period has been identified. Since this exacting form of decoration was taught in Paris, it seems reasonable to assume that it was executed in this case by Amiot himself. The harmony between the embossed and openwork elements certainly suggests that they were produced by the same hand. The calyx was made out of a single sheet of silver, and there are no joints or solderings. To my knowledge, this is the earliest example of eighteenth-century Quebec silverware that combines the two techniques. The parish of Baie-du-Febvre had every reason to be proud, for they owned the first storiated chalice ever made by Amiot. (Perhaps in acquiring it the council was following the recommendation of Benedict XIII, who had suggested that parish churches that could afford it should possess two chalices, one for regular use and another more ornamental one for major celebrations.) All the more unfortunate, then, that the vessel has been irremediably vandalized.[26] A comparison of the

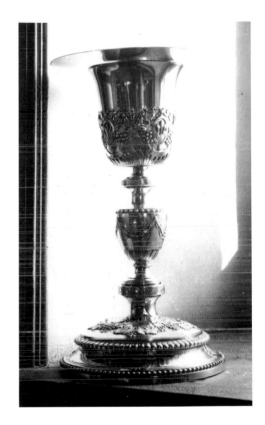

Fig. 3.1
Chalice of Baie-du-Febvre 1791

Fig. 3.2
François Ranvoyzé (1739–1819)
Chalice (detail) c. 1784

Ciborium c. 1800
Cat. 17

chalice with another from around the same period by François Ranvoyzé (fig. 3.2) reveals how radically original Amiot's work was. The form of Ranvoyzé's cup echoes that of pieces dating from the late seventeenth century, and the low-relief decoration – a mass of roughly rendered flowers, foliage and large pieces of exotic fruit, arranged asymmetrically and dynamically across the surface – is very much in the baroque spirit.

Another work dating from the same early period is a ciborium (cat. 17) of unknown provenance that is now part of the National Gallery of Canada's collection.[27] This vessel, designed to hold the consecrated wafers distributed to the faithful during communion, takes the form of a wide-mouthed cup with a lid, whose knopped stem is supported on a round foot. A small cross symbolizing Golgotha rises out of the cover's flattened top. Although more restrained, the ornamental style echoes that of the chalice, for the motifs have once again been drawn from the neoclassical repertoire. For this shorter, broader vessel Amiot created a simpler openwork calyx that envelops the entire cuppa. Foliage-filled medallions alternate with pairs of half acanthus leaves to form a frieze whose lower edge is finished by a band of gadrooning. The broad, squat knop, ornamented with scrollwork and foliage, harmonizes with the body of the vessel, while the cast metal cross that surmounts it is of a strikingly elegant design.

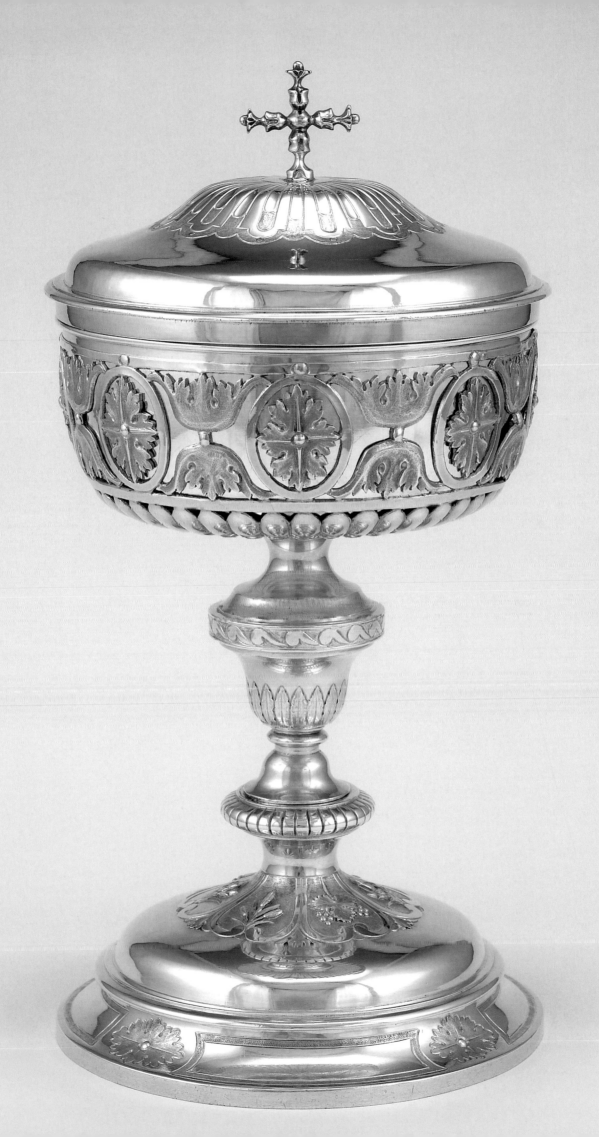

Amiot seems never to have been short of work. Like other silversmiths, he often received requests to repair, restore or polish damaged pieces, and undertaking such tasks was a way of demonstrating his talent and broadening his clientele. In 1790 he gilded a monstrance and a small chalice for the church council of Saint-Charles-de-Bellechasse,[28] his first commission for this authority. The parish was clearly very pleased, since it later asked him to execute a crucifix (cat. 6), a very rare piece in the oeuvre.[29] The planned function of this object remains unclear: it may have been intended to adorn the high altar during major celebrations. It is listed in an inventory drawn up in 1884, and in another dating from 1896.[30] During the 1930s, when the cabinet in the present sacristy was built, a central niche was designed especially to contain it. The commission was evidently of great moment to the parish, for it accounted for half of its disbursements for 1793 and a quarter of its income.[31] But the exceptional quality of the crucifix more than confirmed the talent of its designer and maker. The masterpiece is still in excellent condition. The heavy cast cross is supported on a moulded oval foot whose discreet guilloche decoration reflects the master's now established ornamental vocabulary. The fluting adorning the top of the base creates an upward movement that draws the gaze toward the cross. For the body of Jesus and probably also the titulus that surmounts the piece, Amiot employed the services of François Baillairgé,[32] the city's best sculptor, who was renowned for the expressiveness of his Christ figures.[33] The silversmith made a cast of the model supplied to him by Baillairgé, subsequently adding incised detail to the hair and beard by means of a burin (see cat. 6, detail). He then matt-chased the figure to reduce the shine and smoothness of the metal, and to add texture to the hair and loincloth.

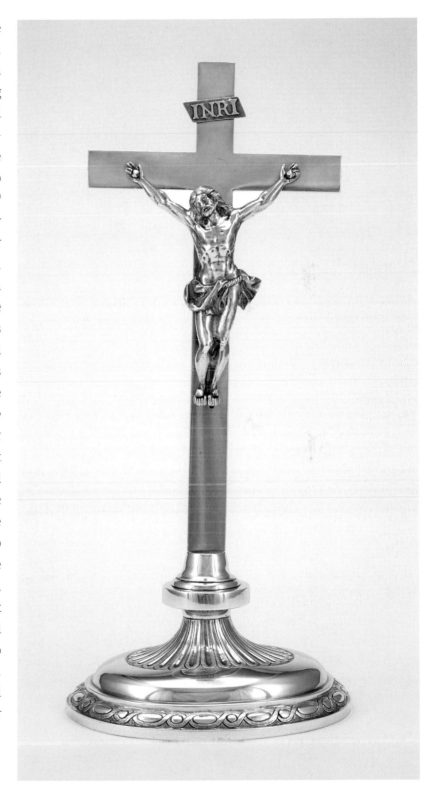

Crucifix of Saint-Charles-de-Bellechasse (detail) 1793

Crucifix of Saint-Charles-de-Bellechasse 1793
Cat. 6

Holy Water Stoup of Cap-Santé (detail) 1794

Holy Water Stoup and Aspergillum
of Cap-Santé 1794
Cat. 8

The Holy Water Stoup: A Pivotal Work

The following year, 1794, Amiot executed a holy water stoup and aspergillum for the parish of Cap Santé (cat. 8). The ensemble, used in the ritual sprinkling of holy water, is apparently the first he ever made. The stoup is also the largest, and like the other works just discussed it can be seen in both its size and its formal and decorative originality as a kind of manifesto. The beautifully proportioned urn-shaped bucket features a ring of flattened gadroons around the opening. The sphere in the centre of the hinged handle is designed to fit the hand, making the object easy to carry. A garland of finely chased laurel leaves adorns the paunch, standing out in relief from the ground and looping into three festoons separated by plain bays. Despite the passage of time, the effects of the matt-chasing that helped define them are still visible. This decorative motif became virtually the artist's signature, while the overall form of the stoup – also called an aspersorium – would set the standard for several decades to come. The aspergillum, too, is of interest, for the use of turned butternut wood for the upper part of the handle was an innovation. A silver sheath was added at a later date to extend it. A sanctuary lamp displaying a similar aesthetic was made for the same parish, and the administrators were evidently extremely satisfied: Amiot became Cap-Santé's official silversmith for the next thirty-four years, providing the parish with a chalice, a ciborium, a baptismal ewer, cruets and a basin, an incense boat, a censer, and a box and flasks for holy oil. In 1795 the parish of La Nativité de La Prairie commissioned a very similar (although somewhat smaller) holy water stoup, demonstrating the immediate popularity of this highly innovative design.

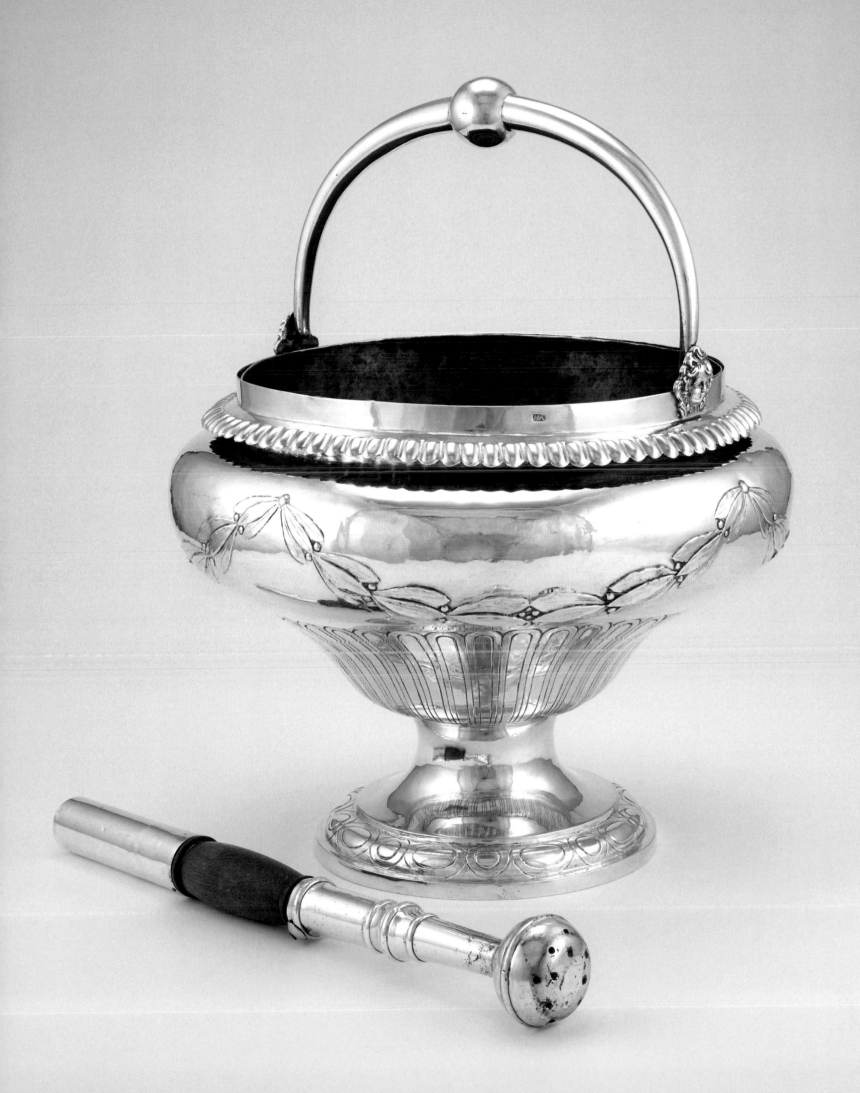

Ciborium of Saint-Marc (detail) 1795

Ciborium of Saint-Marc 1795
Cat. 14

An Innovative Approach to Neoclassicism

In 1795 Amiot delivered a silver ciborium (cat. 14) to the parish of Saint-Marc, newly established on the banks of the Richelieu River. Aesthetically speaking it is an unusual piece, as close study reveals. Amiot adopted the form of the neoclassical ciborium he had assimilated in Paris, and the decorative motifs adorning the foot are also typical of that style. The originality of the work lies in the ornamentation of the calyx and lid. Inspired by his observation of earlier motifs, Amiot created a rich decoration of flowers and exotic fruit that has a flavour of the baroque, and even of chinoiserie. François Ranvoyzé made use of the same vocabulary, but the effect in the Saint-Marc piece is tempered by a touch of classicism. To form the calyx, the artist created a flowing openwork frieze joined below to a ring of elongated gadroons and encircled at its upper edge by a series of open ovoid forms. The techniques he employed in making the calyx were evidently similar to those used earlier for the Baie-du-Febvre chalice, but Amiot's growing skill resulted in even greater unity, and he took considerable care to smooth the edges and remove all trace of tool marks. The vegetal ornamentation of the lid is restricted to the dome that supports the crowning cross, leaving a broad polished band running around the outer edge. In spite of its originality, the approach seems not to have been pursued.

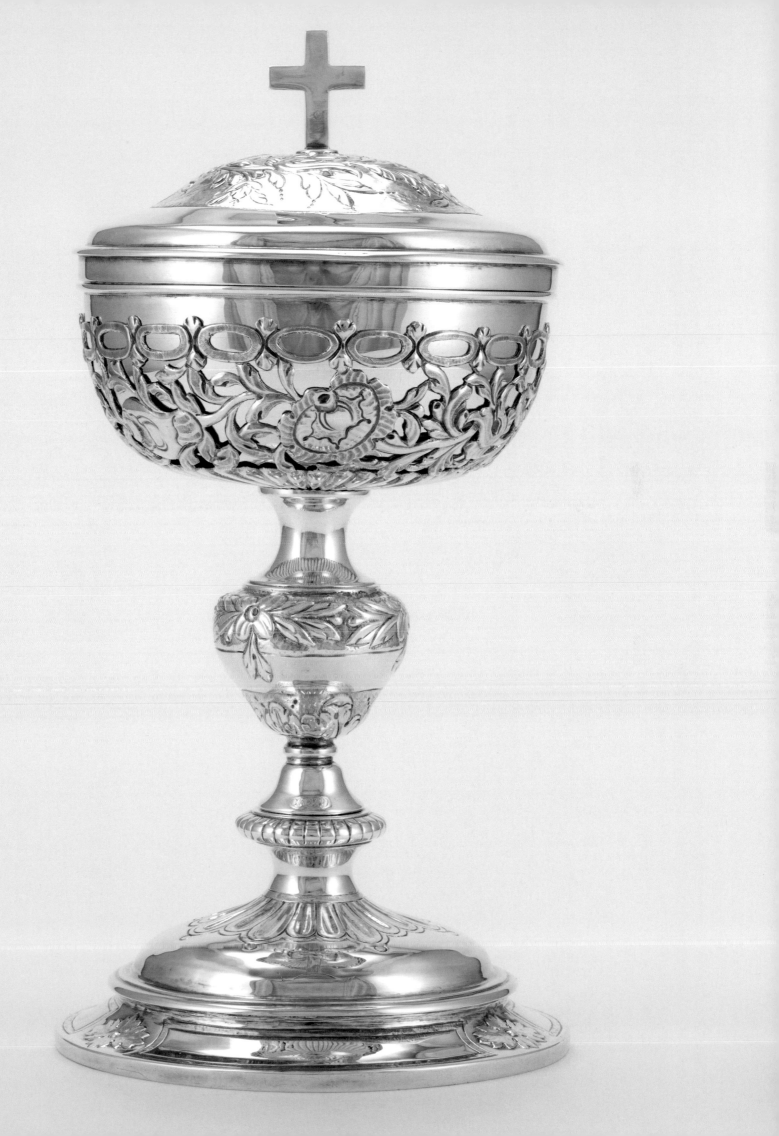

Baptismal Ewers

Baptismal ewers, used to pour water onto the forehead during the sacrament of baptism, became part of the repertoire of Canadian silversmiths in the last third of the eighteenth century. Since the tradition defining such objects in this country was less strict than for other liturgical accessories, in making them artists could give freer rein to their creativity. The earliest examples, executed with flair and imagination by François Ranvoyzé, are based on models developed in Paris between the end of the seventeenth century and the middle of the eighteenth (see fig. 3.3).[34] Amiot, though, would invent new forms and explore new avenues. In its shape, his *Baptismal Ewer of Cap-Santé* (cat. 22), paid for in 1804,[35] is reminiscent of a miniature watering can. Each of its elements – the conical paunch, the straight, narrow spout, the handle in the form of a question mark – marries with the others to produce an object at once functional, elegant and refined, while the small crescent shape bordering the opening lends a touch of distinction to the whole.

Baptismal Ewer of Cap-Santé 1804
Cat. 22

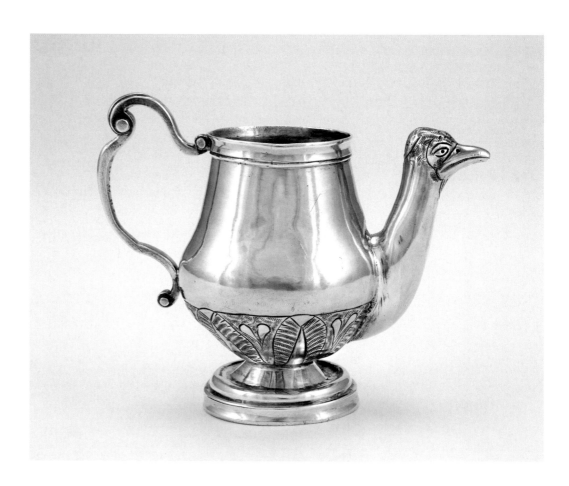

Fig. 3.3
François Ranvoyzé (1739–1819)
Baptismal Ewer of Saint-Ambroise-de-la-Jeune-Lorette c. 1800

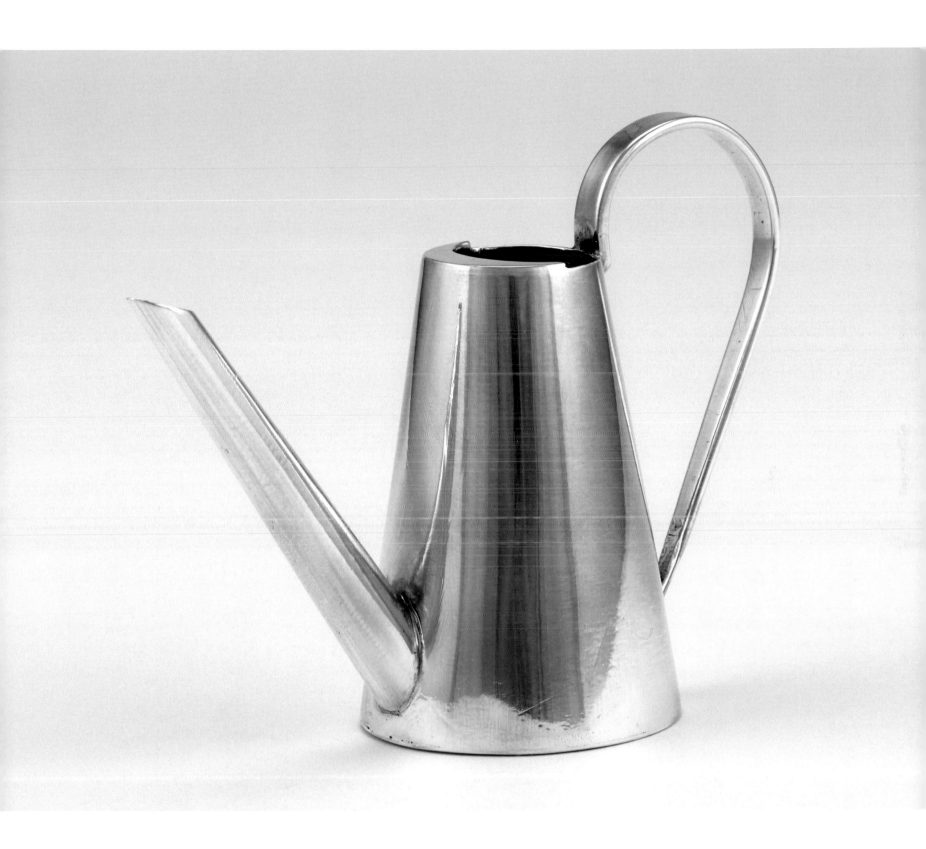

The *Baptismal Vessel of Saint-Joachim* (cat. 24),[36] for which the artist took a quite different approach, is similar in form to an English sauceboat of the period, making it unique in the realm of Canadian silverware. The handle has been designed for easy pouring, with room for two fingers to pass through while the thumb rests on top. The thick metal out of which the vessel is made is everted to form a lip along the edges of the handle and around the opening, which lends the piece solidity (see cat. 24, detail). A final example, the *Baptismal Vessel of Charlesbourg* (cat. 25),[37] is very similar in form to a pap boat (see cat. 20), the small

Baptismal Vessel of Saint-Joachim 1805
Cat. 24

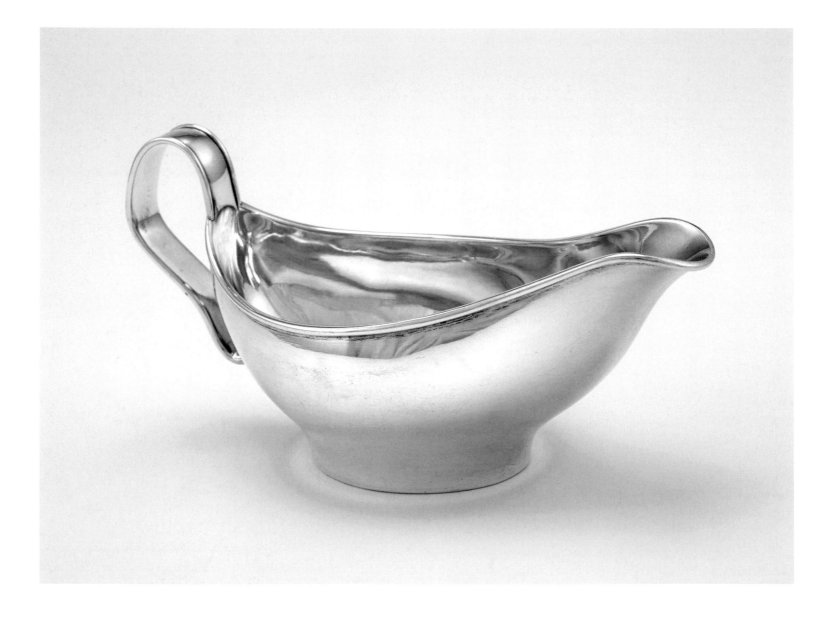

receptacle used for feeding bed-ridden invalids. Amiot adapted the object to its new function, however: the spout is shorter, and the handle takes the form of a ring surmounted by a slightly concave thumb rest. The object has once again been executed from a thick sheet of silver, and the double edge of the opening adds to its presence.

In designing all three of these additions to his repertoire, Amiot drew inspiration from domestic silverware. Other silversmiths would experiment with different ewer forms, but two of those designed by Amiot – the ones made for Cap-Santé and Charlesbourg – copied in many variations over the decades, would become touchstones.

Baptismal Vessel of Charlesbourg 1809/37
Cat. 25

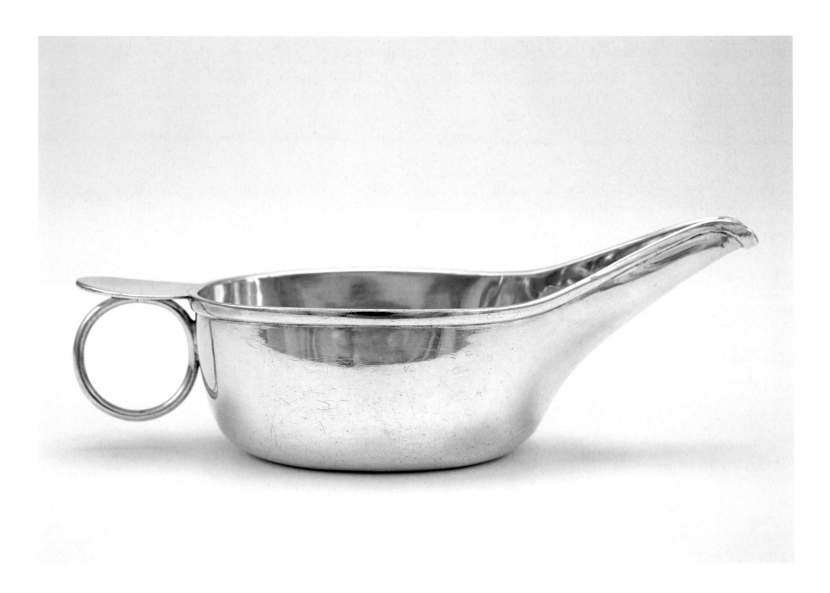

Baptismal Vessel of Charlesbourg (detail) 1809/37

Variations on a Theme

A few years after making the vessel for Charlesbourg, Amiot executed a major work for the neighbouring parish: the *Chalice of Saint-Ambroise-de-la-Jeune-Lorette* (cat. 29).[38] The desire of the Church to reiterate, through its clergy, the importance of the Eucharist was no doubt the motive force behind the commissioning of such a sumptuous object, for cups like this one lie at the very heart of the most significant celebration of the liturgy. The large storiated chalice shows clear links to the 1791 vessel made for Baie-du-Febvre, although it is even more elaborately decorated and its execution was undoubtedly more complex. The beading on the foot has been replaced by a frieze composed of engraved laurel branches, and a larger area of the dome has been left undecorated, as plain polished metal. The shape of the knop has also been simplified, although it retains its ergonomic design. The calyx is as ornate as ever. Like the earlier examples, it represents something of a technical feat, since it is made from a single piece of hammered metal that has been chased, pierced, engraved and possibly patinated (see cat. 29, detail). For a master silversmith eager to exploit the full range of his technical virtuosity, it was a splendid opportunity. The iconographical motifs, which refer to the Eucharist, include three oval medallions surmounted by ribbons, bulrushes and waterleaves separated by

Chalice of Saint-Ambroise-de-la-Jeune-Lorette 1811
Cat. 29

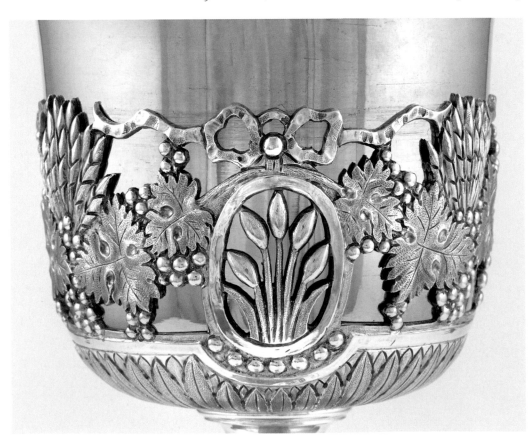

Chalice of Saint-Ambroise-de-la-Jeune-Lorette (detail) 1811

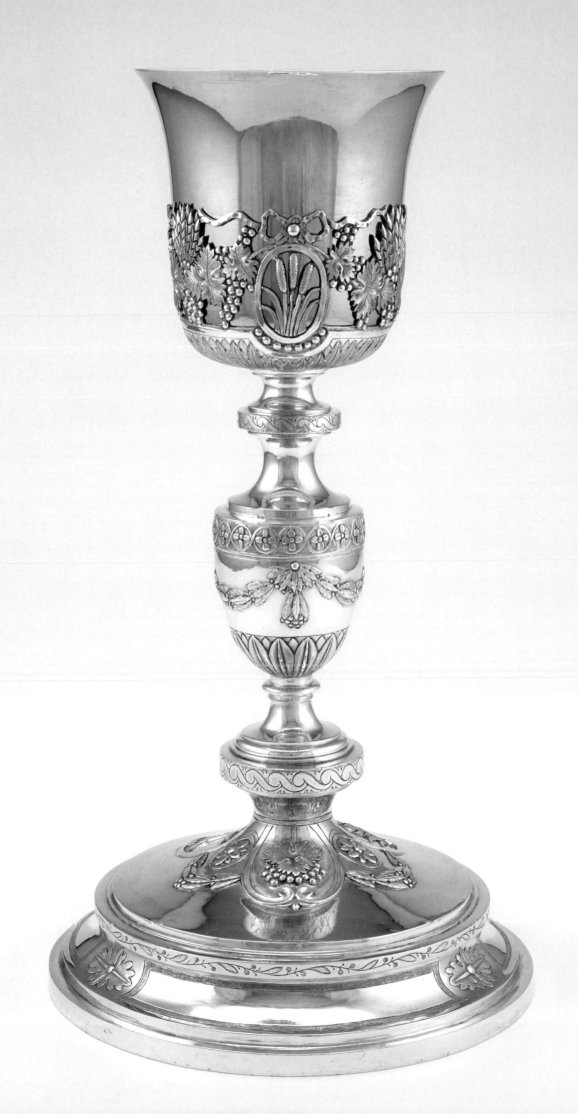

large wheatsheafs, and bunches of grapes and vine leaves. Amiot would continue to develop the theme in the chalice executed for the parish of Saint-Cuthbert in 1812 – described as "extremely rich"[39] – and the one made for Saint-Martin in 1820.[40]

While the three vessels seem similar at first glance, close study reveals differences in the ornamental design. In the Saint-Ambroise chalice the decoration of the calyx displays a tripartite organization, with three medallions alternating with three bouquets, and the same principle has been applied on the knop and the foot. On the two other cups, the surfaces are adorned with four medallions and the same number of bouquets. Visually, the result is balanced, but rather more rigid. This comparison testifies to Amiot's ongoing impulse to experiment with multiple variations on a single theme.

In my view, the instigator behind the commissioning of the Saint-Ambroise chalice was Abbé Antoine Bédard, who was parish priest of Saint-Ambroise during the period it was made, and, like Jean-Baptiste Corbin, was an enlightened churchman. One of Bédard's biographers described him as being close to the bishop, invited to participate in special ceremonies at the cathedral, sometimes to preach, and to accompany his superior on pastoral visits.[41] These encounters may well have been occasions for discussion and exchange. The major commissions undertaken by François Baillairgé in 1808–09 and 1813–15[42] to construct a baptistery and a church-wardens' pew for the parish church, which were contemporaneous with the order for the chalice and Bédard's incumbency, tend to support this idea. Moreover, Bédard was serving as the curé of Charlesbourg when, at the beginning of the following decade, Thomas Baillairgé designed the existing church and its interior.[43] In both Saint-Ambroise and Saint-Joachim, silverware and sculpture present a coherent whole, reflecting the same aesthetic principles and values.

The spirit of the *Chalice of Saint-Ambroise-de-la Jeune-Lorette* and the subsequent derived works was echoed in other objects related to the Eucharist. Liturgical vessels with storiated medallions became increasingly popular with clients and patrons over the years. As noted in the previous chapter, a number of vessels were imported during the 1820s that originated in the Paris workshop of Jean-Charles Cahier. Around 1845 François Sasseville produced the *Ciborium of Saint-Denis de Kamouraska* (fig. 3.4), whose ornamental calyx was executed by the Paris silversmith Alexis Renaud.[44] Sasseville was clearly capitalizing on an idea first introduced by Amiot.

These chalices and ciboria bear witness to the central importance assigned by the Church at the time to the celebration of Mass, and particularly of its desire to reassert the significance of the liturgy. According to canon law, the curé had the

Fig. 3.4
François Sasseville (1797–1864) and
Alexis Renaud (active in Paris, 1831–1847)
Ciborium of Saint-Denis de Kamouraska c. 1845

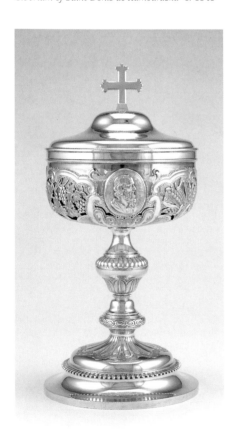

strict obligation to celebrate the Eucharist for his parishioners once a week, on Sundays, as well as on holy days of precept, and the event was to be an occasion of ceremony and display. All the vessels and accessories employed were to be as rich and sumptuous as the parish's finances permitted. On Sundays, the parish high Mass (the *pro populo* Mass) was preceded by the aspersion of holy water – an evocation of baptism – and sometimes followed by special prayers and devotions. In fact, all the Church's public acts were formal ceremonies, and luxurious silver objects served to enhance their sacred character. As a consequence, many of the objects created by silversmiths were destined for use in religious ceremonies. The altar – the focal point of the sanctuary, around which most of the rites revolved – was to be embellished by a set of six candlesticks with a matching cross. Examples of such ensembles made of solid silver were rare in Canada, no doubt owing to their high cost. Amiot may have executed a set for the church of Saint-François de Montmagny in 1807,[45] since he was one of the silversmiths working regularly for the parish during this period. One altar candlestick (fig. 3.5) known to be by him has come down to us. Its small size suggests that it was not part of a set of six, but rather one of a pair used during low Masses.[46] The sets of six candlesticks were reserved for major celebrations, but it was common on such occasions to also place smaller candlesticks on the predella, between the large ones. All the emphasis in this rare example by Amiot[47] is on form, subtly highlighted by a few mouldings.

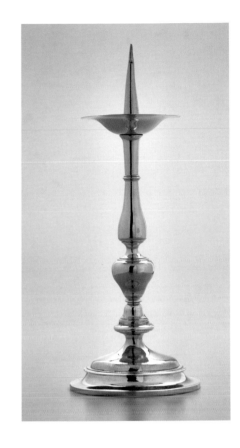

Fig. 3.5
Altar Candlestick c. 1820

A Pax

A pax, or osculatorium, is a small tablet made of noble material bearing a religious image – often a Crucifixion, a Resurrection or a Madonna and Child – with a handle on the back that sometimes doubles as a stand. Usage varied from region to region, but its central function was to receive the Kiss of Peace. First documented in thirteenth-century Europe, the pax is no longer in regular use.[48] It appeared in the mid-eighteenth century in Canada, where it played a regular part in the liturgy between 1780 and 1830.[49] Charles Trudelle offered the following description of the object and its role:

> The pax was a small implement generally bearing a crucifix, or the image of a saint, that was kissed by the assisting cleric whose task it was to take up the collection in church, which used to be called "passing the cup" because – in Charlesbourg at least – the collection was gathered in a small silver cup. Holding a candle supported by a flowered staff, the cleric stood facing the congregation at the baluster at the foot of the altar, while the celebrant was blessing bread.[50]

Of the several paxes executed by Amiot, the one for L'Islet-sur-Mer,[51] which dates from 1831 (cat. 68), counts among the most accomplished. Pierre Bourget, who was curé of the parish during this period, also commissioned Amiot to make a snuffbox and a soup spoon for his own private use.[52] The pax, traditional in style and fashioned from thick sheets of silver, can be propped up vertically, supported by the curved handle attached to the back (see cat. 68, reverse). The front of the tablet, which is in the form of a semi-circular shouldered arch, bears an imposing crowned Madonna with child, supported by a crescent moon and crushing a serpent beneath her feet. The details of the hair and clothing of both cast figures have been enhanced by incising and chasing. The lace-like decorative band surrounding the group is echoed in another, enhanced with dots, bordering the tablet itself – a decorative choice that shows the influence of British neoclassicism. Amiot would occasionally employ a frieze of bright-cut engraving inspired by the same style.[53] The contrast of textures between the central motif and the ground has the effect of focusing attention on the holy image.

Pax of L'Islet-sur-Mer 1831
Cat. 68

Pax of L'Islet-sur-Mer (reverse) 1831

Cope Clasp c. 1825
Cat. 53

A Cope Clasp

A cope is a long lined mantle or cloak made of silk. Semicircular in shape and open in the front, it is worn over an alb or surplice on ceremonial occasions by ordinary clerics and bishops alike. According to Tridentine practice, the celebrant wears a cope on Sundays for the aspersion that precedes the parish Mass, as well as during the general absolution, sometimes during vespers, for processions and for formal blessings. The cope is held in place at chest level by two clasps sewn to the edge of the garment, which hook into rings at either end of a short chain. Such clasps were only rarely the work of a silversmith. Amiot was commissioned to make a pair for the cathedral of Quebec City right at the start of his career, in 1792,[54] and he executed others for the parish of Sainte-Anne-de-la-Pérade in 1831.[55] The clasp shown here (cat. 53), whose twin is missing, is in the form of a fleur-de-lys with a bevelled edge that ends in a curved hook, for attaching to the chain. It would have been sewn to the cope by means of the three small rings soldered to the back. The iconography of the piece may have been dictated by the embroidery adorning the vestment, or the pattern of the damask of which it was made. This clasp, which so vividly reflects the pageantry of religious ceremony, is the only known example by Amiot.[56]

Viaticum Pyxes and a Viaticum Case

Given the importance of the Eucharist, the question soon arose within the Church of how to administer Holy Communion to invalids, prisoners and other people unable to attend Mass. To counter the problem, the priest keeps a supply of consecrated Eucharistic species (the bread) to be administered as *viaticum* – the Latin translation of a Greek term designating a meal offered to someone setting out on a journey. In Christian terminology, it has come to be used almost exclusively to refer to Holy Communion given to those approaching death, the final journey. In Amiot's time, it was one of the priest's tasks to visit such members of his flock in their homes, carrying with him a small vessel containing the consecrated host called a viaticum pyx. Enhanced by the simplest of moulding, the example by Amiot seen here (cat. 55) is beautifully proportioned. The lid, attached at the back by a small hinge, is surmounted by a cross that also serves as a handle, and the

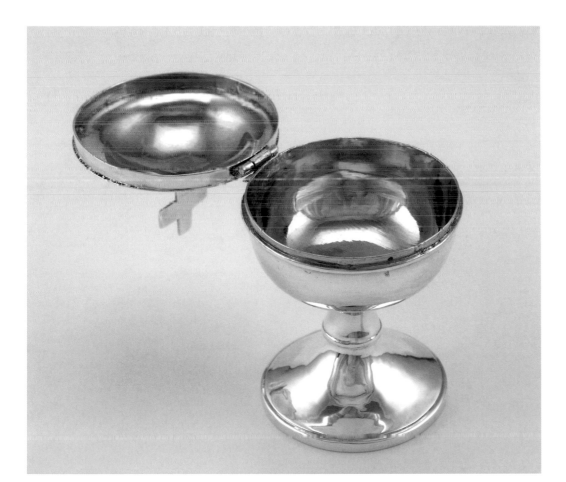

Viaticum Pyx (open) c. 1825

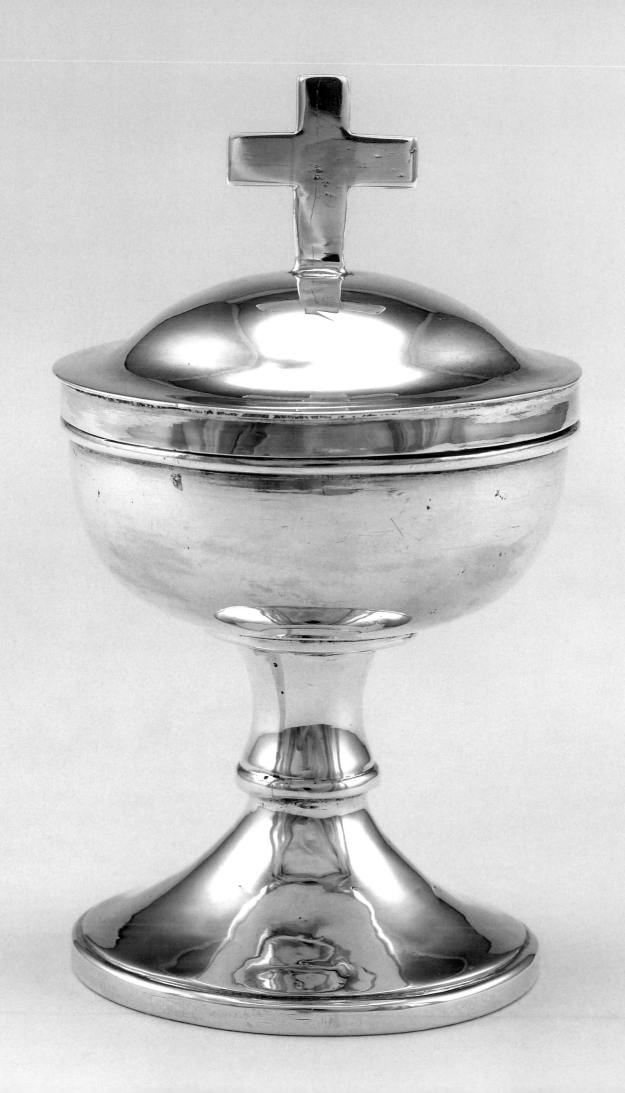

interior of both the cup and lid is gilded. In his design for another pyx (cat. 72), a slight a variation on the theme, the pedestal has been reduced to a simple flared foot. Amiot presented this plan to the parish of Sainte-Croix de Lotbinière in 1837, but it is not known if the object was ever executed.[57] In fact, such vessels were relatively rare in Canada, possibly because they were awkward to carry over long distances. The viaticum case (cat. 57) seems to have been used more frequently, no doubt because the form it took – a small, flat circular box, resembling a pocket watch – was far more practical. This example has a small boss in the centre, designed to facilitate removal of the host, and the entire interior of the box and lid is gilded. A heart-shaped ring allowed the priest to hang the case around his neck while administering the last rites, and the lid has a bayonet fastener that keeps it tightly closed. A delicate incised border encircles the cap, and the centre is adorned with an engraved cross, reflecting its sacred function.

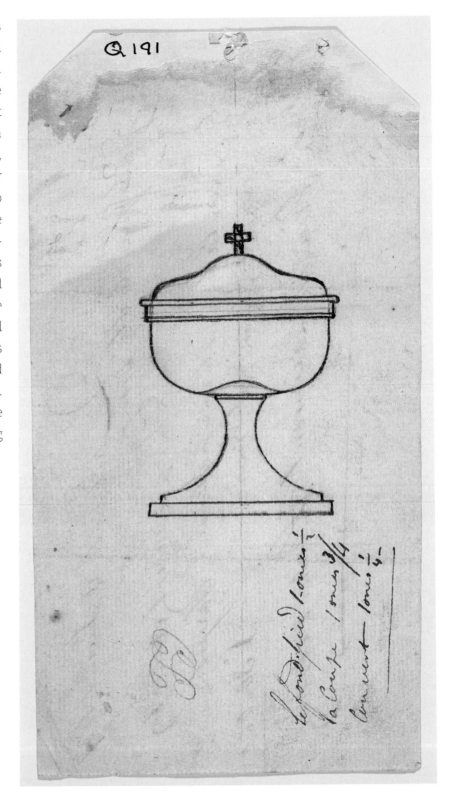

Viaticum Pyx c. 1825
Cat. 55

Design for a Viaticum Pyx c. 1837
Cat. 72

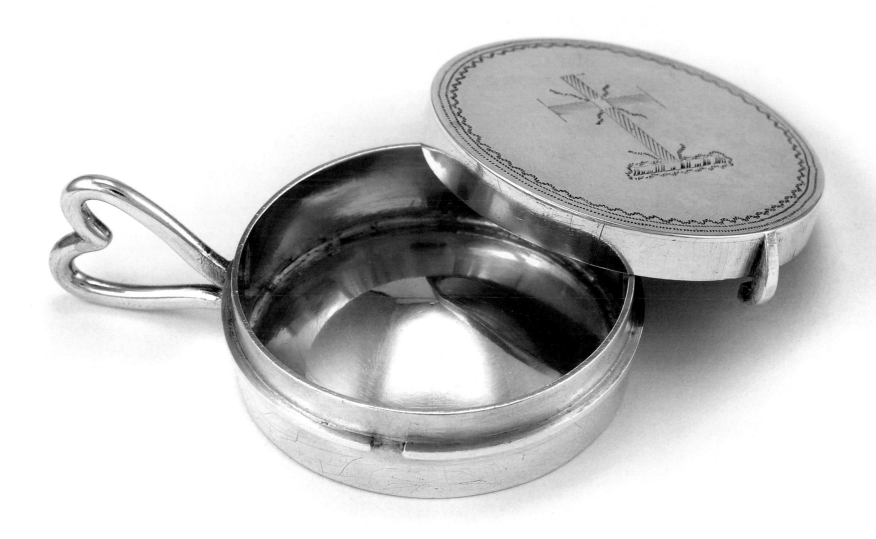

A Processional Cross and a Verger's Mace

The liturgical year is punctuated by a number of processions, during which members of a congregation perform a ritual act by marching ceremonially from one point to another, often while praying, singing or practising other forms of devotion. Such processions are symbolic of the pilgrimage of life accomplished in the company of God. Some are simple occasions held inside the church, while others take place outdoors in an atmosphere of considerable pomp. But whether large or small, they bring the faithful together in a collective expression of religious vitality. Heading the procession is a cross bearing the figure of Jesus facing forward, so that "Christ leads the way." This portable crucifix, supported on a staff, is the true liturgical cross, also used during funerals. The Rubrics stipulate that the cross is to be richly decorated and highly visible.

Although the cathedral of Notre-Dame de Québec had been in possession of a silver processional cross since the seventeenth century,[58] the diocese's other more affluent parishes acquired theirs in the years between 1770 and 1825. Amiot executed several to order, including the imposing *Processional Cross of Sainte-Marie* (cat. 34), whose restrained design effectively focuses attention on the Christ figure. The tortured body stands out against the stark rigidity and highly polished surface of the cross. The simple titulus, placed at a slight angle above a stylized halo, adds to the mood of solemnity, but the terrible gravity of the image is attenuated somewhat by the fleurs-de-lys that adorn the three extremities of the cross. The presence on the reverse of a Madonna and Child supported by a crescent moon – cast, like the Christ figure – represents a medieval survival in this classical piece. The execution of such a cross would have been a challenge for the silversmith – because of its size, but also from a technical viewpoint: the cross itself is composed of four sections, each enveloping an inner wooden structure like a sheath. The central joins are concealed beneath the stylized haloes, and the cross is solidified by the nuts and bolts used to attach the figures. The large moulded casing covering the copper cylinder that joins the cross to the staff (see cat. 34, detail) is in aesthetic harmony with the rest of the piece. The staff, no doubt executed by a professional turner, includes two slight swellings near the bottom designed to facilitate carrying. Originally painted black, the surface has been altered several times and currently displays a faux-mahogany finish.

Viaticum Case c. 1825
Cat. 57

Processional Cross of Sainte-Marie
(detail of reverse) c. 1815

I believe that the instigator of the commission was Abbé Jean-Mandé Sigogne, a French-born priest who was curé of the parish of Sainte-Marie in Nova Scotia and pastor for a vast surrounding area, described by his biographer as a man of refinement, sensibility and culture.[59] Execution of the work may have been encouraged by Monsignor Denaut – who in 1803 became the first Catholic bishop to visit the region – or it could have coincided with the construction around 1820 of the parish's new neoclassical-style church.[60] Comparison of the figures with those that appear on the processional cross of Deschambault confirm that it was designed and made between these dates.[61] It is not exceptional to find a work by Amiot in this region: Sainte-Anne-du-Ruisseau, situated further south in Nova Scotia and also part of Sigogne's ministry, owns a pair of cruets with tray.[62] A chalice commissioned in 1831 for Saint-Pierre de Pubnico[63] from the Nova Scotia silversmith Peter Nordbeck (fig. 3.6), whose style is reminiscent of Amiot's, suggests that local parish authorities and silversmiths were familiar with the master's

**Processional Cross
of Sainte-Marie** c. 1815
Cat. 34

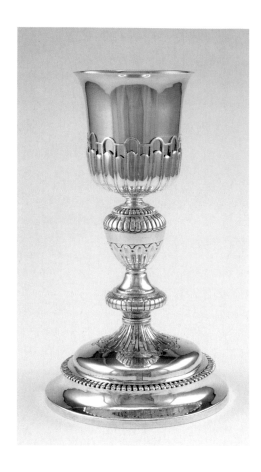

Fig. 3.6
Peter Nordbeck (1789–1861)
Chalice of Saint-Pierre de Pubnico 1831

work. This is hardly surprising, for as already noted Amiot began receiving commissions from Montreal and the surrounding area at the very start of his career, and the resulting works did much to enhance and expand his reputation. They include items made for the parishes of Repentigny, Saint-Ours, La Prairie, Saint-Marc and Sault-au-Récollet before 1800, and later for Longueuil, Saint-Denis, Saint-Cuthbert and La Présentation. He also executed pieces for Caraquet[64] and Carleton,[65] in the Baie-des-Chaleurs, and for Prince Edward Island, including in 1821 a pastoral ring and a pectoral cross for the island's new bishop, Angus MacEachern.[66] There may even be examples of his work in Newfoundland.[67] Clearly, during the first few decades of the nineteenth century Amiot was not only Quebec City's leading master silversmith – he was also the official silversmith to the huge diocese under its sway.

The offices of verger and the sexton are often confused in the common mind, since in some parishes the same individual filled both functions. Strictly speaking, a sexton is a church official charged with taking care of the sacristy and the rest of the church edifice, while a verger is generally a layperson who assists in the ordering of religious services without actually taking part. Although there is documentary evidence that the cathedral of Notre-Dame de Québec owned a verger's mace as early as 1680,[68] this accessory did not come into general use in other parishes until the late eighteenth century,[69] possibly under the influence of Anglican practice.[70] The vestments worn by a verger have been described by Charles Trudelle:

> Joseph Bédard was the first verger in the parish to wear the regulation costume, which was ordered for him by M. de Boucherville and which was more or less the same in all the parishes until recently: a cloak made of blue cloth with a triple collar of red fabric edged with a pale braid border of silk or silver thread.[71]

Aside from this special costume, the verger carried a mace, a sign of authority that recalled the traditional function of serrefile. His tasks varied from one parish to another, but they included walking at the head of processions, escorting the preacher to the pulpit, receiving the body of the deceased and accompanying it to the rear of the church during funerals, and directing a new churchwarden to the churchwardens' pew. It was an essentially symbolic role, designed to add impact to the religious spectacle. The office of verger has for the most part disappeared in the Catholic tradition, and as a consequence vergers' maces are now obsolete. They were still being used during the first third of the nineteenth century,

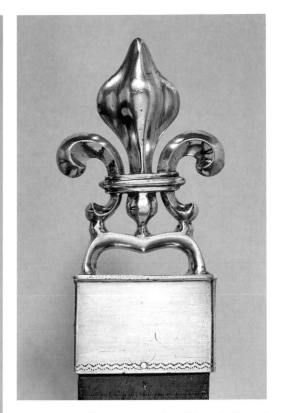

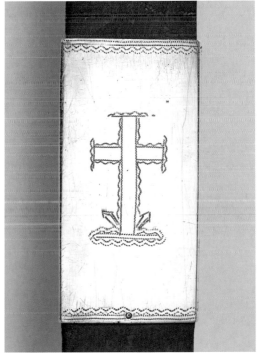

however, and Amiot made several. The verger's mace (cat. 39) he executed for Saint-Michel-de-Bellechasse has been selected for the exhibition owing to its exceptional quality. It consists of a long pole of varnished mahogany with a curved front face. The base and middle of the pole are encased in simply engraved silver ferrules, and the top is adorned by the fleur-de-lys that indicates its unique official function. The middle ferrule has been repositioned somewhat higher than originally, in order to hide an old crack in the wood.

**Verger's Mace of
Saint-Michel-de-Bellechasse** c. 1820
Cat. 39

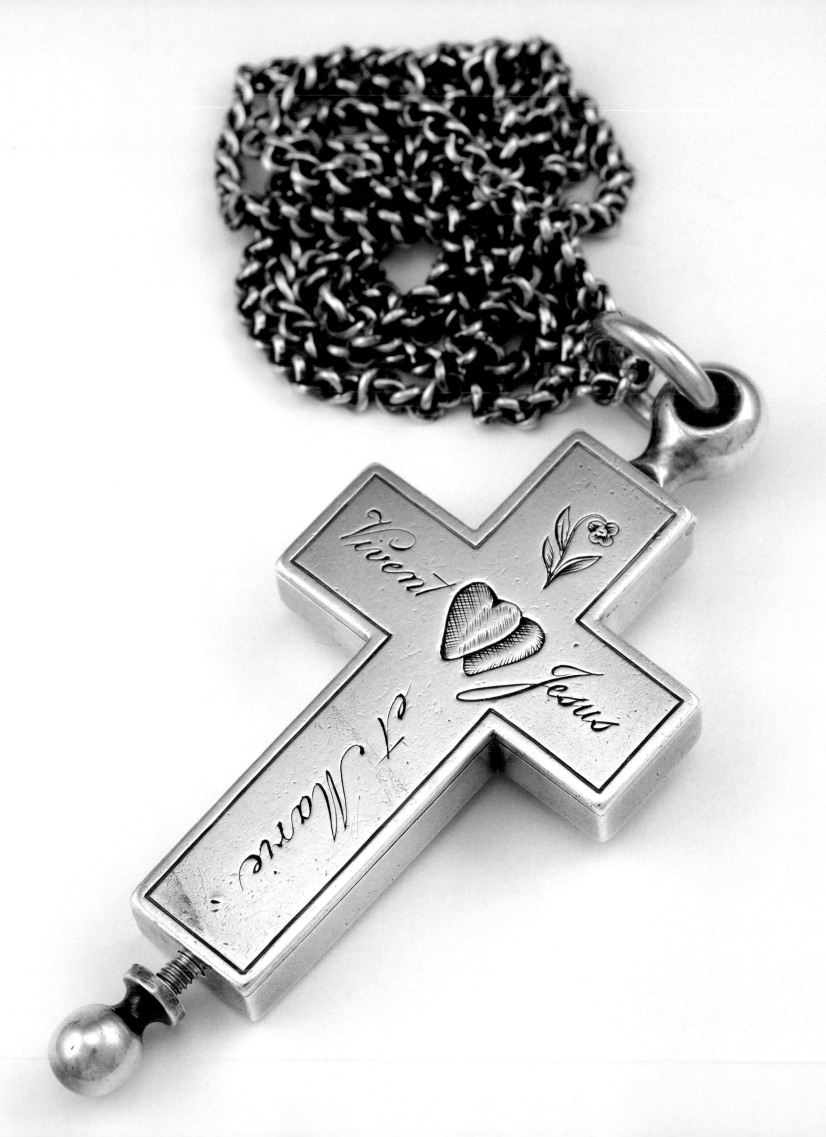

A Reliquary Pectoral Cross and a Personal Devotional Object

As well as the various accessories required for the liturgy, the Church sometimes commissioned objects of a less public nature, such as the reliquary pectoral crosses worn by the Hospitaller sisters who ran the Hôpital général de Québec (see cat. 56). Monsignor Saint-Vallier had founded the monastery in 1692, and in 1718 he accorded its nuns the right to wear these silver crosses over their habits.[72] The practice would be taken up in other monasteries much later, during the nineteenth century; the privilege would not be extended to the Hospitallers of the Hôtel-Dieu, for example, until 1881.[73] Veritable items of jewellery, these crosses are personalized by the invocations engraved on the outer face and a few delicate ornamental motifs. This example, hinged just below the ring that holds the chain, can be opened by means of a small rowel at the bottom, thus revealing its contents. It contains thirteen tiny relics, placed against a semitransparent red ground and surrounded by spangles, little cords and various other materials that create an effect similar to the rolled paper reliquaries dating from the same period (see cat. 56, detail).[74] The rather less delicate *Reliquary Pendant of Monsignor Turgeon* (cat. 69) is similar, although it was an object of strictly private devotion. Its original owner, Pierre-Flavien Turgeon, became archbishop of Quebec in 1850.[75]

Reliquary Pectoral Cross c. 1825
Cat. 56

Reliquary Pectoral Cross (detail) c. 1825

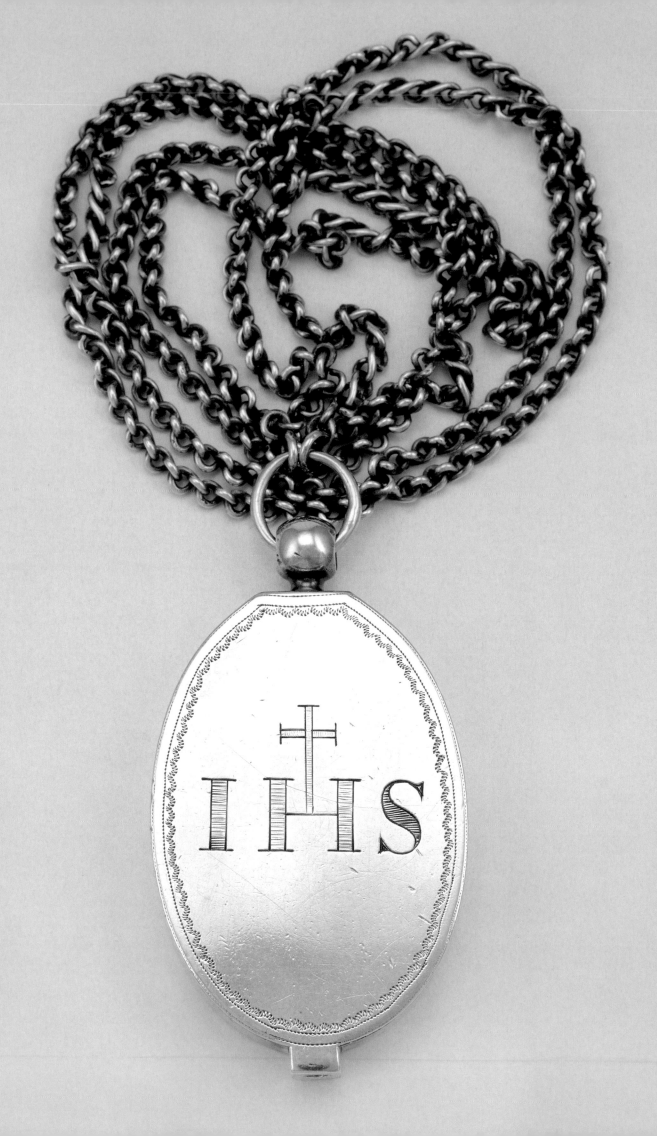

Patronage under Monsignor Joseph Octave Plessis

Church councils and religious communities began hiring Amiot as soon as he returned from Europe, but before long his creativity would be spurred by commissions from the bishop himself. Monsignor Joseph Octave Plessis (see cat. 86), a key historical figure of the first quarter of the nineteenth century, was made a bishop in 1806 and archbishop of Quebec in 1819. A politician as well as a clergyman, he reinforced the Church's structural soundness by ensuring its legal recognition and concentrating his pastoral efforts on education and moral reform.[76] When he became leader of the diocese, the cathedral had recently undergone a number of modifications: the church council had built a baldachin in the sanctuary in 1787, refurbished the high altar in 1797 and added a churchwardens' pew in 1799. Despite these improvements, however, there was still no vault and the nave remained unadorned. The cathedral would be the site of additional building and refurbishment projects throughout the nineteenth century.[77] On 28 August 1804, only a short distance away, the city's Anglican diocese consecrated its own magnificent cathedral. The interior was spacious and bright, and the bell tower rose a metre higher than Notre-Dame's.[78] Innovatively modern in style, this first Anglican cathedral to be built outside the British Isles impressed all who saw it.

JOSEPH OCTAVE PLESSIS
Catholic Bishop of Quebec

Asher Brown Durand (after John James)
(1796–1886)
Joseph Octave Plessis,
Catholic Bishop of Quebec c. 1826
Cat. 86

In 1808, moreover, King George III presented it with an exceptional communion service, a pair of altar candlesticks and a matching offering plate executed by Philip Cornman for the firm of Rundell and Bridge,[79] along with various other liturgical ornaments and a set of prayer books bound in embossed Moroccan leather and bearing the royal coat of arms. The neoclassical building and the splendours it contained evidently had a major impact on Plessis, who had no wish to be outdone. Reflecting an effort to enhance the magnificence of pontifical celebrations and thereby reaffirm the presence of the Catholic Church,

Reliquary Pendant of
Monsignor Turgeon c. 1832
Cat. 69

there was a surge in commissions for specialized items of liturgical silver. It was in this context that Amiot executed the *Holy Oil Flasks with the Coat of Arms of the Diocese of Quebec* (cat. 32). These three covered vessels are used on Holy Thursday during the blessing of the three oils (the Oil of Catechumens, the Oil of the Infirm and the Holy Chrism) used during the liturgical year throughout the diocese. The blessing must be performed by the bishop, but the ceremony – one of the most spectacular in the Roman Catholic liturgy – also requires the presence of twelve priests, seven deacons and seven subdeacons.[80] The flasks are quite large, each measuring almost forty centimetres in height, and in their classically simple shape they resemble the oil and vinegar containers that adorn contemporary dining tables. The broad, curved paunch narrows into a long neck whose domed cap is surmounted by a cross. It took close to 7.5 kilos of silver to make the flasks, and one wonders where it came from. It may be that an early set of altar candlesticks was melted down to provide the precious metal.[81]

Whatever the case, fabrication of the flasks was a technical tour de force: the body of each vessel has been hammered out of a single sheet of thick silver. Each cross has been solidly attached by means of a ring inside the cap, testifying to the extent of the silversmith's technical knowledge. The diocesan coat of arms engraved on the belly of each vessel is enclosed within a mandorla whose form and decorative detail, inspired by British neoclassicism, suggest the origins of the unidentified engraver, who likely specialized in such ornamentation.

The patrons of the diocese of Quebec – the Virgin Mary and Saint Louis – provide the main motifs of the coat of arms, flanked by a mitre and a crozier. The image is a variant of the armorial bearings that appear on *L'ordonnance de Mgr l'Évesque de Québec du 6 octobre 1685*, printed in Paris in 1687–88, which were also used on a pastoral letter issued in 1690.[82] The ten tassels on either side mirror the engraved version faithfully but are in fact inaccurate, since ten tassels denote an archdiocese rather than a diocese. The motto *Tales Ambio Defensores* (I surround myself with such defenders) has been omitted. The significance of the clearly marked date of 1814, when the flasks were apparently executed, remains obscure. The initials engraved on each vessel that identify their contents and owner are repeated on the caps. Over two centuries after they were made, these spectacular and singular objects are still in use and are as striking as ever.

Holy Oil Flasks with the Coat of Arms of the Diocese of Quebec c. 1814
Cat. 32

Spatula for the Blessing of the Holy Oils with the Monogram of the Bishop of Quebec c. 1814
Cat. 31

Liturgical Funnel with the Monogram of the Bishop of Quebec c. 1814
Cat. 30

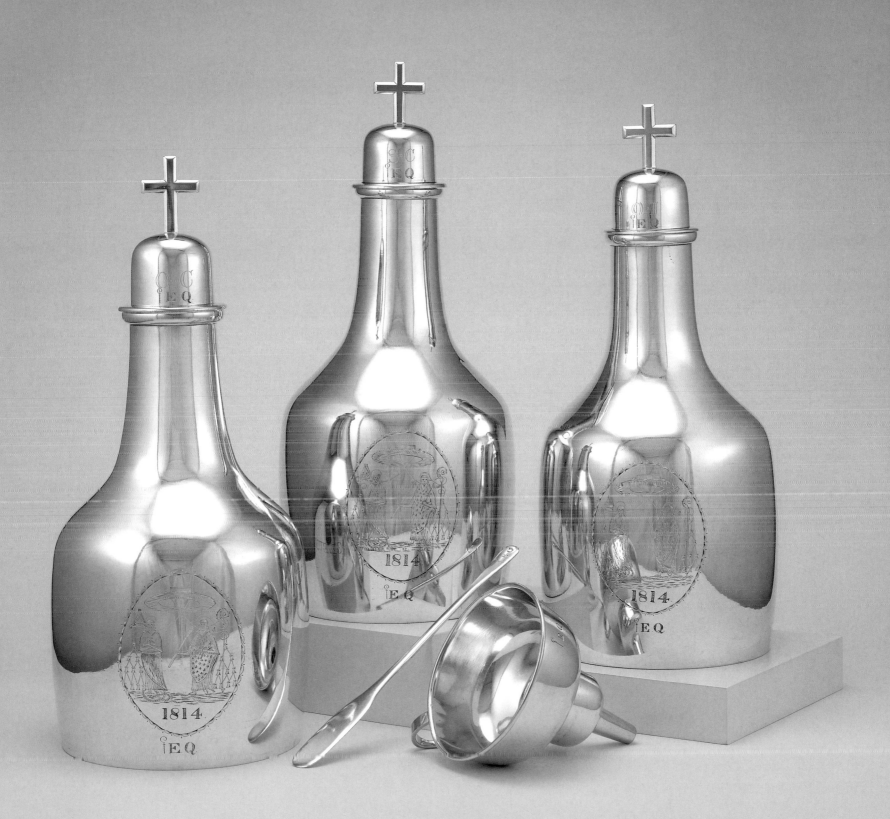

**Liturgical Funnel with the Monogram
of the Bishop of Quebec** c. 1814
Cat. 30

**Spatula for the Blessing of the Holy Oils with
the Monogram of the Bishop of Quebec** c. 1814
Cat. 31

Amiot was also the author of two accessories associated with the flasks'
function: the *Liturgical Funnel with the Monogram of the Bishop of Quebec* (cat. 30) and
the *Spatula for the Blessing of the Holy Oils with the Monogram of the Bishop of Quebec*
(cat. 31). The particular shape of the funnel, which has a ring handle on one side,
is designed to fit perfectly inside the flasks' necks when the moment comes for
the bishop to fill them with the appropriate holy oil. The prelate uses the spatula
to mix the oil and balsam that compose the chrism. Like the flasks, these plain
but elegant accessories have been fashioned out of thick, lustrous silver.

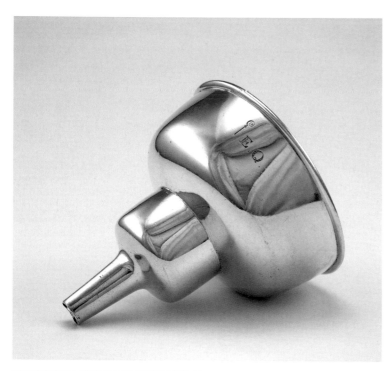

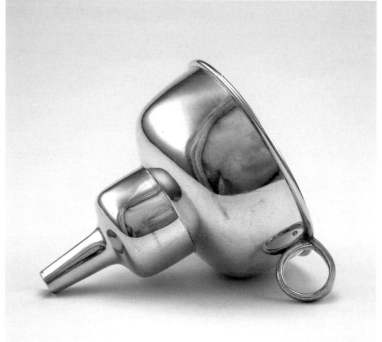

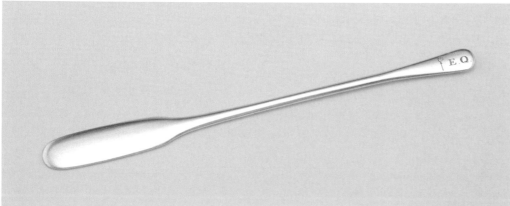

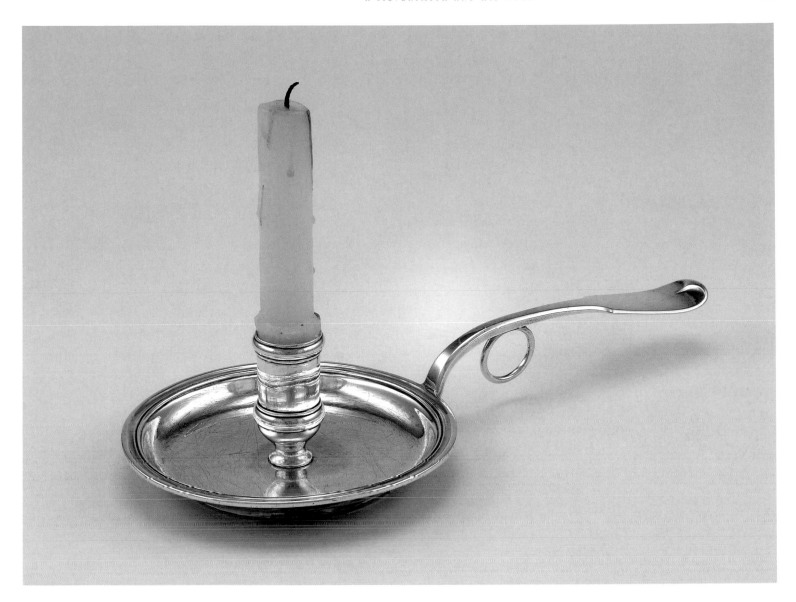

The pontifical bugia, smaller than an acolyte's candlestick, is another accessory employed only by bishops and certain other high-ranking members of the clergy. It had its source in necessity, for the candle it held enabled the celebrant to read or sing the words of the day's service in a dark interior. Its use was later maintained to symbolically illuminate the books containing the liturgy during pontifical Masses and other ceremonies. The first bishop of Quebec, François de Laval, employed a candlestick presented by the Séminaire de Québec, and this object was still in use at the death of Monsignor Briand.[83] Research has also revealed that sometime between 1764 and 1790 Ignace François Delezenne made a pontifical candleholder bearing the initials of the seminary, employed whenever a bishop was officiating.[84] The *Bugia with the Monogram of the Bishop of Quebec* (cat. 33) has been linked to Monsignor Plessis since it was first documented,[85] and was likely commissioned when he embarked on the refurbishment of the cathedral: the underside of the handle bears the same engraved inscription that appears on the flasks and their accessories. It is a type of object rarely seen in Canadian silverware. Although similar in form to a domestic chamber candlestick, it is

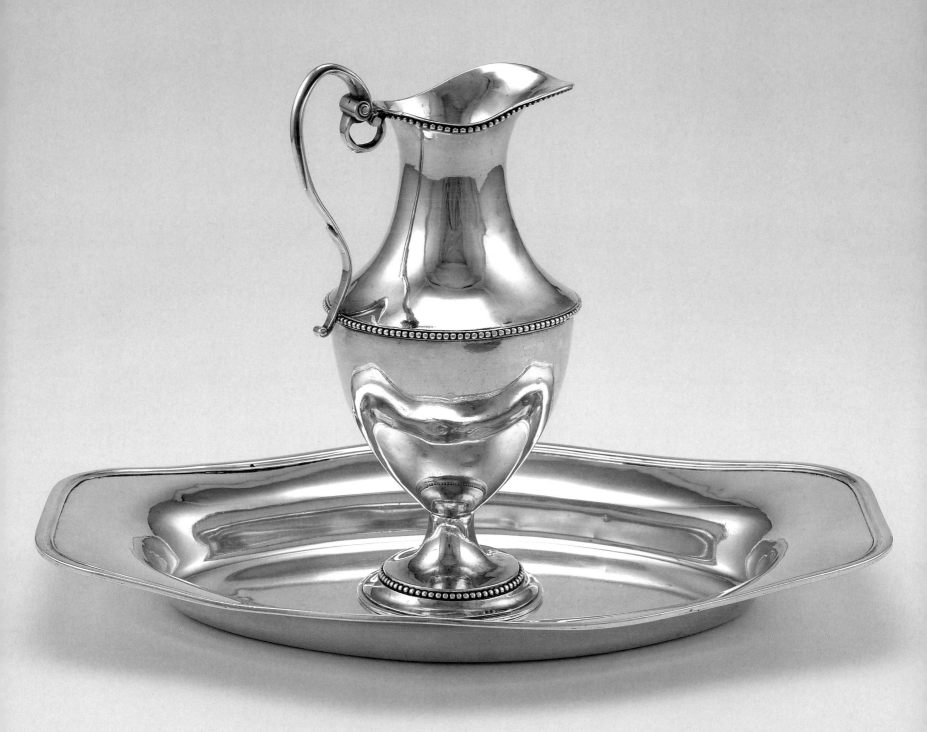

Ceremonial Ewer and Basin with the Monogram of the Bishop of Quebec (detail) c. 1820

larger. The moulded socket, which narrows toward the base, rises from the centre of a plain drip pan, whose edge is also adorned with moulding. The piece owes its distinction to the long handle, reminiscent of flatware, that includes a judiciously placed finger ring. Again, Amiot has made use of unusually thick, richly toned silver, imbuing the object with a dignity and nobility evocative of episcopal power. He would later make another bugia – for Monsignor Joseph Signay – that has a shorter handle and is generally smaller, suggesting that it may have been designed for use during pastoral visits.[86]

The *Ceremonial Ewer and Basin with the Monogram of the Bishop of Quebec* (cat. 38), ordered during the same wave of commissions, were originally part of the cathedral treasure.[87] The ensemble was used for hand washing during a pontifical Mass, but also on other occasions, including Ash Wednesday, Palm Sunday and the ritual washing of feet on Maundy Thursday. It was for the bishop's exclusive use. The vessels previously employed on these occasions have not been identified, and the only other ensemble that seems to have survived is the one belonging to Monsignor de Pontbriand, which bears his coat of arms and whose elements are now dispersed.[88] In designing the objects, Amiot drew inspiration from two different traditions. In its general shape the ewer resembles English neoclassical examples from around 1770–90, also echoed in the flared foot and the beading. The delicate handle, though, is more evocative of continental Europe, and the deep basin also resembles silver and porcelain pieces produced in France in the last quarter of the eighteenth century. In its fusion of two aesthetic approaches, the service marks another high point in the artist's career. Original and inventive, it is the first such ensemble ever made in Canada, and the two objects are unlike anything else in the master's wide-ranging oeuvre.

Ceremonial Ewer and Basin with the Monogram of the Bishop of Quebec c. 1820
Cat. 38

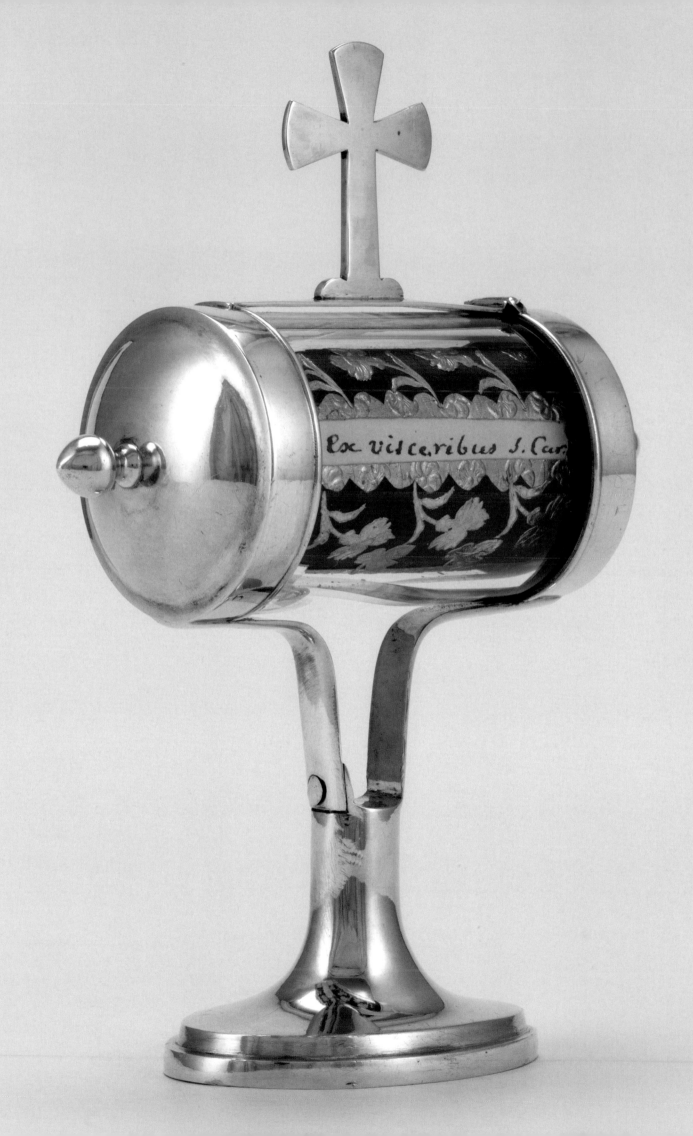

Reliquaries

To the exceptional pieces just discussed, all of which were designed to enrich services conducted by the bishop, must be added two other works that reflect Plessis' desire to reaffirm the power of the Church by means of the silversmith's art. While on a visit to Europe in 1820 he entered into a correspondence with Monsignor Cajetan Oppizoni, archpriest and curé of the cathedral of Milan, who sent him a few fragments of the entrails of Saint Charles Borromeo,[89] a leading figure of the Counter Reformation. A first relic was presented to the Séminaire de Québec the following year,[90] and in November 1821 the seminary paid Amiot for a vessel designed to hold it – now unfortunately untraced.[91] The gift was understandable, since Charles Borromeo, a reformer who played a major role in the education of priests as laid down by the Council of Trent, is the patron of all Catholic seminaries. In the spring of 1823 Plessis presented the parish of Charlesbourg – also under the patronage of Saint Charles Borromeo – with another relic,[92] visiting the region on 14 July.[93] This parish evidently took the recognition of its patron saint extremely seriously: in 1788, at the request of its curé, the Pope had accorded a plenary indulgence on his feast day.[94] Later in 1823 Plessis gave a third relic to the church of Saint-Charles-sur-Rivière-Boyer,[95] which was placed near the end of the nineteenth century on a side altar dedicated to Saint François Xavier.[96] Both the reliquaries executed to contain these relics are still in their respective parishes.

The *Reliquary of Saint Charles Borromeo* (cat. 51) consists of a short glass cylinder in a silver mount that is supported on an oval foot and crowned by a small cut-out cross. Glass was commonly used in repositories for relics. Here, the object itself is enclosed in a tube of red silk – an allusion to the saint's status as cardinal – decorated with delicate floral motifs in gold foil. Although modest in size, the container of precious metal makes the relic tangible while exalting its spiritual significance. Similar in its basic design, the *Reliquary-Monstrance of Saint Charles Borromeo* (cat. 52) is far more elaborate and in a different class altogether. First, it is large – comparable in size to a ciborium. In formal and decorative terms, the stem and foot employ a vocabulary that was in vogue during the late eighteenth century, when the artist was in Paris, and that is echoed in numerous liturgical vessels of the period. The focal point of the piece – the large horizontal cylinder of glass that protects and displays the relic – is more modern in style. The relic itself is concealed by a piece of gold-coloured corded silk highlighted with sequins and artificial gems, but the faithful would

Reliquary of Saint Charles Borromeo c. 1823
Cat. 51

**Reliquary-Monstrance of
Saint Charles Borromeo** c. 1823
Cat. 52

have been well aware of its powerful presence behind the glass. The top of the stem divides into two luxuriant palm fronds with striated leaves, symbolizing the triumph of sanctity, which rise up to support the receptacle and glorify its contents. The whole is crowned by a cross, the pre-eminent symbol of the Christian faith. In this work, Amiot has achieved a perfect synthesis of form and expression.

Further research into the patronage of Monsignor Plessis must be undertaken if we are to fully appreciate its scope. Among other items of interest, the cathedral of Notre-Dame owns a set of vestments that includes a chasuble, a dalmatic, a tunicle and their accessories, together with four copes in silk and red velvet bearing Plessis' coat of arms, which were possibly acquired in Europe during the trip of 1820. An inventory dating from 1832 also lists a white ecclesiastical garment given by the bishop.[97] During the establishment of the Quebec City parish of Saint-Roch, Plessis contributed a large collection of silver tableware,[98] and a covered ecuelle and several place settings from this service bearing his initials are still kept at the archbishopric of Quebec.

*Reliquary-Monstrance of
Saint Charles Borromeo (detail)* c. 1823

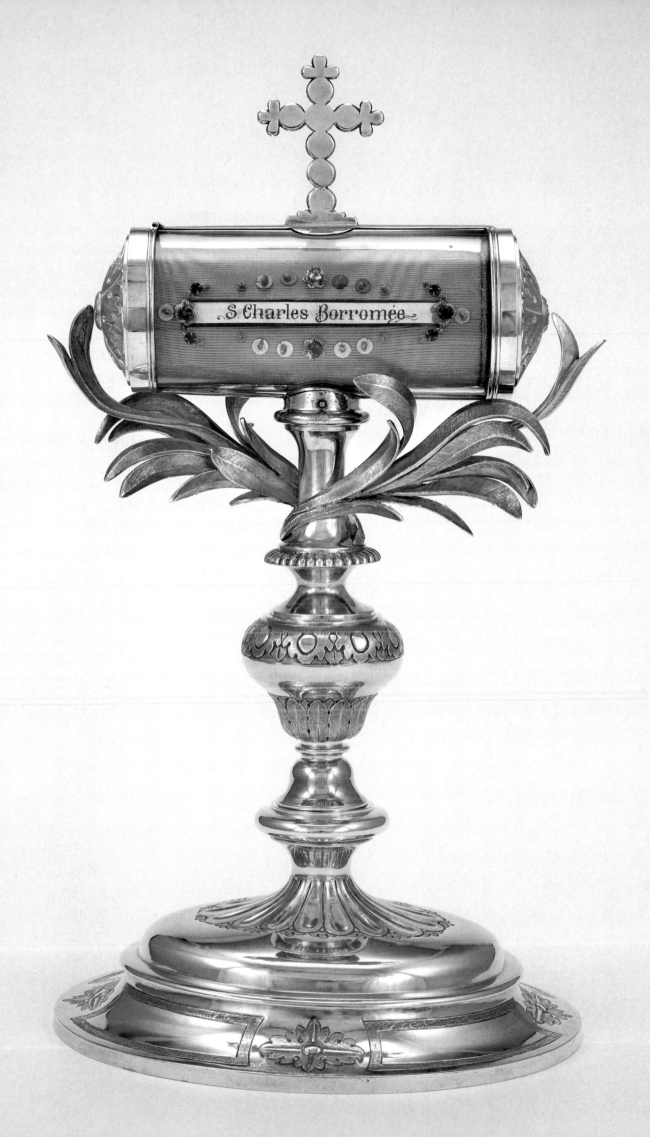

sanctuary's decorative elements, the new altarpieces in the side chapels, the bishop's throne and the churchwardens' pew were gilded during the summer of 1828, and the tabernacle in the chapel of Saint Anne and the organ case were given the same treatment the following year.[108] So the two lamps were intended to add the finishing touch to a major program of beautification.

There had actually been a sanctuary lamp in Notre-Dame de Québec since before it became a cathedral: on 14 November 1671, Charles Aubert de la Chesnaye set up a fund for a perpetual lamp near the high altar,[109] subsequently donating one made of chased silver.[110] This lamp was sent to the Ursuline monastery in Trois-Rivières with the rest of the cathedral's treasure and vestments before the siege of 1759. It was returned in 1766[111] and inventoried at that time, along with the small lamps belonging to the confraternities of the Holy Family and Saint Anne.[112] In 1771 it seems to have been in the seminary chapel, where parish services were held, but by 1775 it was back before the high altar in Notre-Dame.[113] It may be that in 1827 the seventeenth-century lamp was considered too small or too old-fashioned to suit the new interior, on which no expense had been spared. In any case, a few days after the meeting of the church council, the old lamp, a cross and a collection of coins totalling 200 ounces of silver were handed over to Amiot.[114] He and the committee had evidently reached an agreement.

While exquisitely designed and executed, the lamp for the chapel of Saint Anne is more conventional than the others by Amiot dating from this period. The *Hanging Sanctuary Lamp of the Cathedral of Notre-Dame de Québec* (cat. 65), however, is remarkable in a number of ways. As the formation of a special committee to oversee its execution indicates, something out of the ordinary was required for the diocese's mother church. We are struck first by the lamp's imposing size, commensurate with the huge nave where it hangs. The inverted cone of the basin swells more generously than in other examples by Amiot, but the ornamentation is similar and includes a number of classical motifs: concentric circles, garlands of laurel leaves, fluting, scrollwork friezes and acanthus leaves. More unusual – unique in the oeuvre, in fact – are the putti heads that appear on the bulge of the paunch at the three points where the chains are attached, designed to echo those adorning the canopy of the nearby bishop's throne. The artist took great pains with the design and fabrication of these heads, which involved a double mould, personalizing them with chasing after they were cast (see cat. 65, details). The six wings were made separately and affixed individually to the main body. Unlike most ecclesiastical vessels and ornaments, the sanctuary lamp is on

Hanging Sanctuary Lamp of the Cathedral of Notre-Dame de Québec 1827–29
Cat. 65

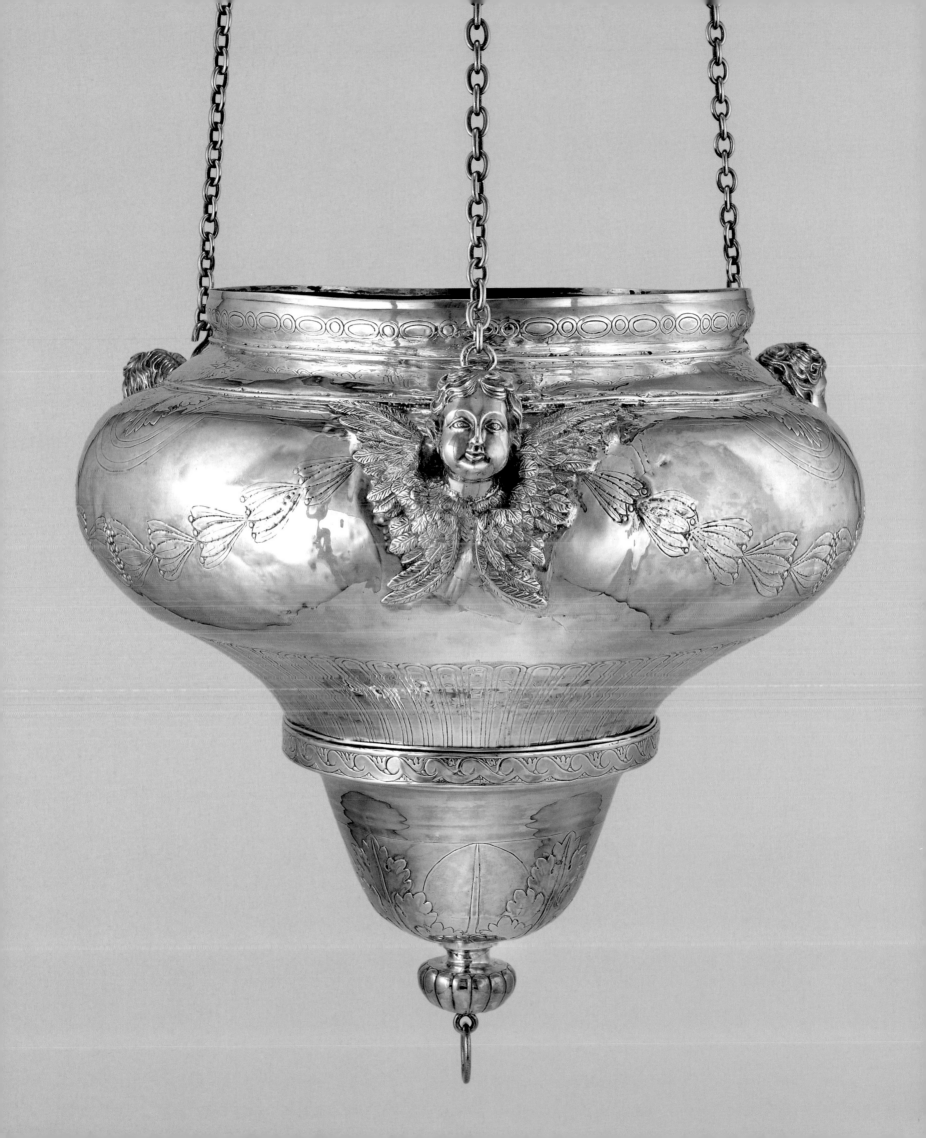

Hanging Sanctuary Lamp of the Cathedral
of Notre-Dame de Québec (details) 1827–29

permanent display. Hanging in this hallowed place, it pays perennial tribute to the master's extraordinary talent.

During the fire that ravaged the cathedral on 22 December 1922, the lamp was damaged. Taken together, the account of the fire and a careful examination of the object suggest that as the roof gradually caved in the lamp sank lower and lower, eventually falling onto its side. It was found under the ruins. Rather than having it melted down, the authorities decided to preserve it, and it was entrusted to a silversmith – possibly the workshop of F. Cernichiaro & Frère[115] – for restoration. In accordance with their knowledge and the means at their disposal, the restorers kept their interventions to a minimum, simply reshaping the lamp and repairing the original decoration. It was an enlightened approach for the time and one that showed great respect for the work of a master.

Once appointed archbishop of Quebec, Signaÿ made it his duty to conduct pastoral visits throughout the vast diocese. The comments and rulings he issued in the various parishes echoed those of Monsignor Plessis. From the many details recorded, we gain a picture of a man concerned with the strict observance of the Rubrics who believed that churches should be stately places furnished with fine liturgical vessels. This attitude had a direct impact on the career of Amiot, whose

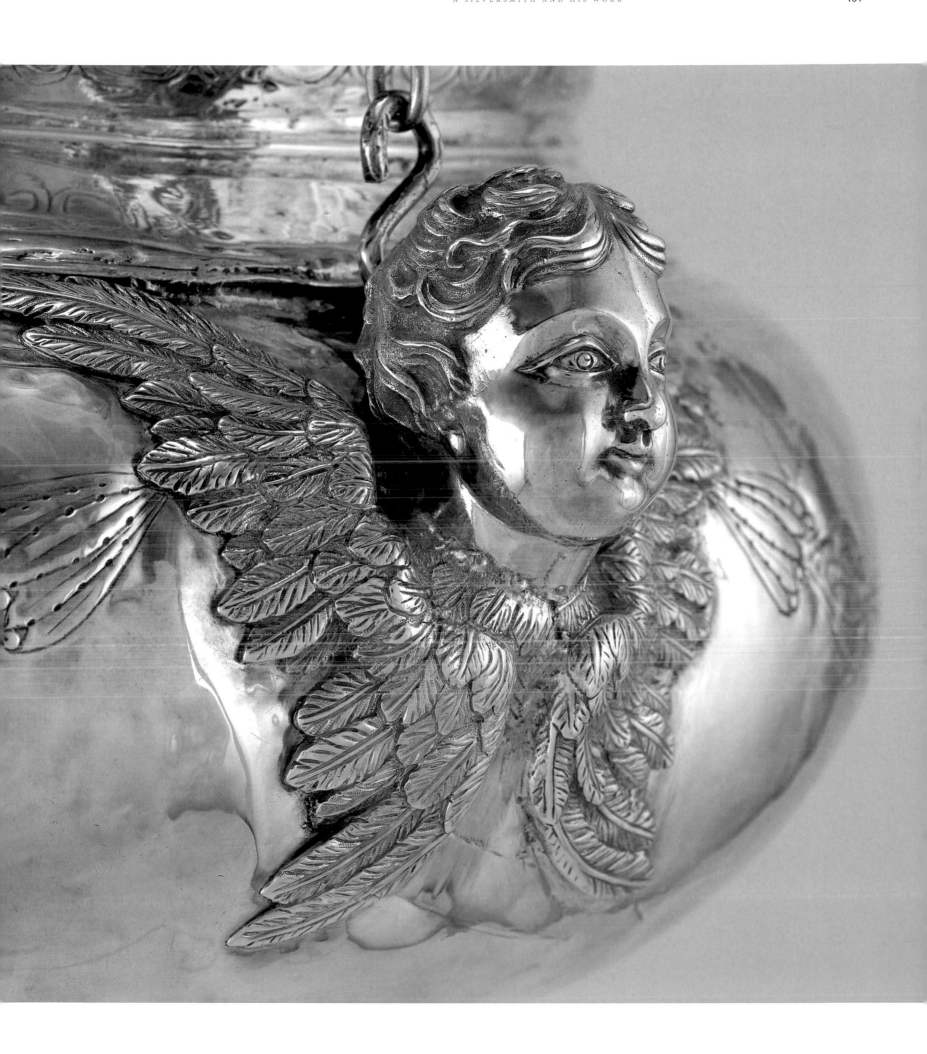

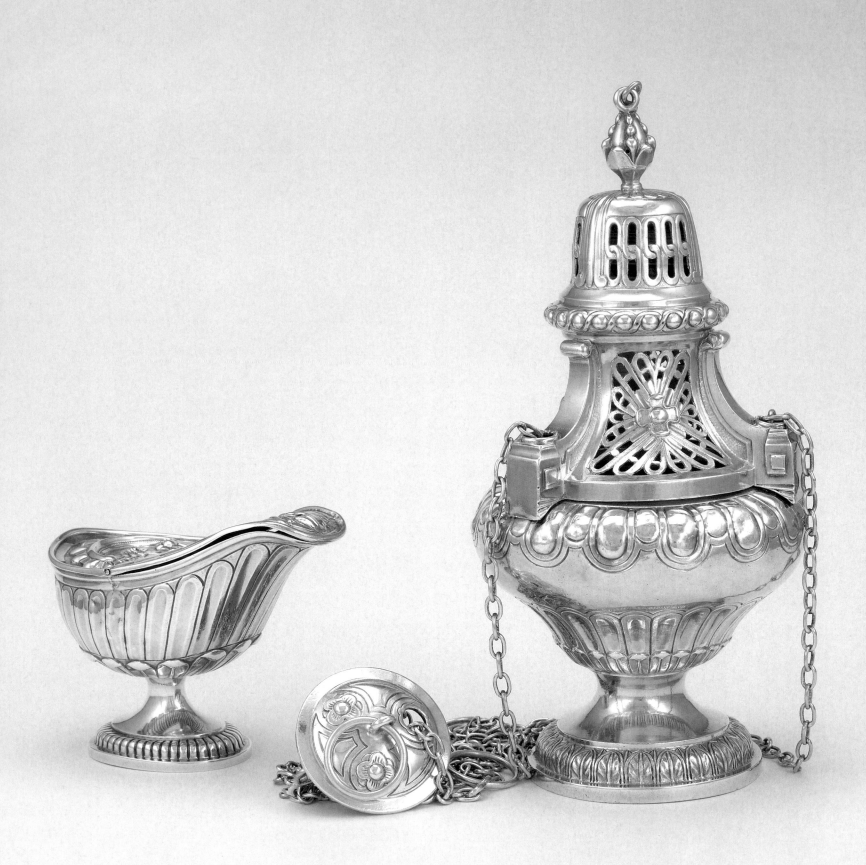

work Signaÿ seems to have actively promoted. In 1834, for example, when in Baie-Saint-Paul, he ordered the parish to acquire "a monstrance larger than the one being used."[116] Two years later, in Bécancour, the archbishop demanded "that the cups of the two chalices be regilded" and that "a silver incense boat be purchased."[117] On 7 July 1837, on a visit to Saint-Anselme, he instructed the church council to acquire a ciborium, a censer and an incense boat, all of silver.[118] That same year the parish ordered these items from Amiot. In executing the *Censer and Incense Boat of Saint-Anselme* (cat. 74), the artist employed his habitual formal vocabulary. But he rarely made two censers the same, constantly varying both their dimensions and their proportions. This example is distinctive for the deep shoulder of the vessel, characteristic of his late works. In decoration, too, Amiot avoided convention: the openwork of the chimney displays a new complexity, peculiar to this period, and the addition of a circular panel in the centre bearing a cross motif serves to strengthen this fragile area. The rim of the censer's foot shows a border of stylized veined leaves, while the under part of the paunch is decorated with *rais-de-cœur* that are echoed on the body of the incense boat. The most notable innovations, though, can be seen on the chain-holder, decorated with rosebuds, and on the lid of the incense boat, which combines large C shaped volutes and rosebuds set against a relief rocaille ground. In making this piece, and the next one to be discussed, Amiot was introducing the neo-rococo style into Canadian silver.

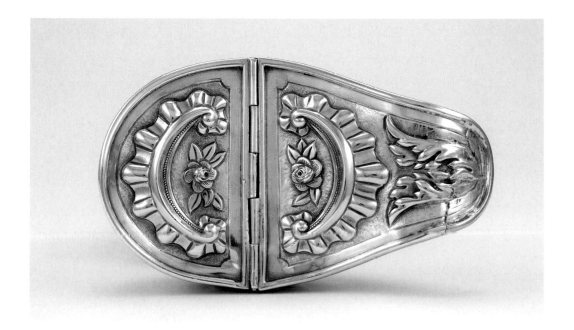

Censer and Incense Boat of Saint-Anselme 1837
Cat. 74

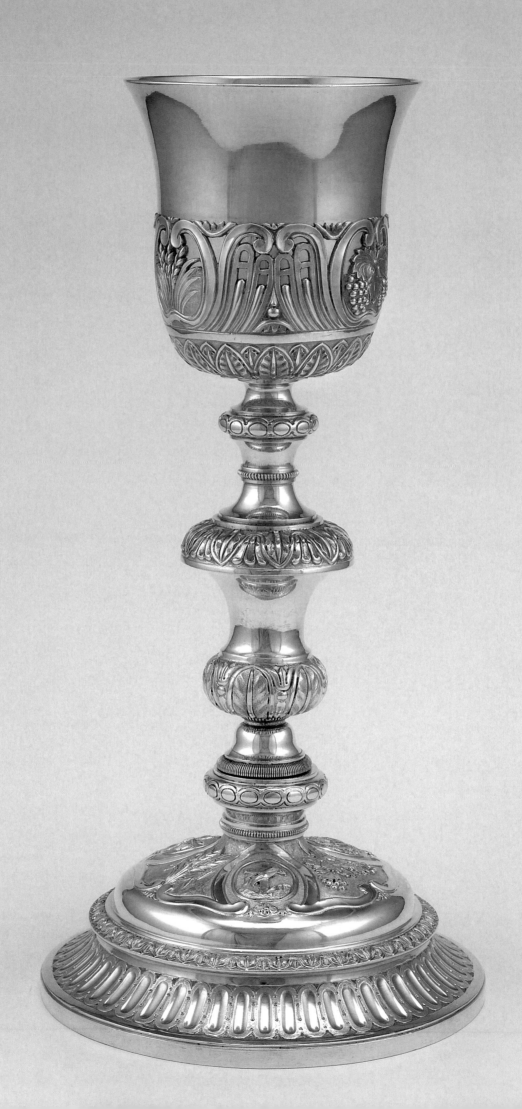

Signaÿ's support and encouragement of Amiot's artistic career achieved their ultimate expression in the chalice the silversmith made in September 1837 for the archbishop's own personal use (cat. 73). Quite remarkably, the cup has been preserved in virtually perfect condition – even its original fire-gilt finish has survived. Signaÿ was a connoisseur of the silversmith's art, and one imagines that the commission was preceded by much discussion. Amiot opted for a large storiated cup similar to others executed earlier in his career, but he took a fresh approach, drawing inspiration in the new design from French models that he may have seen in engravings. The general outline of the piece, with its perfectly proportioned masses, was without precedent in the realm of Canadian silver. The deep rim of the foot is adorned with fluting, while the slender stem features a central knop in the shape of a sharply shouldered urn. In keeping with the object's function, the ornamentation relates to the Eucharist and the theme of Redemption. The three medallions on the dome of the foot feature the cross of Golgotha flanked by the three nails of the Crucifixion, encircled by a crown of thorns and the instruments of the Flagellation. Between the medallions are other figures that reappear in the openwork calyx: cornstalks, grapes, vine leaves and reeds, symbolizing bread, wine and water (see cat. 73, detail). These iconographical elements are enclosed in medallions whose sinuously curving lines herald the neo-baroque style. This highly original work, executed with masterly skill, no doubt

Chalice of Bishop Joseph Signaÿ 1837
Cat. 73

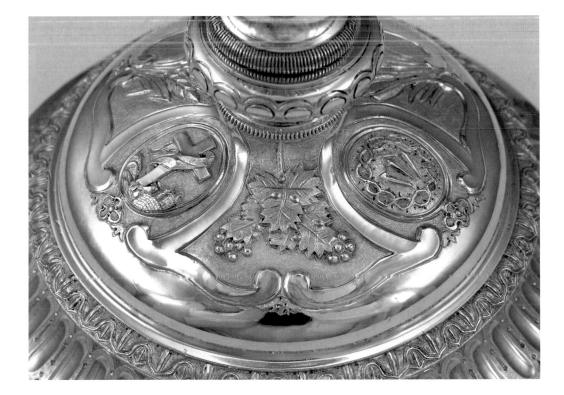

Chalice of Bishop Joseph Signaÿ (detail) 1837

delighted its commissioner. Amiot – over seventy years old and at the crest of his career – could still surprise and impress. The chalice, which is extraordinarily heavy, evidently meant a great deal to Signaÿ, who described it in detail in a codicil to his first will,[119] and again in later dictated versions.[120] Shrewdly, he had his initials engraved on each of the cup's components (invisible when it is assembled) (see cat. 73, detail). The master would never repeat this new model, indissociable from the prestige of its owner, but after Amiot's death François Sasseville would not hesitate to copy and popularize it. His *Chalice for Saint-Jean de l'Île d'Orléans*, for example, made in 1840, is an almost exact replica, although slightly smaller,[121] and it was followed in 1842 by the one for Bécancour, whose knop is a different

Chalice of Bishop Joseph Signaÿ (detail) 1837

shape.[122] Traditional historiography identifies Sasseville as the author of the design,[123] but we now know better. The younger silversmith nonetheless developed the model inherited from Amiot by integrating (as of 1845) cast medallions into the calyx and the dome of the foot.[124]

Signaÿ was not only an enlightened patron, whose sustained enthusiasm and interest undoubtedly helped shape the course of Amiot's career – he was also one of Quebec's first collectors of silver.[125] He seems to have been constantly on the lookout for fine pieces. In August 1846, when the widow of Lawrence Oran bequeathed her collection of silver flatware to the Société pour la Propagation de la Foi, Signaÿ purchased it from the society's treasurer after it had been evaluated by François Sasseville.[126] Among the masterpieces he assembled were Amiot's *Jug with Lid, with the Monogram of Monsignor Joseph Signay* (cat. 5) and a tea tray and cake-basket by Salomon Marion. Signaÿ collected French silver as well, including a ewer and an ecuelle by the Paris silversmiths Éloi Guérin and Claude-Antoine Charivet, respectively, along with a small anonymous chalice. And as witness an anonymous coffee pot and a large pair of candlesticks (fig. 3.7), dating from the eighteenth century and engraved with his name, his interest extended to English silverware. Extremely knowledgeable, Signaÿ was a pioneer in the realm of collecting.

On 11 July 1838 the archbishop of Quebec visited Saint-André de L'Islet du Portage, where he examined the accounts and drew up a long list of items to be purchased "under the direction of Monsieur Le curé." The list included a monstrance.[127] The particular reason for the commission is not known, but the *Monstrance of Saint-André* (cat. 75) – the last Amiot ever made – offers vivid evidence of how he reinvented the form. The function of a monstrance is to display the conse-crated host to the faithful, and during the eighteenth century it essentially took the form of a small lunette set in a radiating sunburst, with alternating straight and wavy rays, mounted on a stem whose degree of decoration depended on the wealth of the parish. For reasons of economy, the monstrance was some-times screwed onto the foot of a ciborium. Amiot made several examples based

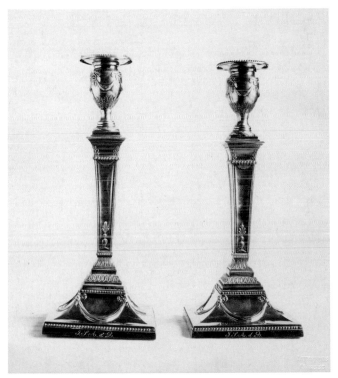

Fig. 3.7
Jules-Ernest Livernois (1851–1933)
Pair of Candlesticks that Previously Belonged to Bishop Joseph Signaÿ
c. 1915

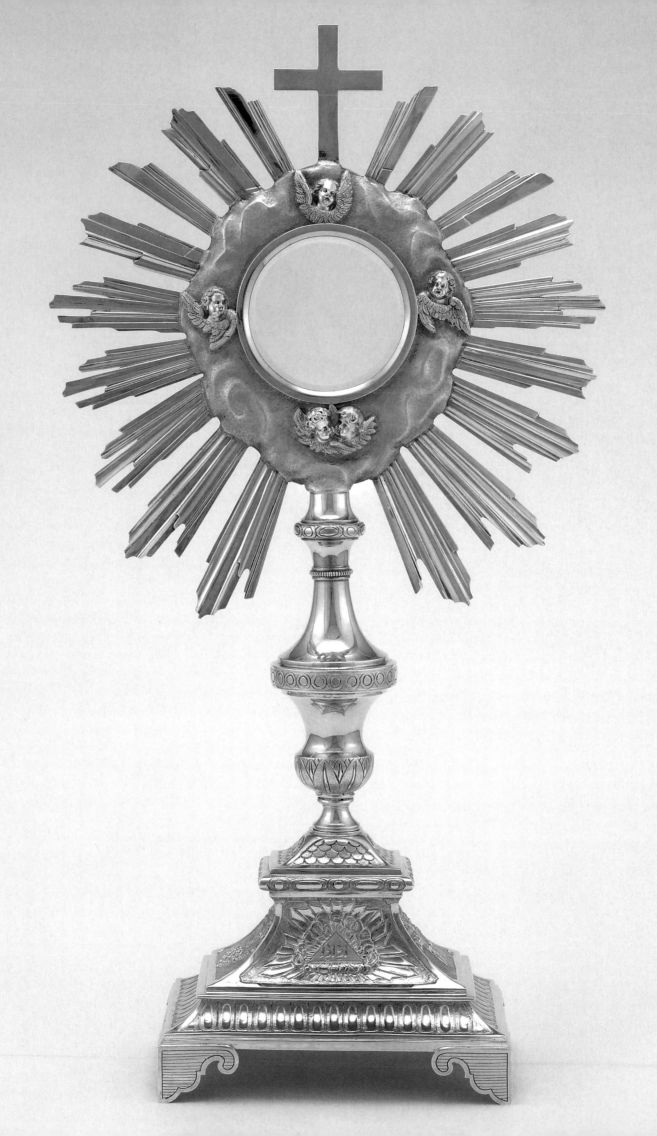

Fig. 3.8
Monstrance of La Malbaie 1806

Fig. 3.9
Monstrance of Saint Jean Port Joli 1810

on this model before developing an entirely new approach. The *Monstrance of La Malbaie* (fig. 3.8), which dates from 1806,[128] is large and solidly built, and its pared down design signals the start of a new era. The sunburst motif, which first appeared after the Counter-Reformation, symbolizes the regeneration afforded by Christ and his glory. According to the book of **Genesis**, on the fourth day God created the sun and the moon, two great lights with the power to illuminate darkness. The monstrance Amiot made for Saint-Jean-Port-Joli, dated 1810 (fig. 3.9), is a rare transitional work. The decoration of the foot and stem remains relatively simple, but the design of the sunburst surrounding the lunette is more elaborate, so as to glorify and focus attention on the Eucharist. The work included in the exhibition represents the culmination of a design first explored in 1809, in the monstrance for Saint-François de l'Île d'Orléans. In the Saint-André work, the rectangular footed base, the slender urn-shaped stem and the radiating sunburst have all been reconceived to achieve a maximum of harmony and splendour. Subsequent generations of Canadian silversmiths would emulate the approach, adapting it and extending the forms to create works in tune with the sensibilities of their times.

Monstrance of Saint-André 1838–39
Cat. 75

As crucial as the regular support and patronage of the Catholic Church was to the establishment and flourishing of Amiot's practice, it was not the only religious denomination to become a client. On the one occasion that the Anglican Church hired a local silversmith to execute a work – generally preferring to import its silverware from the United Kingdom – it was to Amiot that the authorities turned. Around 1837[129] the master silversmith executed a communion cup (fig. 3.10) for the cathedral of Holy Trinity, which joined the communion service by Thomas Heming that had been presented to the parish of Quebec City in June 1766.[130] This additional cup, which was modelled on the earlier one, took Amiot in a new aesthetic direction. The "Good Cup," officially in use in the Church of England since 1550, symbolized Protestantism and marked a radical change in the evolution of ecclesiastical silver. Compared to a chalice, the stem is short and the cup itself broad – large enough to contain sufficient wine for the entire congregation, since in Protestant practice both the clergy and the faithful receive communion in the form of bread and wine. Within this tradition, the Eucharist is not placed on the altar, facing the wall at the rear of the chancel, but on a table in the middle of the nave or at the crossing of the transept. This religious shift was embodied in the cup, which is more like a piece of domestic silverware than a chalice.[131] Execution of the work, which is slightly larger than Heming's, represented a technical challenge for Amiot, for the approach was not the same as for a chalice. The cuppa was hammered out of a single sheet of silver, while the stem and the foot were created by assembling and soldering together numerous separate elements, composed of unusually thick metal. To ensure that the cup would remain stable during religious services, Amiot designed it so that much of the weight is in the base, even adding an extra layer of metal under the foot. The general weightiness of the piece is a reminder that silverware was still considered at the time a form of capital reserve. The elegance of the design and the quality of the metal employed for the cup – which does not bear the royal coat of arms that appears on the items in the original service – eloquently reflect the talent of its creator. As for the Presbyterians of St. Andrew's church, they never seem to have thought of taking advantage of Amiot's talents to meet their needs. In 1839 they acquired two ewers, six communion cups, three trays and a baptismal ewer from the British silversmith William Bellchambers.

Fig. 3.10
Communion Cup of Holy Trinity Cathedral c. 1837

◊ ◊ ◊

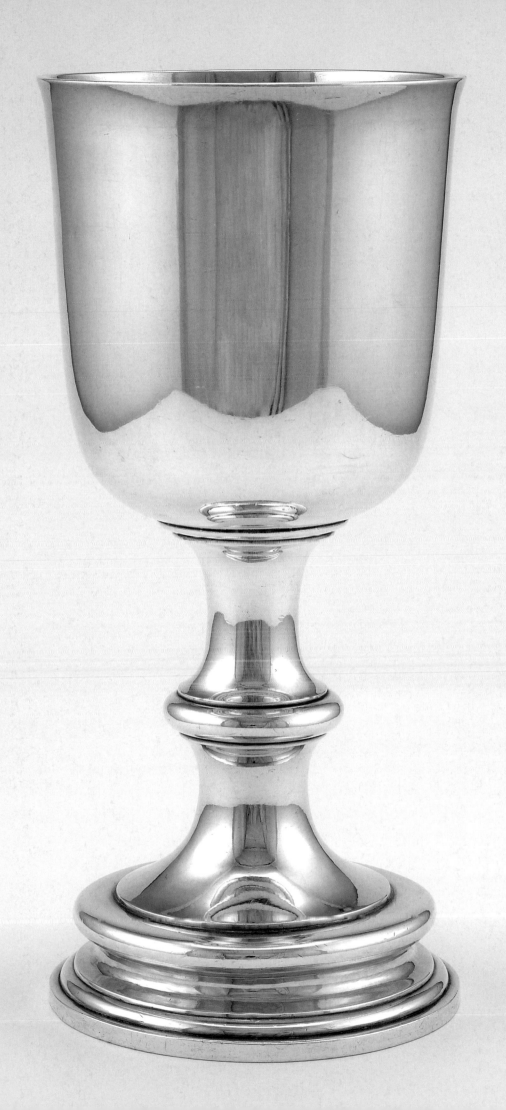

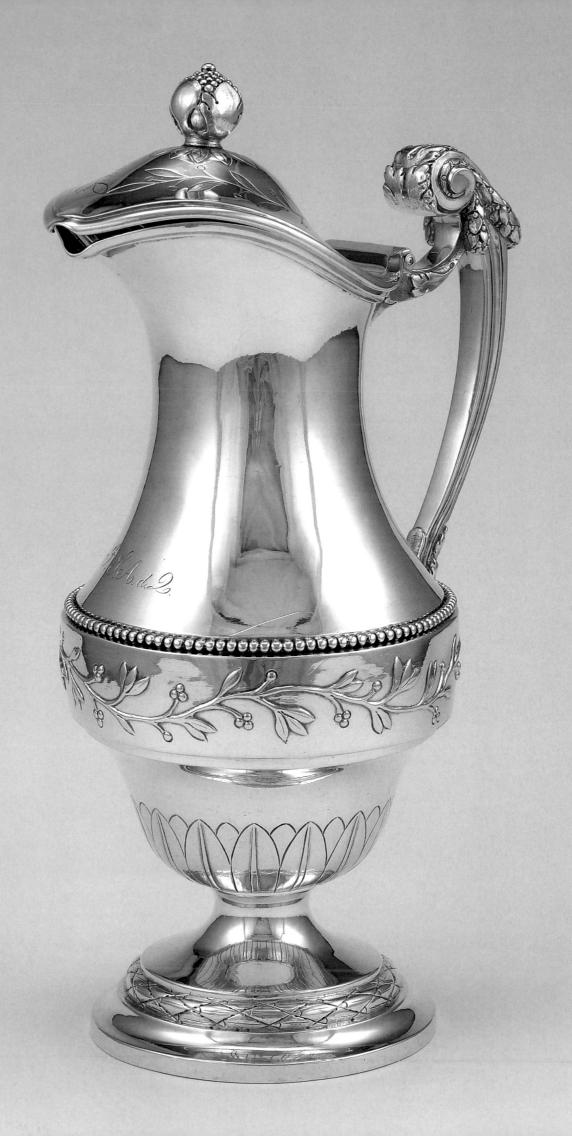

Private Patronage

Since time immemorial money has exerted an indisputable fascination over men and women, over their bankers and silversmiths, over monarchs and their lords, ministers and representatives, over merchants, over the rich and the poor. Giving an accurate and discerning account of the question of private patronage – or, more precisely, of any patronage not associated with the Church – at the time of Amiot and in the context defined by this exhibition is no easy task. Although it is generally agreed that the possession of items made of silver represented an affirmation of an individual's or a family's social status, most of the works that survive are no longer in their original milieu. Those rare examples that are, or that are reasonably well documented, can hardly ever claim a provenance as detailed and comprehensive as those associated with ecclesiastical objects. Documents are often lacking – although some extraordinarily rich archival sources have nevertheless survived – but examination of the works themselves can reveal a great deal about the period and the person who produced them. At first view, it may seem rather arbitrary to make a distinction between Church patronage and that of private individuals and civil institutions, which occurred more or less concurrently. The aim is to identify the peculiarities of both and to fully comprehend the extent and diversity of the forces at work, so as to draw a clear and detailed picture.

The years that saw Amiot's return from Paris, the opening of his workshop and his early commissions for the Church were a time of such innovation, in terms of both form and decoration, that they can justly be described as a new era. Amiot's success was due in part to his use of a limited number of classical decorative motifs that, because of their flexibility, he was able to apply to all types of objects in an interesting and varied way. The unique adaptation of this ornamental repertoire to many different items has given this period in the history of silver a feeling of unity not equalled before or since. Study of the works Amiot made for domestic use, equally fascinating, reveals a first decade that was just as richly productive. Although it is not known who commissioned them, two large lidded jugs bear marks that clearly date them to the start of his career. Such jugs were still fashionable among the wealthy classes in the last third of the eighteenth century. Novelist Philippe Aubert de Gaspé offered a glimpse of the period in his sketch of a supper at the house of a French-Canadian seigneur, where he describes the dining room and a "great silver jar of water, for the use of those who cared to dilute their beverage."[132] The *Jug with Lid, with the Monogram of Monsignor Joseph Signaÿ* (cat. 5), which was noted by E. Alfred Jones in 1912, has been exhibited many

Jug with Lid, with the Monogram of Monsignor Joseph Signaÿ c. 1790
Cat. 5

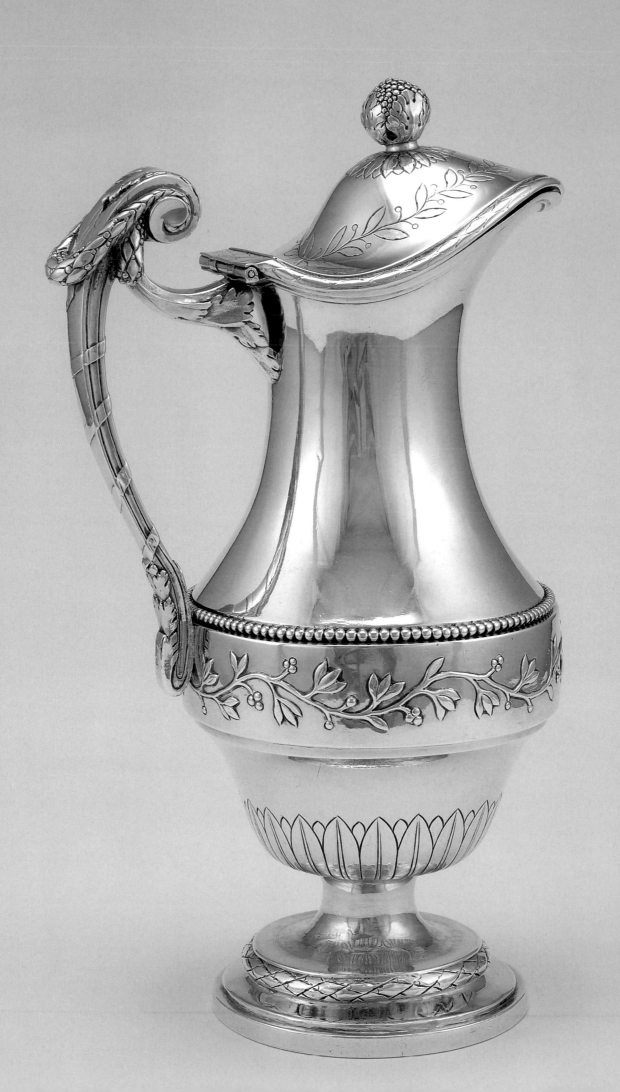

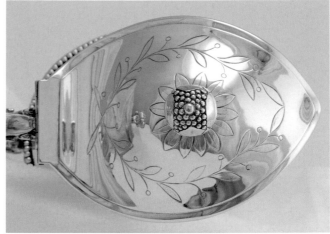

times. Given its date of execution, it is impossible that Signaÿ commissioned it himself, and the details of how he acquired it remain obscure. He nonetheless mentioned the jug in his will.[133]

It is an outstandingly elegant work. Supported on a circular foot that incorporates ogee moulding and a delicate torus bearing a lozenge design, the body of the vessel is urn shaped. The lower section is decorated with a corolla of stylized water leaves and the widest part of the belly by a frieze of laurel, identifiable by the round berries and elongated leaves. A row of beading defines the start of the rising in-curve of the neck. The convex hinged lid is decorated with two laurel branches that come together above the spout, and an open pomegranate surrounded by a ring of stylized leaves serves as the finial. An acanthus cluster marks the point near the top where the volute-shaped handle attaches to the body.

Although exhibited several times in previous years, and therefore known to specialists, the *Jug with Lid* (cat. 4), formerly in the collection of Cyrille Tessier, created something of a stir among collectors when it appeared in 1965 at the Bauer sale and graced the cover of its catalogue.[134] Purchased at that time by Henry G. Birks, it immediately became the icon of his prestigious collection. Similar in size to the *Jug with Lid, with the Monogram of Archbishop Joseph Signaÿ*, it nonetheless shows several differences of form and, especially, of decorative detail. For example, the silhouettes of the pedestal mouldings are not identical, and neither are the spouts, that of the Signaÿ piece remaining slightly open and the other closing entirely. In ornamental terms, the laurel frieze is somewhat different on the second jug, the moulding running around the spout is adorned with a delicate lozenge pattern, the laurel branches on the lid are denser, and the knob is a kind of hybrid between an open pomegranate and a pine cone (see cats. 4, 5, details). Finally, the volute of the handle is beribboned, adding to the richness of the piece. Right at the start of his career, then, Amiot revealed the approach he intended to take, offering his clients original forms and taking advantage of each iteration to explore new effects.[135]

Jug with Lid (detail) c. 1790

Jug with Lid, with the Monogram of Monsignor Joseph Signaÿ (detail) c. 1790

Jug with Lid c. 1790
Cat. 4

A couple of years later, in 1792, the master made a vessel that took a whole new direction and provided evidence of his remarkable inventiveness: a tea urn, whose tap was based on a model executed by François Baillairgé.[136] Unfortunately, this work – the only one of its kind in the history of Canadian silver and an eloquent testimony to high-society practices of the time – has never been found.

In 1794, the same year that he produced the magnificent *Holy Water Stoup* (cat. 8) for the parish of Cap-Santé, Amiot completed another masterpiece of Canadian art: the *Tureen of the Hertel de Rouville Family* (cat. 7).[137] This work was commissioned by an enlightened collector, the seigneur and politician Jean-Baptiste-Melchior Hertel de Rouville,[138] shortly after the death of his father, whom he succeeded.[139] A few years later he added to the family gallery by commissioning William Berczy to paint portraits of himself (cat. 82) and his wife.[140] It was also at Hertel's request that Berczy painted an altarpiece for the church of Saint-Jean-Baptiste de Rouville.[141]

A tureen is a deep bowl placed on the dining table to serve soups or stews – dishes where meat is cooked with vegetables in a pot, rather than roasted on a spit or in the oven. In formal terms, this example is a clear heir to the various classical tureens being made during Amiot's years in Paris, but he took a uniquely personal approach. The vessel, whose bulbous oval body is supported on four ball-and-claw feet inspired by the British rococo style, is covered with a convex lid. The two moulded handles affixed at either end, decorated with rather stiff leaf motifs, are asymmetrical in design, making the tureen easier to lift and lending a sense of dynamism to the whole. Garlands of embossed and chased laurel encircle the paunch, and to enhance the relief of the leaves the silversmith roughened their edges and reduced their surface shine. Engraved on one side is an element from the family's coat of arms and their motto, along with the patron's initials. The rim of the lid is decorated with four bands of textured moulding punctuated by four rosettes of acanthus leaves. In the centre of the dome, a raised area composed of four large acanthus leaves arranged in a cross – exquisitely chased and worked to contrast with the polished ground – supports the berry finial. In their fusion of French and English traditions, the form and ornamentation of the piece represent a unique moment in this country's aesthetic development. As was common in Europe, but very rare in Canada, the object's weight is engraved on the underside. This may have been done at the time of execution or possibly later, when an inventory was being made. The exuberant design and flawless workmanship of the tureen has transformed it from a domestic object into a

William Berczy (1744–1813)
Jean-Baptiste Melchior Hertel de Rouville
c. 1810
Cat. 82

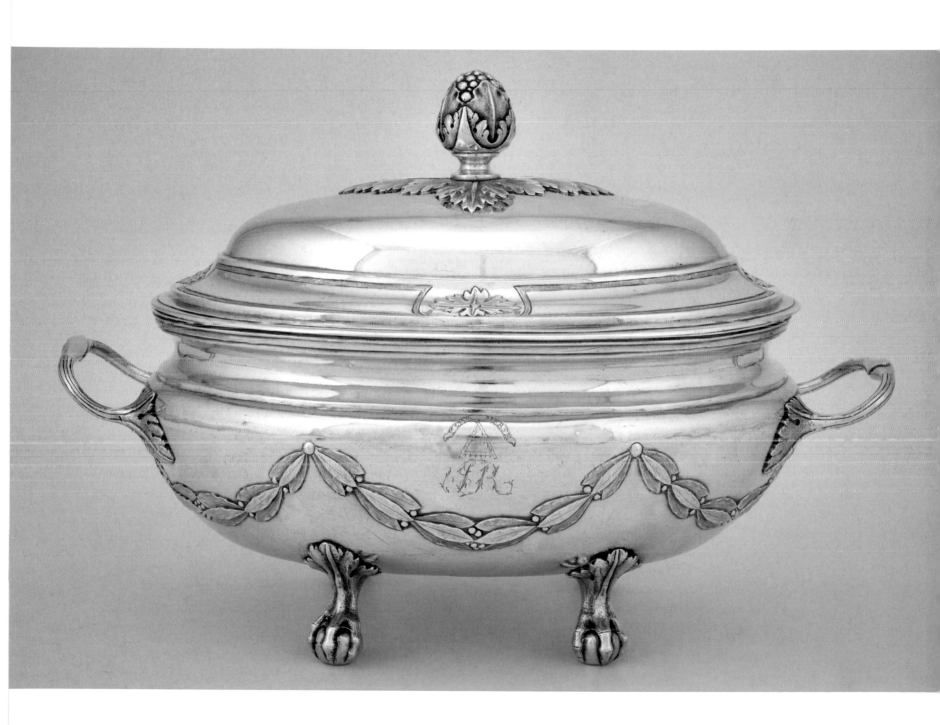

**Tureen of the Hertel de
Rouville Family** 1793–94
Cat. 7

Whatever its immediate origin, the Le Moine coffee pot is a transitional work. To the neoclassical body have been appended a handle and spout in the British rococo style. The artist paid meticulous attention to every component, and the result is a masterpiece. He would certainly have developed his design in a preliminary sketch, adjusting the various forms, balancing the proportions, and establishing the details and extent of the ornamentation. The sculptor François Baillairgé made an all-important contribution by providing the models needed for casting the spout, the socket of the handle and the finial on the lid. He also carved the mahogany handle.[152] Technically, the work is impeccable: the swaging and hammering have been executed with remarkable skill, and great pains were taken in the casting. The frieze of medallions and garlands that runs around the top of the paunch has not been cast apart but executed by hand, on the main body, and the beads encircling the foot were chased one by one. The absolute care taken at every stage, from initial conception to final polishing, enabled Amiot to reach another pinnacle of his art. The piece seems to have been well received, moreover, since at an unknown date he made another similar one, possibly for a member of the Globensky family (fig. 1.4, p. 23). Exhibited briefly in Montreal in 1941, this second example has not been seen since. Here again, Amiot was producing objects that cast light on changing social practices.

Silver baskets designed to hold fruit or cake were an English invention inspired by the taste for fine wickerwork. The first examples appeared during the seventeenth century, and it would be some while before similar receptacles were made on the Continent. Shapes and decorative styles evolved according to changing fashions, and the form reached the height of its popularity during the eighteenth century. Such baskets were technically complex to make, requiring the combined talents of several qualified silversmiths,[153] and a number of London workshops made them their speciality. Robert Cruickshank produced a small sweetmeat basket,[154] but the first true example made in Canada is the *Basket with the Monogram JMA* by Amiot (cat. 9), another outstanding work about which there is still much to be learned. The circumstances of its execution remain obscure, and it is not known to whom the initials engraved in the centre of the base refer, although the maker's marks do allow us to date it to near the end of the eighteenth century. Supported on a foot finished with ogee moulding, the oval body has a flat bottom and sides that curve up and out to form a broad rim. The curvature of the hinged handle, attached to the body in the centre of each long side, echoes that of the everted edge. Remarkably lavish, the decoration marries perfectly with the forms it serves to emphasize and enhance: in both vocabulary and syntax it reflects a mastery of the art of composition. Of first note is the vertical gadrooning, whose

Basket with the Monogram JMA c. 1795
Cat. 9

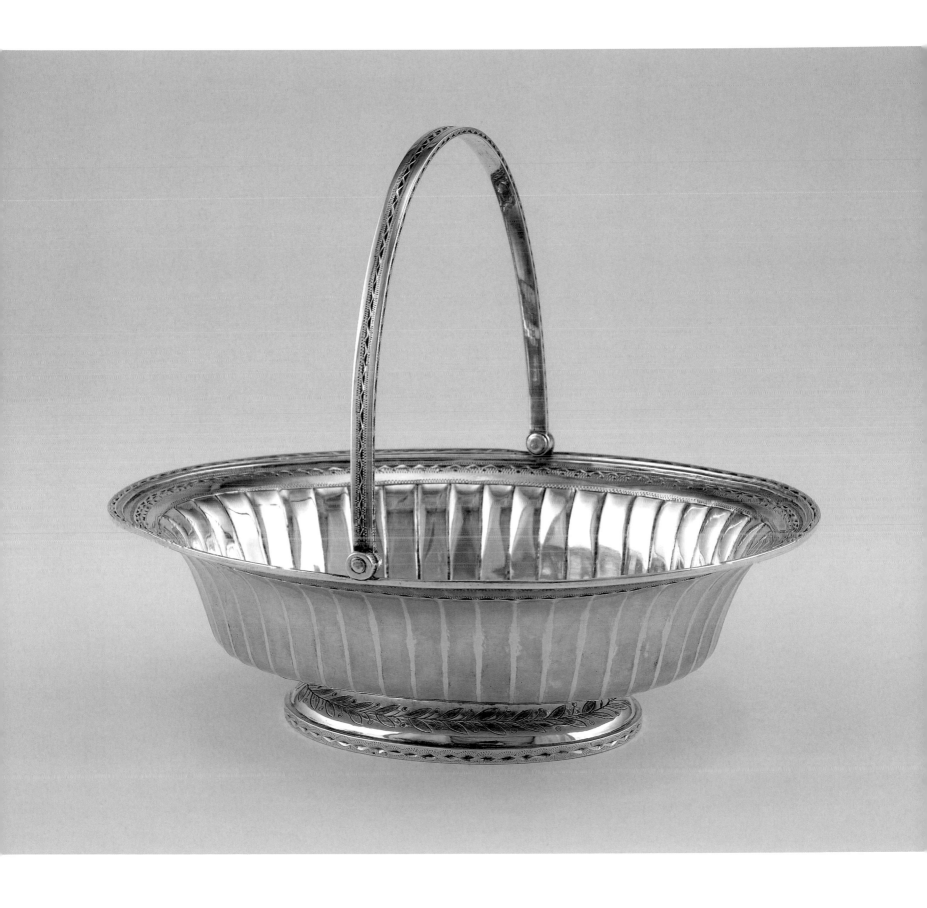

broad, flat lobes adorn the entire surface. To this Amiot has added several bands of bright-cut engraving (a characteristically British form of decoration), which appear on the edge of the pedestal, along the top of the gadrooning, around the rim – and even on three of the handle's four sides, so that the decoration is not interrupted when the handle is lowered. Nowhere else in the oeuvre does this decorative technique play such a major role. A frieze of matte laurel leaves, which would have been executed by a local engraver, further enhances the moulding of the foot. Stylistically, the work is a free interpretation of the late Adam style with Louis XVI overtones. Unique in its form and exceptional for the extent of its decoration, the basket is a minor monument of unity, refinement and originality that illuminates yet another facet of Amiot's genius while evoking an opulent lifestyle of days gone by.

Mustard Pot with the Coat of Arms of George III c. 1795–1800
Cat. 12

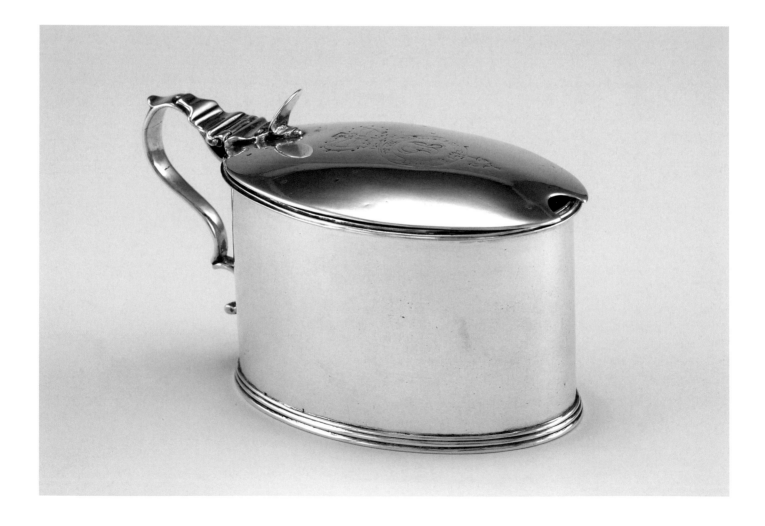

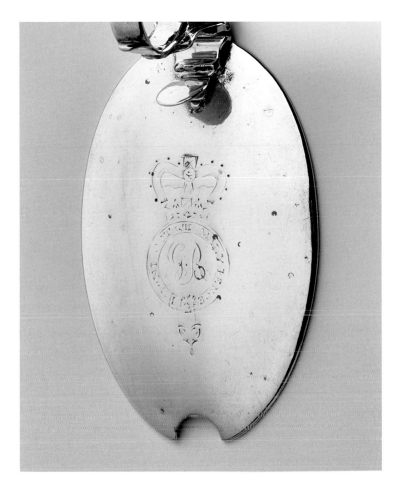

Around 1800, Amiot received at least one commission from the British government – or so the existence of his *Mustard Pot with the Coat of Arms of George III* (cat. 12) would seem to indicate. In England, it was the Jewel House, located in the Tower of London, which was in charge of supplying the court and the government with silverware, but it has proved impossible to ascertain just how this Quebec commission was granted. Was there a sudden need for an extra piece for the governor's table? Since the silver belonging to the nation came under the authority of the Crown, each piece bore the monogram of the reigning monarch, and the oval hinged lid of the mustard pot bears that of King George III. In all probability, the person who actually placed the order supplied the silversmith with an image of the monogram, so it could be reproduced exactly. Fortunately for posterity, a drawing has survived (cat. 78). Though simple, this little piece – unique in the realm of Canadian art – confirms that Amiot's work was admired in the loftiest spheres.

Mustard Pot with the Coat of Arms of George III (detail) c. 1795–1800

Unidentified artist
Drawing of Royal Coats of Arms c. 1795–1800
Cat. 78

It was also during this highly productive period that Amiot created the *Brandy Saucepan from the Livingston Family* (cat. 13).[155] This type of receptacle, British in origin, was used for heating brandy or wine over a spirit lamp on festive occasions, a common custom around 1800. Amiot's version is particularly elegant. Instead of making a bulbous replica of a full-sized saucepan, like so many silversmiths, he opted for a truncated bell-shape, fashioning the pan out of a single sheet of silver and adding a round, hinged lid, a handle and a quaintly distinctive drop motif just beneath the spout. The long handle, made of turned ebony and attached at an oblique angle, is original. Engraved on the underside is the name *Robert Armstrong Livingston*, surmounted by the image of a ship and the motto *Spero Meliora*, along with the date 1854. According to unconfirmed tradition, the person named belonged to a family from Albany, in the state of New York, and the object migrated there following his marriage to a woman from Quebec.

Brandy Saucepan from the Livingston Family (detail) c. 1795–1800

Brandy Saucepan from the Livingston Family c. 1795–1800
Cat. 13

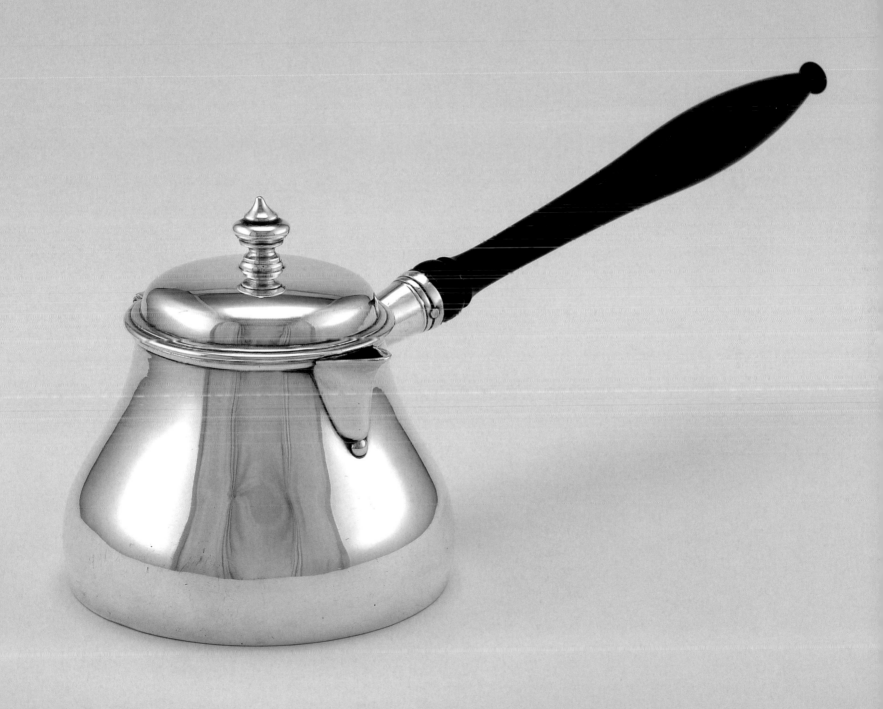

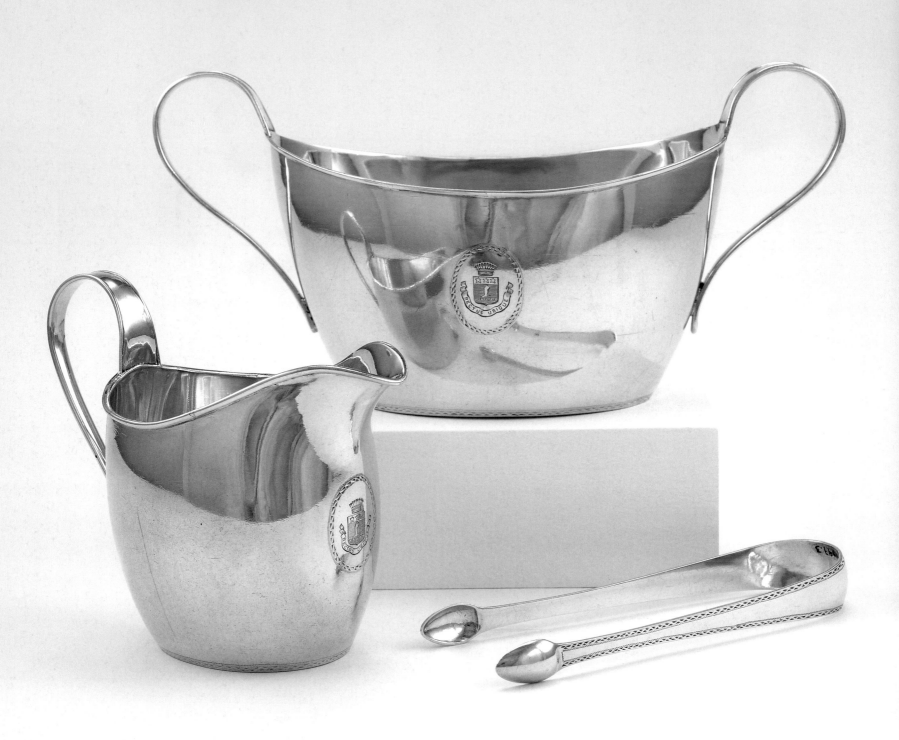

Several members of the Chaussegros de Léry family occupied positions of importance in the eighteenth century, and their descendants continued to wield influence during the nineteenth.[156] Generation after generation, they showed proof of a veritable passion for silver. The *Ragout Spoon with the Coat of Arms of the Chaussegros de Léry Family* (fig. 3.12), sole survivor of what was originally a set of four, is one of the earliest pieces to have been owned by them. Aside from the works that have come down to us, there exist two eighteenth-century documents that describe the collection, built up over many years.[157] The items identified indicate that the family patronized the most highly reputed silversmiths, first in France and later in Canada.[158] Around 1800 Amiot executed the *Creamer, Sugar Bowl and Sugar Tongs with the Coat of Arms of the Chaussegros de Léry Family* (cat. 19) – perhaps to accompany a teapot purchased from James Hanna on 27 October 1795[159] – that may have been commissioned by Louis-René Chaussegros de Léry (see fig. 3.13).[160] The armorial bearings, *Azure a boot spurred above a bar abaised embattled, on a chief Argent three mullets Azure*, were engraved at a later date (sometime between 1830 and 1850), and the engraver seems to have taken several liberties in his interpretation.[161] The boat shape of the jug and bowl echoes similar English pieces, in silver and ceramic, from around the same period. Near the end of the nineteenth century, at the family's request, Ambroise Lafrance executed faithful replicas of the milk jug and sugar bowl.[162]

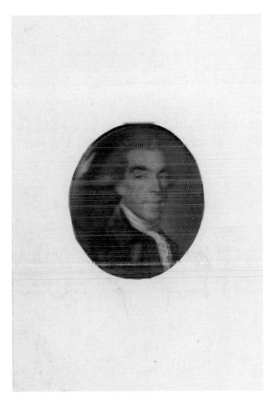

Fig. 3.12
Jacques Besnier (c. 1668–1761)
Ragout Spoon with the Coat of Arms of the Chaussegros de Léry Family (detail) c. 1754–55

Fig. 3.13
Jules-Ernest Livernois (1851–1933)
Louis-René Chaussegros de Léry n.d.

During this period, the tea service became the focus of an important and elegant ritual, an event at which people gathered to share conversation and refreshments. The first silver teapots executed in Canada made their appearance virtually simultaneously in Quebec City and Montreal, toward the end of the eighteenth century, and their formal development follows a clear pattern. In quantity, Amiot outdid all his contemporaries, executing no fewer than six teapots on commission between 1791 and 1799.[163] Only one of those by him that have come down to us dates from this early period: the teapot bequeathed by

Creamer, Sugar Bowl and Sugar Tongs with the Coat of Arms of the Chaussegros de Léry Family c. 1800
Cat. 19

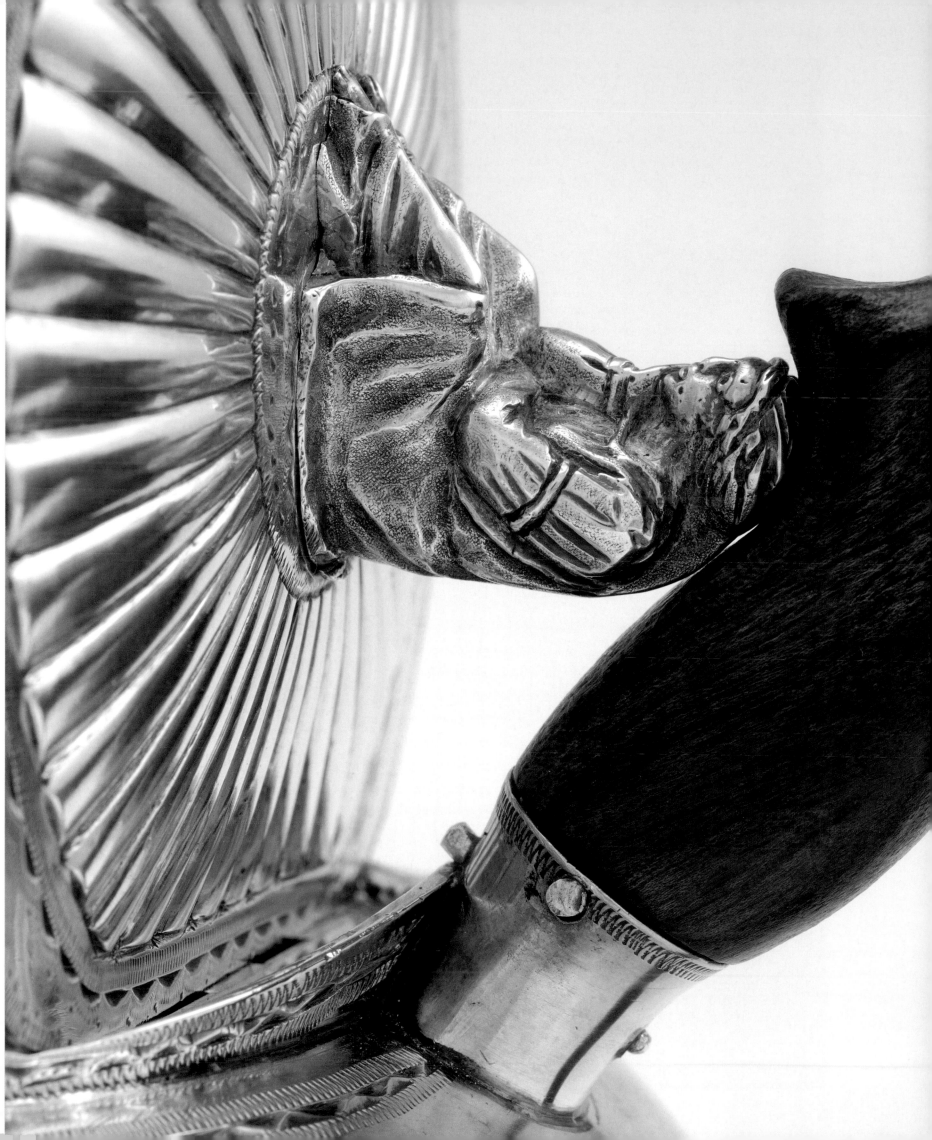

sculptural presence. The body, supported on a very discreet foot, takes the form of a slightly flattened sphere. Both the lower part of the paunch and the convex lid are enhanced with flat gadrooning. The small angled spout and bands of bright-cut engraving that adorn the top of the body, the inner and outer edges of the undulating collar and the edge of the lid are derived from the Adam style. A scrollwork frieze runs around the middle of the body, creating a visual link between the spout and the handle. The crest of a demi-lion on a wreath engraved on the side was used by a number of families and is not enough, on its own, to identify the original owners with certitude. A sibyl seated in the centre of the lid serves as finial. This figure was likely made using a mould taken from a model in fine earthenware. The sturdy handle of carved mahogany is highly ergonomic, and – stratagem of an experienced designer – there is a small, cradle-like indentation in which the sibyl rests when the lid is open (see cat. 41, detail). True to the Regency style, the artist has sought to create an effect of grandeur without being overly purist in the combination of decorative elements. The use of a greyish, cold-toned silver adds to the classical spirit. It was a masterly hand that hammered and swaged an unusually thick sheet of silver into the faultless form we see. A metal of such thickness has the advantage of preserving the heat, which improves the infusion. The decorative engraving and the carving of the handle were no doubt executed by artists from other workshops. All in all, the *Teapot with a Sibyl* represents an outstanding variation on the neoclassical theme.[166]

In the late winter of 2009, the National Gallery of Canada decided to add the *Regency Teapot* (cat. 61) to its collection. This work had been unknown to historians before it appeared on the market a few months earlier. Aside from representing a crucial addition to the artist's catalogue raisonné, the piece is without parallel in the realm of nineteenth-century Canadian silver. The teapot is known to have belonged for several decades to a family called Flint from Saint-Lambert, near Montreal, but it has not been possible to determine either who commissioned the piece or the precise circumstances surrounding the commission. There is every indication, however, that it took place in Quebec City: at the start of the nineteenth century, the capital offered a number of possibilities to anyone wishing to purchase a high-quality teapot or even a full tea service. John Neilson (see cat. 85), for example, politician and editor of the *Quebec Gazette* – also a neighbour and client of Amiot's[167] – chose a white, soft-paste porcelain set made by Flight, Barr & Barr (cat. 83)[168] that included a boat-shaped teapot decorated with acanthus-leaf scrolls and delicate gold bands. James Leslie, preferring solid silver, purchased a

Teapot with a Sibyl (detail) c. 1820

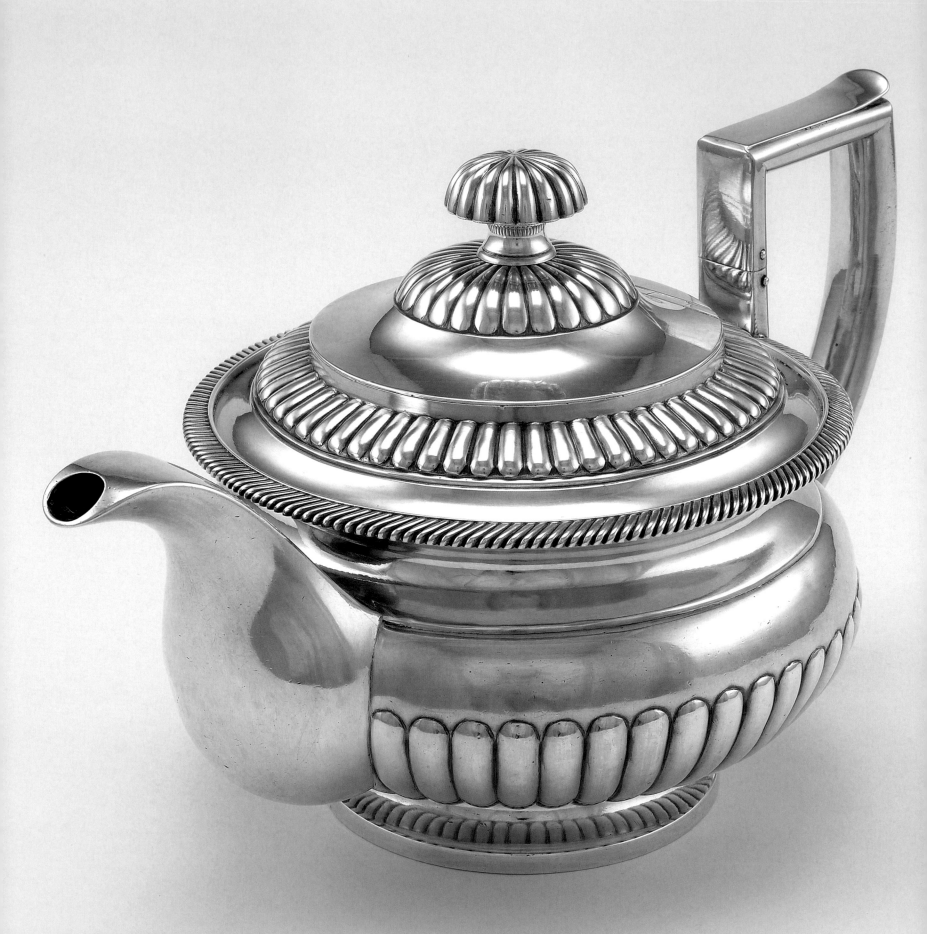

neoclassically inspired service made in London in the workshop of Charles Price.[169] Evidently as eager as they were to purchase a quality piece, possibly even keen to outdo them in refinement, our unknown client decided to engage a local artist rather than settle for a standardized English import. It was certainly not a matter of either chance or convenience that prompted the commissioner of the *Regency Teapot* to turn to Amiot.

Executed at a time when Amiot's work was highly sought after, the teapot is striking in its sculpturality. The body displays the flattened spherical form typical of the early Regency style. The graceful S-shape of the short spout counterbalances the angles of the handle and attenuates the severity of the whole. The fact that the handle projects farther than the spout lends dynamism to the piece and helps create a sense of psychological balance between the arc it describes in space and the volume of the body. The positioning of the various elements reflects the artist's quest for total perfection: the highest point of the spout is exactly level with the top edge of the pot's opening, and the upper part of the handle is precisely in line with the bottom of the finial surmounting the lid. Obviously, logic requires that the spout rise higher than the body, but by assembling the components with such exquisite precision Amiot revealed himself to be a true master of his art. The oval opening at the tip of the spout is the only interruption in the single sheet of silver that forms the spout's upper surface. This unusual approach results in an extremely elegant line and lends solidity to an element that is inevitably fragile, as well as improving the pot's pouring action. The silver handle is equipped with insulators to prevent it becoming too hot, but here – and it is the only such case in the whole of Amiot's production – they have been placed inside the hollow handle, thus preserving its pure, flowing line. The top of the handle features a delicately curved thumb piece, which, aside from facilitating

John James (active 1811–1845)
John Neilson c. 1820
Cat. 85

Regency Teapot c. 1825
Cat. 61

a sure grasp, adds a point of visual interest. The design and execution of these two components combine in a perfect harmony of form and function.

The decoration of the piece marries flawlessly with the forms it serves to emphasize and enhance. The principle decorative element is the gadroon, subtly adapted to the different surfaces chosen for ornamentation: a first frieze of gadrooning runs around the lower part of the body, another encircles the rim of the opening, and a third adorning the convex part of the lid is echoed in the finial knob. The knob itself has been hammered and assembled in a way that reflects a clear concern for visual cohesiveness and overall elegance. The ring of fine diagonal gadroons running around the rim that supports the handle adds a lively and distinctive note (see cat. 61, detail). The silversmith has refrained from adding the motif to the foot, but the gadroons around the underside of the paunch are reflected in its scooped surface, adding another ingenious decorative touch. Finally, careful attention has even been paid to the application of the maker's mark, which Amiot had been using since around 1810: it appears four times on the underside of the pot, arranged in a cross formation reminiscent of standard English practice. The *Regency Teapot* is a paragon of unity and refinement that carries echoes of works made by Chinese silversmiths for export.[170] Unique among Canadian silver of the period, it offers vivid proof of Amiot's versatility and of the major role he played in the redefinition of taste that occurred in this country during the first half of the nineteenth century. Each of the three teapots included here represents an aesthetic statement in and of itself, not only in its form and ornamentation but also in the particular techniques employed to make it, the silversmith invariably selecting those best suited to the realization of each design.

Regency Teapot (detail) c. 1825

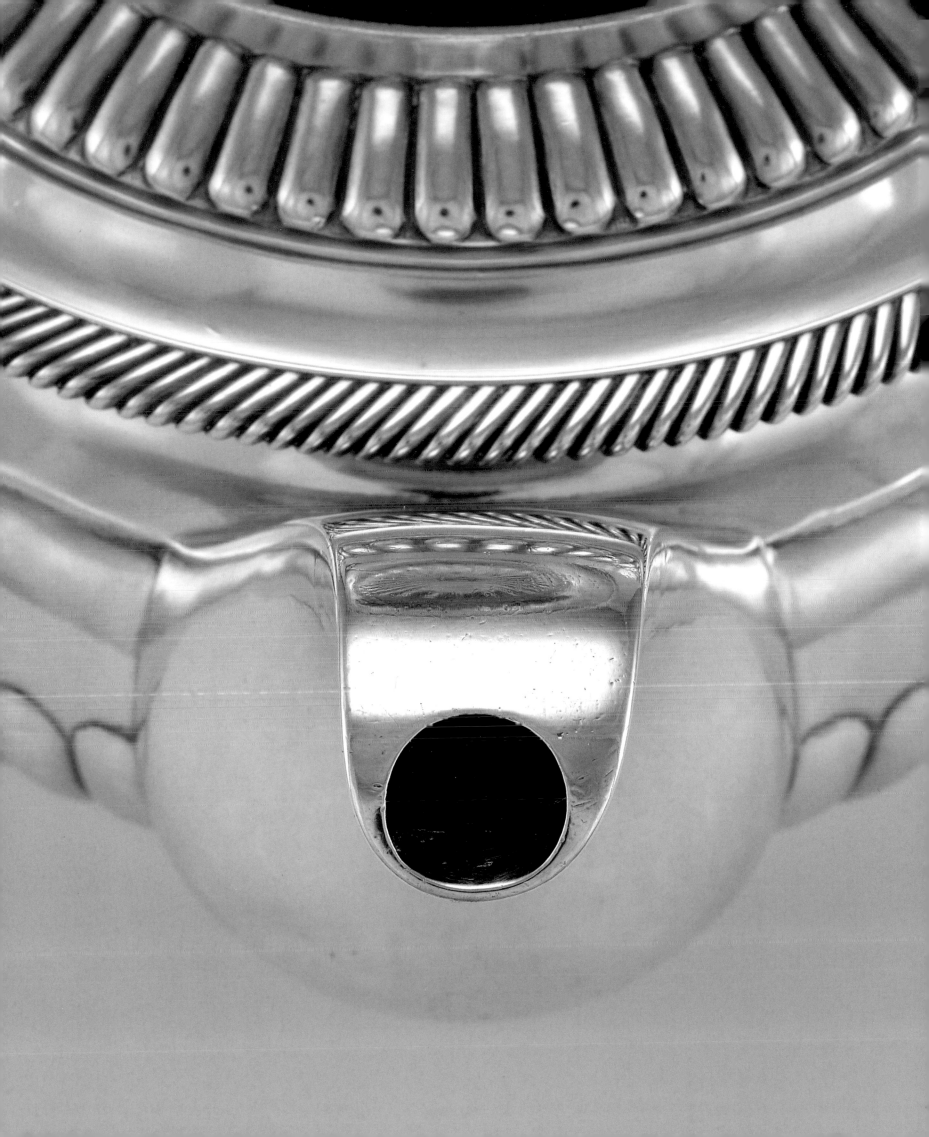

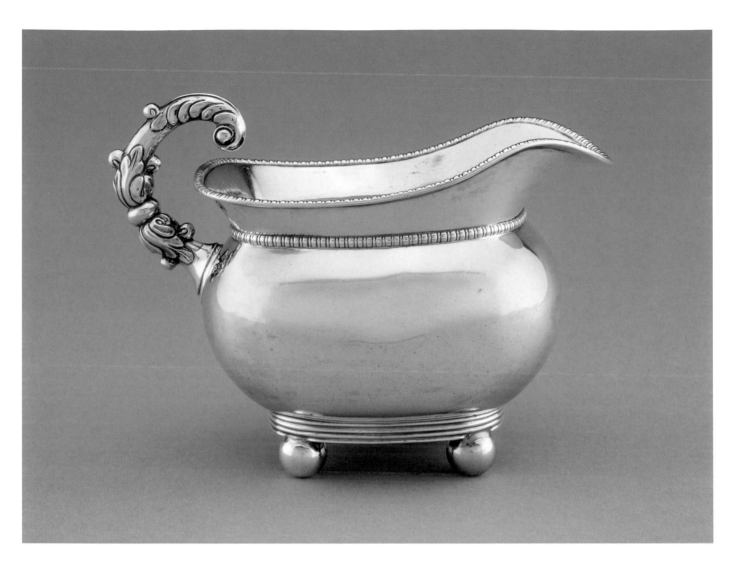

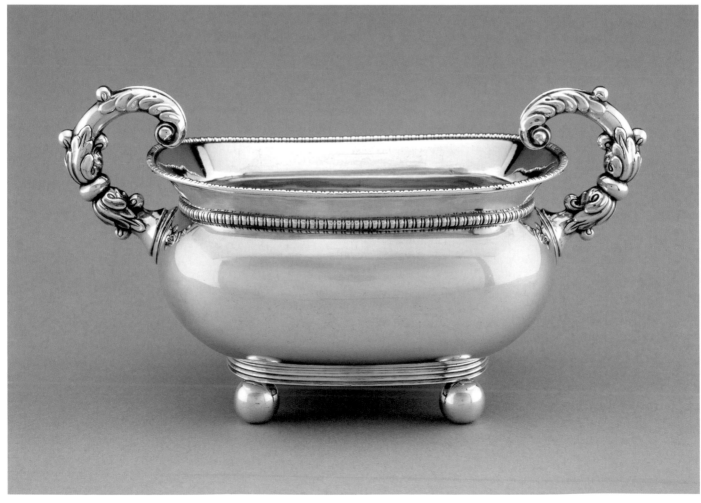

Although no tea service by Amiot has so far been found or even identified in documentary sources, a matching sugar bowl and creamer (cat. 40) have come down to us that may have originally been accompanied by a teapot. Executed a couple of decades after the bowl and jug bearing the Chaussegros de Léry family coat of arms, they are stylistically worlds apart. Each bulbous body, basically rectangular, rests on a band of moulding supported by ball feet. The sturdy C-shaped handles covered in foliage, whose impact is enhanced by the thickness of the metal employed, are of a type seen commonly in pieces made in the English city of Sheffield around 1820. The gilded interiors, which create a contrast with the outer surfaces, are in slightly different tones, giving each receptacle its individual character. Similar in its oval-bodied form to these two pieces is the famous sugar bowl and cover (cat. 60) from the collection of Cyrille Tessier. As well as a horizontal handle on either side, there is a third affixed to the top of the bowl's domed lid. The edge of the lid is encircled with moulding, and the interior of the vessel is covered with a delicate, pale gilding barely noticeable at first. Resembling a miniature tureen, this work is unique in the field of Canadian art.[171]

Creamer and Sugar Bowl c. 1820
Cat. 40

Sugar Bowl and Cover c. 1825
Cat. 60

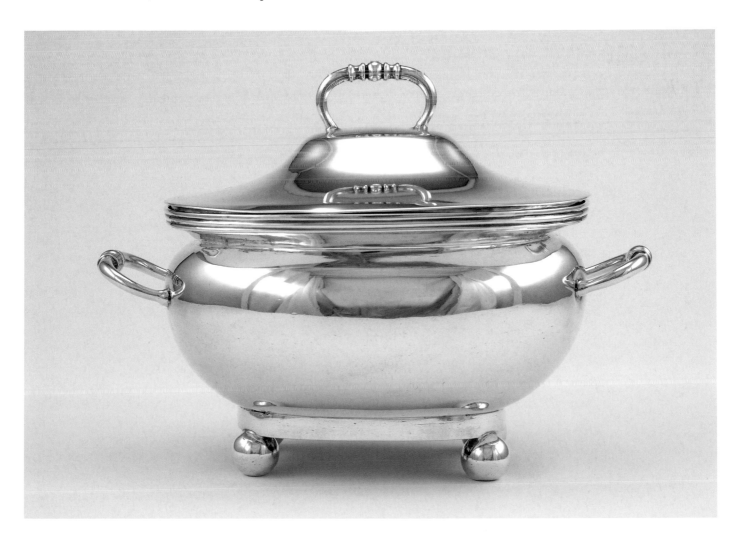

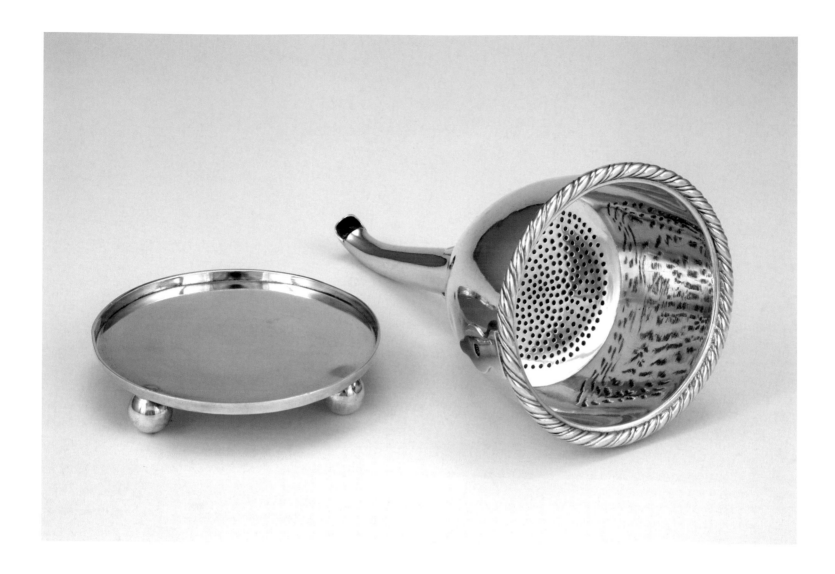

Wine Funnel Stand c. 1810–15
Cat. 27

Wine Funnel c. 1810–15
Cat. 28

Another item in Amiot's repertoire of domestic objects that reflects the increasing sophistication of Canadian lifestyles is a wine funnel (cat. 28), used to decant red wine. This example – another innovation in the silver of this country – is composed of two parts, the strainer and the funnel itself. During use, a piece of muslin would have been placed between the two to catch the sediment, or lees. The tip of the funnel is curved to ensure that the wine runs down the side of the carafe, keeping exposure to air to the minimum. The spout has three short ribs on its outer face to permit air to escape during decanting. A border of feather-edge moulding runs around the funnel's rim, to which is affixed a small cut-out hook. It is on this surface that the silversmith chose to strike his mark.

Such funnels were sometimes equipped with a stand. The only known Canadian example, made by Amiot (cat. 27), is circular (to accommodate the upside-down funnel), has a lipped edge and sits on four ball feet.

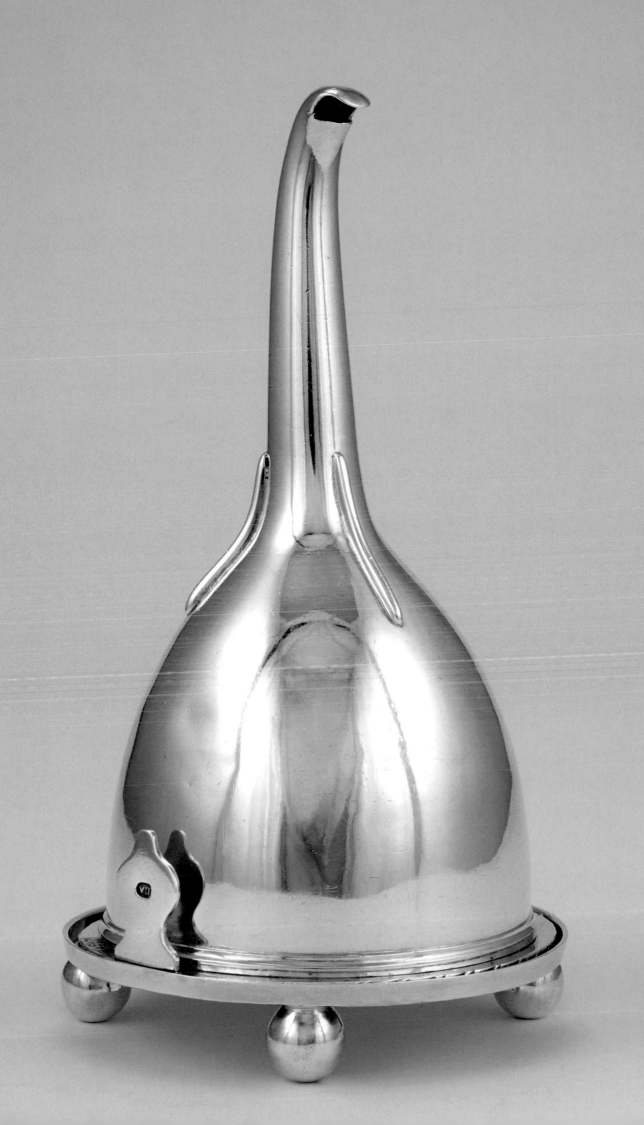

Bottle Ticket for Port 1815–20
Cat. 36

The *Bottle Ticket for Port* (cat. 36) harks back to an era when practices surrounding the sale and consumption of wine and spirits were different from today. Initially, the contents of a bottle – made of thick greenish-black glass – were identified on a handwritten paper label held by the wax that sealed the cork. Etiquette required a way of indicating the contents once the bottle had been opened or they had been transferred to a carafe, generally used for liqueurs and spirits. In Europe, the fashion for labels – which reached a height during the Georgian period – gave rise to a wide variety in all sorts of materials, although silver remained the most popular. This extremely rare Canadian example by Amiot was possibly designed to be part of a set. In making it, he took a functionalist approach: the oblong silver plaque is slightly curved, so as to fit closely on the bottle or carafe, and the small chain (partially restored) would have hung around the vessel's neck. The engraved inscription, in capital letters and surrounded by a double outline, is clear and instantly legible.

In the first quarter of the nineteenth century Amiot executed another piece
of formal tableware whose precise provenance still remains obscure. The *Ewer
with the Monogram of the Séminaire des Missions Étrangères* (cat. 54) was definitely used
during religious ceremonies,[172] but the form of the piece can be related to works
intended for domestic table use, and it is possible that this was its original func-
tion. The vessel's overall shape resembles that of neoclassical wine jugs made in
England during the 1760–1800 period. The master individualized the piece, how-
ever, by inserting a knop between the foot and the paunch, and refining the design
of the handle – a sweeping, asymmetrical volute decorated with a row of leaves
and olives. Both knop and volute are of French inspiration, and by drawing upon
different traditions Amiot created an original and distinctive work.

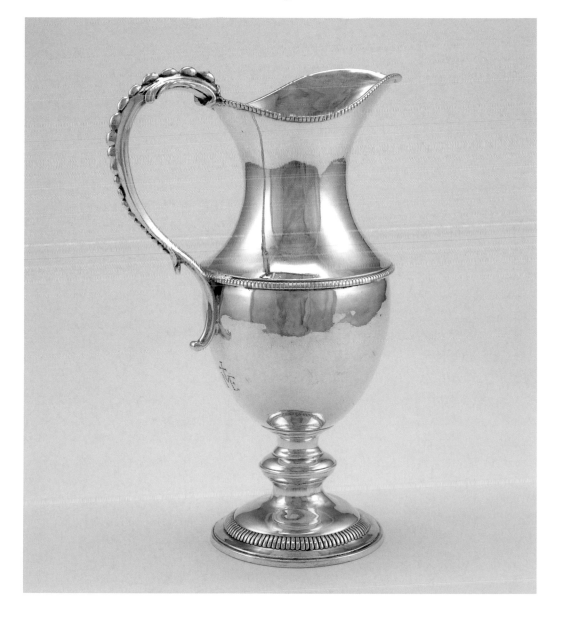

*Ewer with the Monogram of the Séminaire des
Missions Étrangères* c. 1825
Cat. 54

During approximately the same period the artist made a pap boat (cat. 20), which is the only such object bearing his mark and the first executed in Canada. The name Nault, incised on the underside with a burin, may be that of a former owner. The piece apparently also belonged at one time to Cyrille Tessier, although this has yet to be confirmed. Silver pap boats, long obsolete, were used to feed infants and invalids. They first appeared in Europe at the very end of the seventeenth century, and examples made there after 1830 are rare. Modelling his version on contemporary English pap boats, Amiot fashioned the sturdy little container from a thick sheet of metal. The flat bottom lends the piece stability, and the form of both the looped handle and the long spout are clearly designed to follow function (see cat. 20, detail). But the grace of the spout's curve and the delicate moulding bordering the opening make this simple object a work of art.

Pap Boat c. 1800–35
Cat. 20

Pap Boat (detail) c. 1800–35

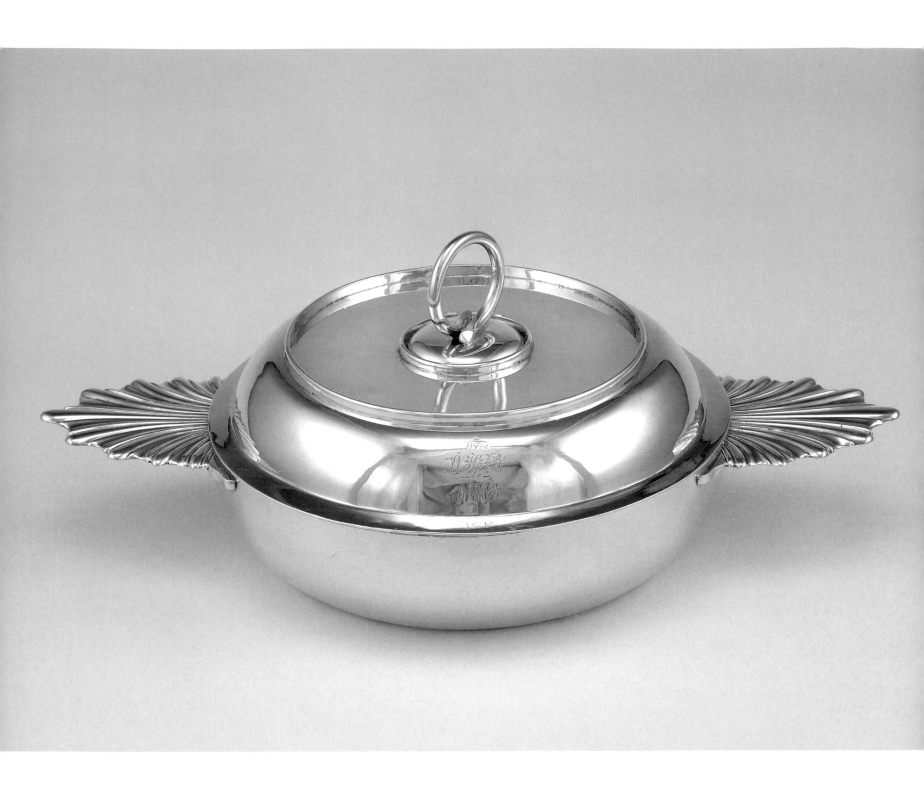

Entrée Dish of the Coffin Family c. 1825
Cat. 58

Another unique piece by Amiot is the *Entrée Dish of the Coffin Family* (cat. 58), which can be linked to a descendant of the loyalist John Coffin (possibly Margerite), who died in Quebec City in September 1808.[173] On each side of the low, circular, lidded container is a horizontal handle in the shape of a palmette. Formally, the piece resembles the ecuelles that were in wide use during the 1750–75 period. But by the start of the nineteenth century, these receptacles had fallen out of fashion, and silversmiths no longer made them. Those that had survived were likely used for something other than their original function (serving an individual portion of soup or stew). Amiot's piece is actually a variation on the theme, for the diameter of the opening is a little larger than usual, and the sides are higher. Like a number of British examples, the moulded cover has a detachable ring handle on the top. Once the handle is removed, the lid can be turned over and used as a second dish (see cat. 58, open).

Entrée Dish of the Coffin Family (open) c. 1825

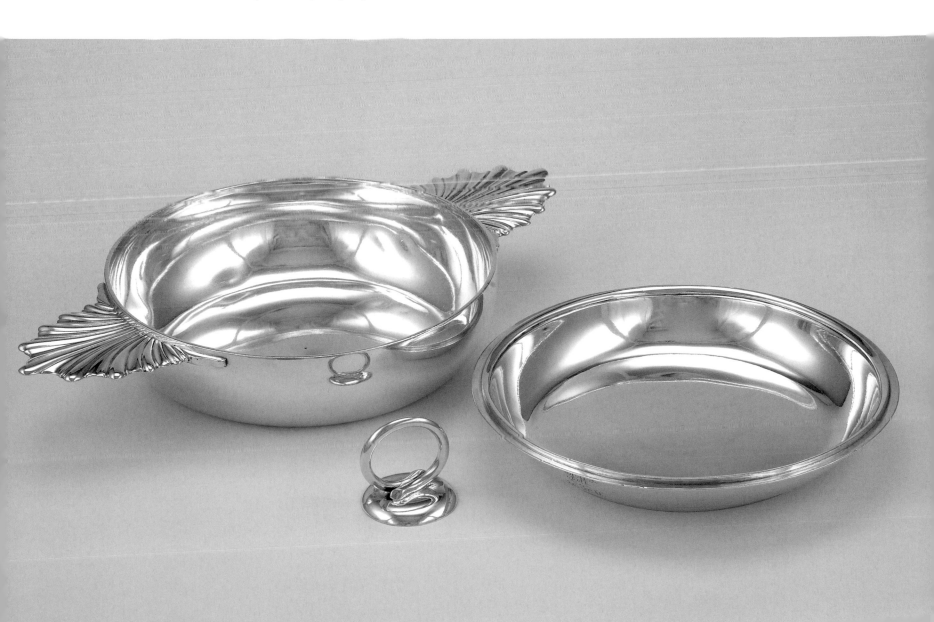

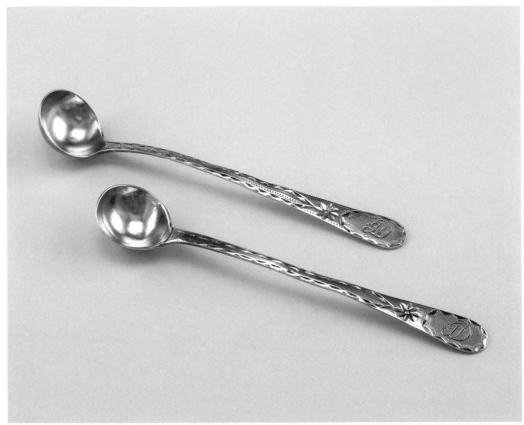

Condiment Ladles with the Monogram of Ibraïm Dufresne c. 1795
Cat. 10

Fig. 3.14
Serving Spoon from the Barons Club c. 1825

Over the years, Amiot made many sets of cutlery and individual utensils that reflected changing tastes. Some were derived from French models, but most are in the Old English or Fiddle style. While hardly an opportunity for formal inventiveness, such commissions were welcome, for they allowed the silversmith to expand his reputation and keep his workshop busy. In drawing up his inventory, Gérard Morisset noted or identified the provenance of some of Amiot's flatware, and we learn that the silversmith executed works for the families of Douaire de Bondy, Quetton de Saint-Georges, Hertel La Rocque, Andrew Stuart and Joseph Carrier.[174] To these may be added the pair of *Condiment Ladles with the Monogram of Ibraïm Dufresne* (cat. 10), the pair of *Sauce Ladles* with the monogram of Pierre Pelletier[175] (patron of the painter Antoine Plamondon), the *Serving Spoon with the Coat of Arms of Jonathan Sewell*[176] and the large *Serving Spoon from the Barons Club* (fig. 3.14). This panoply of utensils – along, no doubt, with many more that have yet to be identified – bears witness once again to Amiot's talent and the esteem in which he was held by an extensive clientele.

It was toward the end of his career that Amiot made the *Rococo Revival Coffee Pot* (fig. 3.15) that appeared at an auction in Europe in 1970, without any accompanying provenance.[177] With this piece, he opted for a formal and decorative vocabulary from the mid-eighteenth century, then undergoing a revival and characterized by sinuous, flowing lines and an extensive use of volutes. Although asymmetrical, the decoration flows coherently over the pear-shaped body, its many different textures creating very natural and lively effects. The little vignette of a rustic scene on one side adds a distinctive touch, and the large and magnificent spout lends dynamism to the piece. But Amiot seems to have had difficulty moving away from the classical idiom, for he failed to capture the essence of the rococo style: the composition of the motifs is laboured and their execution unconvincing. The fact that there have been several alterations – a decorative frieze was added near the top of the paunch at some later date, and both the handle and the finial have been replaced – serves to further weaken the piece. Nevertheless, it was Amiot who introduced the rococo revival style that would dominate Canadian silver – domestic, but also ecclesiastical (see cat. 74) – during the second half of the nineteenth century. Even as his extraordinarily productive career was drawing to a close, he continued to influence aesthetic developments in this country

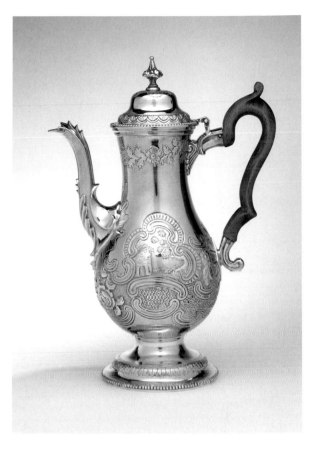

Fig. 3.15
Rococo Revival Coffee Pot c. 1835

Incense Boat of Saint-Anselme 1837

As a general silversmith, Amiot was in a position to respond to particular requests and even to anticipate client needs.[178] He executed a number of extremely rare objects – such as a shoe buckle (cat. 16) – that in Europe would have been made by a specialist. From the mid-seventeenth century to the end of the eighteenth, fashion and social practice deemed decorative buttons and shoe buckles a way of expressing personal identity. Seen as the finishing touch of an elegant outfit, shoe buckles of varying quality were common at all levels of society. All-important to the fashion conscious, they were one of the few accessories worn by both women and men. Their design reflected the styles in vogue, and some silversmiths made them a speciality.[179] The buckles could be worn with different shoes, and people often owned several pairs from which they could choose, depending on the type of event they were attending. By the end of the eighteenth century, their use was

Shoe Buckle c. 1800
Cat. 16

largely restricted to court apparel and the attire of bishops. There has been no published research concerning their prevalence in this country, but we know that they were in use during the eighteenth century: the bishop Henri-Marie Dubreil de Pontbriand owned some,[180] as did Monsieur and Madame Joseph Gaspard Chaussegros de Léry.[181] The merchant William Franckling advertised to the citizens of Quebec City that he had received some from England,[182] and François Baillairgé sold his – to Laurent Amiot![183]

Although in an earlier style, the buckle presented here was made near the end of the period when they were in vogue. The name of the commissioner is not known. Amiot seems to have been familiar with the execution of this sophisticated, jewellery-like object. Designed to be seen from a distance, it is nonetheless exquisitely made. It consists of two cast oval rings, curved to fit over the top of the shoe and mounted on a steel framework. The front surface, worked into small, faceted squares that reflect the light like cut stones, is punctuated by four rosettes. Although the details have become worn over time, and the squares now resemble pearls rather than diamonds, the effect is still most attractive.

By the mid-eighteenth century the taking of snuff had spread to all classes of society and had become a codified social ritual, popular with both men and women.[184] An essential accessory of the practice was the snuffbox – an airtight receptacle used to contain the powdered, scented tobacco, which had to be kept dry. Made in a wide range of materials, from inexpensive to highly valuable, snuffboxes were often commissioned from silversmiths, and a number of European practitioners made them a speciality.

There has been little published on the subject of snuffboxes in Canada. We know that there were fine examples to be found in this country during the eighteenth century: Monsignor Jean-Olivier Briand owned a gold snuffbox made in Paris by Jean-Charles Ducrollay,[185] and the Chaussegros de Léry family also possessed a gold one,[186] possibly from the same source. René Boileau, a gentleman of independent means from Chambly, noted in his journal on 19 March 1796 that his wife had "received the gold snuffbox made for her by Monsieur Henri Polonceau,"[187] and Abbé Pierre-Joseph Périnault bequeathed his own gold snuffbox to Monsignor Jean-Jacques Lartigue on 5 June 1821.[188] By this time Amiot had already made a good number, including the *Double Snuffbox* (cat. 11) formerly in the collection of Charles de Volpi.[189] This work, unique in the field of Canadian art, is an oblong table model whose main

*Jug with Lid Presented to Father
Charles-Joseph Asselin* (detail) c. 1833

**Jug with Lid Presented to Father
Charles-Joseph Asselin** c. 1833
Cat. 71

Another shipping incident provided Amiot with a new opportunity to exercise
his skill with the creation of the *Jug with Lid Presented to Father Charles-Joseph Asselin*
(cat. 71). Records show that the winter of 1832–33 came particularly early, for by
mid-November the Saint Lawrence was already largely choked with ice. The English
schooner *Rosalind*, under the command of Captain Boyle, which had left Quebec
City for England carrying a valuable cargo, became stuck in the ice on 27 November
at the level of Île aux Coudres. The island's inhabitants, led by their pastor, rescued
the ship's company and its cargo, and the entire crew spent the winter on the
island. The same fate befell two other ships that autumn, and their crews were
also taken in by the islanders.[209] According to the inscription engraved on the
jug's paunch, it was commissioned by the English owners and insurers of the ship
and its cargo – most likely at the instigation of the captain, since the piece was
made in Quebec City. The pear-shaped vessel is reminiscent of the beer jugs
popular in England during the eighteenth century, but it probably had no particular
function, being essentially commemorative. Drawing upon his favourite classical
vocabulary, Amiot ornamented the lower part of the body and the moulding of
the foot with relief gadrooning like that adorning the two cups. On one side of the
highly polished upper part of the paunch is a lively image of a storm-tossed ship
(see cat. 71, detail), while the other bears an inscription relating the events that
led to the work's creation. The engraver, extremely skilful, remains anonymous.
Since James Smillie Jr. had already left Quebec City, the work may possibly be that
of J. Jones. Whatever the case, Amiot was certainly the creator of the first pres-
entation jug ever made in Canada.

The End of an Era

During the spring of 1839 Amiot may have still been completing a commission received from the parish of Saint-André de Kamouraska,[210] and we know he was doing maintenance work for his own parish.[211] The end was abrupt: on 3 June, at the age of seventy-five, Amiot died suddenly of a stroke.[212] The funeral, conducted by Curé Charles-François Baillargeon, was held in the cathedral of Notre-Dame on 7 June. The mourners included Louis Fortier, Pierre Pelletier, Charles-Maxime De Foy and Antoine-Archange Parent, and Amiot's body was buried in the chapel of Sainte-Anne.[213] In front of its altar there still burns today the great lamp he had executed a decade earlier. At the end of the month, the pew Amiot had been renting for decades reverted to the parish and was immediately reassigned to a certain Édouard Dugal.[214] On Wednesday, 29 July 1840, at seven in the morning, a service commemorating the first anniversary of the silversmith's death was held in the cathedral.[215] An era was over.

By the time of the memorial, it had already been more than a year since Amiot's sons, Noël-Laurent and Stanislas – a priest and a notary, respectively – had rented their father's workshop to François Sasseville, ceding to him "the small amount of silver that may remain, along with all the ingredients and all the effects and articles used in the art of silversmithing."[216] Unfortunately, no inventory of the contents of the workshop has come to light. Sasseville published an advertisement aimed at members of the clergy, informing them that he would be "continuing the establishment previously occupied by the late Laurent Amiot."[217] The Séminaire de Québec subsequently oversaw the settling of Amiot's estate, ensuring that everything was accomplished in proper order.[218] The seminary would ultimately buy the property on côte de la Montagne in 1852,[219] by which time the city had already developed plans to widen the street.[220] All the properties on the north side were expropriated and the buildings – including Amiot's workshop – demolished to make way for this urban development project.

Sasseville, Amiot's artistic heir, worked with his nephew Pierre Lespérance,[221] the deceased master's last apprentice. Although the workshop continued to make some domestic items, as time passed it seems to have aimed its production increasingly at a religious clientele. Formally and decoratively, the objects created bore the master's stamp: Gérard Morisset actually identified the *Chalice of Cap-Santé* as being by Sasseville,[222] although we now know that it was based on the *Chalice of Bishop Joseph Signaÿ* (cat. 73).

As the nineteenth century advanced, the market changed. An expanding population resulted in the founding of new parishes and the erection of new churches, which led in turn to the emergence of firms dedicated to ecclesiastical fixtures and fittings. Before long, there were specialized concerns capable of supplying everything needed for the operation of a place of worship. Gradually, the clergy stopped commissioning vestments from embroiderers or tailors, carvings from sculptors and sacred vessels from silversmiths, since they could now order stained glass windows, ecclesiastical garments, religious vessels and other necessary equipment all from one of these specialized firms, which offered a wide range of materials, qualities and prices to match the resources of poor and wealthy parishes alike. In fact, industrialization altered the world of religious silver as it did the domestic: the process of electroplating was being refined in Europe just as Amiot's career was coming to a close. But although this and other factors would transform the trade in a fundamental and lasting way, some silversmiths still continued to practise their art.

With the expropriation of his workshop, Sasseville was obliged to open a new establishment, and in 1852 he moved to premises in the Upper Town, near the Hôtel-Dieu, situated at 18 rue du Palais.[223] When he died in 1864, Pierre Lespérance published a notice indicating that he would be taking over the enterprise.[224] Ambroise Lafrance, who had apprenticed under Sasseville, succeeded him in 1882 and continued operating the same workshop for the next twenty years. In 1905 his widow and sons moved the business a short distance to 26 rue Saint-Nicolas.[225] It was there that E. Alfred Jones met them in 1912 and purchased part of a portfolio of Amiot's drawings (cats. 26, 42–50, 63), along with a cross and a mug by one of Lafrance's sons, who would die shortly afterward of tuberculosis.[226] After this brief but all-important visit, other researchers began to show an interest in Amiot's work. At the same time, workshops and practitioners succeeded one another, and a heritage continued to be passed down. In 1898 D. Cernichiaro – possibly Cernichiara – immigrated to Quebec from Italy with his sons Blaise and François, and the census of 1901 lists them as residing in Lévis.[227] An advertisement from 1923 refers to "F. Cernichiaro & Frère," then established in Quebec City on Rue Sous-le-Fort,

Design for a Censer c. 1827
Cat. 63

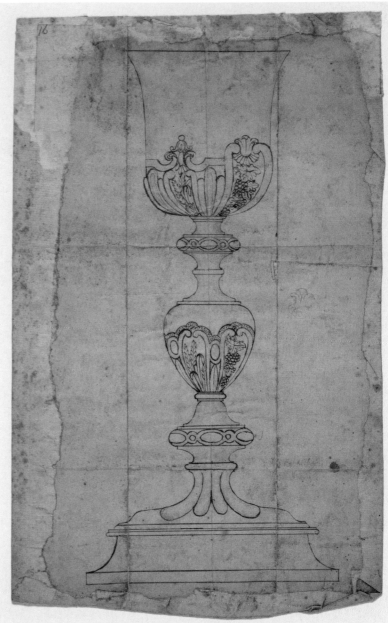

Design for a Chalice c. 1801
Cat. 21

Design for a Chalice c. 1810
Cat. 26

as a "firm founded in Canada in 1885"[228] – perhaps an attempt to enhance the business' prestige by extending its history. In any case, Gérard Morisset asserted that Cernichiaro (without giving a first name) was apprenticed to Lafrance and purchased his workshop material.[229] Finally, J. Arsène Belleville, who was already working as a silversmith around 1915,[230] acquired the old firm of F. Cernichiaro & Frère in 1923.[231] When the business went bankrupt in 1952, Rodolphe Paquette, the only silversmith then working for Belleville, purchased the stock-in-trade and moved to 26 côte de la Montagne. After Rodolphe's death, his son Adrien moved in 1972 to 31 Sault-au-matelot. Around 1960 Rodolphe Paquette had sold a few old articles belonging to the business, which are in the collection of the McCord Museum. Adrien followed suit in 1971–72, and the tools he sold to an antique dealer are now at the Musée des maîtres et artisans[232] and in various other collections. It is conceivable that some of these items were Amiot's, although his tools would likely not have survived: the objects probably vary in age, each generation of silversmiths having added and discarded tools as dictated by wear and tear.

This succession of events – unremarkable when taken in isolation, but significant when combined – occurred over the first seven decades of the twentieth century. Together, they have helped keep alive the name of Laurent Amiot and his immense contribution to the development of art in this country. The memory of this Quebec-born genius – the youngest son of a large family, full of talent, inspiration and enthusiasm, who at the end of the eighteenth century travelled to Paris in pursuit of his goal and who returned to his native land to give concrete form to a deeply held vision – endures, and still today inspires amazement, admiration and respect.

♦ ♦ ♦

NOTES

1 The vast Temple of Jerusalem was unbelievably opulent. The results of the massive reconstruction project that took place during Christ's lifetime, completed in the year 64, were immediately evident: the huge façade was plated with gold, as were the wall and door between the porch and the Holy of Holies. The latter contained the seven-branched candlestick – two talents in weight – taken to Rome by Titus following the sacking of the Temple that gave impetus to Christianity. See Joachim Jeremias, *Jerusalem in the Time of Jesus*, trans. from the German by F.H. and C.H. Cave (Philadelphia: Fortress Press, 1969), pp. 21–25.

2 Exodus 25: 23–24, 29.

3 Genesis 44: 2.

4 Jeremiah 51: 7.

5 Numbers 7: 84.

6 John 2: 1–11.

7 Luke 22: 17–18.

8 Danielle Gaborit-Chopin, "L'abbatiat de Suger 1122–1151," in *Le trésor de Saint-Denis*, exhib. cat. (Paris: Musée du Louvre / Réunion des musées nationaux, 1991), p. 123.

9 Revelation 21: 9–27.

10 Ivan Cloulas, *Jules II: le pape terrible* (Paris: Fayard, 1990), p. 157.

11 *Mandements, lettres pastorales et circulaires des évêques de Québec*, vol. 1 (Quebec City: Imprimerie générale A. Côté et Cie, 1887), p. 273.

12 For more on the *Rituel du diocèse de Québec*, see Claude La Charité, "Les deux éditions du *Rituel du diocèse de Québec* de Mgr de Saint-Vallier, datées de 1703: de l'édition janséniste à l'édition revue et corrigée par la Compagnie de Jésus," *Revue de Bibliothèque et Archives nationales du Québec*, no. 3 (2011), "Histoire du livre, de l'imprimé et de l'édition," pp. 74 –85.

13 *Mandements, lettres pastorales et circulaires des évêques de Québec*, vol. 4 (Quebec City: Imprimerie générale A. Côté et Cie, 1888), p. 109.

14 *Inventaire des œuvres d'arts (IOA)*, Laurent Amiot folder (p. 810), Fonds Ministère de la Culture et des Communications. Les grands inventaires nationaux, Bibliothèque et Archives nationales du Québec, Quebec City.

15 Register of proceedings, 1825–64, vol. 4, 13 May 1827, fol. 9 (CM27/A.1), Fabrique Notre-Dame de Québec fonds, Archives de l'Archidiocèse de Québec, Quebec City.

16 Journal of François Baillairgé, 26 February 1798 (p. 173), François Baillairgé fonds, Bibliothèque et Archives nationales du Québec, Quebec City.

17 Luc Noppen, "Le rôle de l'abbé Jérôme Demers dans l'élaboration d'une architecture néo-classique au Québec," *The Journal of Canadian Art History / Annales d'histoire de l'art canadien* 2, no. 1 (summer 1975), pp. 19–33; Luc Noppen, "L'architecture intérieure de l'église Saint-Joachim de Montmorency: l'avènement d'un style," *Revue d'art canadienne* 4, no. 1 (1979), pp. 3–16; Martin Bressani and Marc Grignon, "Une protection spéciale du ciel: le décor de l'église de Saint-Joachim et les tribulations de l'église catholique québécoise au début du XIXe siècle," *The Journal of Canadian Art History / Annales d'histoire de l'art Canadien* 29 (2008), pp. 8–47.

18 Letter from Bte Corbin to Jacques Robert, 25 February 1811 (letter O, no. 126), Archives du Séminaire de Québec, Service des collections, des archives historiques et de la bibliothèque, Musée de la civilisation, Quebec City. The Abbé owned a silver ecuelle with a lid, a beaker and a ladle. The ladle is likely the one that now belongs to the parish of Saint-Joachim.

19 Loose sheet dated 24 January 1789, inserted in account book no. 2, 1788, Archives of the fabrique Saint-Joachim de Montmorency. Abbé Corbin also paid for the decoration and gilding of the altar candlesticks.

20　The belly of the censer has a lining made of copper or tin that is filled almost to the top with fine sand. The sand supports the glowing embers, and the incense is placed on top. When the censer is swung, air passes through the openwork sections, fanning the embers and keeping them alight.

21　*Inventaire des œuvres d'arts (IOA)*, church of L'Islet-sur-Mer folder, Fonds Ministère de la Culture et des Communications. Les grands inventaires nationaux, Bibliothèque et Archives nationales du Québec, Quebec City.

22　Account book, 1756–1877, expenses for 1788 (p. 58), Archives of the fabrique de la Purification-de-la-Bienheureuse-Vierge-Marie, Repentigny. The lamp was paid "to the account of Mr la Jus," probably a chargé d'affaires. See René Villeneuve, "Orfèvrerie de l'église de la Purification-de-la-Bienheureuse-Vierge-Marie," in *Les chemins de la mémoire*, vol. 3, *Biens mobiliers du Québec* (Quebec City: Les publications du Québec, 1999), p. 238.

23　Account book, 1788, vol. 1, Archives of the fabrique de Deschaillons.

24　The cruets acquired by the parish of Saint-Antoine de Tilly, now at the National Gallery of Canada, Ottawa (24746.1-2), confirmed the popularity of the new style.

25　Account book, 1734–1819, vol. 1, 1791, fol. 54b, Archives of the fabrique Saint-Antoine de la Baie-du-Febvre.

26　The piece currently belongs to the Musée des maîtres et artisans du Québec, Montreal, which acquired it in 1969 (1969.2.14). Sometime between 1946 and 1969 it was radically altered and damaged: the knop was cut and reassembled, and the beading was removed. The base was cut at the bottom of the stem, and all the ornamentation on the top of the foot was removed and replaced by a disc of silvered metal. The Henry Birks Collection of Canadian Silver, now at the National Gallery of Canada, includes another chalice by Amiot (27884) that displays a number of stylistic and technical similarities to the one from Baie-du-Febvre. The maker's mark indicates that it dates from early in the artist's career. Its provenance is unknown.

27　A note in the acquisitions register of the Henry Birks Collection of Canadian Silver indicates that it came from the Saint-Hyacinthe region of Quebec.

28　Accounts and proceedings, 1750–1859, vol. 1, 1790, fol. 25, Archives of the fabrique Saint-Charles-de-Bellechasse. The monstrance was probably the one acquired from Schindler in 1767. See ibid., 1767, fol. 14.

29　Ibid., c. 1793, fol. 26v.

30　Q61CD, 1:114 and 1:138, 14 July 1884, 1896, Saint-Charles-de-Bellechasse fonds, Archives de l'Archidiocèse de Quebec, Quebec City.

31　The crucifix cost 319 *livres*, the parish's total expenses were 647 *livres* 4 *sols*, and its total income was 1272 *livres* 8 *sols*.

32　Journal of François Baillairgé, 23 May and 27 July 1793 (pp. 142–143), François Baillairgé fonds, Bibliothèque et Archives nationales du Québec, Quebec City.

33　In 1782–83 Baillairgé carved a large *Christ Crucified* for the parish of Montmagny that is now at the Musée national des beaux-arts du Québec, Quebec City (1934.709), and in 1785 he decorated the altar of the church of Saint-Joachim, which is still in its original state. In 1797 he executed the *Calvary* of Saint-Jean-Port-Joly, followed in 1798 by the large *Christ* for the parish of Saint-François de Montmagny, where it remains today.

34　The baptismal ewer made for Saint-Michel-d'Yamaska, dating from 1783, is now kept at the Musée national des beaux-arts du Québec, Quebec City (69.268). The one from Sault-au-Récollet, dated 1788, is at the National Gallery of Canada, Ottawa (24601).

35　Accounts and proceedings, 1714–1812, vol. 1, accounts for 1804, Archives of the fabrique Sainte-Famille de Cap-Santé.

36　Account book, 1784–1814, vol. 2, accounts for 1805, Archives of the fabrique Saint-Joachim de Montmorency.

37　Accounts and proceedings, 1775–1841, vol. 2, 1809, fol. 64v; 1837, fol. 110, Archives of the fabrique Saint-Charles-Borromée de Charlesbourg.

38　Book of receipts, expenses and other business concerning the parish of Saint-Ambroise-de-la-Jeune Lorette (begun in 1796), 1811, Archives of the fabrique Saint-Ambroise-de la-Jeune-Lorette.

39　Book of proceedings, 1787–1848, vol. 1, accounts for 1812, fol. 27, Archives of the fabrique Saint-Cuthbert. This work is part of the collection of the National Gallery of Canada, Ottawa (27739).

40　Account book, 1820, vol. 1, Archives of the fabrique Saint-Martin. This work is kept at the Musée des beaux-arts du Québec, Quebec City (70.67.01).

41　Charles Trudelle, *Paroisse de Charlesbourg* (Quebec City: Imprimerie générale A. Côté et Cie, 1887), pp. 210–213.

42　René Villeneuve, *Baroque to Neo-Classical: Sculpture in Quebec*, exhib. cat. (Ottawa: National Gallery of Canada, 1998), pp. 166–171.

43　René Villeneuve, *Le cœur du trait-carré: les églises de Charlesbourg* (Quebec City: Éditions du Pélican, 1986), pp. 41–68.

44　This ciborium is apparently the one presented to the parish by Joseph Roy. A monstrance also by Sasseville now belongs to the Detroit Institute of Arts (70.650). It was a gift from the Honourable Amable Dionne. See Book of proceedings of the parish (begun in October 1841), 22 January 1846, fols. 1-2, Saint-Denis-de-la-Bouteillerie (Kamouraska) fonds, Archives of the Côte du Sud, La Pocatière.

45 Account book no. 3, 1790–1871, accounts for 1807; six silver candlesticks for the high altar, 4848), Archives of the fabrique Saint-François de Montmagny. The current whereabouts of the candlesticks are unknown. The censer made by Amiot in 1806 still belongs to the parish.

46 This pair of altar candlesticks may have come from the church of Petite-Rivière-Saint-François. See Laurent Amiot and his works file 1/2 (B279 F19), Marius Barbeau fonds, Archives of the Canadian Museum of History, Gatineau.

47 The Musée national des beaux-arts du Québec, Quebec City, possesses a similar pair (67.192–193).

48 After 1840 its use seems to have been restricted to certain offices celebrated in the presence of the bishop. See Marcel Dubois, *Cérémonial des servants et du clergé* (Quebec City: Imprimerie Charrier et Dugal, 1952), p. 360.

49 Gérard Morisset, "L'instrument de paix," *Royal Society of Canada: Proceedings and Transactions*, third series, section 1, vol. 39 (May 1945), pp. 143–161.

50 Trudelle, *Paroisse de Charlesbourg*, pp. 140–141.

51 Account book, 1831, vol. 3, Archives of the fabrique de L'Islet-sur-Mer.

52 Book no. 19, 1938, Archives du grand Séminaire de Québec (B332 F3), Marius Barbeau fonds, Archives of the Canadian Museum of History, Gatineau.

53 Such a frieze can be seen in the Deschambault pax, on deposit at the Musée national des beaux-arts du Québec, Quebec City (DLT.1969.27).

54 Account of proceedings of the churchwardens of the parish church of Notre-Dame de Québec, 1786–1804, vol. 7 (CM2/C1.1, p. 162), Fabrique Notre-Dame de Québec fonds, Archives de l'Archidiocèse de Québec, Quebec City.

55 Partial transcription of the accounts of the parish of Sainte-Anne-de-la-Pérade (B279 F19), Marius Barbeau fonds, Archives of the Canadian Museum of History, Gatineau.

56 The Hôtel-Dieu de Québec, Quebec City, owns a pair of cope clasps by François Sasseville commissioned on the occasion of the institution's bicentenary in 1839, the year of Amiot's death.

57 The Hôtel-Dieu de Québec possesses a viaticum pyx by Amiot (2001.1318) that is quite similar to the design included in the exhibition (cat. 72).

58 Luc Noppen and René Villeneuve, *Le trésor du Grand Siècle: l'art et l'architecture du XVIIᵉ siècle à Québec*, exhib. cat. (Quebec City: Musée du Québec, 1984), pp. 112–113.

59 Bernard Pothier, "Sigogne, Jean-Mandé," in *Dictionary of Canadian Biography*, vol. 7, University of Toronto / Université Laval, 2003–, www.biographi.ca/en/bio/sigogne_jean_mande_7E.html (accessed 29 July 2013).

60 *L'Église Sainte-Marie, 1905–2005, Pointe-de-l'Église, Nouvelle-Écosse* (Yarmouth: Sentinel Printing Limited, 2005), pp. 11–15.

61 The figures appear to have been made from the same moulds, although there are variations in a few details and in the incising and engraving work. The Deschambault cross is dated 1810. See Johanne Chagnon, "Orfèvrerie de l'église Saint-Joseph de Deschambault," in *Les chemins de la mémoire*, vol. 3, *Biens mobiliers du Québec* (Quebec City: Les publications du Québec, 1999), pp. 64–66.

62 This ensemble is currently kept at the church of Sainte-Marie, where the author was able to examine it on 20 August 2013.

63 At that time, Saint-Pierre came under the control of Sainte-Anne-du-Ruisseau.

64 *Les Ursulines de Trois-Rivières: depuis leur établissement jusqu'à nos jours*, vol. 3 (Montreal: A.P. Pigeon, 1898), p. 45.

65 *Inventaire des œuvres d'arts (IOA)*, Carleton church folder, Fonds Ministère de la Culture et des Communications. Les grands inventaires nationaux, Bibliothèque et Archives nationales du Québec, Quebec City.

66 Draft, expenses, 1815–23, November 1821, Archives du Séminaire de Québec, Service des collections, des archives historiques et de la bibliothèque, Musée de la civilisation, Quebec City.

67 Don Beaubier, *Precious Metal: Historic Silver from Newfoundland Churches*, exhib. cat. (St. John's: Art Gallery of Newfoundland and Labrador, 1997), pp. 22–23.

68 Account book, 1664–1718, accounts for 1680, fol. 62, Fabrique Notre-Dame de Québec fonds, Archives de l'Archidiocèse de Québec, Quebec City.

69 Payment for a verger's mace was made by the cathedral of Notre-Dame de Québec in 1784; account book, 1768–86, vol. 6, accounts for 1784, fol. 62 (CM2/C1.1), Fabrique Notre-Dame de Québec fonds, Archives de l'Archidiocèse de Québec, Quebec City. In 1796 the parish of Rivière-Ouelle paid for the repair of a fleur-de-lys adorning its verger's mace; account book, 1796, Archives of the fabrique Notre-Dame-de-Liesse, Rivière-Ouelle.

70 G. Bernard Hughes, "The Story of English Maces," *Country Life* (8 August 1952), pp. 405–406. The verger's staff of the Holy Trinity Cathedral in Quebec City bears the marks of James Smillie.

71 Trudelle, *Paroisse de Charlesbourg*, p. 169.

72 Account book, 1718, Archives of the Monastère des Augustines de l'Hôpital général de Québec, Quebec City. Jacques Pagé, *dit* Quercy made eighteen such crosses.

73 Annals of l'Hôtel-Dieu de Québec, 4 April 1877 – 21 April 1888, vol. 3, 19 May 1881 (p. 166), Archives of the Monastère des Augustines de l'Hôtel-Dieu de Québec, Quebec City.

74 See *Trésors de ferveur: reliquaires à papier roulés des XVII^{ème}, XVIII^{ème}, XIX^{ème} siècles: actes de la journée d'étude du 24 septembre 2004* (Chalon-sur-Saône: Association trésors de ferveur, 2005), pp. 49–151.

75 Armand Gagné, "Turgeon, Pierre-Flavien," in *Dictionary of Canadian Biography*, vol. 9 (Toronto: University of Toronto / Quebec City: Université Laval, 1976), pp. 797–800.

76 James H. Lambert, "Plessis, Joseph Octave," in *Dictionary of Canadian Biography*, vol. 6 (Toronto: University of Toronto / Quebec City: Université Laval, 1987), pp. 506–599. L.O. David, *Monseigneur Plessis* (Montreal: G.E. Desbarats, 1872).

77 Luc Noppen, *Notre-Dame de Quebec: son architecture et son rayonnement (1647–1922)* (Quebec City: Éditions du Pélican, 1974), pp. 165–181.

78 Luc Noppen and Lucie K. Morisset, *La présence anglicane à Québec: Holy Trinity Cathedral* (Sillery, Quebec: Septentrion, 1995), pp. 40–128.

79 Fred C. Wurtele, "Silver Communion at Quebec," *The Gazette* (Montreal) 147, no. 305 (21 December 1918), p. 14; Michael Snodin, "J. Boileau: A Forgotten Designer of Silver," *Connoisseur* 198, no. 196 (June 1978), pp. 124–133; Arthur Grimwade, "New Light on a Canadian Treasure: The Royal Communion Service of Quebec," *Country Life* 177 (31 January 1985), pp. 268–273.

80 Léon Gromier, *Commentaire du Caeremoniale épiscoporum* (Paris: Éditions du vieux colombier, 1959), pp. 391–395. For the ceremony itself, see *Pontificale Romanum: Summorum Pontificum* (Mechliniae: Dessain, 1892), pp. 391–406.

81 The parish of Notre-Dame de Québec once possessed a set composed of a cross and eight candlesticks that appeared in various inventories drawn up between 1640 and 1775, but that is not mentioned in the one done in 1832. The parish had a new set in silvered wood made for the high altar in 1773, and a new altar was built in 1797. The old silver set probably no longer matched the new décor. The candlesticks could have been the source of the silver for the flasks. The cross may have been kept a few years longer and then finally melted down in 1827, for a cross was on the list of objects given that year to Amiot in order to execute the sanctuary lamp.

82 Former bishops of Quebec folder, vol. 1, 6 October 1685, "Ancien" fonds, Archives du Séminaire de Québec, Service des collections, des archives historiques et de la bibliothèque, Musée de la civilisation, Quebec City. My warm thanks to Monsignor Armand Gagné (C.S.S.), emeritus diocesan archivist, for having explained to me the evolution of the diocesan armorial bearings, from their origins to the present day, and for having directed me to this source.

83 Inventory of the possessions of Monsignor Briand, 1794, bishops folder, no. 99, Archives du Séminaire de Québec, Service des collections, des archives historiques et de la bibliothèque, Musée de la civilisation, Quebec City.

84 This work is now at the Musée de la civilisation, Quebec City (Collection du Séminaire de Québec, 1991.101/).

85 Henri Têtu, *Histoire du palais épiscopal de Québec* (Quebec City: Pruneau & Kirouac, 1896), p. 291; E. Alfred Jones, "Old Church Silver in Canada," *Royal Society of Canada: Proceedings and Transactions*, third series, section 2, vol. 12 (1918), p. 145; Ramsay Traquair, *The Old Silver of Quebec* (Toronto: Macmillan, 1940), p. 138.

86 This candlestick is now in the collection of the Montreal Museum of Fine Arts (980.Ds.3).

87 Inventory of 1832, box 12, no. 93, Fabrique Notre-Dame de Québec fonds, Archives de l'Archidiocèse de Québec, Quebec City.

88 This ensemble was made in Paris in 1740–41 by an unidentified silversmith. The ewer is in Montreal, in the collection of the priests of Saint-Sulpice (1976.0984), and the basin is kept at the archbishopric of Quebec.

89 Letter from Cajetan Oppizoni to Joseph Octave Plessis, 23 May 1820 (92CM, Italie, 1 14), Archives de l'Archidiocèse de Québec, Quebec City.

90 Authentication of the relic of Saint Charles Borromeo for the Séminaire de Québec, 2 November 1821, Register of ecclesiastical transcriptions, vol. II, 303vo, Archives de l'Archidiocèse de Québec, Quebec City.

91 Draft, expenses, 1815–23, November 1821, Archives du Séminaire de Québec, Service des collections, des archives historiques et de la bibliothèque, Musée de la civilisation, Quebec City. The information that the object's whereabouts are unknown comes from Vincent Giguère (email to the author, 26 January 2015).

92 Authentication of the relic of Saint Charles Borromeo, 15 April 1823, Register of ecclesiastical transcriptions, vol. I, fol. 38vo, Fabrique Saint-Charles-Borromée de Charlesbourg fonds, Archives de l'Archidiocèse de Québec, Quebec City.

93 Trudelle, *Paroisse de Charlesbourg*, pp. 189–190.

94 Ibid., p. 149. The parish also boasted another type of relic, owned since the seventeenth century: a letter bearing the signature of Saint Charles Borromeo.

95 Authentication of the relic of Saint-Charles-sur-Rivière-Boyer, 11 June 1823, Register of ecclesiastical transcriptions, vol. I, fol. 44, Archives de l'Archidiocèse de Québec, Quebec City.

96 Saint-Charles-de-Bellechasse, 61CD 1:114 (14 July 1884); 1:138 (1896), Archives de l'Archidiocèse de Québec, Quebec City.

97 Inventory of 1832, p. 5, file 12, no. 93, Fabrique Notre-Dame de Québec fonds, Archives de l'Archidiocèse de Québec, Quebec City.

98 List of items given to the parish of Saint-Roch de Québec by Monsignor Plessis, 13 October 1829, miscellaneous documents, Archives of the fabrique Saint-Roch de Québec, Quebec City.

99 Nive Voisine, "Panet, Bernard-Claude," in *Dictionary of Canadian Biography*, vol. 6, University of Toronto / Université Laval, 2003–, www.biographi.ca/en/bio/panet_bernard_claude_6E.html (accessed 26 June 2015).

100 Paul-Henri Hudon, *Rivière-Ouelle de la Bouteillerie: 3 siècles de vie* (Rivière-Ouelle: Comité du tricentenaire, 1972), pp. 213–229.

101 *Inventaire des œuvres d'arts (IOA)*, Rivière-Ouelle church folder, Fonds Ministère de la Culture et des Communications. Les grands inventaires nationaux, Bibliothèque et Archives nationales du Québec, Quebec City. See also, René Villeneuve, "Orfèvrerie ancienne," in *Le Musée du Québec: 500 œuvres choisies* (Quebec City: Musée du Québec, 1983), pp. 310–311.

102 René Villeneuve, "Orfèvrerie de l'église Notre-Dame-de-Bonsecours," in *Les chemins de la mémoire*, vol. 3, *Biens mobiliers du Québec* (Quebec City: Les publications du Québec, 1999), pp. 105–108; René Villeneuve, "François Ranvoyzé, Silversmith: Patronage from the Church at L'Islet-sur-mer," *Journal of the Silver Society of Canada* 11 (2008), pp. 22–32.

103 Register of proceedings, 1775–1825, vol. 3 (CM2/A1, p. 392), Fabrique Notre-Dame de Québec fonds, Archives de l'Archidiocèse de Québec, Quebec City.

104 Ibid. (p. 443). See also, register of accounts submitted by the churchwardens of the parish Church of Notre-Dame de Québec, 1803–29, vol. 8 (CM2/C1.1, p. 385).

105 Register of proceedings, 1825–64, vol. 4, fol. 21v (CM27/A.1), Fabrique Notre-Dame de Québec fonds, Archives de l'Archidiocèse de Québec, Quebec City. See also, account book, 1823–54, vol. 9, accounts for 1832 (CM2/C1.1, n.p.)

106 Register of proceedings, 1825–64, vol. 4, fol. 9–9v (CM27/A.1), Fabrique Notre-Dame de Québec fonds, Archives de l'Archidiocèse de Québec, Quebec City.

107 Noppen, *Notre-Dame de Québec*, p. 180.

108 Book of notices, 1822–27, vol. 14 (Ms 82), and Book of notices, 1827–32, vol. 15 (Ms 83), Fabrique Notre-Dame de Québec fonds, Archives de l'Archidiocèse de Québec, Quebec City. A review of the work undertaken appears at the beginning of each book.

109 Establishment of a fund for the maintenance of a lamp in Notre-Dame de Québec by Monsieur de la Chesnaye, 14 November 1671, box 12, no. 7, Fabrique Notre-Dame de Québec fonds, Archives de l'Archidiocèse de Québec, Quebec City.

110 General inventory of the furnishings, vestments and linen of the parish church of Notre-Dame de Québec, 1675, box 12, no. 84, Fabrique Notre-Dame de Québec fonds, Archives de l'Archidiocèse de Québec, Quebec City. It was likely in 1674 that Charles Aubert de la Chesnaye donated two other silver sanctuary lamps, the first to Notre-Dame de Foy and the second to Notre-Dame de Lorette. The latter is still kept at Wendake. See Pierre-Joseph-Marie Chaumonot, *Notre-Dame de Lorette et le père Chaumonot/choix des textes, Gilles Drolet* (Sainte-Foy: Anne Sigier, 1985), p. 107.

111 Return of the items sent to Trois-Rivières before the siege of 1759, box 12, nos. 89 and 89a, Fabrique Notre-Dame de Québec fonds, Archives de l'Archidiocèse de Québec, Quebec City.

112 Inventory of 1766, box 12, no. 87, Fabrique Notre-Dame de Québec fonds, Archives de l'Archidiocèse de Québec, Quebec City.

113 Inventory of 1771, box 12, no. 91, and inventory of 1775, box 12, no. 92, Fabrique Notre-Dame de Québec fonds, Archives de l'Archidiocèse de Québec, Quebec City.

114 Box 11, no. 317c, Fabrique Notre-Dame de Québec fonds, Archives de l'Archidiocèse de Québec, Quebec City.

115 F. Cernichiaro & Frère was apparently the firm generally employed by the parish council during this period. During the drawing up of an inventory in 1917, it was they who examined all the silverware belonging to the cathedral (inventory of the basilica of Notre-Dame de Québec and the church of the Lower Town, vol. 2, 1917 [CM2/C2.11], Fabrique Notre-Dame fonds, Archives de l'Archidiocèse de Québec, Quebec City). An advertisement for the firm also appears in Amédée Edmond Gosselin's *Album souvenir de la basilique Notre-Dame de Québec*, published in 1923 (p. 62).

116 Parish accounts, 1826–1940, accounts for 1834, Archives of the fabrique Saint-Pierre et Saint-Paul de la Baie Saint-Paul.

117 Meetings of the parishes, etc., Bécancour, elections of churchwardens, vol. 3, 1836, fol. 20v, Archives of the fabrique de la Nativité de la Bienheureuse Vierge Marie.

118 Account book, 1830–42, vol. 1, accounts for 1837, Archives of the fabrique Saint-Anselme.

119 Codicil (dated 18 May 1838) to the will of Monsignor Joseph Signaÿ, 13 March 1835, minute book of notary Antoine-Archange Parent (minute no. 7515), Bibliothèque et Archives nationales du Québec, Quebec City.

120 Will of Monsignor Joseph Signaÿ, 14 December 1841, minute book of notary Antoine-Archange Parent (minute no. 8930); will of Monsignor Joseph Signaÿ, 10 December 1849, minute book of notary Antoine-Ambroise Parent (minute no. 2143), Bibliothèque et Archives nationales du Québec, Quebec City.

121 This work is now in the collection of the Musée national des beaux-arts du Québec, Quebec City (73.31.0[2]).

122 Elections of churchwardens, parish meetings, etc., Bécancour, 1833–52, vol. 3, 1842, fol. 30v, Archives of the fabrique de la Nativité de la Bienheureuse Vierge Marie.

123 Gérard Morisset, *Le Cap-Santé: ses églises et son trésor* (revised and annotated edition) (Montreal: The Montreal Museum of Fine Arts, 1980), notes by Robert Derome, pp. 167–168.

124 Gérard Morisset, "Un chef-d'œuvre de François Sasseville," *Technique* (October 1942), pp. 526–539.

125 René Villeneuve, *Quebec Silver from the Collection of the National Gallery of Canada*, exhib. cat. (Ottawa: National Gallery of Canada, 1998), pp. 18–19.

126 Seminary folder, 75, 13 August 1846, Archives du Séminaire de Québec, Service des collections, des archives historiques et de la bibliothèque, Musée de la civilisation, Quebec City.

127 Account book, 1791–1866, accounts for 11 July 1838 and accounts for 1839, Archives of the fabrique Saint André de Kamouraska.

128 The account books of the parish of Saint-Étienne de La Malbaie were destroyed in a fire. Fortunately, Marius Barbeau had consulted them in 1924. See Marius Barbeau fonds (B319 F14), Archives of the Canadian Museum of History, Gatineau.

129 During his visit to Quebec City in 1912, E. Alfred Jones dated the piece to c. 1837. See notebook of E. Alfred Jones, 1912, box 15, file 13, John E. Langdon fonds, Thomas Fisher Rare Book Library, University of Toronto. Efforts to gain access to the archives of the Anglican diocese of Quebec City have gone unacknowledged.

130 Arthur Grimwade, "New Light on a Canadian Treasure," p. 268.

131 James Gilchrist, *Anglican Church Plate* (London: The Connoisseur & Michael Joseph, 1967, A Connoisseur Monograph series), pp. 59–88.

132 Philippe Aubert de Gaspé, *Les anciens Canadiens* (Montreal: Fides, 1970 [1864], Bibliothèque canadienne-française series), p. 76; this English quotation is taken from Philippe Aubert de Gaspé, *Canadians of Old*, trans. Charles G.D. Roberts (New York: D. Appleton and Company, 1890), pp. 76–77.

133 Will of Monsignor Joseph Signaÿ, 10 December 1849, minute book of notary Antoine-Ambroise Parent (minute no. 2143), Bibliothèque et Archives nationales du Québec, Quebec City.

134 *Collections of the Late Joseph H. Bauer, Esquire*, catalogue of the sale held from 15 to 17 June 1965 (Toronto: Gardner Auctions Limited, 1965).

135 The small jug in the collection of the Musée des beaux-arts du Québec (60.76), Quebec City, contemporary with these two vessels, is a simplified and miniaturized version of them. It also once belonged to Cyrille Tessier.

136 Journal of François Baillairgé, 25 May 1792 (p. 133), François Baillairgé fonds, Bibliothèque et Archives nationales du Québec, Quebec City.

137 Ibid., 14 January 1794 (p. 146).

138 Céline Cyr, "Hertel de Rouville, Jean-Baptiste Melchior," in *Dictionary of Canadian Biography*, vol. 5 (Toronto: University of Toronto / Quebec City: Université Laval, 1983), pp. 421–422.

139 Pierre Tousignant and Madeleine Dionne-Tousignant, "Hertel de Rouville, René-Ovide," in *Dictionary of Canadian Biography*, vol. 4, University of Toronto / Université Laval, 2003–, www.biographi. ca/en/bio/hertel_de_rouville_rene_ovide_4E.html (accessed 12 February 2016).

140 John Russell Harper, "La Galerie de portraits de la Famille Hertel de Rouville," *Vie des arts* 12, no. 47 (summer 1967), pp. 16–22.

141 Mary Macaulay Allodi, Peter N. Moogk and Beate Stock, *Berczy*, exhib. cat. (Ottawa: National Gallery of Canada, 1991), pp. 230–232.

142 *Exhibition of Canadian Handicrafts*, 1905, exhib. cat. (Montreal: Montreal Branch of the Woman's Art Association, 1905), no. 702, p. 25. See also, Valerie E. Kirkman and Hervé Gagnon, *Louis-François-George Baby: un bourgeois canadien-français du 19e siècle (1832–1906)* (Sherbrooke: GGC Éditions, 2001), p. 89; and René Villeneuve, "La terrine du seigneur de Rouville," *Ornamentum* 34, nos. 1–2 (spring/summer 2017), pp. 27–31.

143 Discussed and illustrated by virtually every historian of Quebec silver, the tureen was also singled out by Michael Clayton in his famous book *The Collector's Dictionary of the Silver and Gold of Great Britain and North America* (New York and Cleveland: The World Publishing Company, 1971), p. 267. In 1968 the Campbell Soup Company was looking to acquire a work for their collection of tureens – now in the collection of the Witherthur Museum, Garden and Library, Wilmington, DE. Letter from John E. Langdon to Helen I. Drummond, 22 August 1968; Letter from Helen I. Drummond to John E. Langdon, 28 August 1968; Letter from John E. Langdon to Helen I. Drummond, 3 September 1968, Henry Birks Collection of Canadian Silver fonds, National Gallery of Canada Library and Archives, Ottawa.

144 Journal of François Baillairgé, 12 October 1793 (p. 160), François Baillairgé fonds, Bibliothèque et Archives nationales du Québec, Quebec City.

145 David Y. Hodgson, loan file, 1959 (A1549), Archives of the Montreal Museum of Fine Arts.

146 Jean Trudel, *Silver in New France*, exhib. cat. (Ottawa: National Gallery of Canada, 1974), illus. pp. 226–227. The cover is by Robert Cruickshank.

147 Pierre-Georges Roy, "L'ameublement d'un seigneur canadien sous l'Ancien Régime," in *Rapport de l'archiviste de la province de Québec pour 1921–1922* (Quebec City: Louis-Amable Proulx, 1922), p. 242.

148 Monsieur Hocquart concerning the sale of the effects of M. Dupuy, former intendant, detailed inventory of the sale of his effects, October 1731, vol. 55 (MG1, C11A, pp. 46–139), fols. 105–158, French Colonial Archives, Library and Archives Canada, Ottawa.

149 List of silverware with the prices paid and the years of acquisition, 1795 (P386, D959), p. 4, Famille Chaussegros de Léry fonds, Bibliothèque et Archives nationales du Québec, Quebec City.

150 Inventory of the property owned jointly by the late Jacques Duperron Bâby and Suzanne Réaume, his widow, 8 November 1800, minute book of notary Joseph Bernard Planté (minute no. 2508), p. 6, Bibliothèque et Archives nationales du Québec, Quebec City.

151 See, for example, W.A. Seaby and R.J. Hetherington, "The Matthew Boulton Pattern Books," parts 1 and 2, *Apollo* 51 (February and March 1950), pp. 48–50 and 78–80; Michael Snodin, "Matthew Boulton's Sheffield Plate Catalogues," *Apollo* 126 (July 1967), pp. 25–32.

152 Journal of François Baillairgé, 30 May, 3 June and 15 December 1796 (pp. 164 and 167), François Baillairgé fonds, Bibliothèque et Archives nationales du Québec, Quebec City. To gain an idea of the importance of the collaboration between sculptor and silversmith, see Ubaldo Vitali, "Retooling for the Rococo: Assembling the Complex Network of Talents, Skill and Language to Express the New Style," in Ellenor M. Alcorn, ed., *Rococo Silver in England and Its Colonies: Papers from a Symposium at Virginia Museum of Fine Arts, Richmond 2004* (London: The Silver Society, 2006, Silver Studies series, no. 20), pp. 72–85.

153 Peter Kaellgren, "English Silver Baskets," *Antiques* (June 2000), pp. 940–947.

154 René Villeneuve, "A Scottish-born Silversmith in Montreal: Robert Cruickshank," in Peter E. Rider and Heather McNabb, *A Kingdom of the Mind: How the Scots Helped Make Canada* (Montreal and Kingston: McGill-Queen's University Press, 2006), pp. 142–143.

155 The only two other known examples made in Canada, both different in shape, were made by Michael Arnoldi.

156 Pierre-Georges Roy, *La famille Chaussegros de Léry* (Lévis: s.n., 1934).

157 List of silverware with the prices paid and the years of acquisition, 1795 (P386, D959); and Inventory of the estates of the late Monsieur and Madame Joseph Gaspard Chaussegros de Léry, 19 February 1798 (p. 15), minute book of notary Joseph Bernard Planté (minute no. 1665); both in the Famille Chaussegros de Léry fonds, Bibliothèque et Archives nationales du Québec, Quebec City. François Ranvoyzé evaluated the collection on 21 February 1798.

158 Villeneuve, *Quebec Silver*, p. 25.

159 List of silverware with the prices paid and the years of acquisition, 1795 (P386, D959), p. 6), Famille Chaussegros de Léry fonds, Bibliothèque et Archives nationales du Québec, Quebec City.

160 Roch Legault, "Chaussegros de Léry, Louis-René," in *Dictionary of Canadian Biography*, vol. 6 (Toronto: University of Toronto / Quebec City: Université Laval, 1987), pp. 133–134.

161 The armorial bearings included in the ex libris of Joseph Gaspard Chaussegros de Léry are more complex, as witness an example in the Fauteux collection at the Montreal centre of Bibliothèque et Archives nationales du Québec, Quebec City.

162 These works are now in the collection of the Musée national des beaux-arts du Québec, Quebec City (2003.312-313).

163 Journal of François Baillairgé, 24 October 1791 (p. 10); 24 May 1794 (p. 149); 18 February 1795 (p. 155); 16 April 1796 (p. 163); 31 March 1798 (p. 173); 15 April 1799 (p. 178); François Baillairgé fonds, Bibliothèque et Archives nationales du Québec, Quebec City.

164 Waddington's, Toronto, *Decorative Arts & Design Auction*, 12 December 2012, lot 69. This spoon is now in a private collection in Montreal.

165 Diana Edwards, *Black Basalt: Wedgwood and Contemporary Manufacturers* (Woodbridge, Suffolk: Antique Collectors Club, 1994), pp. 56–59, 125–127, 139, 148 and 206.

166 René Villeneuve, "Art Speak: Neoclassicism," *Vernissage* 6, no. 1 (winter 2004), p. 27.

167 *Inventaire des œuvres d'arts (IOA)*, Laurent Amiot file, Fonds Ministère de la Culture et des Communications. Les grands inventaires nationaux, Bibliothèque et Archives nationales du Québec, Quebec City, referencing Miscellaneous receipts, Amiot file, Neilson fonds, Archives de l'Université de Montréal. John Neilson purchased a wedding ring from Amiot in 1802 and a silver snuffbox in 1820. In 1822 Neilson's son Samuel commissioned the silversmith to make a gold key and a ring. The transcription of these documents was undertaken in 1939, but we have not been able to locate the originals.

168 Elizabeth Collard, *Nineteenth-Century Pottery and Porcelain in Canada*, 2nd. ed. (Kingston and Montreal: McGill-Queen's University Press, 1984), p. XVI.

169 Villeneuve, *Quebec Silver*, p. 66.

170 Henry A. Crosby Forbes, *Chinese Export Silver, 1785 to 1885* (Milton, Mass.: Museum of the American China Trade), 1975, p. 178, fig. 87.

171 The first published photograph of this piece intimates that it is part of a set, but this is not the case. See John E. Langdon, *Canadian Silversmiths, 1700–1900* (Toronto: Stinehour Press, 1966), plate 51.

172 The ewer was used during religious services with a French tray bearing the coat of arms of Monsignor de Pontbriand, also kept at the archbishopric of Quebec. The ewer that originally accompanied the tray is now in Montreal, in the collection of the priests of Saint-Sulpice (1976.0984), and was probably part of the bishop's accessories, along with his crozier, which is also in Montreal (1976.0616).

173 E. Alfred Jones, *The Loyalists of Massachusetts: Their Memorials, Petitions and Claims* (London: The Saint Catherine Press, 1930), p. 94; Pierre-Georges Roy, "La famille Coffin," *Bulletin des recherches historiques* 40, no. 4 (April 1934), pp. 229–232, Marie-Paule R. LaBrèque, "Coffin, John," in *Dictionary of Canadian Biography*, vol. 5, University of Toronto / Université Laval, 2003–, www.biographi.ca/en/bio/coffin_john_1729_1808_5E.html (accessed 15 September 2014).

174 Inventaire des œuvres d'art, Laurent Amiot folder, Fonds Ministère de la Culture et des Communications. Les grands inventaires nationaux, Bibliothèque et Archives nationales du Québec, Quebec City.

175 Kept at the Musée national des beaux-arts du Québec, Quebec City (60.77–78).

176 This piece is in a private collection.

177 Sotheby's, New Bond Street, *Catalogue of Fine English and Foreign Silver and Plate*, London, 2 July 1970, lot 156.

178 Shena Mason, ed., *Matthew Boulton. Selling What All the World Desires* (New Haven and London: Yale University Press, 2009).

179 Clive Taylor, "George Smith of Huggin Lane: A Georgian Silver Bucklemaker," *Silver Studies: The Journal of the Silver Society*, no. 26 (2010), pp. 60–68.

180 "Testament et inventaire des biens (1760) de Mgr de Pontbriand, dernier évêque de Québec sous le régime français," in *Rapport de l'archiviste de la province de Québec* (Quebec City: Redempti Paradis, 1959), p. 367.

181 Inventory of the estate of the late Monsieur and Madame Joseph Gaspard Chaussegros de Léry, 19 February 1798, minute book of notary Joseph Bernard Planté (minute no. 1665, p. 15), Famille Chaussegros de Léry fonds, Bibliothèque et Archives nationales du Québec, Quebec City.

182 *La Gazette de Québec*, no. 837 (20 September 1781), p. 3.

183 Journal of François Baillairgé, 21 June 1792 (p. 132), François Baillairgé fonds, Bibliothèque et Archives nationales du Québec, Quebec City.

184 Clare Le Corbeiller, *European and American Snuff Boxes, 1730–1830* (New York: Viking Press, 1966), p. 13.

185 It is now in the collection of the archbishopric of Quebec.

186 Inventory of the estate of the late Monsieur and Madame Joseph Gaspard Chaussegros de Léry, 19 February 1798, minute book of notary Joseph Bernard Planté (minute no. 1665, p. 15), Famille Chaussegros de Léry fonds, Bibliothèque et Archives nationales du Québec, Quebec City.

187 Quoted in Gustave Drolet, *Zouaviana*, 2nd edition (Montreal: Eusèbe Sénécal & Cie, imprimeurs-éditeurs, 1898), p. 560.

188 E.Z. Massicotte, "Les tabatières de nos grands-parents," *Bulletin des recherches historiques* 49, no. 7 (January 1943), p. 11.

189 *The Charles de Volpi Collection of Canadian Silver*, catalogue of the sale held 18 May 1979, Phillips Ward-Price Limited, Toronto, p. 39, no. 180.

190 *Inventaire des œuvres d'arts (IOA)*, Laurent Amiot file, Fonds Ministère de la Culture et des Communications. Les grands inventaires nationaux, Bibliothèque et Archives nationales du Québec, Quebec City, referencing Miscellaneous receipts, Amiot file, Neilson fonds, Archives de l'Université de Montréal. The transcription of these documents was undertaken in 1939, but we have not been able to locate the originals.

191 This is the case with two chalices by unidentified Paris silversmiths, dating from 1700–01 and belonging to the parishes of Neuville and L'Islet-sur-Mer, whose cups were recast by Amiot.

192 Dated 1806, it is kept at the McCord Museum, Montreal (M2005.133.1).

193 An inscription under the foot reads "Root W. Smillie Engraver, g large, January 1st 1827, 1827 Quebec Lower Canada." For more on James William Cumming Smillie, see Mary Macaulay Allodi and Rosemarie L. Tovell, *An Engraver's Pilgrimage: James Smillie in Quebec, 1821–1830*, exhib. cat. (Toronto: Royal Ontario Museum, 1989), pp. 19 and 21.

194 *La Gazette de Québec* (14 May 1827), p. 1; Eileen Reid Marcil, *The Charley-Man: A History of Wooden Shipbuilding at Quebec, 1763–1893* (Kingston: Quarry Press, 1995), pp. 346, 351 and 357.

195 Marjory Whitelaw, *The Dalhousie Journals* 3 (Ottawa: Oberon Press, 1982), pp. 100–101 (15 May 1827).

196 *La Gazette de Québec* 4, no. 32 (17 May 1827), pp. 3 and 6.

197 Personal account book of Lord Dalhousie, 1825–28, 15 May 1827 (GD45-3-577), Dalhousie fonds, National Archives of Scotland, Edinburgh. He paid thirty pounds for the cup.

198 René Villeneuve, "John Bridge, for Rundell, Bridge & Rundell: Drummond Cup, 1830–1831," in *Hidden Treasures from the Bytown Museum* (Ottawa: Bytown Museum, 2011), pp. 28–31.

199 Villeneuve, *Quebec Silver*, pp. 66–68.

200 Sylvia Lassam, "The Strachan Epergne," *Journal of the Silver Society of Canada* 15 (2012), pp. 32–38.

201 Some years earlier, François Baillairgé had supplied Michel Forton with a number of models for crests, but by 1827 François was elderly, and the commission may have been executed by his son Thomas. See Journal of François Baillairgé, November–December 1798 (p. 177); July–August–September 1799 (p. 180); November 1799 (p. 181); and November 1800 (p. 183); François Baillairgé fonds, Bibliothèque et Archives nationales du Québec, Quebec City.

202 René Villeneuve, "La licorne argentée de Laurent Amiot," *Vernissage* 3, no. 1 (winter 2001), pp. 34–35.

203 René Villeneuve, *Lord Dalhousie: Patron and Collector*, exhib. cat. (Ottawa: National Gallery of Ottawa, 2008).

204 Eileen Reid Marcil, *Tall Ships and Tankers: The History of the Davie Shipbuilders* (Toronto: McClelland & Stewart, 1997), pp. 19–25.

205 *La Gazette de Québec*, no. 4806 (21 March 1832), p. 2.

206 Ibid., no. 4805 (19 March 1832), p. 2.

207 Ibid., no. 4815 (9 April 1832), p. 3.

208 *The Gazette* (Montreal) 42, no. 103 (4 September 1834), p. 2.

209 H.R. Casgrain, *Une excursion à l'Île aux Coudres* (Montreal: Librairie Beauchemin limitée, 1885), pp. 62–63; Edgar Morin, "Il y a 120 ans, trois navires s'échouent au même endroit," *Le Petit Journal* (8 March 1953), p. 5. It is worth noting that the *Rosalind* is slated to be repaired at the shipyard founded by George Taylor. See Eileen Reid Marcil, *L'héritage d'Elizabeth Davie* (Quebec City: Les Éditions GID, 2017), p. 27.

210 The sanctuary lamp and monstrance bearing his mark were paid for in 1839. Register of accounts, 1791–1866, 1839, Archives of the fabrique Saint-André de Kamouraska.

211 Account book, 1823–54, vol. 9, accounts for 1839 (CM2/C1.1, n.p.), expenses for the parish church, 8 July 1839, "paid to the Amiot estate L 3-5-0," Fabrique Notre-Dame de Québec fonds, Archives de l'Archidiocèse de Québec, Quebec City.

212 *La Gazette de Québec*, no. 5403 (6 June 1839), p. 2; *The Quebec Mercury* 35, no. 66 (4 June 1839), p. 3.

213 Register of births, marriages and deaths, 1839, vol. 58, S.109 (CM1/A1.1), Fabrique Notre-Dame de Québec fonds, Archives de l'Archidiocèse de Québec, Quebec City.

214 Pew assignment book for the church of Notre-Dame, 28 December 1817 – 26 December 1859, vol. 3, 30 June 1839 (CN2/D1.1, n.p.), Fabrique Notre-Dame de Québec fonds, Archives de l'Archidiocèse de Québec, Quebec City.

215 Book of notices, 1832–43, vol. 16, 26 July 1840 (CM1/C2.1, p. 451), Fabrique Notre-Dame de Québec fonds, Archives de l'Archidiocèse de Québec, Quebec City.

216 Noël Laurent Amiot, priest, to Frs Sasseville, 2 July 1839, minute book of notary Antoine-Archange Parent (minute no. 8479), Bibliothèque et Archives nationales du Québec, Quebec City.

217 *Le Canadien* 9, no. 30 (29 July 1839), p. 2.

218 *Polygraphy* 23, nos. 38, a, b and c (n.d., 1849, 1850, 1851); *Polygraphy* 30, no. 14 (1854?), Archives du Séminaire de Québec, Service des collections, des archives historiques et de la bibliothèque, Musée de la civilisation, Quebec City.

219 Minute book, 8 November 1852 (MS-13.2), Archives du Séminaire de Québec, Service des collections, des archives historiques et de la bibliothèque, Musée de la civilisation, Quebec City.

220 Joseph Hamel, *Plan of the Widening of Mountain Hill*, 2 September 1851 (DO1278/DO1279), Archives de la ville de Québec.

221 *Le Journal de Québec* (26 October 1850), p. 2.

222 Morisset, "Un chef-d'œuvre de François Sasseville," pp. 526–539.

223 *Le Journal de Québec* (14 June 1853), p. 3.

224 Ibid. (17 March 1864), p. 3.

225 René Villeneuve, "Lafrance, Ambroise," in *Dictionary of Canadian Biography*, vol. 13 (Toronto: University of Toronto / Quebec City: Université Laval, 1994), pp. 563–564.

226 Jones, "Old Church Silver in Canada," p. 150.

227 Federal census of 1901, district of Lévis / town of Lévis sub-district (district 164) C11, p. 4, line 16, Library and Archives Canada, Ottawa.

228 *Album souvenir de la Basilique Notre-Dame de Québec* (Quebec City: s.n., 1923), p. 62.

229 Gérard Morisset, *Évolution d'une pièce d'argenterie* (Quebec City: Collection Champlain, 1943), pp. 26–27.

230 Gérard Morisset, "Les églises de Kamouraska," in Alexandre Paradis, *Kamouraska 1674–1948* (Quebec City: s.n., 1948), p. 341.

231 Specimens: instruments, stamps, marks, silversmithing file (B278 F10: CD220-0997-B278-10.1.1 and CD2003-0997-B278-10.1.2), Marius Barbeau fonds, Archives of the Canadian Museum of History, Gatineau. The file contains an undated inventory of tools drawn up by Marius Barbeau.

232 Nicole Vallières, "Les outils et les techniques des orfèvres au Québec: période pré-industrielle," master's thesis, Université du Québec à Montréal, 1985, pp. 198–199.

MAKER'S MARKS OF LAURENT AMIOT

Over the course of a fifty-two-year career, Laurent Amiot identified his works using five different maker's marks whose affiliation is confirmed by their appearance on documented pieces. A sixth may now be added to this list, with the qualification that it has been observed on works whose provenance is not firmly documented but whose context of creation strongly suggests that they are by Amiot.

The marks struck on items of silver made in this country at that time generally indicate the identity of the silversmith who executed them, but this is not always the case. In England, every item of silver has been required to bear a mark since 1363, and since 1739 an Act of Parliament has stipulated that this mark include the initials of the maker's first and family names.

Between about 1790 and 1840, this maker's – or "master's" – mark was in fact that of the person who presented the item to the guild in order to ensure that its precious metal content met the traditional standard for sterling silver (an alloy consisting of 92.5 percent silver and 7.5 percent copper). In the late eighteenth century, this individual was often the head of a large workshop or a retailer rather than the person who had actually made the piece, and the notion of the "sponsor's mark" accordingly developed. In the Canada of Amiot's time there was no official control over items of precious metal, nor any legal requirement that they bear a mark. Nevertheless, most silversmiths used a mark consisting of their initials and seem to have obeyed the spirit of the laws governing the purity of metal in England. As there, the mark applied in this country identified the master of the workshop. In Amiot's case, the presence of his mark indicates that the work was designed and in all likelihood largely made by him, but that an assistant or collaborator may have played a part in the execution process, under the master's direction, or in strict accordance with the standards he had established, and subject to his final approval.

Like most of the silversmiths working in Canada at the time, Amiot followed the English tradition of marking all the completed items released by his workshop. Over the years, the marks he used changed, and although the different marks seem to be linked to distinct chronological periods, there are exceptions. It must also be noted that Ambroise Lafrance, one of Amiot's successors, used one of the master's marks throughout his career, but always accompanied by a second – a profile head within an oval – and sometimes a third reading "Quebec." This has led to confusion among some scholars. To follow is a detailed description of the various marks employed by Amiot, along with a number of observations. This information is not definitive and may well be modified as research progresses.

MARK A (1788) / cat. 1

L, a pellet, A, within an irregular isosceles trapezium. The crossbar linking the two legs of the A is shaped like a small V. This mark has been observed on four works executed for three commissions for religious objects, all completed in 1788, which is the first year to which documented works can be dated.

MARK B (1793–1806; c. 1814) / cat. 6

L, a pellet, A, within a rectangle. The crossbar linking the two legs of the A is straight, and the rectangle is regular. This mark appears numerous times between 1793 and 1806, although this does not preclude it having been used both earlier and later. It appears on works possibly executed around 1814, but this seems to be exceptional.

MARK C (c. 1790–1810) / cat. 10

L, a pellet, A, within a rectangle. This mark is very similar to mark B, but smaller. It appears on the back of items of flatware that, for stylistic reasons, can be dated to the period from 1790 to 1810. It seems to have been contemporary with mark B, used for smaller items of similar quality. Although none of the works examined possesses an ironclad provenance, I have attributed this mark to Amiot. It was generally applied twice, side by side.

MARK D (1811–39) / cat. 52

L, a pellet, A, within an irregular oval. This is the best known of Amiot's marks, since it was used over a lengthy period and therefore appears frequently. It was employed in 1811, and also appears on the silversmith's last works, delivered in 1839, the year of his death. Slight variations in the shape of the oval may be an indication that more than one mark was being used, although they could be accounted for by wear of the punch. Generally, although not invariably, this mark was applied twice, side by side.

MARK E (1822) / cat. 41

L, a four-point star, A, within a rectangle. This rare mark appears on a work dated 1822 and on three others whose stylistic features indicate that they were produced during the same period.

MARK F (1832) / cat. 70

LA, within a notched rectangle. This mark is smaller than the others, and the punch must have been curved, so it could be applied to curved surfaces. Its use is well documented for 1832, but it may have been employed before or after that date. It is found on very small items and in cases where the mark needed to be discreet: on weddings rings and medals, and on the rim of patens and chalices. It was generally applied twice, side by side.

LIST OF WORKS

All works are by Laurent Amiot (1764–1839), unless stated otherwise.
Dimensions are height × width × depth.

1

Censer and Incense Boat of Saint-Joachim 1788
censer with chains: 110 × 12 × 11.8 cm; 897.54 g
censer: silver, copper lining; 24 × 12 × 11.8 cm
incense boat: silver; 8.5 × 8 × 14.8; 202.31 g
Fabrique Saint-Joachim, Saint-Joachim-de-Montmorency
Purchased in part by the fabrique of Saint-Joachim and in part
by Abbé Jean-Baptiste Corbin, curé of Saint-Joachim, 1788
illus. pp. 58, 97 (detail of the censer, p. 96; maker's mark,
back cover)

2

Pair of Altar Cruets of Deschaillons 1788
silver
13.1 × 6.3 × 6.3 cm; 106.13 g; 12.8 × 6.4 × 6.3 cm; 109.99 g
National Gallery of Canada, Ottawa
Gift of the Henry Birks Collection of Canadian Silver, 1979
(24748.1-2)
Inscriptions: *A* (on the belly of the water cruet); *V* (on the belly of the
wine cruet)
illus. pp. 59, 100

3

Bowl of the Hanging Sanctuary Lamp of Repentigny 1788
silver
50.3 × 39 cm; 3.24 kg
Fabrique de la Purification-de-la-Bienheureuse-Vierge-Marie,
Repentigny
Payed to Monsieur Lajus by the fabrique de la
Purification-de-la-Bienheureuse-Vierge-Marie, 1788
illus. pp. 58, 99 (details, pp. 8, 98)

4

Jug with Lid c. 1790
silver
28 × 16.5 × 11.6 cm; 913.35 g
National Gallery of Canada, Ottawa
Gift of the Henry Birks Collection of Canadian Silver, 1979 (24008)
illus. pp. 28, 164 (details, pp. 30, 31, 165)

5
Jug with Lid, with the Monogram of Monsignor Joseph Signaÿ c. 1790
silver
28.7 × 12 × 18.2 cm; 989.94 g
Archidiocèse de Québec, Quebec City
Bequest of Archbishop Joseph Signaÿ, 1850
Inscriptions: + *J.S. A. d. Q.* (on the belly)
illus. p. 162 (detail, p. 165)

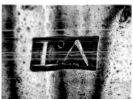

6
Crucifix of Saint-Charles-de-Bellechasse 1793
silver
31 × 13.7 × 11.2 cm; 804.55 g
Fabrique Saint-Charles Borromée, Saint-Charles-de-Bellechasse
Purchased by the fabrique Saint-Charles-Borromée, 1793
illus. p. 105 (detail, p. 104)

7
Tureen of the Hertel de Rouville Family 1793–94
silver
25.7 × 43.3 × 22.3 cm; 2.3 kg
National Gallery of Canada, Ottawa
Purchased 2015 (46867)
Inscriptions: *HERSE HERSE* (on a scroll); *une herse / JR* (on the belly);
9. MAR: 3 ONCES et MIE. (on the underside)
illus. pp. 66, 167 (details, pp. 67, 168)

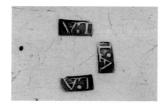

8
Holy Water Stoup and Aspergillum of Cap-Santé 1794
holy water stoup: silver; lining: copper and tin; 33.7 × 27.6 × 27.4 cm
(handle upright) / 24.5 × 27.6 × 27.4 cm (handle down); 1.62 kg
aspergillum: silver, iron and turned butternut wood; 31.7 × 4.1 × 4.1 cm;
276.36 g
Fabrique Sainte-Famille de Cap-Santé, Cap-Santé
Purchased by the fabrique Sainte-Famille de Cap-Santé, 1794
illus. p. 107 (detail of the holy water stoup, p. 106)

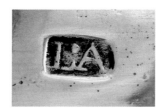
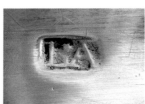

9
Basket with the Monogram JMA c. 1795
silver
17 × 20.4 × 16.1 cm; 440 g
National Gallery of Canada, Ottawa
Gift of Léon Simard, Westmount, Quebec, 2010, in memory of his wife
Jacqueline Levasseur Simard (43065)
Inscriptions: *IMA* (in the centre of the basket)
illus. p. 171

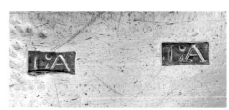

10
Condiment Ladles with the Monogram of Ibraïm Dufresne c. 1795
silver
15 × 2.1 × 1.5 cm each (approx.); 7.10 g / 6.85 g
National Gallery of Canada, Ottawa
Gift of Suzy M. Simard, Westmount, Quebec, 1994, in memory
of Dr. and Mme Guy Hamel (37675.1-2)
Inscriptions: *ID* (on the end of each spatula)
illus. p. 196

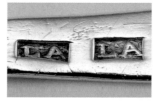
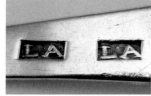

11
Double Snuffbox c. 1795
silver and brass
3.4 × 10.7 × 7.6 cm; 248.74 g
National Gallery of Canada, Ottawa
Gift of the Henry Birks Collection of Canadian Silver, 1979 (27079)
illus. pp. 35, 200

12
Mustard Pot with the Coat of Arms of George III c. 1795–1800
silver and transparent glass
6.3 × 10.4 × 5.5 cm; 247.3 g (mount)
National Gallery of Canada, Ottawa
Purchased 2010 (43198.1-2)
Inscriptions: *Armoiries du roi George III / GR /
HONNI SOIT QUI MAL Y PENSE* (on the lid)
illus. p. 172 (detail, p. 173)

13
Brandy Saucepan from the Livingston Family c. 1795–1800
silver and ebony
10.1 × 25.4 × 9.6 cm; 299 g
John Kirk Collection
Purchased through the New York art market, c. 2000
Inscriptions: *SPERO MELIORA* (on a scroll, above a ship);
ROBERT ARMSTRONG LIVINGSTON / 1854 (on the belly)
illus. p. 175 (detail, p. 174)

14
Ciborium of Saint-Marc 1795
silver and gold
24.6 × 12.5 × 12.5 cm; 547.82 g
Fabrique Saint-Marc, Saint-Marc-sur-Richelieu
Purchased by the fabrique Saint-Marc, 1795
illus. p. 109 (detail, p. 108)

15
Coffee Pot of the Le Moine Family c. 1796
silver, brass and mahogany
32.9 × 22.2 × 11.8 cm; 1.03 kg
National Gallery of Canada, Ottawa
Gift of Suzy M. Simard, Westmount, Quebec, 1994, in memory of
Dr. and Mme Guy Hamel (37674)
illus. p. 37 (detail, p. 4)

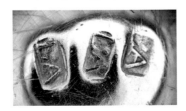

16

Shoe Buckle c. 1800
silver and steel
6.7 × 7.7 × 2.8 cm; 72.28 g
McCord Museum, Montreal
Acquired from Mabel Molson by an intermediary of Cleveland Morgan,
4 April 1936 (M18566.2)
illus. p. 198

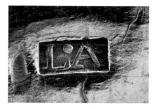

17

Ciborium c. 1800
silver and gold
26.6 × 13.9 × 13.9 cm; 937.06 g
National Gallery of Canada, Ottawa
Gift of the Henry Birks Collection of Canadian Silver, 1979 (24795)
illus. p. 103

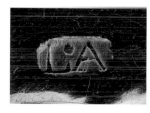

18

Beaker c. 1800
silver
7.4 × 6.2 cm; 123.3 g
The Metropolitan Museum of Art, New York
Bequest of Alphonso T. Clearwater, 1933 (33.120.102)
Inscriptions: *H. MERCIER* (on the belly)
illus. p. 21 (detail of maker's mark, p. 20)

19

*Creamer, Sugar Bowl and Sugar Tongs with the Coat of Arms
of the Chaussegros de Léry Family* c. 1800

Creamer
silver
11.1 × 13.7 × 7.6 cm; 189.58 g
National Gallery of Canada, Ottawa
Gift of the Henry Birks Collection of Canadian Silver, 1979 (24097.1)
Inscriptions: *RECTUS UBIQUE* (on the belly, in a scroll, beneath the coat
of arms of the Chaussegros de Léry family, surrounded by a wreath,
and all in an oval)
illus. p. 176

Sugar Bowl
silver
11.4 × 23.4 × 10.5 cm; 347.45 g
National Gallery of Canada, Ottawa
Gift of the Henry Birks Collection of Canadian Silver, 1979 (24097.2)
Inscriptions: *RECTUS UBIQUE* (on the belly, in a phylactère, beneath the
coat of arms of the Chaussegros de Léry family, surrounded by a wreath,
and all in an oval)
illus. p. 176

Sugar Tongs
silver
13.9 × 5.1 × 1.9 cm; 38.97 g
National Gallery of Canada, Ottawa (24097.3)
Gift of the Henry Birks Collection of Canadian Silver, 1979
illus. p. 176

20
Pap Boat c. 1800–35
silver
5.4 × 14.8 × 7.2 cm; 97.51 g
National Gallery of Canada, Ottawa
Gift of the Henry Birks Collection of Canadian Silver, 1979 (25058)
Inscriptions: *NAULT* (engraved with a metal point, on the underside)
illus. pp. 32, 192 (detail, p. 193)

21
Design for a Chalice c. 1801
sepia, brown ink and graphite on ivory laid paper
31.85 × 20.4 cm (irregular)
Royal Ontario Museum, Toronto
Gift of the estate of Francis Patrick Garvan, 1948 (948.279.18)
Inscriptions: recto: *17* (in graphite, upper left corner) /
additions in ink (near the right edge); verso: drawing of
an Old English model teaspoon (in graphite) / inscriptions
in graphite (illegible)
illus. p. 212

22
Baptismal Ewer of Cap-Santé 1804
silver
7.3 × 4.95 × 9.1 cm; 60.81 g
Fabrique Sainte-Famille de Cap-Santé, Cap-Santé
Purchased by the fabrique Sainte-Famille de Cap-Santé, 1804
illus. p. 111

23
Teapot c. 1805
silver and wood
15.1 × 28.4 × 12.1 cm; 626.4 g
Montreal Museum of Fine Arts
Ramsay Traquair Bequest, 1952 (1952.Ds.41)
Inscriptions: *FWO* (on the belly, in an oval)
illus. pp. 27, 178

24
Baptismal Vessel of Saint-Joachim 1805
silver
8.1 × 6 × 16.2 cm; 158.58 g
Fabrique Saint-Joachim, Saint-Joachim de Montmorency
Purchased by the fabrique Saint-Joachim, 1805
illus. p. 112 (detail, p. 113)

25
Baptismal Vessel of Charlesbourg 1809/37
silver
4.4 × 5.6 × 12.9 cm; 69.03 g
Fabrique Saint-Charles-Borromée de Charlesbourg, Quebec City
Purchased by the fabrique Saint-Charles-Borromée de Charlesbourg,
1809; recast in 1837
illus. p. 114 (detail, p. 115)

26

Design for a Chalice c. 1810
sepia, brown ink and graphite on ivory laid paper, glued to paper
33.2 × 20.5 cm (irregular)
Royal Ontario Museum, Toronto
Gift of the estate of Francis Patrick Garvan, 1948 (948.279.20)
Inscriptions: recto: *16* (in graphite, upper left corner)
illus. p. 212

27

Wine Funnel Stand c. 1810–15
silver
1.7 × 9 × 9 cm; 83.86 g
Private collection
Purchased through the Montreal art market, 2000
illus. pp. 188, 189

28

Wine Funnel c. 1810–15
silver
15.1 × 8.5 cm; 238.48 g
National Gallery of Canada, Ottawa
Gift of the Henry Birks Collection of Canadian Silver, 1979 (27842)
illus. pp. 188, 189

29

Chalice of Saint-Ambroise-de-la-Jeune-Lorette 1811
silver and gold
31.6 × 16.8 cm; 950.67 g
Fabrique Saint-Ambroise-de-la-Jeune-Lorette, Loretteville
Purchased by the fabrique Saint-Ambroise-de-la-Jeune-Lorette, 1811
illus. pp. 16, 117 (details, pp. 2–3, 17, 116)

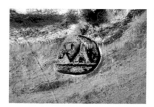

30

Liturgical Funnel with the Monogram of the Bishop of Quebec c. 1814
silver
12.5 × 11.2 × 14.5 cm; 300 g
Archidiocèse de Québec, Quebec City
Probably commissioned by Monsignor Joseph Octave Plessis
Inscriptions: crozier, *E.Q.* (on the external edge)
illus. pp. 137, 138

31

Spatula for the Blessing of the Holy Oils with the Monogram of the Bishop of Quebec c. 1814
silver
24.7 × 2.3 × 4.3 cm; 60 g
Archidiocèse de Québec, Quebec City
Probably commissioned by Monsignor Joseph Octave Plessis
Inscriptions: crozier, *E.Q.* (on the edge of the spatula)
illus. pp. 137, 138 (detail, p. 138)

32
Holy Oil Flasks with the Coat of Arms of the Diocese of Quebec c. 1814

Flask for the Oil of Chatechumens
silver
39.1 × 17.3 × 17.35 cm; 2.46 kg
Inscriptions: Coat of Arms of the Diocese of Quebec / *1814* / crozier,
E.Q. (on the belly); *Oleum Cathechumenorum* (on the other side of the
belly); crozier, *E.Q. / O.C* (on the lid)
Archidiocèse de Québec, Quebec City
Probably commissioned by Monsignor Joseph Octave Plessis
illus. pp. 14, 137

Flask for the Holy Chrism
silver
39.1 × 17.3 × 17.35 cm; 2.46 kg
Inscriptions: Coat of Arms of the Diocese of Quebec / *1814* / crozier,
E.Q. (on the belly); *Sanctum Chrisma* (on the other side of the belly);
crozier *EQ / S.C* (on the lid)
Archidiocèse de Québec, Quebec City
Probably commissioned by Monsignor Joseph Octave Plessis
illus. pp. 14, 137

Flask for the Oil of the Sick
silver
38.4 × 16.6 × 16.6 cm; 2.46 kg
Inscriptions: Coat of Arms of the Diocese of Quebec / *1814* / crozier,
E.Q. (on the belly); *Oleum Infirmorum* (on the other side of the belly);
crozier *E.Q. / O.I* (on the lid)
Archidiocèse de Québec, Quebec City
Probably commissioned by Monsignor Joseph Octave Plessis
illus. pp. 14, 137

33
Bugia with the Monogram of the Bishop of Quebec c. 1815
silver
5.7 × 12.4 × 27 cm; 320 g
Basilique-cathédrale Notre-Dame de Québec, Quebec City
Probably commissioned by Monsignor Joseph Octave Plessis
Inscriptions: crozier, *E.Q.* (under the spatula of the handle)
illus. p. 139

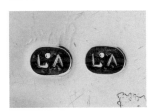

34
Processional Cross of Sainte-Marie c. 1815
silver on wooden structure, leather; painted
and varnished wooden staff and copper cylinder
229 × 38 × 7 cm (total) / 47 × 38 × 4.5 cm (cross);
2.18 kg (including internal structure)
Église Sainte-Marie, Church Point
Probably commissioned by the parish of Sainte-Marie
no maker's mark
illus. p. 128 (copper ferule, p. 74; detail of the reverse, p. 129)

35
Snuffbox with the Monogram ACB c. 1815
silver, gold and brass
2.1 × 7 × 4.2 cm; 103.13 g
National Gallery of Canada, Ottawa
Gift of the Henry Birks Collection of Canadian Silver, 1979 (24102)
Inscriptions: *ACB* (centre of lid, in a shield)
illus. pp. 24, 200

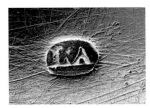

36
Bottle Ticket for Port 1815–20
silver
15.5 × 4.1 × 0.1 cm; 9.62 g
National Gallery of Canada, Ottawa
Purchased 2011 (43387)
Inscriptions: *PORT*
illus. p. 190

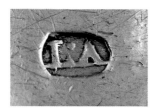

37
Christening Mug of Helen Scott Black c. 1817
silver
7.6 × 9.6 × 6.6 cm; 133.18 g
National Gallery of Canada, Ottawa
Gift of the Henry Birks Collection of Canadian Silver, 1979 (24141)
Inscriptions: *From J.B. to his Cousin / Helen Scott Black / Quebec 4th December / 1817*
illus. p. 202

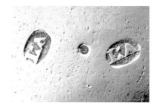

38
Ceremonial Ewer and Basin with the Monogram of the Bishop of Quebec
c. 1820
silver
ewer: 19.5 × 9.2 × 11.7 cm; 299.83 g
basin: 3.4 × 29.8 × 23 cm; 481.91 g
Archidiocèse de Québec, Quebec City
Probably commissioned by Monsignor Joseph Octave Plessis
Inscriptions: crozier, *E.Q.* (on the belly of the ewer); crozier, E.Q. (on the back of the basin)
illus. p. 140 (detail, p. 141)

39
Verger's Mace of Saint-Michel-de-Bellechasse c. 1820
mahogany and lightly pigmented varnish, and silver
125.5 × 4.5 × 1.5 cm; 388.51 g
Fabrique Saint-Michel, Saint-Michel-de-Bellechasse
Acquired by the fabrique Saint-Michel, c. 1820
no maker's mark
illus. p. 131 (details, p. 131)

40
Creamer and Sugar Bowl c. 1820

Creamer
silver and yellow gold
12 × 16.3 × 9.5 cm; 40.4 g
Musée national des beaux-arts du Québec, Quebec City
Purchased 1994 (1994.17)
illus. p. 186

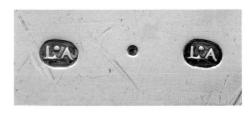

Sugar Bowl
silver and red gold
11.6 × 20.6 × 11.6 cm; 51.8 g
Musée national des beaux-arts du Québec, Quebec City
Purchased 1994 (1994.16)
illus. p. 186

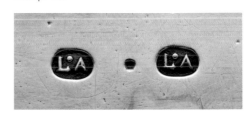

41
Teapot with a Sibyl c. 1820
silver and mahogany
14 × 32 × 15.5 cm (approx.); 1.2 kg
National Gallery of Canada, Ottawa
Purchased 2002 (41081)
Inscriptions: crest of a demi-lion surmounted on a wreath (on the belly)
illus. p. 179 (details, pp. 179, 180)

42
Design for a Holy Water Stoup c. 1822
brown ink and graphite on green-grey laid paper
22.5 × 20.5 cm (irregular)
Royal Ontario Museum, Toronto
Gift of the estate of Francis Patrick Garvan, 1948 (948.279.4)
Inscriptions: recto: *10 onces / 13 onces* (in brown ink) / *9* (in graphite,
upper left corner) / a cross (in blue pencil, on the right, under the belly);
verso: *£ 20″0″0* (in brown ink, lower right corner)
illus. p. 49

43
Design for a Chalice c. 1822
brown ink and graphite on ivory laid paper
32.7 × 20.5 cm (irregular)
Musée des maîtres et artisans du Québec, Montreal
Collection of Cégep de Saint-Laurent
Acquired from William P. Wolfe Rare Books, 23 March 1976 (1976.39.5)
Inscriptions: verso: drawing of a holy water stoup, with the notes
10 onces / 13 onces (in graphite)
illus. p. 44

44
Design for a Chalice c. 1822
sepia, brown ink and graphite on ivory laid paper, glued to paper
30.3 × 18.6 cm (irregular)
Royal Ontario Museum, Toronto
Gift of the estate of Francis Patrick Garvan, 1948 (948.279.22)
Inscriptions: recto: *24* (in graphite, upper left corner);
verso: writing test (in brown ink, on the auxiliary support)
illus. p. 80

45
Design for a Chalice c. 1822
brown ink and graphite on ivory laid paper, glued to paper
32.9 × 20.5 cm (irregular)
Royal Ontario Museum, Toronto
Gift of the estate of Francis Patrick Garvan, 1948 (948.279.16)
Inscriptions: recto: *11* (in graphite, upper left corner) / *X* (in red pencil,
on the right, close to the cup)
illus. p. 80

46
Designs for a Chalice, Ciborium and Viaticum Pyx c. 1822
brown ink and graphite on green-grey laid paper
33 × 41.2 cm
Royal Ontario Museum, Toronto
Gift of the estate of Francis Patrick Garvan, 1948 (948.279.6.2-3)
Inscriptions: *X* (in red pencil, on the right, close to the cup of the chalice
/ *X* (in red pencil, close to the knop of the ciborium) / *X* (in red pencil,
close to the cup of the viaticum pyx)
illus. p. 50

47
Designs for a Chalice and the Socket of a Processional Cross
c. 1822
brown ink and graphite on green-grey laid paper
33 × 41.2 cm
Royal Ontario Museum, Toronto
Gift of the estate of Francis Patrick Garvan, 1948 (948.279.12.4;1)
Inscriptions: cross (in red pencil, on the right close to the cup) /
3 onces 4 gros / 8 onces (in ink, on the socket) / *£ 40 – 00* (in graphite,
on the base) / *14* (in graphite, upper left corner)
illus. p. 50

48
Design for a Censer c. 1822
brown ink and graphite on green-grey laid paper
33 × 20.7 cm (irregular)
Royal Ontario Museum, Toronto
Gift of the estate of Francis Patrick Garvan, 1948 (948.279.5)
Inscriptions: *8* (in graphite, upper left corner) / *X* (in blue pencil,
upper left corner) / *X* (in red pencil, on the right, close to the chimney)
illus. p. 81

49
Design for a Monstrance c. 1822
brown ink and graphite on green-grey laid paper
33 × 41.2 cm
Royal Ontario Museum, Toronto
Gift of the estate of Francis Patrick Garvan, 1948 (948.279.6.1)
Inscriptions: *7* (in graphite, upper left corner)
illus. p. 81

50
Three Designs for Cruets and Design for a Cruet Basin c. 1822
brown ink and graphite on green-grey laid paper
33 × 41.2 cm
Royal Ontario Museum, Toronto
Gift of the estate of Francis Patrick Garvan, 1948 (948.279.12.2-3)
Inscriptions: *10 onces / 4 onces* (in brown ink, on the cruet basin)
illus. p. 51

51
Reliquary of Saint Charles Borromeo c. 1823
silver, glass, textile and gilt paper
13.8 × 10.4 × 4 cm; 182.02 g
Fabrique Saint-Charles Borromée, Saint-Charles-de-Bellechasse
Probably commissioned to enclose the relic presented by Monsignor
Joseph Octave Plessis, 11 June 1823
illus. p. 142

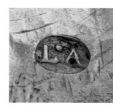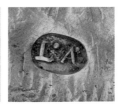

52
Reliquary-Monstrance of Saint Charles Borromeo c. 1823
silver, glass, textile, metal paillettes, gold foil and paper
28 × 16 × 12 cm; 667.47 g
Fabrique Saint-Charles Borromée de Charlesbourg, Quebec City
Probably commissioned by the fabrique Saint-Charles Borromée to
enclose the relic presented by Monsignor Joseph Octave Plessis,
15 April 1823
illus. p. 145 (details, cover, pp. 90, 144)

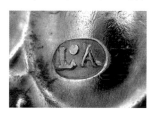 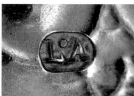

53
Cope Clasp c. 1825
silver
5.5 × 4.5 × 1.8 cm; 18.03 g
Archidiocèse de Québec, Quebec City
undocumented provenance
illus. p. 122

54
Ewer with the Monogram of the Séminaire des Missions Étrangères c. 1825
silver
21.6 × 8.8 × 15 cm; 299.83 g
Archidiocèse de Québec, Quebec City
undocumented provenance
Inscriptions: *ME* surmounted on a Latin cross
(on the belly, under the handle)
illus. p. 191

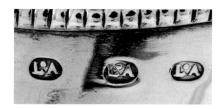

55
Viaticum Pyx c. 1825
silver and gold
8.2 × 5 cm; 54.36 g
National Gallery of Canada, Ottawa
Gift of the Henry Birks Collection of Canadian Silver, 1979 (24775)
illus. p. 124 (open, p. 123)

56
Reliquary Pectoral Cross c. 1825
silver and brass
5.7 × 3.7 × 8.75 cm; chain: 35 cm long; 69.76 g
Archidiocèse de Québec, Quebec City
undocumented provenance
Inscriptions: *Vivent Jesus / et Marie* (obverse); *Marie a été Conçue /
Sans péché* (reverse); *St Agnès* (inside the lid)
illus. p. 132 (detail, p. 133)

57
Viaticum Case c. 1825
silver and gold
1.9 × 7.6 × 5 cm; 68.81 g
National Gallery of Canada, Ottawa
Gift of the Henry Birks Collection of Canadian Silver, 1979 (24939)
illus. p. 126

58
Entrée Dish of the Coffin Family c. 1825
silver
11.1 × 29.5 × 17.9 cm; 976 g
National Gallery of Canada, Ottawa
Gift of the Henry Birks Collection of Canadian Silver, 1979
(24015.1-2)
Inscriptions: *From / WHB / to / WMC* (on the lid and on the belly)
illus. p. 194 (open, p. 195)

59
Design for a Lidded Cup c. 1825
brown ink and graphite on green-grey laid paper
33.3 × 21.2 cm (irregular)
Musée des maîtres et artisans du Québec, Montreal
Collection of Cégep de Saint-Laurent
Acquired from William P. Wolfe Rare Books, 23 March 1976 (1976.39.8)
illus. p. 204

60
Sugar Bowl and Cover c. 1825
silver and yellow gold
13.6 × 18.4 × 11.6 cm; 467.23 g
National Gallery of Canada, Ottawa
Gift of the Henry Birks Collection of Canadian Silver, 1979 (24096)
illus. pp. 34, 187

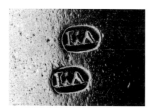

61
Regency Teapot c. 1825
silver and wood
15.8 × 26.3 × 16.3 cm; 986.04 g
National Gallery of Canada, Ottawa
Purchased 2009 (42518)
illus. p. 182 (detail, p. 185; maker's mark, p. 223)

62
Cup c. 1827
silver
17.6 × 12 cm; 494.91 g
National Gallery of Canada, Ottawa
Purchased 1990 (30574)
Inscriptions: *Quebec / Low c* [?]/ *182* [?] *1827 / Roo to Mr Smillie Engra* [?] (with a metalic point on the reverse of the plinth). An inscription on the cup has been buffed out.
illus. p. 203

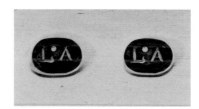

63
Design for a Censer c. 1827
brown ink over graphite on ivory paper
22.4 × 21 cm
Royal Ontario Museum, Toronto
Gift of the estate of Francis Patrick Garvan, 1948 (948.279.2)
Inscriptions: recto: *Petite* (in brown ink, on the belly); *4* (in graphite, upper left corner); verso: *Je me resouviendrai que les trois petit Piton qui sont sur le culot sont soudé a vu la Bate pour leur donner plus de force* (in brown ink, alterations in graphite)
illus. p. 211

64
Cup Presented to George Taylor 1827
silver
30.7 × 16.8 × 16.7 cm; 2 kg
National Gallery of Canada, Ottawa
Purchased 2000 with the assistance of a grant from the Government of Canada under the terms of the Cultural Property Export and Import Act (40385.1-2)
Inscriptions: *THIS CUP WAS PRESENTED BY THE / Earl of Dalhousie G.C.B. Governor General & Commander of the Forces in British North America / To Mr. George Taylor / As a distinguished mark of / His Lordship approbation / of the great Skill / and Attention / DISPLAYED IN BUILDING THE GOVERNMENT BRIG KING FISHER / Launched at Quebec 14 May 1827*
Arms: Argent an eagle displayed Sable, beaked and membered Gules
Crest: A unicorn head couped Argent armed Or
Supporters: Two griffins proper
Motto: *Ora et labora* (on the obverse of the cup)
Secondary motifs: *Martin-pêcheur* (on the edge of the lid)
no maker's mark visible
illus. pp. 38, 205 (detail, p. 39)

65

Hanging Sanctuary Lamp of the Cathedral of Notre-Dame de Québec
1827–29
silver
152.5 × 49.8 × 49.5 cm; 7.68 kg
Basilique-cathédrale Notre-Dame de Québec, Quebec City
Commissioned under a resolution of the church council of the fabrique of
Notre-Dame de Québec, 13 May 1827, and purchased 29 December 1829
illus. p. 149 (details, pp. 150, 151)

66

Wedding Band c. 1830
red gold
0.2 × 1.8 cm; 1.3 g
National Gallery of Canada, Ottawa
Gift of the Henry Birks Collection of Canadian Silver, 1979 (27369)
illus. p. 201

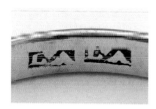

67

Wedding Band c. 1830
gold
0.9 × 2.1 cm; 8 g
Musée national des beaux-arts du Québec, Quebec City
Purchased 1962 (1962.31)
illus. p. 201

68

Pax of L'Islet-sur-Mer 1831
silver
10.16 × 6.9 × 4.1 cm; 144 g
Fabrique Notre-Dame de Bonsecours, L'Islet-sur-Mer
Purchased by the fabrique Notre-Dame de Bonsecours, 1831
Deposited at the Musée national des beaux-arts du Québec,
Quebec City, 1974 (DLT 1974.21)
illus. p. 120 (reverse, p. 121)

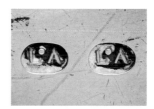

69

Reliquary Pendant of Monsignor Turgeon c. 1832
silver
6.2 × 3.15 × 8.4 cm; chain: 41.5 cm long; 51.02 g
Archidiocèse de Québec, Quebec City
Probably acquired from Monsignor Pierre Flavien Turgeon
Inscriptions: *IHS* (obverse); *AM* (reverse); *Messire / Turgeon / Québec /
30 août 1832* (with a metallic point, inside the lid)
illus. p. 134

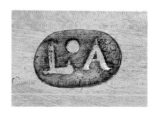

70

Medal Awarded to Alexis Saint-Laurent 1832
silver
5.4 × 0.4 cm (under the ring); 66.5 g
Musée de la civilisation, Quebec City
Collection of the Séminaire de Québec
Acquired before 1904 (1992.325)
Inscriptions: *TO / ALEXIS S^T LAURENT / FROM / A NUMBER OF THE
INHABITANTS / of / QUEBEC / 1832* (recto); *LAURENT CHABOT. /
AUGUSTINE BEGIN, BALTH^R VIEN, / JEAN LECOUR DIT BARRAS, /
PIERRE PICHETTE, ALEX^S S^T LAURENT. / who by thier prompt exertions
saved / FIVE out of TEN persons upset in / a Canoe on thier pafsage
from / QUEBEC to P^T LEVI on the 17^th / MARCH this medal is presented
/ as an incitement to similar / ACTS.* (reverse)
illus. p. 207

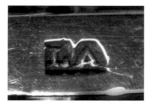

71

Jug with Lid Presented to Father Charles-Joseph Asselin c. 1833
silver
26.4 × 13.6 × 19.9 cm; 1.09 kg
Archidiocèse de Québec, Quebec City
Probably bequeathed by Father Charles-Joseph Asselin, 1856
Inscriptions: *Tribut de respect et de reconnaifsance / OFFERT /*
par les propriétaires et assureurs du / BRIG ROSALIND DE
LONDRES, CAPT. BOYLE / AU / Revd Mefsire Asselin P^{tre} Curé de
S. Louis / DE L'ISLE AUX COUDRES / pour avoir / par son example
engagé ses paroifsiens / à aider à sauver le Vaifseau et sa /
Cargaison jetés par les glaces sur cette / Isle le 27 Nov. 1832 /
et pour / ses bontés envers les naufragés pendant / LEUR
SEJOUR SUR L'ISLE
illus. p. 209 (detail, p. 208)

72

Design for a Viaticum Pyx c. 1837
brown ink and graphite on grey-green laid paper
20.3 × 10.6 cm (irregular)
National Gallery of Canada Library and Archives, Ottawa
Gift of the Henry Birks Collection of Canadian Silver (Box 1, File 8)
Inscriptions: recto: *Le fond .pied 1-once 1/2 / la Coupe 1 once ¾ /*
Couvert 1 once ¼ (in brown ink) */ TSD?* (in graphite); verso: *Québec*
le 11 Juillet 1837 / La Fabrique de Ste Croix / Doit à Laurent Amiot /
Un Calice et une patenne, dargent / argent, façon, et dorure £ 30"0"0 /
Reçu le paiement Laurent Amiot (in brown ink)
illus. p. 125

73

Chalice of Bishop Joseph Signaÿ 1837
silver and gold
31.1 × 15.2 cm; 871.63 g
Basilique cathédrale Notre-Dame-de Québec, Quebec City
Bequeathed by Monsignor Joseph Signaÿ for the use of succeeding
archbishops and bishops of Quebec, 1850
Inscriptions: *+.J.S.* (under the calyx, under the cup, on the upper edge of
the knop and on the foot, at the meeting points of the other components
so that the inscriptions are not visible)
illus. p. 154 (details, pp. 155, 156)

74

Censer and Incense Boat of Saint-Anselme 1837
silver
censer with chains: 117.2 cm
censer: 26.8 × 12.9 cm (diameter); 1.03 kg
incense boat: 10.5 × 13.6 × 8.3 cm; 260.04 g
National Gallery of Canada, Ottawa
Purchased 1965 and 1967 (14815; 15322)
illus. p. 152 (incense boat, pp. 153, 197)

75
Monstrance of Saint-André 1838–39
silver and crystal
46.6 × 24.5 × 11 cm; 1.26 kg
National Gallery of Canada, Ottawa
Gift of the Henry Birks Collection of Canadian Silver, 1979 (24049)
illus. p. 158

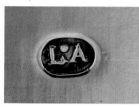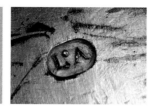

OTHER ARTISTS

76
Tudor & Leader (active Sheffield, England, 1761–1783)
Coffee Pot c. 1765–70
line engravings with a bit of etching on paper
37.5 × 23.5 cm (page)
Henry Francis Dupont Winterthur Museum, Garden & Library,
Wilmington, Delaware
Gift of Edmond L. Lincoln, 1996 (NK7250 T91 TC F)
illus. p. 52

77
Unidentified engraver (for Matthew Boulton) (England, 18th century)
Candlestick c. 1785
engraving
35.7 × 21.1 cm
Victoria and Albert Museum, London (E.1236-1979)
illus. p. 52

78
Unidentified artist (Quebec, late 18th / early 19th century)
Drawing of Royal Coats of Arms c. 1795–1800
pen and brown ink with traces of graphite on grey-green laid paper
13 × 9.9 cm (irregular)
Musée des maîtres et artisans du Québec, Montreal
Collection of Cégep de Saint-Laurent
Acquired from William P. Wolfe Rare Books, 23 March 1970 (1970.39.17)
Inscriptions: verso: *139 / 63 / 212* (in brown ink); another illegible
inscription
illus. p. 173

79
Unidentified engraver (England, 18th century)
Cup with Two Handles, Beaker and Wine Funnel c. 1800
engraving
35 × 22 cm
Victoria and Albert Museum, London (E.639-1927, plate 74)
illus. p. 52

80
Unidentified engraver (England, 18th century)
Types of Borders c. 1800
engraving
32.2 × 26.5 cm
Victoria and Albert Museum, London (E.640-1927, plate 49)
illus. p. 53

81
Unidentified artisan (Quebec, 19th century)
Case for a Chalice c. 1810
tin-plated iron, wool, silk, bast fibre and leather
40.1 × 16.7 × 16.7 cm; 657.28 g
Fabrique Saint-Jean-Port-Joli
Probably made to transport the chalice acquired by the parish in 1810
illus. p. 75

82
William Berczy (1744–1813)
Jean-Baptiste Melchior Hertel de Rouville c. 1810
oil on canvas
62.5 × 49 cm
McCord Museum, Montreal
Purchased 1966 (M966.62.3)
illus. p. 166

83
Flight, Barr & Barr (1813–1840)
Selected Elements of John Neilson's Tea Service c. 1817
gilded porcelain
Teapot and Stand: 18.6 × 14.7 × 26.9 cm (overall dimensions; teapot
with lid: 18 × 14.7 × 26.9 cm; stand: 2.4 × 9 × 20 cm)
Sugar Bowl: 12 × 18.3 × 10.4 cm
Creamer: 11 × 9 × 14.9 cm
Coffee Cup: 6.5 × 6.4 × 8.1 cm
Tea Cup: 5.5 × 8.7 × 10.5 cm
Saucer: 2.45 × 14.5 × 14.5 cm
Canadian Museum of History, Gatineau
Purchased 1983 (983.64-2.1 a-c; 983.64-2.2; 983.64-2.3; 983.64.2.40;
983.64.2.19; 983.64.2.8)
illus. p. 78

84
Unidentified artist (Quebec, beginning of the 19th century)
De la Montagne Street at the Top of the Champlain Staircase c. 1818
watercolour, pen and black ink over graphite on wove paper
32.5 × 42.3 cm
National Gallery of Canada, Ottawa
Purchased 1970 (16681)
illus. p. 63

85
John James (active 1811–1845)
John Neilson c. 1820
oil on canvas
74 × 58.5 cm
Musée national des beaux-arts du Québec, Quebec City
Purchased 1984. Restored thanks to a contribution from Les Amis
du Musée national des beaux-arts du Québec (1984.30)
illus. p. 183

86
Asher Brown Durand (1796–1886) (after John James)
Joseph Octave Plessis, Catholic Bishop of Quebec c. 1826
engraving on wove paper
sheet: 49 × 38.2 cm
plate mark: 46.8 × 33.8 cm
Musée des Ursulines de Québec, Quebec City
Monastère des Ursulines de Québec Collection (1997.304)
undocumented provenance
illus. p. 135

87
James Pattison Cockburn (1779–1847)
The Prescott Gate c. 1829
watercolour, pen and ink on wove paper
27.3 × 34.2 cm
Library and Archives Canada, Ottawa
Peter Winkworth Collection of Canadiana (e000756931)
illus. p. 64

88
James Pattison Cockburn (1779–1847)
Looking up the Steps of Champlain Street, Quebec City 1830
watercolour, pen and ink on wove paper
27 × 33 cm
Library and Archives Canada, Gatineau
Peter Winkworth Collection of Canadiana (e000756748)
illus. p. 61

89
James Pattison Cockburn (1779–1847)
Looking up Mountain Street Toward the Prescott Gate 1830
watercolour, pen, ink and pencil on wove paper
25.7 × 36.5 cm
Royal Ontario Museum, Toronto
Gift of the Sigmund Samuel Fund, 1951 (951.205.1)
illus. p. 64

90
Antoine Plamondon (1804–1895)
Monsignor Joseph Signaÿ 1836
oil on canvas
76.2 × 63.5 cm
Archidiocèse de Québec, Quebec City
Bequest of Archbishop Joseph Signaÿ, 1850
Deposited at the Musée de la civilisation, Quebec City (1993.53859)
illus. p. 147

91
Samuel Palmer (England, active Canada c. 1834–1845)
George Taylor, Master Shipbuilder 1843
oil on canvas
92.5 × 84.5 cm
National Gallery of Canada, Ottawa
Purchased 2010 (43036)
illus. p. 206

LIST OF FIGURES

Fig. 2.4
François Ranvoyzé (1739–1819)
Chalice c. 1784
silver and gold
National Gallery of Canada, Ottawa
Gift of the Henry Birks Collection of Canadian Silver, 1979
(24016)

Fig. 2.5
Michael Arnoldi and Société d'Arnoldi & Oakes (active in Montreal, c. 1792)
Tea Service 1792
silver and tiger maple
National Gallery of Canada, Ottawa
Purchased 2012
(43199.1-5)

Fig. 2.6
Joseph Légaré (1795–1855)
Location of La Gazette de Québec c. 1835
oil on paper
Bibliothèque et Archives nationales du Québec, Quebec City
Neilson Family Fonds
(P192, S1, D3, P14)

Fig. 2.7
James Smillie (1807–1885)
A Perpetual Almanack by which may be found in a few seconds of time the day of the week, or month, in any year to come 1825
engraving on paper
Bibliothèque et Archives nationales du Québec, Montreal
(FV 207)

Fig. 2.8
James Smillie (1807–1885)
A General Table of New and Full Moons Shewing the days of new and full Moon untill the year 1900 with the Moons age on every day 1827
engraving on paper
Archives de la Ville de Montréal, Montreal
(BM007-2-D02-P016)

Fig. 2.9
J. Jones (active in Quebec City, c. 1830–1836)
Ex Libris of the Honourable John Stewart, Esq. c. 1835?
engraving on paper
McGill University Library, Montreal
Rare Books and Special Collections
(XV-2835)

Fig. 2.10
J. Jones (active in Quebec City, c. 1830–1836)
Ex Libris of Samuel Wright c. 1835
engraving on paper
Archives de la Ville de Montréal, Montreal
(BM007-3-D01)

Fig. 2.11
Jean-Charles Cahier (1772–1857)
Chalice of Charlesbourg c. 1820
silver and gold
Fabrique Saint-Charles-Borromée, Quebec City

Fig. 3.1
Laurent Amiot (1764–1839)
Chalice of Baie-du-Febvre 1791
archival photograph taken by Marius Barbeau in 1946, before the work was damaged
Canadian Museum of History, Gatineau
Marius Barbeau Fonds
(100274)

Fig. 3.2
François Ranvoyzé (1739–1819)
Chalice (detail) c. 1784
silver and gold
National Gallery of Canada, Ottawa
Gift of the Henry Birks Collection of Canadian Silver, 1979
(24016)

Fig. 3.3
François Ranvoyzé (1739–1819)
Baptismal Ewer of Saint-Ambroise-de-la-Jeune-Lorette c. 1800
silver
Fabrique Saint-Ambroise de la Jeune-Lorette, Loretteville

Fig. 3.4
François Sasseville (1797–1864) and Alexis Renaud (active in Paris, 1831–1847)
Ciborium of Saint-Denis de Kamouraska c. 1845
silver and gold
National Gallery of Canada, Ottawa
Gift of the Henry Birks Collection of Canadian Silver, 1979
(24800)

Fig. 3.5
Laurent Amiot (1764–1839)
Altar Candlestick c. 1820
National Gallery of Canada, Ottawa
Gift of the Henry Birks Collection of Canadian Silver, 1979
(24064)

Fig. 3.6
Peter Nordbeck (1789–1861)
Chalice of Saint-Pierre de Pubnico 1831
silver and gold
National Gallery of Canada, Ottawa
Gift of the Henry Birks Collection of Canadian Silver, 1979
(24182)

Fig. 3.7
Jules-Ernest Livernois (1851–1933)
Pair of Candlesticks that Previously Belonged to Bishop Joseph Signaÿ c. 1915
photograph
Canadian Museum of History, Gatineau
Marius Barbeau Fonds
(IMG2014-0110-0002-Dm)

INDEX

BIBLIOGRAPHY

A. PRIMARY SOURCES

I. MANUSCRIPTS

Archidiocèse de Québec, Archives, Quebec City
12A, Register of ecclesiastical transcriptions, vol. H
Authentication of the relic of Saint Charles Borromeo,
2 November 1821

12A, Register of ecclesiastical transcriptions, vol. I
Authentication of the relic of Saint Charles Borromeo,
15 April 1823
Authentication of the relic of Saint Charles Borromeo,
11 June 1823

31-13A, Monsignor Joseph Signaÿ Papers
Vol. 5-1 Journal

61CD, Saint-Charles-de-Bellechasse, 1:114 (14 July 1884)

61CD, Saint-Charles-de-Bellechasse, 1:138 (1896)

90CM, Angleterre, 5:170
Letter from E. Alfred Jones to an unidentified recipient in
Quebec City, 20 November 1926

92CM, Italie, 1-14
Letter from Monsignor Cajetan Oppizoni to Joseph-Octave
Plessis, 23 May 1820

Fabrique Notre-Dame de Québec fonds
Account book, 1664–1718
Account book, 1768–86, vol. 6 (CM2/C1.1)
Account book, 1823–54, vol. 9 (CN2/C1.1)
Account of proceedings of the churchwardens of the parish
church of Notre-Dame de Québec, 1786–1804, vol. 7
(CM2/C1.1)
Book of notices, 1793–94, vol. 4 (CM1/C2.1)
Book of notices, 1822–27, vol. 14 (CM1/C2.1)
Book of notices, 1827–32, vol. 15 (CM1/C2.1)
Book of notices, 1832–43, vol. 16 (CM1/C2.1)
Box 6, nos. 188 a and b; 189–210
Box 11, no. 317a and c
Box 12: no. 7, Establishment of a fund for the maintenance of
a lamp in Notre-Dame de Québec, 14 November 1671;
no. 84, General inventory of 1675; no. 87, Inventory of 1766;
nos. 89, 89a, Return of the items sent to Trois-Rivières before
the siege of 1759; no. 91, Inventory of 1771; no. 92, Inventory
of 1775; no. 93, Inventory of 1832
General inventory of the movable property of the parish of
Notre-Dame-de Recouvrance de Kebek; additions in 1645,
1646, 1647, 1648, 1649, 1649, 1650, 1651, 1652
Inventory made by Monsieur Bégon, intendant, 19 August 1714
Inventory (undated, second half of the 19th century)
Inventory of the basilica of Notre-Dame de Québec and the
church of the Lower Town, 1862
Inventory of the basilica of Notre-Dame de Québec and the
church of the Lower Town, 1888, 1894, 1917, vol. 2 (CM2/C2.11)
Inventory of the furnishings, utensils and ornaments of the
parish church of Quebec, 1653; additions in 1655 and 1656
Pastoral visit in the parish beginning 20 August 1833
(CM1/F1.12)
Pew assignment book for the church of Notre-Dame,
28 December 1817 – 26 December 1859, vol. 3 (CM2/D1.1)
Register of accounts submitted by the churchwardens of the
parish Church of Notre-Dame de Québec, 1803–29, vol. 8
(CM2/C1.1)
Register of births, marriages and deaths, 1748–49
Register of births, marriages and deaths, 1759–69, vol. 16
(CM1/A1.1)
Register of births, marriages and deaths, 1793–94, vol. 23
(CM1/A1.1)
Register of births, marriages and deaths, 1830
Register of births, marriages and deaths, 1839, vol. 58
(CM1/A1.1)
Register of proceedings, 1775–1825, vol. 3 (CM2/A1)

Register of proceedings, 31 August 1777 – 15 December 1825,
vol. 3 (CM2/A.1)
Register of proceedings, 1825–64, vol. 4 (CM27/A.1)

Fabrique Saint-Charles-Borromée de Charlesbourg fonds
Accounts and proceedings, 1761–1774, vol. 2
Accounts and proceedings, 1775–1841, vol. 3
Authentication of the relic of Saint Charles Borromeo,
15 April 1823

Archives of American Art, Washington Center, Washington, D.C.
Francis Patrick Garvan fonds
Customs declaration, 29 January 1948
Letter from E. Alfred Jones to Francis Patrick Garvan,
1 November 1929

Archives nationales (France)
Archives de la communauté des orfèvres de Paris
*Expéditions sur parchemin des contrats d'apprentissage des
orfèvres,* 18th century
*Liste chronologique des réceptions de maîtres orfèvres
(1620), 1679–1789*
*Registre de la capitation des marchands, orfèvres, joailliers,
tireurs et batteurs d'or, avec leur adresse,* 1782–84
Répertoire alphabétique des marchands orfèvres, joailliers…,
18th century

Minute book of notary Jean Simon Vanin
Certificate of apprenticeship of Jean Simon Pontanneau,
6 February 1761

Minute book of notary Richard Marcel Jarry
Certificate of apprenticeship of Étienne-Thomas Sentinier,
23 September 1761
Certificate of apprenticeship of Jean Joseph André Rouen,
20 June 1761
Certificate of apprenticeship of Jean-Pierre Faÿs, 29 July 1761
Certificate of apprenticeship of Michel Bourget, 13 June 1761
Certificate of apprenticeship of Pierre François Bernard,
8 July 1761

Archives privées de la ville de Lévis
Lionel Saint-George Lindsay fonds

Bibliothèque et Archives nationales du Québec, Quebec City
Famille Chaussegros de Léry fonds (P386)
List of silverware with the prices paid and the years of
acquisition, 1795 (P386, D959)

Fonds Ministère de la Culture et des Communications. Les
grands inventaires nationaux. Inventaire des œuvres d'arts (IOA).

Parish files:
Cap-Santé
Carleton
Charlesbourg
Deschaillons
La Prairie
Les Becquets
L'Islet-sur-Mer
Longueuil
Loretteville
Montreal, Louis-Carrier collection
Neuville
Repentigny
Rivière-Ouelle
Rimouski
Saint-André de Kamouraska
Saint-Charles-de-Bellechasse
Saint-Cuthbert
Saint-Épiphane
Saint-Joachim de Montmorency
Saint-Marc sur Richelieu
Saint-Martin, Ile Jésus
Saint-Michel de Bellechasse
Saint-Pierre de la Rivière du Sud
Saint-Roch des Aulnaies
Sault-au-Récollet

Artists and artisans:
Amiot, Jean
Amiot, Jean-Nicolas
Amiot, Laurent
Delagrave, François
Forton, Michel
Schindler, J.
Smillie, James

François-Baillairgé fonds
Journal of François Baillairgé

Gérard-Morisset fonds (P597)
Jules Bazin correspondence, 1935–59

Minute book of notary Antoine-Archange Parent
Minute no. 255, 21 December 1816
Agreement between Joseph Babineau and Laurent Amiot

Minute no. 521, 5 March 1818
Bond from Laurent Amiot to Louis Gauvreau 200 *livres*

Minute no. 522, 5 March 1818
Bond from Stanislas Amiot to Laurent Amiot 300 *livres*

Minute no. 2055, 13 November 1821
Bond from Jas. Mitchell to Laurent Amiot

Minute no. 2058, 15 November 1821
Bond from Sr François Bélanger to Laurent Amiot

Minute no. 2257, 3 April 1822
Bond from Louis Latouche to Laurent Amiot

Minute no. 2353, 4 June 1822
Obligation veuve from J.-Bte Gaulin to Laurent Amiot

Minute no. 2701A, 2 May 1823
Receipt from Laurent Amiot to Louis Latouche

Minute no. 2784, 31 May 1823
Obligation veuve from Reid to Laurent Amiot

Minute no. 2943, 14 November 1823
Bond from Joseph Dorion to Laurent Amiot

Minute no. 3145, 1 June 1824
Establishment of life annuities from Chs Eusèbe Casgrain to
Laurent Amiot

Minute no. 3469, 13 June 1825
Establishment of life annuities from J.-B. Grenier to
Laurent Amiot

Minute no. 5579, 2 June 1830
Act of recognition from Laurent Amiot and Martin Chinic
regarding François Morin

Minute no. 6011, 16 April 1831
Sale of the rent of Octave alley from J.-B. Vachon to
Laurent Amiot

Minute no. 6033, 7 May 1831
New title from Ls. Emond to Laurent Amiot

Minute no. 6034, 7 May 1831
New title from Ant. Renaud to Laurent Amiot

Minute no. 6416, 2 April 1832
Sale from Laurent Amiot to Nicolas Paradis

Minute no. 6442, 16 April 1832
Conveyance from M. de Tonnancourt to Laurent Amiot

Minute no. 6642, 12 October 1832
Conveyance from Laurent Amiot to Pierre Gauvin

Minute no. 6952, 3 September 1833
Receipt from Laurent Amiot to Elizabeth George

Minute no. 7128, 6 March 1834
Establishment of life annuities from Et. Parent et al. to Laurent Amiot

Minute no. 7308, 29 June 1834
Receipt from Laurent Amiot to Frs. Bâby

Minute no. 7325, 28 July 1834
Transport from Elz. Bédard to Laurent Amiot

Minute no. 7515, 13 March 1835
Will of Monsignor Joseph Signaÿ
Codicil of 10 May 1838

Minute no. 7536, 23 April 1835
Establishment of life annuities from Vital Têtu to Laurent Amiot

Minute no. 7554, 15 May 1835
Waiver from Nicolas Paradis to Laurent Amiot

Minute no. 7581, 24 June 1835
Sale and cession from Laurent Amiot to Narcisse Gravelle

Minute no. 7672, 11 September 1835
Establishment of life annuities from Frs. Bâby to Laurent Amiot

Minute no. 7859, 25 April 1836
Establishment of life annuities from Ambroise Verret to Laurent Amiot

Minute no. 7878, 9 May 1836
Bond from Jacques Voyer to Laurent Amiot

Minute no. 7912, 20 June 1836
Agreement between Pierre Rocheleau and Laurent Amiot

Minute no. 8082, 9 March 1837
Document from Frs. Gourdeau to Laurent Amiot

Minute no. 8201, 19 September 1837
Establishment of life annuities from Frs. Baby to Laurent Amiot

Minute no. 8215, 20 October 1837
Bond from Étienne Parent to Laurent Amiot

Minute no. 8368A, 15 October 1838
Receipt (23 April 1835) from Laurent Amiot to Chs. E. Casgrain et al.

Minute no. 8369A, 15 October 1838
Receipt (9 June 1825) from Laurent Amiot to C.E. Casgrain

Minute no. 8463, 28 May 1839
Bond from Michel Tessier to Laurent Amiot

Minute no. 8479, 2 July 1839
Noël Laurent Amiot, priest, to Frs Sasseville

Minute no. 8930, 14 December 1841
Will of Monsignor Joseph Signaÿ

Minute no. 2143, 10 December 1849
Will of Monsignor Joseph Signaÿ

Minute book of notary Charles Voyer
Minute no. 397, 29 April 1790
Jacques Duval to Laurent Amiot

Minute no. 720, 10 September 1791
Certificate of apprenticeship of Paul Morin with Laurent Amiot

Minute no. 1057, 7 April 1793
Marriage certificate between Laurent Amiot and Marguerite Levasseur, dit Borgia

Minute no. 1145, 16 August 1793
Will of Jean Amiot

Minute no. 1427, 12 January 1795
Certificate of apprenticeship of Jacques-Richard Filteau and Laurent Amiot

Minute book of notary Errol Boyd Lindsay
Minute no. 3421, 4 March 1841
Inventory of the moveable estate of the *Communauté de Biens* of John W. Wolsey and Julie Lemoine

Minute book of notary Jacques Nicolas Pinguet
Unnumbered minute, 11 May 1790
Bond from Laurent Amiot to Alexander Gray

Minute book of notary Jean-Claude Louet
Minute of 9 February 1767
Certificate of apprenticeship of Jean Nicolas Amiot with S. Schindler

Minute book of notary Joseph Bernard Planté
Minute no. 66, 12 May 1790
Cancellation of the agreement between Paul Morin and Louis Robitaille, 27 June 1791

Minute no. 1665, 19 February 1798
Inventory of the estate of the late Monsieur and Madame Joseph Gaspard Chaussegros de Léry

Minute no. 1278, 11 August 1796
Receipt by M. Berthelot Dartigny on behalf of the Honourable Thomas Dunn to Mr. Laurent Amiot

Minute no. 2508, 8 November 1800
Inventory of the property owned jointly by the late Jacques Duperron Bâby and Suzanne Réaume, his widow

Minute no. 2793, 27 August 1801
Will of Jean Amiot

Minute book of notary Louis Huguet Latour
Minute no. 540, 14 June 1810
Agreement between Pierre Huguet *dit* Latour and Salomon Marion

Neilson fonds (P192)
Folder 135-141
Folder 142-158, document 152
Invoice from Richard Clarke & Sons, 18 November 1817
Printing Office Memorandum Commenced 1 October 1822

Canadian Guild of Crafts (formerly the Canadian Handicrafts Guild), Archives, Montreal
Letter from Marius Barbeau to Helen I. Drummond, 16 January 1940

Canadian Museum of History, Gatineau
Marius-Barbeau fonds
B120 F2: Argenterie – Silversmiths file
B120 F4: Marium Barbeau, catalogue raisonné of Quebec silver
B174: Fieldwork expenses 1946
B214 F32: Lionel Lindsay
B229 F31: John Marshall Phillips correspondence (1936–40)
B233 F1: E.P. Richardson correspondence
B275 F2: Silverware (notes)
B275 F3: Silverware (notes)
B275 F8: New Information (1/2)
B276 F1: Silverware-1
B276 F11: Canadian silverware
B277 F5: Montreal silversmith – recent: Hendery, Savage, Birks
B277 F13: Parish silver
B277 F15: Silverware
B277 F19: Laurent Amiot and his works
B278 F6: Photostats
B278 F8: Typed parish notes (silverware)
B278 F9: Original receipts for payments for silverware
B278 F10: Specimens: instruments, stamps, marks, silversmithing
B279 F5: Silverware – ciboria – chalices
B279 F19: Partial transcription of the accounts of the parish of Sainte-Anne-de-la-Pérade
B316 F2: Parish and communities: Basilique Notre-Dame de Québec
B316 F6: Parish and communities: Séminaire de Québec
B318 F3: Parish and communities: Saint-Charles de Bellechasse
B319 F6: Parish and communities: Saint Joachim
B319 F14: Saint-Étienne de La Malbaie
B320 F1: Saint-Vallier
B320 F11: Rivière-Ouelle
B323 F12: Parish and communities: Grondines
B324 F3: Parish and communities: Cap-de-la-Madeleine
B332 F3: Field notes, Quebec: Archives du Grand Séminaire de Québec
B332 F4: Field notes, Lorette, August 1919 (Charlesbourg, Quebec, St-Joachim…)
B338 F15: Folklore surveys, summer 1946
B349 F1: Exhibition of Architecture and Allied Arts, 1935 [Art Gallery Toronto]
B354 F6: History of Canada: *Piastres et sous*
B354 F9: Old manuscripts

Côte du Sud, Archives, La Pocatière
Fabrique Saint-Denis-de-la-Bouteillerie (Kamouraska) fonds
Book of proceedings of the parish (begun in October 1841)

Fabrique de Deschaillons, Archives
Account book, 1788, vol. 1.

Fabrique de la Nativité de la Bienheureuse Vierge Marie, Bécancour, Archives
Elections of churchwardens, parish meetings, etc., 1833–52, vol. 3

Fabrique de la Purification-de-la-Bienheureuse-Vierge-Marie, Repentigny, Archives
Account book, 1756–1877

Fabrique L'Islet-sur-Mer, Archives
Account book, 1831, vol. 3

Journal of Abbé Jacques Panet

Fabrique Notre-Dame de Liesse, Archives, Rivière-Ouelle
Account book, 1796

Fabrique Saint-Ambroise-de-la-Jeune-Lorette, Archives
Book of receipts, expenses and other business concerning the parish of Saint-Ambroise-de-la-Jeune-Lorette (begun in 1796)

Fabrique Saint-André de Kamouraska, Archives
Register of accounts, 1791–1866

Fabrique Saint-Anselme, Archives
Account book, 1830–42, vol. 1

Fabrique Saint-Antoine de la Baie-du-Febvre, Archives
Account book, 1734–1810, vol. 1

Fabrique Saint-Charles-de-Bellechasse, Archives
Accounts and proceedings, 1750–1859, vol. 1

Fabrique Saint-Cuthbert, Archives
Book of proceedings, 1787–1878, vol. 1

Fabrique Saint-Étienne de Beaumont, Archives
Account book, 1024

Fabrique Sainte-Famille de Cap-Santé, Archives
Accounts and proceedings, 1714–1812, vol. 1

Fabrique Saint-François de Montmagny, Archives
Account book no. 3, 1790–1871

Fabrique Saint-Joachim de Montmorency, Archives
Account book, 1784–1814, vol. 2

Declaration of churchwardens, 24 January 1789

Fabrique Saint-Martin, Archives
Account book, 1820, vol. 1

Fabrique Saint-Michel de Bellechasse, Archives
Accounts and proceedings, 1806

Fabrique Saint-Pierre et Saint-Paul de la Baie Saint-Paul, Archives
Parish accounts, 1826–1940

Fabrique Saint-Roch de Québec, Archives
Documents, B-1

List of items given to the parish of Saint-Roch de Québec by Monsignor Plessis, 13 October 1829, miscellaneous documents

Fabrique Saint-Roch des Aulnaies, Archives
Parish accounts and proceedings, 1781–1860

The Goldsmiths' Company, Archives, London
Edward Alfred Jones folder
Letter from John Marshall Phillips to George R. Hughes, 25 July 1944

Library and Archives Canada, Ottawa
Federal census of 1901, district of Lévis / town of Lévis
sub-district (district 164) C11, p. 4, line 16

Letter from E. Alfred Jones to Arthur Doughty, Arthur Doughty
papers, 6 October 1914 (RG37)

Monsieur Hocquart concerning the sale of the effects of
M. Dupuy, former intendant, detailed inventory of the sale of his
effects, October 1731, vol. 55 (MG1, C11A)

Literary and Historical Society of Quebec, Archives
General Accounts, 1827–75 / Society for the Encouragement
of Arts and Sciences (L1D11)

The Metropolitan Museum of Art, New York
American Wing, Laurent Amiot beaker (33.120.102)
 Letter from Louis Carrier to C. Louise Avery, 5 July 1944

Missions Étrangères de Paris, Archives
Expenses, 1776–87 (1519)

Expenses, 1776–92 (1543)

History of the Séminaire de Québec (0345)

Revenue and expenses, 1827–44 (1544)

Statements of accounts, 1771–1827 (1542)

**Monastère des Augustines de l'Hôpital Général de Québec,
Archives, Quebec City**
Account book, 1718

**Monastère des Augustines de l'Hôtel-Dieu de Québec,
Archives**
Annals of l'Hôtel-Dieu de Québec, 4 April 1877 – 21 April 1888,
vol. 3

Montreal Museum of Fine Arts, Archives
David Y. Hodgson, loan file, 1959 (A1549)

French Canadian Arts Exhibition, Art Association of Montreal,
25 June – 28 August 1955, no. 64, exhibition list

**Musée de la civilisation, Service des collections, des
archives historiques et de la bibliothèque, Quebec City**
Archives du Séminaire de Québec
 Accounts, 1845–49
 Draft, expenses, 1815–23
 Former bishops of Quebec folder, vol. 1, 6 October 1685
 Inventory of the possessions of Monsignor Briand, 1794,
 bishops folder, no. 99
 Journal, 1776–1825
 Journal, 1810–21
 Journal de la Dépense du Séminaire des Missions Étrangères
 établies à Québec, 1753–80
 Letters, Box O, no. 126, 25 February 1811
 Letters, Box P, no. 22, 7 February 1787
 Letters, Box P, no. 29, 22 May 1783
 Letters, Box P, no. 35, 30 January 1785
 Minute book, 8 November 1852
 Polygraphy 23, nos. 38 a,b,c (n.d., 22 December 1849;
 17 December 1850; 12 December 1851)
 Polygraphy 30, no. 14, 1854?
 Polygraphy 46, no. 11L, 21 January 1816
 Seminary 130, no. 217, 10 July 1839
 Seminary folder, 75, 13 August 1846
 Student list: Amiot, Laurent

**Musée national des beaux-arts du Québec, Curatorial
Archives, Quebec City**
*Exposition de la Province de Québec (Visages du Canada –
Vallée du Saint-Laurent),* Grands Magasins du Louvre, Paris,
17 January – 28 February 1958, Exhibition list

Jules Bazin fonds
 Correspondence with Gérard Morisset (1935–65)

National Archives of Scotland, Edinburgh
Dalhousie fonds (GD45-3-577)
 Personal account book of Lord Dalhousie, 1825–28

The National Archives (United Kingdom), Richmond
Colonial Office (42)
 Lord Dorchester to Lord Grenville, 21 June 1791 (no. 92)
 Petition for a University, 31 October 1790 (no. 71)

National Gallery of Canada, Library and Archives, Ottawa
Henry Birks Collection of Canadian Silver fonds
 Letter from John E. Langdon to Helen I. Drummond,
 22 August 1968
 Letter from Helen I. Drummond to John E. Langdon,
 28 August 1968
 Letter from John E. Langdon to Helen I. Drummond,
 3 September 1968

Thomas Fisher Rare Book Library, University of Toronto
John E. Langdon fonds
 Letter from Gérard Morriset to John E. Langdon,
 6 November 1944, box 12, file 6
 Notebook of E. Alfred Jones, 1912, box 15, file 13

Louis Melzac Collection, box 4, item 3 (MS 210)
 The Neilson Paybook, 1793–98.

**Université Laval, Bibliothèque des sciences humaines et
sociales, thèses et livres rares, Quebec City**
Old Silver in the Archevêché, the Seminary and the Basilica
at Quebec

Old Silver in the Seminary at Quebec

Victoria and Albert Museum, London
Silver Department
 Acquisitions register, M568-1916 to M21-1920

Ville de Québec, Archives
Finance, assessment and tax ledger, 1821

Joseph Hamel, *Plan of the Widening of Mountain Hill,*
2 September 1851 (DO1278/DO1279)

II. BOOKS AND ARTICLES

L'Abeille (Quebec City), 25 April 1878.

Album souvenir de la Basilique Notre-Dame de Québec. Quebec
City: s.n., 1923.

Allaire, Jean-Baptiste. *Dictionnaire biographique du clergé
canadien-français. Les anciens.* Montreal: Imprimerie de l'École
catholique des sourds-muets, 1910.

Arminjon, Catherine, ed. *L'art du métal: vocabulaire technique.*
Paris: Caisse nationale des monuments historiques et des
sites, 1998.

Aubert de Gaspé, Philippe. *Les anciens Canadiens.* Montreal:
Fides, 1970 [1864], Bibliothèque canadienne-française series.

Avery, C. Louise. *American Silver of the XVII & XVIII Centuries:
A Study Based on the Clearwater Collection.* New York:
The Metropolitan Museum of Art, 1920.

Baillairgé, George Frederick. *Notices biographiques, fascicule
n°1, Jean Baillairgé, 2ᵐᵉ du nom (souche des Baillairgé du
Canada) 1726 à 1805, ses ancêtres et ses descendants
(vue d'ensemble) 1645 à 1892.* Joliette: Bureau de l'étudiant,
du couvent et de la famille, 1891.

Bender, P. *Old and New Canada. 1753–1844. Historic Scenes
and Social Pictures, or The Life of Joseph-François Perreault.*
Montreal: Dawson Brothers, Publishers, 1882.

*A book of eighteen leaves containing divers subjects for the use
of goldsmiths, chasers, carvers, etc. / from Messrs. Germain,
Messonnier, Sig. Cattarello &c.* London: To be had of the
proprietor Robt. Clee at the Golden Head in Panton Street,
St. James's Hay Market, & at the printsellers in London, 1757.

Brephol, Erhard. *The Theory and Practice of Goldsmithing.*
Translated by Charles Lewton-Brain. Edited by Tim McCreight.
Portland, Maine: Brynmorgen Press, 2001.

Le Canadien 9, no. 30 (29 July 1839), p. 2.

Canadian Handicrafts Guild Annual Report for the Year 1940.
Montreal: s.n., 1941.

Casgrain, H.R. *Une excursion à l'Île aux Coudres.* Montreal:
Librairie Beauchemin limitée, 1885.

Casgrain, René-E. *Histoire de la paroisse de l'Ange-Gardien.*
Quebec City: Dussault & Proulx, 1902.

*Catalogue des manuscrits et des imprimés en langues sauvages
ainsi que des reliques indiennes, exposés à Québec à l'occasion
du XVᵉ Congrès international des américanistes.* Exhibition
catalogue. Quebec City: Dussault & Proulx, 1906.

Catalogue of Fine English and Foreign Silver and Plate.
Exhibition catalogue. Sotheby's, New Bond Street, London,
July 1970.

*Catalogue of the Fifth Biennial Exhibition of Architecture and
Allied Arts: Toronto Chapter, Ontario Association of Architects.*
Toronto: The Art Gallery of Toronto, 1935.

The Charles de Volpi Collection of Canadian Silver. Catalogue of
the sale held 18 May 1979, Phillips Ward-Price Limited, Toronto.

Chaumonot, Pierre-Joseph-Marie. *Notre-Dame de Lorette et le
père Chaumonot / choix des textes, Gilles Drolet.* Sainte-Foy:
Anne Sigier, 1985.

Christie's, Manson & Wood. *Catalogue of Miscellaneous Books
chiefly on material history the property of colonel V.C.S.
Williams, O.B.E., Standard Works on Old Plate the property of
E. Alfred Jones Esq. deceased (sold by the Order of the
Executors…),* London, 25 July 1944.

Clayton, Michael. *The Collector's Dictionary of the Silver and
Gold of Great Britain and North America.* New York and
Cleveland: The World Publishing Company, 1971.

Corbeil, Gilles. "Collections et collectionneurs canadiens:
Louis Carrier." *Art et pensées,* no. 16 (April 1954), pp. 115–118.

Demers, Benjamin. *Quelques notes historiques sur les
missionnaires, curés, desservants et vicaires de la paroisse de
Saint-François de Sales de Neuville dite La Pointe-aux-Trembles.*
Quebec City: Imprimerie de l'Action Sociale, 1915.

De Robillard de Beaurepaire, Charles. *Inventaire-sommaire des
archives départementales antérieures à 1790. Seine-inférieure.
Archives ecclésiastiques, série G,* vol. 5. Rouen: Imprimerie
Julien Lecerf, 1892.

Drolet, Antonio. *La Ville de Québec: histoire municipale,* vol. 3.
Quebec City: La Société historique de Québec, 1967.

Drolet, Gustave. *Zouaviana,* 2nd edition. Montreal: Eusèbe
Sénécal & Cie, imprimeurs-éditeurs, 1898.

Faris, William. *The Diary of William Faris: The Daily Life of an
Annapolis Silversmith.* Edited by Mark B. Letzer and Jean B.
Russo. Baltimore, MD: Press at the Maryland Historical Society,
2003.

Forbes, Esther. *Paul Revere and the World He Lived In.* Boston:
Houghton Mifflin Company, 1942.

The French in America, 1520–1880. Exhibition catalogue.
Detroit: The Detroit Institute of Arts, 1951.

Gagnon, Philéas. *Essai de bibliographie canadienne,* vol. 1.
Quebec City: Imprimerie générale A. Côté et Cie, 1895.

Gagnon, Philéas. "Graveurs canadiens." *Bulletin des recherches
historiques* (Lévis) 2, no. 7 (July 1896), pp. 108–109.

Gale, George. *Quebec 'Twixt Old and New.* Quebec City:
The Telegraph Printing Co., 1915.

La Gazette de Québec, no. 732 (9 September 1779), p. 3.

La Gazette de Québec, no. 776 (13 July 1780), p. 4.

La Gazette de Québec, no. 819 (7 May 1781), p. 1.

La Gazette de Québec, no. 818 (10 May 1781), p. 2.

La Gazette de Québec, no. 824 (21 June 1781), n.p.

La Gazette de Québec, no. 825 (28 June 1781), p. 2.

La Gazette de Québec, no. 832 (16 August 1781), p. 3.

La Gazette de Québec, no. 837 (20 September 1781), p. 3.

La Gazette de Québec, no. 857 (7 February 1782), p. 3.

La Gazette de Québec, no. 948 (23 October 1783), p. 3.

La Gazette de Québec, no. 981 (17 June 1784), p. 3.

La Gazette de Québec, no. 1361 (18 August 1791).

La Gazette de Québec, no. 1481 (28 November 1793).

La Gazette de Québec, no. 1492 (13 February 1794).

La Gazette de Québec, no. 1504 (4 June 1795).

La Gazette de Québec, no. 1601 (11 February 1796), p. 3.

La Gazette de Québec, no. 1602 (18 February 1796), p. 4.

La Gazette de Québec, no. 1603 (25 February 1796), p. 3.

La Gazette de Québec, no. 1767 (21 March 1799).

La Gazette de Québec, no. 1799 (10 July 1799).

La Gazette de Québec, no. 1824 (10 April 1800).

La Gazette de Québec, no. 1881 (14 May 1801).

La Gazette de Québec, no. 2044 (14 June 1804).

La Gazette de Québec, no. 2000 (27 June 1805).

La Gazette de Québec, no. 2146 (12 June 1806)

La Gazette de Québec, no. 2202 (9 July 1807).

La Gazette de Québec, no. 2253 (30 June 1808).

La Gazette de Québec, no. 2317 (14 September 1809).

La Gazette de Québec, no. 2650 (16 November 1815), p. 4.

La Gazette de Québec, no. 2652 (30 November 1815), p. 4.

La Gazette de Québec, no. 2653 (7 December 1815), p. 8.

La Gazette de Québec, no. 2656 (28 December 1815), p. 4.

La Gazette de Québec, no. 3016 (5 June 1820).

La Gazette de Québec, no. 3031 (27 July 1820), supplement, p. 5.

La Gazette de Québec, no. 3319 (21 April 1823).

La Gazette de Québec, no. 8747 (14 May 1827), p. 1.

La Gazette de Québec 4, no. 32 (17 May 1827), pp. 3 and 6.

La Gazette de Québec, no. 4806 (19 March 1832), p. 2.

La Gazette de Québec, no. 4807 (21 March 1832), p. 2.

La Gazette de Québec, no. 4815 (9 April 1832), p. 3.

La Gazette de Québec, no. 5403 (6 June 1839), p. 2.

The Gazette (Montreal) 42, no. 103 (4 September 1834), p. 2.

Gleason, Thomas Henri. *The Quebec Directory for 1822 containing an alphabetical list of the merchants, traders and house keepers.* Quebec City: Neilson and Cowan, 1822.

Gottesman, Rita Susswein. *The Arts and Crafts in New York, 1726–1776.* New York: The New York Historical Society, 1938.

Le Journal de Québec (9 April 1832).

Le Journal de Québec (10 October 1846), p. 2.

Le Journal de Québec (26 October 1850), p. 2.

Le Journal de Québec (7 June 1853), p. 2.

Le Journal de Québec (14 June 1853), p. 3.

Le Journal de Québec (1 March 1864), p. 3.

Le Journal de Québec (17 March 1864), p. 3.

Lindsay, Lionel Saint-George. *Notre-Dame de la Jeune-Lorette en la Nouvelle-France: étude historique.* Montreal: La C^ie de Publication de la Revue Canadienne, 1900.

Mackay, Hugh. *The Directory for the City and Suburbs of Quebec.* Quebec City: William Moore, 1790.

Mandements, lettres pastorales et circulaires des évêques de Québec, vol. 1. Quebec City: Imprimerie générale A. Côté et Cie, 1887.

Marcil, Eileen Reid. *L'héritage d'Elizabeth Davie, première femme constructeur de navires au Canada.* Quebec City: Les Éditions GID, 2017.

Massicotte, E.Z. "Dominique Rousseau, maître orfèvre et négociant en pelleteries." *Bulletin des recherches historiques* 10, no. 11 (November 1913), pp. 342–348.

Massicotte, E.Z. "Les tabatières de nos grands-parents." *Bulletin des recherches historiques* 49, no. 7 (January 1943), pp. 10–13.

Meissonnier, Juste-Aurele. *Œuvre de Juste Aurèle Meissonnier, peintre sculpteur architecte &c: dessinateur de la chambre et cabinet du Roy / Première partie exécutée sous la conduite de l'auteur.* Paris: Chez Charles Huquier, c. 1750.

Metalwork trade catalogue. Sheffield, UK: s.n., c. 1790s?.

La Minerve 4, no. 73 (24 October 1831), p. 12.

Modèles d'orfèvrerie, choisis à l'exposition des produits de l'industrie française au Louvre, en 1819…. Paris: Chez Bance aîné, 1822.

Morin, Edgar. "Il y a 120 ans, trois navires s'échouent au même endroit." *Le Petit Journal* (8 March 1953), p. 5.

Murray, Irena and Blackader-Lauterman Library of Architecture and Art. *Ramsay Traquair and His Successors: Guide to the Archive.* Montreal: The Collection, 1987.

Nocq, Henry. *Le poinçon de Paris: répertoire des maîtres-orfèvres de la juridiction de Paris depuis le moyen-âge jusqu'à la fin du XVIIIᵉ siècle*, vol. 3. Paris: H. Floury, 1928.

Plessis, Joseph Octave. "Les dénombrements de Québec." In *Rapport de l'archiviste de la province de Québec pour 1948–1949.* Quebec City: Redempti Paradis, 1949, pp. 26, 76, 125, 177.

Pontificale Romanum: Summorum Pontificum. Mechliniae: Dessain, 1892.

Prescott, Winward. *A List of Canadian Bookplates: With a review of the history of ex libris in the Dominion.* Boston/Toronto: Society of Bookplate Bibliophiles, 1919.

The Quebec Mercury 20, no. 81 (16 October 1824), p. 2.

The Quebec Mercury 32, no. 2 (5 January 1836).

The Quebec Mercury 35, no. 66 (4 June 1839), p. 3.

Radio-Collège 1941–42. Société Radio-Canada.

Recueil de planches, sur les sciences, les arts libéraux, et les arts mécaniques, avec leur explication. Paris: Cercle du Livre Précieux, 1964–66.

Roy, Élias. *Le collège de Lévis. Biographie. Mgr Lionel St-Georges Lindsay.* Lévis: La compagnie de publication de Lévis, 1921.

Roy, J. Edmond. *Histoire de la seigneurie de Lauzon*, vol. 5. Lévis: the author, 1904.

Roy, Pierre-Georges. "La Famille de Jean Amyot." *Bulletin des recherches historiques* 25, no. 8 (August 1919), pp. 232–234.

Roy, Pierre-Georges. "L'ameublement d'un seigneur canadien sous l'Ancien Régime." In *Rapport de l'archiviste de la province de Québec pour 1921–1922.* Quebec City: Louis-Amable Proulx, 1922.

Roy, Pierre-Georges. "Les canotiers entre Québec et Lévis." *Bulletin des recherches historiques* 48 (1942), p. 324.

Roy, Pierre-Georges. *La famille Chaussegros de Léry.* Lévis: s.n., 1934.

Roy, Pierre-Georges. *Glanures lévisiennes*, vol. 1. Lévis: s.n., 1920.

A Selection from the Louis Carrier Collection of Canadian Silver. Exhibition catalogue. Windsor: Windsor Art Gallery, 1953.

Signaÿ, Joseph. *Recensement de la ville de Québec en 1818.* Quebec City: La Société historique de Québec, 1976, Cahiers d'histoire series, no. 20.

Smith, John. *The Quebec Directory, or Strangers Guide in the City for 1826.* Quebec City: T. Cary & Co., 1826.

"Testaments et inventaire des biens (1760) de Mgr de Pontbriand, dernier évêque de Québec sous le régime français." In *Rapport de l'archiviste de la province de Québec pour 1957–1958 et 1958–1959.* Quebec City: Rédempti Paradis, 1959, pp. 359–370.

Têtu, Henri. "L'Abbé André Doucet, curé de Québec, 1807–1814." *Bulletin des recherches historiques* 13, no. 1 (1907), pp. 3–22.

Têtu, Henri. *Histoire du palais épiscopal de Québec.* Quebec City: Pruneau & Kirouac, 1896.

Thiéry, Luc Vincent. *Guide des amateurs et des étrangers voyageurs à Paris*, vol. 2. Paris: Chez Hardouin & Gattey, 1787.

"Très humble requête des citoyens de la ville de Québec (1787)." *Rapport de l'archiviste de la province de Québec*, 1944–45, plate 2.

Trudelle, Charles. *Paroisse de Charlesbourg.* Quebec City: Imprimerie générale A. Côté et Cie, 1887.

Tudor & Leader catalogue. Sheffield, UK: The Company, c. 1761–1816.

Les Ursulines des Trois-Rivières: depuis leur établissement jusqu'à nos jours, vol. 3. Montreal: A.P. Pigeon, 1898.

Whitelaw, Marjorie. *The Dalhousie Journals*, vol. 3. Ottawa: Oberon Press, 1982.

B. SECONDARY SOURCES

BOOKS AND ARTICLES

Un âge d'or des arts décoratifs, 1814–1848. Exhibition catalogue. Paris: Galeries nationales du Grand Palais / Réunion des musées nationaux, 1991.

Aigrin, René, ed. *Liturgia. Encyclopédie populaire des connaissances liturgiques*. Paris: Bloud et Gay, 1947.

Alcouffe, Daniel. "La naissance de la table à manger au XVIIIe siècle." In *La table et le partage* (Rencontres de l'École du Louvre). Paris: La documentation française, 1986, pp. 57–65.

Allodi, Mary. *Printmaking in Canada: The Earliest Views and Portraits / Les débuts de l'estampe imprimée au Canada: vues et portraits*. Exhibition catalogue. Toronto: Royal Ontario Museum, 1980.

Allodi, Mary Macaulay, Peter N. Moogk and Beate Stock. *Berczy*. Exhibition catalogue. Ottawa: National Gallery of Canada, 1991.

Allodi, Mary Macaulay and Rosemarie L. Tovell. *An Engraver's Pilgrimage: James Smillie in Quebec, 1821–1830*. Exhibition catalogue. Toronto: Royal Ontario Museum, 1989.

L'Anjou religieux et les orfèvres du XIXe siècle. Exhibition catalogue. Nantes: Commission régionale Pays de la Loire, 1983.

L'art au Canada. Exhibition catalogue. Bordeaux: Musée de Bordeaux, 1962.

The Arts in French Canada. Exhibition catalogue. Vancouver: Vancouver Art Gallery, 1959.

The Arts of French Canada, 1613–1870. Exhibition catalogue. Detroit: City of Detroit Printing Division, 1946.

Barbeau, Marius. "Deux cents ans d'orfèvrerie chez nous." In *Mémoires de la Société Royale du Canada*, third series, vol. 33, no. 1 (1939), pp. 183–191.

Barbeau, Marius. "Old Canadian Silver." *Canadian Geographical Journal* 22, no. 1 (March 1941), pp. 150–162.

Barquist, David L. *Myer Myers Jewish Silversmith in Colonial New York*. New Haven and London: Yale University Press, 2001.

Barquist, David L. "Refinement in the Illinois Country: Louis Robitaille's Sugar Dish." *Yale University Art Gallery Bulletin* (2004), pp. 58–67.

Barr, Elaine. *George Wickes, 1698–1761, Royal Goldsmith*. New York: Rizzoli, in association with Christie's, 1980.

Beaubier, Don. *Precious Metal: Historic Silver from Newfoundland Churches*. Exhibition catalogue. St. John's: Art Gallery of Newfoundland and Labrador, 1997.

Beaudry, Martine. *Saint-Marc-sur-Richelieu, 1792–1992*. Saint-Marc-sur-Richelieu: Fabrique de Saint-Marc-sur-Richelieu, 1992.

Berthod, Bernard and Elisabeth Hardouin-Fugier. *Dictionnaire des arts liturgiques: XIXe – XXe siècles*. Paris: Éditions de l'Amateur, 1996.

Bidault, Paul. *Étains religieux XVII, XVIIIe et XIXe siècles*. Paris: Charles Massin, n.d.

Birmingham Assay Office. *Matthew Boulton and the Toymakers: Silver from the Birmingham Assay Office*. Exhibition catalogue. London: Worshipful Company of Goldsmiths, 1983.

Blair, Claude. *The History of Silver*. London: Orbis, 1987.

Blondel, Nicole. "L'utilité des objets de la table." In *La table et le partage* (Rencontres de l'École du Louvre). Paris: La documentation française, 1986, pp. 79–88.

Bradbury, Frederick. *History of Old Sheffield Plate*. London: Macmillan and Co. Limited, 1912.

Brassard, Gérard. *Armorial des évêques du Canada: album historico-héraldique contenant les portraits et les armoiries des évêques du Canada depuis Mgr de Montmorency de Laval jusqu'à date, avec notice biographique pour chacun*. Montreal: Mercury Publishing Co., 1940.

Brault, Solange and Yves Bottineau. *L'orfèvrerie française du XVIIIe siècle*. Paris: Presses universitaires de France, 1959.

Bressani, Martin and Marc Grignon. "Une protection spéciale du ciel: le décor de l'église de Saint-Joachim et les tribulations de l'église catholique québécoise au début du XIXe siècle." *The Journal of Canadian Art History / Annales d'histoire de l'art Canadien* 29 (2008), pp. 8–47.

Carbonnier, Youri. "Le cœur de Paris à la veille de la Révolution: Étude de géographie sociale." *Histoire urbaine* 2, no. 6 (2002), pp. 43–68.

Castonguay, Émile. *Le journal d'un bourgeois de Québec*. Quebec City. s.n., c. 1960.

Cauchon, Michel. "L'Inventaire des Œuvres d'Art." In *À la découverte du patrimoine avec Gérard Morisset*. Exhibition catalogue. Quebec City: Ministère des affaires culturelles, 1981, pp. 35–44.

Chabot, Richard. "Amiot, Noël-Laurent." In *Dictionary of Canadian Biography*, vol. 7. University of Toronto / Université Laval, 2003–, www.biographi.ca/en/bio/amiot_noel_laurent_7E.html (accessed 8 May 2015).

Chagnon, Joanne. "Orfèvrerie de l'église Saint-Joseph de Deschambault." In *Les chemins de la mémoire*, vol. 3, *Biens mobiliers du Québec*. Quebec City: Les publications du Québec, 1999, pp. 64–66.

Chassé, Sonia. "Signaÿ, Joseph." In *Dictionary of Canadian Biography*, vol. 7, University of Toronto / Université Laval, 2003–. www.biographi.ca/en/bio/signay_joseph_7F.html (accessed 3 November 2017).

Chassé, Sonia, Rita Girard-Wallot and Jean-Pierre Wallot. "Neilson, John." In *Dictionary of Canadian Biography*, vol. 7, University of Toronto / Université Laval, 2003–. www.biographi.ca/en/bio/neilson_john_7E.html (accessed 3 November 2017).

Clifford, Helen. "The Myth of the Maker: Manufacturing Network in the London Goldsmiths' Trade, 1750–1790." In Kenneth Quickenden and Neal Adrian Quickenden, eds. *Silver and Jewellery: Production and Consumption since 1750*. Birmingham: University of Central England, 1995, pp. 5–12.

Clifford, Helen. *Silver in London: The Parker and Wakelin Partnership, 1760–1776*. New Haven: Yale University Press for the Bard Graduate Center for Studies in the Decorative Arts, Design and Culture, 2004.

Cloulas, Ivan. *Jules II: le pape terrible*. Paris: Fayard, 1990.

Collard, Elizabeth. *Nineteenth-Century Pottery and Porcelain in Canada*, 2nd. ed. Kingston and Montreal: McGill-Queen's University Press, 1984.

The Connoisseur 109, no. 484 (June 1942), pp. 171–172.

Corbeil, Gilles. "Collections et collectionneurs canadiens: Louis Carrier." *Arts et pensées* (April 1954), pp. 115–118.

Courville, Serge and Robert Garon. "Un exemple de rue historique: La Côte de la Montagne." In *Québec, ville et capitale*. Sainte-Foy: Presses de l'Université Laval, 2001, pp. 348–363.

Crosskey, Gordon. *Old Sheffield Plate: A History of the 18th Century Plated Trade*. Sheffield: Treffry Publishing, 2011.

Culme, John. "Rundell, Bridge et Rundell et le commerce londonien de l'orfèvrerie." In *Orfèvrerie au XIXe siècle*. Proceedings of the international symposium held at the Galeries nationales du Grand Palais, Paris, 12–13 December 1991. Paris: La documentation française, 1994, pp. 115–122.

"Curators's Choice: A Portfolio of Personal Pets from the National Gallery of Canada." *City and Country Home* (May 1988), pp. 45–50.

Cyr, Céline. "Hertel de Rouville, Jean-Baptiste Melchior." In *Dictionary of Canadian Biography*, vol. 5. Toronto: University of Toronto / Quebec City: Université Laval, 1983, pp. 421–422.

David, L.O. *Monseigneur Plessis*. Montreal: G.E. Desbarats, 1872.

Delieb, Eric. *The Great Silver Manufactory: Matthew Boulton and the Birmingham Silversmiths, 1760–1790*. London: Studio Vista, 1971.

Derome, Robert. "Delezenne, Ignace-François." In *Dictionary of Canadian Biography*, vol. 4, University of Toronto / Université Laval, 2003–. www.biographi.ca/en/bio/delezenne_ignace_francois_4E.html (accessed 3 November 2017).

Derome, Robert. "Forton, Michel." In *Dictionary of Canadian Biography*, vol. 5, University of Toronto / Université Laval, 2003–, www.biographi.ca/en/bio/forton_michel_5E.html (accessed 9 November 2017).

Derome, Robert. "Ramsay Traquair: The History of Silver in Quebec and the McGill University Archives." In *Ramsay Traquair and His Successors: A Guide to the Archive*, vol. 1. Montreal: McGill University, Blackader-Lauterman Library of Architecture and Art, Canadian Architecture Collection, 1987, pp. 78–105.

Derome, Robert. "Schindler, Joseph (Jonas)." In *Dictionary of Canadian Biography*, vol. 4. Toronto: University of Toronto / Quebec City: Université Laval, 1979, pp. 702–703.

Derome, Robert and José Ménard. "Ranvoyzé, François." In *Dictionary of Canadian Biography*, vol. 5. Toronto: University of Toronto / Quebec City: Université Laval, 1983, pp. 707–710.

Deslandres, Dominique et al. *Les Sulpiciens de Montréal: une histoire de pouvoir et de discretion, 1657–2007*. Montreal: Fides, 2007.

The Development of Canadian Silver: A Winnipeg Centennial Exhibition. Exhibition catalogue. Winnipeg: Winnipeg Art Gallery, 1974.

Dion-Tenenbaum, Anne. "Jean-Charles Cahier et l'orfèvrerie religieuse." In *Orfèvrerie au XIXe siècle*. Proceedings of an international colloquium held at the Galeries nationales du Grand Palais, 12–13 December 1991. Paris: La documentation française, 1994, pp. 17–37.

Dion-Tenenbaum, Anne. *Orfèvrerie du XIXe siècle. La collection du Musée du Louvre*. Paris: Musée du Louvre and Somogy, 2011

Dion-Tenenbaum, Anne. "Orfèvrerie du sacre de Charles X." In *Un âge d'or des arts décoratifs*. Paris: Galerie nationales du Grands Palais, 1990.

"Don d'une remarquable *Cafetière* au Musée: L'histoire d'un trésor de famille." *Contact. Le bulletin des membres du Musée des beaux-arts du Canada* (winter 1996), p. 1.

Drolet, Antonio. *La ville de Québec: histoire municipale*, vol. 3. Quebec City: La Société historique de Québec, 1967.

Drolet, Gustave. *Zouaviana*, second edition. Montreal: Eusèbe Sénéchal & Cie, imprimeurs-éditeurs, 1898.

Dubois, Marcel. *Cérémonial des servants et du clergé*. Quebec City: Imprimerie Charrier et Dugal, 1952.

Edwards, Diana. *Black Basalt: Wedgwood and Contemporary Manufacturers*. Woodbridge, Suffolk: Antique Collectors Club, 1994.

L'Église Sainte-Marie, 1905–2005, Pointe-de-l'Église, Nouvelle-Écosse. Yarmouth: Sentinel Printing Limited, 2005.

Exhibition of Canadian Handicrafts, 1905. Exhibition catalogue. Montreal: Woman's Art Association, 1905.

Exposition rétrospective de l'art au Canada français / The arts in French Canada. Exhibition catalogue. Quebec City: Québec Chronicle-Telegraph, 1952.

Fairbairn, James. *Fairbairn's Book of Crests of the Families of Great Britain and Ireland*. London: T.C. & E.C. Jack, 1905.

Fennimore, Donald L. and Patricia A. Halfpenny. *Campbell Collection of Soup Tureens at Winterthur*. Winterthur, DE: Henry Francis du Pont Winterthur Museum, c. 2000.

Forbes, Henry A. Crosby. *Chinese Export Silver, 1785 to 1885*. Milton, Mass.: Museum of the American China Trade, 1975.

Fox, Ross. "English Silversmiths and Goldsmiths in Canada during the Eighteenth Century." *Silver Studies*, no. 26 (2010), pp. 69–74.

Fox, Ross. "The Immigrant Element in Quebec City's Precious Metals and Stones Trades during the 1820s." *Silver Society of Canada* 17 (2014), pp. 4–15.

Fox, Ross. "Robert Cruickshank (1743–1809), Silversmith of London and Montreal." *Silver Studies: The Journal of the Silver Society* 23 (2008), pp. 83–98.

Fox, Ross. "Silver Standard." *Rotunda* (ROM magazine) 37, no. 3 (spring 2005), pp. 32–39.

Fox, Ross. "The Silverware of Joseph-Gaspard Chaussegros de Léry: An Account from Late 18th Century Quebec." *Silver Society of Canada Journal* 15 (20012), pp. 14–38.

Fox, Ross Allan C. *Presentation Pieces and Trophies from the Henry Birks Collection of Canadian Silver*. Exhibition catalogue. Ottawa: National Gallery of Canada, 1985.

Fox, Ross Allan C. *Quebec and Related Silver at the Detroit Institute of Arts*. Detroit: Wayne State University Press, 1978.

François Ranvoyzé, orfèvre, 1739–1819. Exhibition catalogue. Quebec City: Musée du Québec, 1968.

The French in America, 1520–1880. Exhibition catalogue. Detroit: Detroit Institute of Arts, 1951.

Fuhring, Peter. "Les dessins d'orfèvrerie." *Les orfèvres d'Orléans*. Exhibition catalogue. Paris: Somogy / Orléans: Musée des beaux-arts d'Orléans, 2003, pp. 142–179.

Gagné, Armand. "Turgeon, Pierre-Flavien." In *Dictionary of Canadian Biography*, vol. 9. Toronto: University of Toronto / Quebec City: Université Laval, 1976, pp. 797–800.

Galarneau, Claude. "Demers, Jérôme." In *Dictionary of Canadian Biography*, vol. 8, University of Toronto / Université Laval, 2003–. www.biographi.ca/en/bio/demers_jerome_8E.html (accessed 3 November 2017).

Galarneau, Claude. "Desjardins, Philippe-Jean-Louis." In *Dictionary of Canadian Biography*, vol. 6, University of Toronto / Université Laval, 2003–. www.biographi.ca/en/bio/desjardins_philippe_jean_louis_6E.html (accessed 3 November 2017).

Galarneau, Claude. "Dudevant, Arnaud-Germain." In *Dictionary of Canadian Biography*, vol. 4, University of Toronto / Université Laval, 2003–. www.biographi.ca/en/bio/dudevant_arnauld_germain_4E.html (accessed 3 November 2017).

Galarneau, Claude. "Monseigneur de Forbin-Janson au Québec en 1840–1841." In *Les ultra-montains canadiens-français. Études d'histoire religieuse présentées en hommage au professeur Philippe Sylvain*. Montreal: Boréal express, 1985, pp. 121–142.

Galarneau, Claude. "Neilson, Samuel." In *Dictionary of Canadian Biography*, vol. 7, University of Toronto / Université Laval, 2003–. www.biographi.ca/en/bio/neilson_samuel_1800_37_7E.html (accessed 3 November 2017).

Gardner Auctions Ltd., London, Ontario. *Catalogue of selected pieces of early furniture, Canadian and English silver…Canadian paintings … and other objets d'art personally assembled by the late Joseph H. Bauer… with additions from the… collections of the Misses Antoinette and Lucia Bauer… to be offered for sale by auction at the Crystal Ballroom, the King Edward-Sheraton Hotel… Toronto…on… June 15th, 16th, 17th 1965*. Toronto: Gardner Auctions Ltd., 1965.

Gilchrist, James. *Anglican Church Plate*. London: The Connoisseur & Michael Joseph, 1967.

Gillingham, Harold E. "The Old Silver of Quebec." *The Magazine Antiques*, March 1941, p. 114.

Glanville, Philippa. *Silver in England*. New York: Holmes & Meier, 1987.

Glanville, Philippa. "Women and Goldsmithing." In *Women Silversmiths, 1685–1845. Works from the Collection of the National Museum of Women in the Arts*. New York: Thames and Hudson, 1990, pp. 13–28.

Gosselin, Amédée Edmond. *Album-souvenir de la Basilique de Notre-Dame de Québec*. Quebec City: s.n., 1923.

Gosselin, Amédée Edmond. *Album-souvenir de la Basilique de Québec*. Quebec City: s.n., 1917.

Gosselin, David. *Bulletin paroissial de Charlesbourg pour l'année 1906*. Quebec City: Imprimerie H. Chassé, 1906.

Grandjean, Serge. *L'orfèvrerie du XIXe siècle en Europe*. Paris: Presses universitaires de France, 1962.

Grimwade, Arthur. "New Light on a Canadian Treasure: The Royal Communion Service of Quebec." *Country Life*, no. 177 (31 January 1985), pp. 268–273.

Gromier, Léon. *Commentaire du Caeremoniale épiscoporum*. Paris: Éditions du vieux colombier, 1959.

Gruber, Alain. *L'argenterie de maison: du XVIe au XIXe siècle*. Fribourg: Office du Livre, 1982.

Guillerme, André. *La naissance de l'industrie à Paris: entre sueurs et vapeurs, 1780–1830*. Seyssel: Editions Champ Vallon, 2007.

Hare, John E. "Joseph Quesnel et l'anglomanie de la classe seigneuriale au tournant du XIXe siècle." *Co-incidences* 6, no. 1 (January–February 1976), pp. 23–29.

Hare, John, Marc Lafrance and David-Thiery Ruddel. *Histoire de la ville de Québec, 1608–1871*. Montreal: Boréal / Hull: Canadian Museum of Civilization, 1987.

Harper, John Russell. "La Galerie de portraits de la Famille Hertel de Rouville." *Vie des arts* 12, no. 47 (summer 1967), pp. 16–22.

Hubbard, R.H. and Jean-René Ostiguy. *Three Hundred Years of Canadian Art*. Exhibition catalogue. Ottawa: National Gallery of Canada, 1967.

Hubert, Ollivier. *Sur la terre comme au ciel. La gestion des rites par l'Église catholique du Québec (fin XVIIe – mi-XIXe siècle)*. Sainte-Foy: Presses de l'Université Laval, 2000.

Hudon, Paul-Henri. *Rivière-Ouelle de la Bouteillerie: 3 siècles de vie*. Rivière-Ouelle: Comité du tricentenaire, 1972.

Hughes, G. Bernard. *Georgian Shoe Buckles*. London: Greater London Council, 1972.

Hughes, G. Bernard. "Pierced Silver Table Baskets." *Country Life* (10 November 1950), p. 1605.

Hughes, G. Bernard. *Sheffield Silver Plate*. New York/Washington: Praeger Publishers, 1970.

Hughes, G. Bernard. "The Story of English Maces." *Country Life* (8 August 1952), pp. 405–406.

Introduction to an Exhibition: "From Jacques Cartier to Confederation" or The Founding of Eastern Canada. Exhibition catalogue. Toronto: The Art Gallery of Toronto, 1941.

Jones, E. Alfred. "Canadian Art: Old Quebec Silver." *The Times* (London), no. 48137 (Friday 28 October 1938), p. 10.

Jones, E. Alfred. *The Loyalists of Massachusetts: Their Memorials, Petitions and Claims*. London: The Saint Catherine Press, 1930.

Jones, E. Alfred. "Old Church Silver in Canada." *Royal Society of Canada: Proceedings and Transactions*, third series, section 2, vol. 12 (1918), pp. 135–150.

Jones, E. Alfred. *The Old Silver of American Churches*. Letchworth, UK: Arden Press for the National Society of Colonial Dames of America, 1913.

Jones, E. Alfred. *Old Silver of Europe and America from Early Times to the Nineteenth Century*. London: D.T. Bashford Ltd., 1928.

Jones, E. Alfred. "The Old Silver of Quebec." *The Burlington Magazine for Connoisseurs* 30, no. 166 (January–December 1942), p. 155.

Jones, E. Alfred. "Silver in the Archbishop's Palace at Quebec." *International Studio* 97, no. 400 (September 1930), pp. 25–27 and 80.

Journal – Royal Architecture Institute of Canada 18, no. 3 (March 1941), p. 46. (report on the work of Traquair).

Kaellgren, Peter. "English Silver Baskets." *Antiques* (June 2000), pp. 940–947.

Karel, David. *Dictionnaire des artistes de langue française en Amérique du Nord*. Quebec City: Musée du Québec and Université Laval, 1992.

Kauffman, Henry. *The Colonial Silversmith: His Techniques and His Products*. Camden, NJ: Thomas Neilson, 1969.

Kirkman, Valerie E. and Hervé Gagnon. *Louis-François-George Baby: un bourgeois canadien-français du 19e siècle (1832–1906)*. Sherbrooke: GGC Éditions, 2001.

Koeppe, Wolfram. *Vienna circa 1780: An Imperial Silver Service Rediscovered*. Exhibition catalogue. New York: The Metropolitan Museum of Art / Yale University Press, 2010.

LaBrèque, Marie-Paule R. "Coffin, John." In *Dictionary of Canadian Biography*, vol. 5, University of Toronto / Université Laval, 2003–, www.biographi.ca/en/bio/coffin_john_1729_1808_5E.html (accessed 15 September 2014).

La Charité, Claude. "Les deux éditions du *Rituel du diocèse de Québec* de Mgr de Saint-Vallier, datées de 1703: de l'édition janséniste à l'édition revue et corrigée par la Compagnie de Jésus." *Revue de Bibliothèque et Archives nationales du Québec*, no. 3 (2011), "Histoire du livre, de l'imprimé et de l'édition."

Lahey, Anita and René Villeneuve. "In Dalhousie's Wake: Watercolours, Silver Cups, Monuments and Artists." *Vernissage* 10, no. 2 (spring 2008), pp. 8–11.

Lahey, Anita and René Villeneuve. "Pristine Prints Uncovered in Scottish Castle." *Vernissage* 8, no. 4 (fall 2006), pp. 16–18.

Lambert, James H. "Plessis, Joseph Octave." In *Dictionary of Canadian Biography*, vol. 6. Toronto: University of Toronto / Quebec City: Université Laval, 1987), pp. 506–59.

Lambert, Susan. *Pattern and Design: Designs for the Decorative Arts, 1480–1980.* London: Victoria and Albert Museum, 1983.

Langdon, John E. *American Silversmiths in British North America, 1776–1800.* Toronto: John E. Langdon, 1970.

Langdon, John E. *Canadian Silversmiths, 1700–1900.* Toronto: Stinehour Press, 1966.

Langdon, John E. *Canadian Silversmiths and Their Marks, 1667–1867.* Lunenburg, VT: Stinehour Press, 1960.

Langdon, John E. "Hanna, James Godfrey." In *Dictionary of Canadian Biography*, vol. 8, University of Toronto / Université Laval, 2003–. www.biographi.ca/en/bio/hanna_james_godfrey_8E.html (accessed 3 November 2017).

Lassam, Sylvia. "The Stracham Epergne." *Journal of the Silver Society of Canada* 15 (2012), pp. 32–38.

Laurent, Laval. *Québec et l'église aux États-Unis sous Mgr Briand et Mgr Plessis.* Montreal: Librairie Saint-François, 1945.

Lavallée, Gérard. *Les églises et le trésor de Saint-Laurent en l'Île de Montréal.* Saint-Laurent, QC: Musée d'art de Saint-Laurent, 1983.

Le Corbeiller, Clare. *European and American Snuff Boxes, 1730–1830.* New York: Viking Press, 1966.

Lefébure, Amaury. "L'orfèvrerie de la chapelle de Fontainebleau dans la première moitié du XIXe siècle." In *Objets d'art: mélanges en l'honneur de Daniel Alcouffe.* Dijon: Éditions Faton, 2004, pp. 286–297.

Lefebvre, Jacqueline. *L'abbé Philippe Desjardins, 1753–1833: un grand ami du Canada.* Quebec City: Société historique de Québec, 1982.

Legault, Roch. "Chaussegros de Léry, Louis-René." In *Dictionary of Canadian Biography*, vol. 6. Toronto: University of Toronto / Quebec City: Université Laval, 1987, pp. 133–134.

Letzer, Mark B. "William Faris's Silver and His Shop Designs." *Antiques* (March 2006), pp. 100–109.

Mabille, Gérard. *Orfèvrerie française des XVIe, XVIIe et XVIIIe siècles: catalogue raisonnée des collections du Musée des arts décoratifs et du Musée Nissim de Camondo.* Paris: Flammarion / Musée des arts décoratifs, 1984.

Marcil, Eileen Reid. *The Charley-Man: A History of Wooden Shipbuilding at Quebec, 1763–1893.* Kingston, ON: Quarry Press, 1995.

Marcil, Eileen Reid. *Tall Ships and Tankers: The History of the Davie Shipbuilders.* Toronto: McClelland & Stewart, 1997.

Mason, Shena, ed. *Matthew Boulton: Selling What All the World Desires.* New Haven and London: Yale University Press, 2009.

Morisset, Gérard. *Le Cap-Santé, ses églises et son trésor.* Quebec City: Médium, 1944.

Morisset, Gérard. *Le Cap-Santé: ses églises et son trésor* (revised and annotated edition). Montreal: The Montreal Museum of Fine Arts, 1980.

Morisset, Gérard. "Un chef-d'œuvre de François Sasseville." *Technique* (October 1942), pp. 526–539.

Morisset, Gérard. *Coup d'œil sur les arts en Nouvelle-France.* Quebec City: Charrier et Dugal, 1941.

Morisset, Gérard. "Coup d'œil sur les trésors artistiques de nos paroisses." *Société Canadienne d'histoire de l'Église catholique. Rapport* (1947–48), p. 62.

Morisset, Gérard. "Les églises de Kamouraska." In Alexandre Paradis, *Kamouraska 1674–1948.* Quebec City: s.n., 1948, pp. 317–341.

Morisset, Gérard. *Évolution d'une pièce d'argenterie.* Quebec City: Collection Champlain, 1943.

Morisset, Gérard. "L'instrument de paix." *Royal Society of Canada: Proceedings and Transactions,* third series, section 1, vol. 39 (May 1945), pp. 143–161.

Morisset, Gérard. "L'orfèvre François Sasseville." *Royal Society of Canada: Proceedings and Transactions,* third series, section 1, vol. 49 (June 1955), pp. 51–54.

Myers, R.M. and J.F. Hanlan. "The Compositional Analysis of French-Canadian Church Silver." *Bulletin of the National Gallery of Canada,* no. 21 (1973), pp. 22–33.

Noppen, Luc. "L'architecture intérieure de l'église Saint-Joachim de Montmorency: l'avènement d'un style." *Revue d'art canadienne* 4, no. 1 (1979), pp. 3–16.

Noppen, Luc. *Notre-Dame de Québec: son architecture et son rayonnement (1647–1922).* Quebec City: Éditions du Pélican, 1974.

Noppen, Luc. "Le rôle de l'abbé Jérôme Demers dans l'élaboration d'une architecture néo-classique au Québec." *The Journal of Canadian Art History / Annales d'histoire de l'art canadien* 2, no. 1 (summer 1975), pp. 19–33.

Noppen, Luc and Lucie K. Morisset. *La présence anglicane à Québec: Holy Trinity Cathedral.* Sillery, QC: Septentrion, 1995.

Noppen, Luc and René Villeneuve. *Le trésor du Grand Siècle: l'art et l'architecture du XVIIe siècle à Québec.* Exhibition catalogue. Quebec City: Musée du Québec, 1984.

Normand, Sylvio. "Hanna, James G." In *Dictionary of Canadian Biography*, vol. 5, University of Toronto / Université Laval, 2003–, www.biographi.ca/en/bio/hanna_james_g_5E.html (accessed 9 November 2017).

Oman, Charles. "A Problem of Artistic Responsibility: The Firm of Rundell, Bridge & Rundell." *Apollo* 83 (March 1966), pp. 174–183.

Pleasants, J. Hall and Howard Sill. *Maryland Silversmiths, 1715–1830.* Harrison, NY: Robert Alan Green, 1972.

Pothier, Bernard. "Sigogne, Jean-Mandé." In *Dictionary of Canadian Biography*, vol. 7, University of Toronto / Université Laval, 2003–, www.biographi.ca/en/bio/sigogne_jean_mande_7E.html (accessed 29 July 2013).

Precious Metals: Historic Silver from Newfoundland Churches. Exhibition catalogue. St. John's: Art Gallery of Newfoundland and Labrador, 1997.

Provost, Honorius. "Sorbier de Villars, François." *Dictionary of Canadian Biography*, vol. 4, University of Toronto / Université Laval, 2003–, www.biographi.ca/en/bio/sorbier_de_villars_francois_4E.html (accessed 7 March 2013).

Redfearn, Jerome. *Indiana Silversmiths, Clock Makers and Watchmakers, 1779–1900.* Georgetown, KY: Americana Publications, 1984.

Regency Domestic Silver. London: Her Majesty's Stationery Office, 1952.

Robitaille, Paul. "Louis Robitaille, Orfèvre." *Michigan's Habitant Heritage* 35, nos. 2 and 3 (April and July 2014), n.p.

Roy, Elias. *Mgr Lionel St-George Lindsay.* Lévis: La Cie de publications de Lévis, 1921.

Roy, Pierre-Georges. *La famille Chaussegros de Léry.* Lévis: s.n., 1934.

Roy, Pierre-Georges. "La famille Coffin." *Bulletin des recherches historiques* 40, no. 4 (April 1934), pp. 229–232.

Roy, Pierre-Georges. "La famille Lajus." *Bulletin des recherches historiques* 40, no. 4 (April 1934), pp. 243–247.

Roy, Guy-André and Andrée Ruel. *Le patrimoine religieux de l'Île d'Orléans.* Quebec City: Ministère des Affaires culturelles, 1982.

Ruddell, David-Thierry. *Québec, 1765–1832: l'évolution d'une ville coloniale.* Hull: Canadian Museum of Civilization, 1991.

Saint-Pierre, Serge and Robert Côté. *La fonction commerciale de Place Royale entre 1820 et 1860: Synthèse.* Quebec City: Ministère des Affaires culturelles, 1990.

Sandon, Henry. *Flight and Barr Worcester Porcelain, 1783–1840.* London: The Antique Collector's Club, 1978.

Seaby, W.A. and R.J. Hetherington. "The Matthew Boulton Pattern Books," parts 1 and 2. *Apollo* 51 (February and March 1950), pp. 48–50 and 78–80.

A Selection from the Louis Carrier Collection of Canadian Silver. Exhibition catalogue. Windsor: Willistead Art Gallery, 1953.

Signaÿ, Joseph. *Recensement de la ville de Québec en 1818.* Quebec City: La société historique de Québec, 1976.

Silversmith of Williamsburg. Video. Williamsburg, VA, Colonial Williamsburg Foundation, 2008 [c. 1971].

Snodin, Michael. "J. Boileau: A Forgotten Designer of Silver." *Connoisseur* 198, no. 196 (June 1978), pp. 124–133.

Snodin, Michael. "Matthew Boulton's Sheffield Plate Catalogues." *Apollo* 126 (July 1967), pp. 25–32.

Snodin, Michael and Maurice Howard. *Ornament. A Social History since 1450.* London: Victoria and Albert Museum / London and New Haven: Yale University Press, 1996.

Snowman, Abraham Kenneth. *Eighteenth Century Gold Boxes of Europe.* Woodbridge: Antique Collector's Club, 1990.

Sotheby's & Co. *Catalogue of Fine English and Foreign Silver and Plate.* London, 2 July 1970.

Swan, Conrad. *Canada: Symbols of Sovereignty.* Toronto and Buffalo: University of Toronto Press, 1977.

Tabatières en or: dessins et modèles de Musée des arts décoratifs. Paris: Réunion des musées nationaux / Seuil, 1994.

La table d'un roi: l'orfèvrerie du XVIIIe siècle à la cour de Danemark. Paris: Ministère des affaires étrangères, 1987.

Taylor, Clive. "George Smith of Huggin Lane: A Georgian Silver Bucklemaker." *Silver Studies: The Journal of the Silver Society,* no. 26 (2010), pp. 60–68.

Taylor, Gerald. *Continental Gold and Silver.* London: The Connoisseur and Michael Joseph, 1967.

Telfer, W. "Edward Alfred Jones." *The Cambridge Review* (13 November 1943), p. 74.

Têtu, Henri. "L'abbé André Auclair, curé de Québec 1807–1814." *Bulletin des recherches historiques* 13, no. 1 (January 1907), pp. 3–22.

Têtu, Henri. *Histoire du palais épiscopal de Québec.* Quebec City: Pruneau & Kirouac, 1896.

Thibault, Claude. "Gérard Morisset, conservateur du Musée de la Province de Québec (1953–1965)." In *À la découverte du patrimoine avec Gérard Morisset*. Exhibition catalogue. Quebec City: Ministère des affaires culturelles, 1981, pp. 46–56.

Thibault, Claude. *Trésors des communautés religieuses de la ville de Québec*. Quebec City: Éditeur officiel du Québec, 1973.

Thomson, A.S. "Canadian Silversmiths." *Canadian Collector* (February 1967), p. 12.

Thuile, Jean. *Trésors d'orfèvrerie des églises du Roussillon et du Languedoc méditerranéen*. Carcassone: Église Saint-Nazaire, 1954.

Tousignant, Pierre and Madeleine Dionne-Tousignant. "Hertel de Rouville, René-Ovide." In *Dictionary of Canadian Biography*, vol. 4, University of Toronto / Université Laval, 2003 , www.biographi.ca/en/bio/hertel_de_rouville_rene_ovide_4E.html (accessed 12 February 2016).

Traquair, Ramsay. *The Old Silver of Quebec*. Toronto: Macmillan, 1940.

Trésors de ferveur: reliquaires à papier roulés des XVIIème, XVIIIème, XIXème siècles: actes de la journée d'étude du 24 septembre 2004. Exhibition catalogue. Chalon-sur-Saône: Association trésors de ferveur, 2005.

Trudel, Jean. "Sasseville, François." In *Dictionary of Canadian Biography*, vol. 9. Toronto: University of Toronto / Quebec City: Université Laval, 1976, pp. 701–702.

Trudel, Jean. *Silver in New France*. Exhibition catalogue. Ottawa: National Gallery of Canada, 1974.

Trudelle, Charles. *Paroisse de Charlesbourg*. Quebec City: Imprimerie Générale A. Côté et Cie, 1887.

Tuotoy, Alexandre. *Répertoire général des sources manuscrites de l'histoire de Paris pendant la révolution français*, vol. 6. Paris: Imprimerie nouvelle, 1890.

Turner, Eric. "Les substituts de l'argent aux XVIIIe et XIXe siècles." In *Orfèvrerie au XIXe siècle*. Proceedings of an international colloquium held at the Galeries nationales du Grand Palais, 12–13 December 1991. Paris: La documentation française, 1994, pp. 137–143.

Les Ursulines de Trois-Rivières: depuis leur établissement jusqu'à nos jours, vol. 3. Montreal: A.P. Pigeon, 1898.

Vallières, Nicole. *Art et techniques de l'orfèvrerie aux XVIIIe et XIXe siècles*. Exhibition catalogue. Montreal: Musée d'art de Saint-Laurent, 1984.

Vallières, Nicole. "Les outils et les techniques des orfèvres au Québec: période pré-industrielle." Master's thesis, Université du Québec à Montréal, 1985.

Veitch, Henry Newton. *Sheffield Plate, Its history, manufacture and art*. London: George Bell and Sons, 1908.

Villeneuve, René. "Amiot, Laurent." In *Dictionary of Canadian Biography*, vol. 7, University of Toronto / Université Laval, 2003–. www.biographi.ca/en/bio/amiot_laurent_7E.html (accessed 3 November 2017).

Villeneuve, René. "Art Speak: Neoclassicism." *Vernissage* 6, no. 1 (winter 2004), p. 27.

Villeneuve, René. *Baroque to Neo-Classical: Sculpture in Quebec*. Ottawa: National Gallery of Canada, 1998.

Villeneuve, René. "A Canadian Masterpiece." *Journal of the Silver Society of Canada* 17 (2014), pp. 16–17.

Villeneuve, René. *Le cœur du trait-carré: les églises de Charlesbourg*. Quebec City: Éditions du Pélican, 1986.

Villeneuve, René. "Drawings by Silversmiths: Reflections on Some Key Works from Nineteenth-Century Quebec." *National Gallery of Canada Review* 4 (2013), pp. 149–158.

Villeneuve, René. "A Ewer by Laurent Amiot." *City and Country Home* 7, no. 4 (May 1988), p. 48.

Villeneuve, René. "François Ranvoyzé, Silversmith: Patronage from the Church at L'Islet-sur-mer." *Journal of the Silver Society of Canada* 11 (2008), pp. 22–32.

Villeneuve, René. "John Bridge, for Rundell, Bridge & Rundell: Drummond Cup, 1830–1831." In *Hidden Treasures from the Bytown Museum*. Ottawa: Bytown Museum, 2011, pp. 28–31.

Villeneuve, René. "Lafrance, Ambroise." In *Dictionary of Canadian Biography*, vol. 13. Toronto: University of Toronto / Quebec City: Université Laval, 1994, pp. 563–564.

Villeneuve, René. "La licorne argentée de Laurent Amiot." *Vernissage* 3, no. 1 (winter 2001), pp. 34–35.

Villeneuve, René. *Lord Dalhousie: Patron and Collector*. Exhibition catalogue. Ottawa: National Gallery of Ottawa, 2008.

Villeneuve, René. "Orfèvrerie ancienne." In *Le Musée du Québec: 500 œuvres choisies*. Exhibition catalogue. Quebec City: Musée du Québec, 1983, pp. 307–342.

Villeneuve, René. "Orfèvrerie de l'église de la Purification-de-la-Bienheureuse-Vierge-Marie." In *Les chemins de la mémoire*, vol. 3, *Biens mobiliers du Québec*. Quebec City: Les publications du Québec, 1999, p. 238.

Villeneuve, René. "Orfèvrerie de l'église Notre-Dame-de-Bonsecours." In *Les chemins de la mémoire*, vol. 3, *Biens mobiliers du Québec*. Quebec City: Les publications du Québec, 1999, pp. 105–108.

Villeneuve, René. "Orkney, James." In *Dictionary of Canadian Biography*, vol. 6. Toronto: University of Toronto / Quebec City: Université Laval, 1987, pp. 556–557.

Villeneuve, René. *Quebec Silver from the Collection of the National Gallery of Canada*. Exhibition catalogue. Ottawa: National Gallery of Canada, 1998.

Villeneuve, René. "A Scottish-born Silversmith in Montreal: Robert Cruickshank." In Peter E. Rider and Heather McNabb, eds. *A Kingdom of the Mind: How the Scots Helped Make Canada*. Montreal and Kingston: McGill-Queen's University Press, 2006, pp. 137–148.

Villeneuve, René. "La terrine du seigneur Hertel de Rouville." *Ornamentum* 34, nos. 1-2 (spring/summer 2017), pp. 27–31.

Visser, Margaret. *The Rituals of Dinner: The Origins, Evolution, Eccentricities and Meaning of Table Manners*. Toronto: Harper Collins Publishers, 1991.

Vitali, Ubaldo. "Retooling for the Rococo: Assembling the Complex Network of Talents, Skill and Language to Express the New Style." In Ellenor M. Alcorn, ed. *Rococo Silver in England and Its Colonies: Papers from a Symposium at Virginia Museum of Fine Arts, Richmond, 2004*. London: The Silver Society, 2006, Silver Studies series, no. 20, pp. 72–85.

Voisine, Nive. "Panet, Bernard-Claude." In *Dictionary of Canadian Biography*, vol. 6, University of Toronto / Université Laval, 2003–, www.biographi.ca/en/bio/panet_bernard_claude_6E.html (accessed 26 June 2015).

Wallot, Jean-Pierre. *Un Québec qui bougeait: trame socio-politique du Québec au tournant du XIXe siècle*. Montreal: Éditions du Boréal Express, 1973.

Ward, Gerald W.R., Patricia E. Kane and Helen A. Cooper. *Francis P. Garvan, Collector*. New Haven: Yale University Art Gallery, 1980.

Watts, Florence. "Antoine Oneille of Vincenne." *The Magazine Antiques* (July 1958), p. 60.

Webster, Donald Blake. "Growing Collection: Silver Tureen Acquired by Canadiana Department." *Rotunda* (ROM magazine) 26, no. 2 (fall 1993), pp. 5–6.

Wees, Beth Carver and Medill Higgins Harvey. *Early American Silver in the Metropolitan Museum of Art*. New York: The Metropolitan Museum of Art, 2013.

Weller, Michael J. "A New Pitcher from the Missouri Frontier." *Silver Magazine* 30, no. 6 (1998), pp. 54–58.

Whitfield, Carol M. and Wesley B. Turner. "Sheaffe, Sir Robert Hale." In *Dictionary of Canadian Biography*, vol. 8, University of Toronto / Université Laval, 2003–. www.biographi.ca/en/bio/sheaffe_roger_hale_8E.html (accessed 3 November 2017).

Woodward, Arthur. "Highlights on Indian Trade Silver." *The Magazine Antiques* (June 1945), pp. 328–331.

Wurtele, Fred. C. "Silver Communion Plate at Quebec." *The Gazette* (Montreal) 147, no. 305 (21 December 1918), p. 14.

LENDERS TO THE EXHIBITION

Archidiocèse de Québec, Quebec City

Canadian Museum of History, Gatineau, Quebec

Église Sainte-Marie, Pointe-de-l'Église, Nova Scotia

Fabrique de la Purification-de-la-Bienheureuse-Vierge-Marie, Repentigny, Quebec

Fabrique Notre-Dame de Québec, Quebec City

Fabrique Saint-Ambroise-de-la-Jeune-Lorette, Loretteville, Quebec

Fabrique Saint-Charles-Borromée, Quebec City

Fabrique Saint-Charles, Saint-Charles-de-Bellechasse, Quebec

Fabrique Sainte-Famille de Cap-Santé, Cap-Santé, Quebec

Fabrique Saint-Jean-Port-Joli, Saint-Jean-Port-Joli, Quebec

Fabrique Saint-Joachim, Saint-Joachim-de-Montmorency, Quebec

Fabrique Saint-Marc, Saint-Marc-sur-Richelieu, Quebec

Fabrique Saint-Michel, Saint-Michel-de-Bellechasse, Quebec

Library and Archives Canada, Ottawa

McCord Museum, Montreal

The Metropolitan Museum of Art, New York

Montreal Museum of Fine Arts, Montreal

Musée de la civilisation, Quebec City

Musée des maîtres et artisans du Québec, Montreal

Musée des Ursulines de Québec, Quebec City

Musée national des beaux-arts du Québec, Quebec City

National Gallery of Canada, Library and Archives, Ottawa

Private collections

Royal Ontario Museum, Toronto

Victoria and Albert Museum, London, UK

Winterthur Museum, Garden and Library, Wilmington, Delaware